Travel Photography

A Complete Guide to How to Shoot and Sell

Susan McCartney

SECOND EDITION

© 1999 Susan McCartney

All rights reserved. Copyright under Berne Copyright Convention, Universal Copyright Convention, and Pan-American Copyright Convention. No part of this book may be reproduced, stored in a retrieval system, or transmitted in any form, or by any means, electronic, mechanical, photocopying, recording, or otherwise, without prior permission of the publisher.

05 04 03 02 01 00 99 5 4 3 2 1

Published by Allworth Press An imprint of Allworth Communications 10 East 23rd Street, New York NY 10010

Cover design by Douglas Design Associates, New York, NY

Page composition/typography by Sharp Des!gns, Lansing, MI

ISBN: 1-58115-011-3

Library of Congress Catalog Card Number: 98-72762

Printed in Canada

This book is dedicated to the memory of my mother.

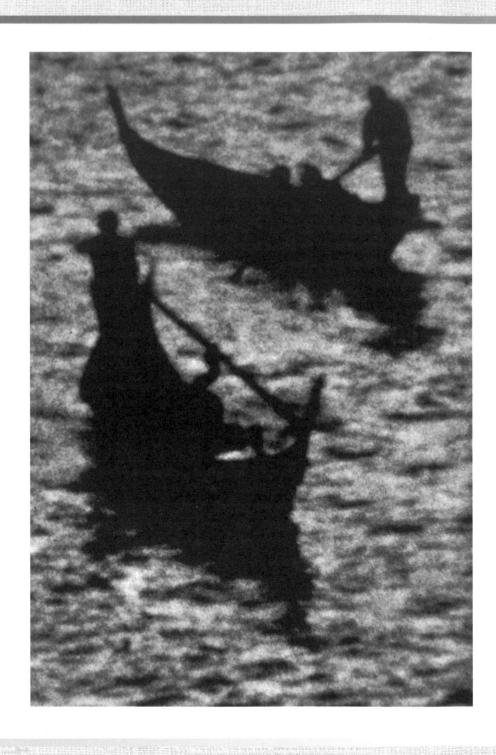

Contents

	List of Illustrations	vii
	Acknowledgments	ix
	Introduction	xi
1	The Pleasures, Realities, and Business of Travel Photography	1
2	Travel Photography Skills	13
3	Equipment: Cameras, Lenses, and Accessories	25
4	Exposure and Metering	43
5	Films, Filters, and Gels	53
6	Daylight and Available Light	71
7	Photographic Lighting	85
8	People, Landscape, Architecture, and Location Still Life	111
9	Ten Travel and Location Self-Assignments	123
10	Editing, the Portfolio, and Self-Promotion	139
11	The Computer, Digital Imaging, and the Internet for Photographers	153
12	Magazine, Editorial, and Tourism Photography	165
13	The Stock Photo Business	183
14	Location Photography	205

15	Planning and Preparing for the Travel Shoot	213
16	The Travel Shoot	229
17	Visual Travel Highlights: North, Central, and South America	243
18	Visual Travel Highlights: Europe, the Middle East, and Africa	263
19	Visual Travel Highlights: Asia and the Pacific	287
20	Releases	305
	Appendix: Resources	321
	Bibliography	329
	Index	333

List of Illustrations

Gondolas: Venice Illustrated Man; Coney Island, New York Bodiam Castle; Sussex, England Actress, Chinese Opera Academy; Taiwan Saguaro National Monument; Arizona King Vulture; Ecuador Ruby Beach, Olympic National Park; Washington Officer, Khyber Rifles; Pakistan Dentist; Peshawar, Pakistan Chefs, Savoy Hotel; London Landscape; South Dakota Regency Hotel; Hong Kong Robert Bushyhead, Chief Cherokee; N.C. Statue of Liberty and Moon Montage; New York Dolomite Valley; Switzerland Harrods at Christmas; London Oil Storage Tanks; New Jersey Monastery; Corfu, Greece Harvest in High Tyrol; Austria Indian Women and Weavings; Otavalo, Ecuador Elephants; Tsavo West National Park, Kenya House of the Humble Administrator; Souzhou, China Three Great Grandmothers; Île d'Ouessant, Brittany, France Langdale Valley; Lake District, England Ackee Fruit; Jamaica, West Indies

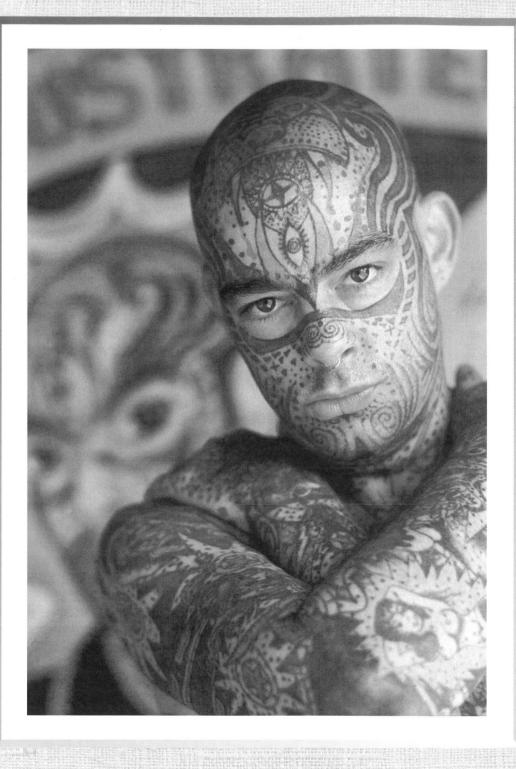

Acknowledgments

hanks to the following photographer colleagues, computer and lighting experts, stock agents, and friends: AGE Fotostock, Van Bucher, Andrew Child, Jon Falk, Les Fincher, Patricia and Wayne Fisher, Michal Heron, Phillip and Edith Leonian, David Milne, A. J. Nye, Jim Pickerell, Richard Steedman, and Bug Sutton, who were all most generous with information and suggestions, and have contributed much to the book.

Publisher Tad Crawford vetted legal aspects and is always supportive. Many others, including students and equipment and film manufacturers, helped both directly and indirectly. I thank them all. Any errors that have crept in despite my best efforts are entirely my own.

Introduction

'm happy that the first edition of this book was popular enough to warrant a revised edition. Here I've rewritten most chapters and updated all factual information. Because the field of stock photography has changed dramatically in the last few years, I have interviewed some top experts about stock strategies. I've added a chapter on the computer and the travel photographer, discussed digital photography with an expert and included the URLs (Internet addresses) of many useful travel related Web sites.

The success of the book has enabled me to visit places new to me, so new information and suggestions are included in the chapters on visual travel highlights and outdated information has been deleted. As before, there are model releases in twenty-nine languages that you can copy and use, diagrams, a list of useful resources, a bibliography, and a detailed index. Each chapter of the book is self-contained and can be read in any order that interests you. I have not received any financial or other considerations for listing or recommending anything.

I hope that this new book will be of value to all photographers seriously interested in travel, and I wish all my readers great travel experiences, great picture taking, and great success on your own terms.

SUSAN MCCARTNEY
New York City

The Pleasures, Realities, and Business of Travel Photography

f you're anything like me, travel is a necessity, not a luxury. I'm willing to go almost anywhere at the drop of a hat. I think of airport security checks, long waits at highway tollbooths, or dragging my gear through porterless railroad stations or ferry terminals as preludes to new adventures, not trials. Travel doesn't have to be first class, hotels deluxe, the food gourmet, or the weather perfect (though all those things are most enjoyable) because seeing new places and people, experiencing new cultures, rediscovering favorite haunts, and making the best possible photographs of all these things are what count.

The Pleasures of Travel

Professional travel photography is creative, often glamorous, varied, exciting, and artistically rewarding, and almost always interesting. I've climbed the Great Wall in China and Hadrian's Wall in Britain, and in cold war times photographed Soviet pilgrims at the Kremlin Wall paying their respects to Lenin. I've whizzed on the bullet train to Mount Fuji and the Eurostar between London and Paris. I've photographed the Taj Mahal by moonlight, sound and light shows at the Pyramids and the Parthenon, and the wonderful neon excesses of Las Vegas. I've been alone at the temples of Angkor Wat and once set up a special performance of the Monkey Dance in a Balinese village, directing a cast of hundreds. I have seen fighting elephants, herds of giraffe at sunset, and the great migration of zebra and wildebeest in Kenya, waited patiently on a chilly platform in Alaska for bears to catch salmon, and observed blue-footed boobies doing their courting on a hot rock on the Galápagos Islands off Ecuador. I've been moved by the piety of faithful Jews at the Western Wall, watched devout Muslims pray at one of the world's great mosques in Pakistan, and floated down the holy Ganges river photographing thousands of Hindu pilgrims making their ablutions from the steps lining the western bank.

I've photographed great actors at Stratford-upon-Avon and the Noh theater in Tokyo (as well as quite a few good and bad actors in off and off-off-Broadway theaters. I've made portraits of hairy old-timers in copper mining towns in Arizona, business executives in

Ohio, blond surfing gods and goddesses on the beach at La Jolla, and charming Indian kids in New Mexico. I've had tea with eccentric nobles in England and drunk too much ouzo with fisherman at an impromptu street party in a tiny village on Santorini (and had my legs rubbed raw laboring up the cliffs there on a balky donkey).

I've been seasick on cruise ships, catamarans, and coracles. I've slept in beds where royalty preceded me—and also in public bath houses, airports, and train stations when connections or reservations were glitched. I've dined at the three-Michelin-starred Auberge de l'Ill in Alsace and the star-studded Savoy Grill in London, eaten salt cod stew in a fisherman's house in Newfoundland, forced down a few bites of grilled intestines at a barbecue in Argentina (it would have been impolite to refuse), and had food poisoning after eating delicious couscous in one of the best restaurants in Morocco. Of course I've also endured innumerable cheap highway and motorway rest-stop meals.

Glamorous or not, 95 percent of those experiences have been paid for by clients. I'm not rich, but I make a fair living. I'd have to be a millionaire to have done those things without my cameras. So to me it's well worth the occasional headache.

The Realities of Travel

Travel satisfies complex fantasies for most of us, but there are realities too. Photographers who haven't yet traveled much think that if only they could go to some historic, exotic, scenic, or remote places like Siena, Peshawar, Alaska, or the outback, they would immediately start taking wonderful pictures. Photographers who have been to those places will tell you that's not true, it's just as easy to take boring pictures in Bangkok as it is in Brooklyn (both are highly photogenic in their own fashion). The Australian outback sounds romantic—and it is in some ways—(read Bruce Chatwin's book *The Songlines* for the legends and history). Much of the region, though, is flat, with endless vistas of red stones, red dust, and scraggly bushes; it's usually broiling hot and hard to do much with visually. If you can make good pictures of people, places, and things close to home, wherever that is, you can certainly create fine pictures when you travel. The photographic advantage of being in unfamiliar places is mainly that you don't take anything for granted.

More than a hundred years ago, Marcel Proust wrote what I think of as the last word on what it takes to be a good travel photographer. He said: "The real voyage of discovery is not in seeing a new landscape, but in seeing with new eyes."

To make fine travel pictures anywhere, you need a sensitivity to people and different cultures; an appreciation of light and of landscape in all its forms; a sense of what makes a place unique, and of what makes it universally appealing.

What Is Professional Travel Photography?

To work in photography is very different from shooting only when you feel like it. Professional travel photography is almost always done to "sell" a place, sometimes it's a hard sell and sometimes a soft, but it's nonetheless "commercial" photography. You are not working just to please yourself, but also to please the person or organization who sent you there. This client has definite feelings about what you should bring back or specific photographic needs that have to be filled. To do professional travel assignments, you must be master of your equipment, well organized, and usually have a specific advance plan of what has to be photographed. You must be able to summarize, select, distill, and interpret your

impressions, and guide your ultimate audience. Ideally, your audience will visit the country, region, or resort vicariously through your pictures. You must convey to your viewers positive emotions that make them feel how historic or luxurious or adventurous it must be in Scotland or Sanibel or Shanghai and, most especially, make them want to go to those places too.

To accept paid assignments—a big responsibility—you will have to hone your photographic skills so that they become second nature, in order to leave yourself free to concentrate on the important things, which are aesthetics and logistics. Pianists don't get to be concert pianists without long hours of practice, and the same is true for photographers who want to do the best possible professional work. I'm not of course talking about just selling the odd picture occasionally, which almost anyone can do with luck, but about making a decent living in travel, tourism, and location photography.

How Does a Professional Travel Photographer Get Started?

Unless your cousin is an art director who loves your work, it's almost a given that you will have to travel before seeking paid travel assignments. You won't be credible unless you have done so. You must have a portfolio of travel-related pictures. If you haven't yet been far afield, refine your aesthetic and your approach to travel, and work out any bugs in your equipment through visiting and photographing the next town or county (which, of course, may well be a travel destination for someone from far away). Without involving yourself in great expense, you can photograph the travel basics—landscapes, interesting people, and major attractions—in different light and weather.

Try to see even familiar places with fresh eyes. No matter where you live, nearby are unspoiled landscapes, historic or important new buildings, and good-looking, characterful, accomplished people. Tourist attractions of greater or lesser magnitude exist everywhere, as do farms and outdoor markets, local celebrations, pockets and regions where people of different cultures live and work. There are also museums, churches, temples, mosques, historic homes, restaurants, stores, and hotels where you can refine your sense of interior lighting and shoot still lifes or set up scenes for the commercial side of travel photography.

It may help to pretend to be an Icelandic or Indonesian photographer, who has never been to the place before. When you see your own region with the eyes of a foreigner, you will find a surprising number of subjects.

A good travel photographer should seek out back roads as well as the best-known places. Most of all, people bring any travel subject to life. Farmers, fishermen, shopkeepers, local notables, artists, craftspeople, performers, elders, anyone in a colorful outfit or uniform are all excellent "travel" subjects.

When photographing people, don't just focus on the quaint or exotic. "Ordinary" people are wonderful subjects too. Tight telephoto shots of faces are okay, and can be powerful, but it's often more revealing to use a wide-angle lens and show the surroundings in a travel portrait. Include the mountain behind the ski instructor, the historic inn as well as the innkeepers, the freckled kid with the blue ribbon and her prize cow at the county fair, the honeymooners and the lake or beach. Move in closer for shots of craftspeople; show faces plus hands, painting, weaving, hammering, or whatever. That way, viewers will get an intimate portrait plus a good look at what is being created.

Communicating well with people of all kinds is perhaps the most important skill a travel

photographer can possess. You may be personally shy, as I am, but you will find that your camera in some way uninhibits you—it's rather like wearing a mask—and with the camera's protection you can approach, talk to, and photograph most people quite easily. Approach strangers slowly, as though they were small frightened animals (which most of us are, deep inside), or as if you were moving in on someone you fancied at a cocktail party. If you act aggressively, you scare people off. Read facial and bodily reactions to see how close you can approach. After a while it's not too hard to do. I'm probably best known for my people pictures. I take a lot of my favorite ones with a 28mm lens, from a few feet away. I want a feeling of intimacy. It usually takes at least half an hour of talking to and photographing someone (whether you speak her language or not!) to get close—within three or four feet.

Speaking of languages, these are a great advantage to any travel photographer but are not essential—you can also communicate well with smiles, hands, gestures, and through friends, guides, and interpreters!

What Makes a Good Travel Photograph?

John Lewis Stage, a classic travel and people photographer, once said to me, "What clients ultimately pay for is one's taste." Taste is a loaded word, yet not to address the subject is to avoid an extremely important issue. Good taste for everyone is what they like; bad taste is what they don't like. But there are acknowledged masters in photography as well as all the arts, and if your aim is to do the best possible professional work, you need and can acquire standards for taste—an artistic frame of reference if you will—as well as technical and seeing skills.

All ambitious photographers should see and study as much great original work as possible by visiting museums and galleries, by joining and attending meetings of professional photographers' associations, and by talking to people who are working in their field of interest. Fine-art photography books, top travel magazines, avant-garde magazines, promotional directories, and some of the best stock catalogs will give you many points of view, styles, and tastes. You will have to decide what you truly like, and where your own taste lies.

Technical Requirements of Professional Travel Photographs

Good travel photographs are technically well composed (the picture frame is filled elegantly or interestingly), exposed the way the photographer wants it (this usually means rich color, or a full range of black to white tones), and not unintentionally blurred. The blurred or partially out of focus pictures you may see in some trendy travel magazines are intentionally that way—photographers are always seeking new ways to express themselves.

If you still have to struggle with some points of technique, don't despair or be embarrassed. Some people have more facility than others, but if you persist you will get the hang of it all eventually. I am one photographer who had to work hard to understand the mysteries of f-stops and reciprocity and flash synchronization, and after exposing many thousands of rolls of film I still need to shoot all the time to keep in peak practice. (I strongly recommend that people who still need to improve basic technical skills take photography courses with good instructors—such courses are offered now in high schools, community colleges, and art schools almost everywhere—and practice continually till you've got technique licked.)

Aesthetic Requirements of Good Travel Photographs

Good travel photographs reveal something about the photographer as well as about the subject. It is important to take time to photograph what personally interests you, not just what an assignment dictates or stock agent or class calls for. I like artists, for instance, and always try to seek them out when I travel. I ask for introductions to local artists, especially "folk" or "primitive" artists. I find out about and attend current exhibits, try to go anywhere else artists are in evidence, and include artists and their work in my coverage of a place wherever possible. (One day perhaps someone will make use of these photographs of artists. If not, talking to many painters and seeing their work has enriched my life as a different kind of artist.)

If you are still unsure about how to approach a serious travel subject, you might consider taking a travel photography workshop. Some are given in lovely locations and are a good way to sharpen your seeing, assess your interests and strengths, develop your point of view and (kindly I hope) compare your work with that of others. Some individual travel photographers give workshops, and some photography schools give travel-related courses. (See the end of this chapter.)

A Brief History of Travel Photography

Try to get a chance to look at originals of early travel pictures. There are superb photography collections in the Metropolitan Museum and the Museum of Modern Art in New York and the National Gallery of Art in Washington, D.C. The Amos Amon Carter Museum in Fort Worth, Texas; the George Eastman House in Rochester, New York; the Victoria and Albert Museum in London; and the Musée d'Orsay in Paris have outstanding photo archives. Many other museums around the world have good photography collections. If you can't get to see originals, look at photo books.

A book I own and love is *Masters of Early Travel Photography*, by Rainer Fabian and Hans Christian Adam. You may be able to find a copy at a photo bookstore; it is available through the Internet. Also worth owning are *The Art of Photography at National Geographic*, and *A World History of Photography*, by Naomi Rosenblum. Both include historic travel pictures.

All old pictures are fascinating as historic records; some are awe inspiring when you consider both what the photographers had to do first to get there and then to make them. Many historic travel pictures that survive are masterpieces—beautiful, evocative, and powerful on any terms.

Serious travel photography began a very few years after the invention of photography itself, in 1839. Following other French photographers, Maxime Du Camp set out from Paris in 1849 with immense amounts of equipment, and a neurotic friend, the novelist Gustave Flaubert, to make a calotype (paper negative) record of the antiquities of Egypt. Du Camp's pictures of the Pyramids and Sphinx, the ruins of Abu Simbel, and assorted hieroglyphics were individually printed and bound and issued in Paris. This was probably the first travel photo book, and it was very successful. Du Camp was quickly followed by the Briton Francis Frith, who traveled up Egypt till he reached the Fifth Cataract of the Nile. He used the collodion process and wrote about the difficulties of working with damp glass plates in blowing sand and 125-degree heat!

In the 1860s another Englishman, John Thompson, went to China and spent four exhaustive years traveling and photographing the people, customs, costumes, landscape, and architecture of that still enigmatic land. Italian-born Felice Béato made beautiful landscapes

and portraits of Japan (then still closed to the world) in the 1870s and 1880s. With the opening of the American West, William Henry Jackson, Edweard Muybridge (who was British born), Timothy O'Sullivan, and Carleton Watkins were the most famous of many American photographers who first recorded on film the glories of some of the most magnificent scenery in the world.

We who view great events from all over—even from space—are entertained by movies and sitcoms made in spectacular locales everywhere and need only money to get almost anywhere around the globe in a dozen or so hours. We cannot possibly appreciate the sensation those early travel photographs created. In the nineteenth century, despite railroads, a trip of a hundred miles from home was a major undertaking to most people. Steriopticon "views" (of famous sights photographed with a horizontal twin-lens camera and mounted together) were all the rage in middle- and upper-class households in Europe and America, bringing the distant world into people's homes.

We can still admire many old travel photographs as enduring classics of composition, light and mood, and interest in and respect and feeling for other cultures. These things are what make great travel photographs.

Modern Masters

In the twentieth century, Ansel Adams (look at the way he uses backlighting on landscapes); Henri Cartier Bresson (best known for catching people at the decisive moment); Bill Brandt (who made incredible images of industrial and literary Britain as well as great nudes and portraits); Brassaï (unbelievable how he got so close to the people of underworld Paris); and Ernst Haas (a superb colorist, interpreter of place, and nature photographer) are my personal gods. Two masters who take wonderful travel (and other) photographs in different styles are Arnold Newman (who invented the environmental portrait) and John Lewis Stage (who has a relaxed, easy way with people and landscape). The work of both of them for *Holiday* magazine in the 1960s (when I was starting to "see") was an inspiration to me. Some other travel photographers I admire are: William Albert Allard, Carol Beckwith, Jim Brandenburg, Jay Maisel, Mary Ellen Mark, Joel Meyerowitz, David Muench, Martin Parr, Jake Rajs, Raghubir Singh, and Galen Rowell. (See the bibliography for a few book suggestions.)

Personal Travel Photography for Fine Art and Fun

Some of my friends are accomplished amateur photographers. They established other careers early and have no wish, or no need, to make their livings as photographers. Some are "semi-pros" who exhibit and sell some stock pictures to help defray expenses. Stock pictures are well-organized collections of existing photographs (marketed mostly through stock photo agencies and discussed in chapter 13). These photographers find that travel with a camera deepens their experience and provides openings to meeting people they otherwise would not get.

My best friend is a talented recorder of her family's extensive travels. She has made about thirty albums of wonderful color prints that document the family's life, friends, and experiences living and traveling all over the world. The albums are future heirlooms. I know a doctor and a lawyer, both busy, who travel with their cameras as relaxation from stressful careers. Both have worked hard to become good photographers; one prints and distrib-

SPECIALIST PHOTO BOOK RESOURCES

I love browsing in bookstores. Two good places to look at photo books:

- A Photographers Place, 133 Mercer Street, New York, NY 10012 is my favorite place to browse
 for photo books. It's crowded with an eclectic collection of new, used, out-of-print and rare
 books on all photographic subjects including travel. They publish a catalog several times a
 year and list some bargains. To receive the catalog, or locate a rare title, phone (212) 4319358, or fax (212) 941-7920. By mail: P.O. Box 274, Prince Street Station, New York, NY 10012.
- Images Media Inc. is a photo specialist with a small showroom at 505 Fifth Avenue, Suite 1102, New York, NY 10017. They produce a catalog. By mail: 9728 Third Avenue, Brooklyn, NY 11209; phone (800) 982-2875; Web site: www.shama.com.

To buy photo books on the Internet, the two top Web sites are Amazon.com (www. amazon.com) and barnesandnoble.com (www.barnesandnoble.com). Between these giants, you can find just about any photo title in print. Amazon lists some rare books; and both give discounts on bestsellers.

utes his own postcards, the other has exhibited in galleries. Another friend is a great traveler, a photographer part-time; she teaches languages when the budget gets tight. She sells stock pictures, has received grants for her photography, and exhibits in New York and Europe. A former student is a financial writer. He branched out into travel writing and has now illustrated a number of his own pieces. All of these people are successful travel photographers in their own way.

Fine-Art Photography

None of us know which, if any, of the images we make will last as art. Julia Margaret Cameron was a wealthy, middle-aged housewife in nineteenth-century London. Her picture-taking started as a hobby when her children left home. She passionately photographed family, friends, and servants but was not taken too seriously by the professionals of her day. Now her esteemed prints are in great collections of photography throughout the world.

Today, many fine-art photographers get a master of fine arts (MFA) degree and teach in colleges, some sell black-and-white and color prints and publish postcards, calendars, posters, and books. Grants to support important projects and exhibits are available to the persistent and dedicated. And fine-art photography is sometimes used in some of the very best magazines.

A good and thorough book on this whole subject is *Photography for the Art Market* by Kathryn Marx.

Who Buys Travel Photography?

Magazines, book publishers, advertising agencies, and design companies are the biggest users of still photographs. A good magazine store half a block from my studio carries about three thousand different titles; over two thousand are magazines published in the United States! About sixty consumer-oriented travel magazines alone are listed in *Bacon's Publicity Checker*, a trade guide to magazines (see chapter 10). Other magazines that assign travel

photography and use travel stock include national and regional magazines, city magazines, and controlled circulation leisure-time magazines aimed at professionals like doctors. Airlines, resorts, and cruise operators publish "in-house" travel publications that are given away free to clients; travel business and tourism trade publications also use travel pictures from many sources. Many photo books include individual travel shots, and trade books, guidebooks, textbooks, and even some cookbooks all use travel pictures at times. Travel picture books are now big sellers. A new trend is to visit the locales of popular television series! Some photographers produce their own books; some are on travel, or travel-related subjects. Self-publication is of course very expensive, and demands entrepreneurial skills, but it can be creatively and financially rewarding if successful.

Travel advertising is a very big business for international and national clients like airlines; campaigns are almost always photographed by big name photographers, but big travel advertisers buy a lot of stock as well, and pay top prices for pictures. Pictures used for advertising must always be "model released," which means that people or private property owners must give legal permission for the use of their, or their property's, image. (See chapter 20 for English and foreign-language model release forms.) Regional and local travel advertising is for smaller airlines, states, resort areas, theme parks, hotels, and more. Still photographs are sometimes used in combination with video or film for travel commercials or programs. Advertisers of many products like glamorous backgrounds and use quite a few landscape stock shots.

The Enormous Tourism Business

Tourism photography is the "commercial" side of travel photography. (I define commercial travel photographs as those that sponsor or advertise something, like television commercials do, not as cheap, hack photography.)

Commercial travel photographs are shot for print advertising, promotional brochures or catalogs, leaflets, public relations handouts, and audiovisuals. Still photographs are used by airlines, bus tour companies, cruise operators, hotel and motel chains, resorts, theme parks, restaurants, clubs and festivals, national, regional, state/provincial and local tourist authorities and national, regional, or even historic railroads. In fact, you photograph for tourism anywhere that people go in fairly large numbers or in organized groups when they are away from home. Also do not forget that what is routine to you may be a tourist attraction to someone else. Even rural America is increasingly being discovered as a foreign tourist destination.

The word "tourist" has always carried something of a stigma, implying that tourists are somehow less worthy than other travelers. There is a 1930s Noel Coward song called "Why Do the Wrong People Travel, When the Right People Stay at Home?" I don't know that this is so. The great majority of tourists I have met are curious, intelligent people of all social classes who are interested in other places and people and who want to enjoy themselves. For reasons of time, money, comfort, and convenience; and sometimes for reasons of inexperience, age, health, or fears about safety, they prefer to go to places where they will probably be with some others like themselves.

Tourists often, but not always, travel in escorted groups. Or they go on a well-earned vacation to relax and enjoy the ocean, sun, snow, lakes, or mountains. Some tourists are history, culture, or music buffs; others are interested in shopping bargains. Some travel to study or to meet people. Since at least some of the above descriptions fit almost everyone

who has done more than take a taxi across town, everyone is a tourist at some time or another and I don't know what there is to be snobbish about. I have always had the greatest respect for tourists' judgment, because major tourist attractions are always outstanding attractions, period. Obviously, there are some problems concerning tourism, most especially overbuilding and crowding in some very popular spots, as well as the dilution of certain cultures. (But tourism also preserves many things that would be lost if they did not attract visitors—and their money.) These are problems of the highly populated, mobile, modern world, not just of tourism. I feel fortunate to have been paid for photographing many things that others spend a lot of money to see and experience. It is something I am proud of, not condescending about.

The first true tourists, who traveled with specific sightseeing in view, were British aristocrats. At the end of the eighteenth century, many people finished off their university education with a grand tour of Italy, then, as now, considered the greatest place to study art and antiquity in the world. Briton Thomas Cook organized the first group tour, a moderately priced train trip from the industrial English Midlands to continental Europe, in the 1850s. Well-to-do Germans, French, and Americans began going abroad in large numbers to view antiquities at about the same time, and all these countries still produce huge numbers of tourists. Mass tourism overseas for the North American middle class took off in the 1960s with the introduction of passenger jet planes.

It is an amazing thought that today millions of "ordinary" people have been to more places than even the greatest explorers had seen a hundred years ago. The newest tourist movement is from East to West, as anyone who has seen the Japanese-language signs in tourist shops everywhere (or been to the Grand Canyon lately) will testify. Visitors from Asia are coming to America, Canada, and Europe in increasing numbers. Worldwide, tourism is the second largest business, after oil. In many countries, including my native Britain, tourism is the single largest earner of foreign currency. The point of this for the photographer is that tourism is heavily promoted. A great deal of that promotion is in printed advertisements, brochures, leaflets, flyers, posters, and public relations pictures. Tourism is therefore a very, very good market for travel assignments and stock sales.

Location Photography

Hollywood coined the term "going on location," which means shooting away from the controlled lighting available in studios. Still photographers also shoot on location, primarily for business, industrial, and corporate clients. Since the skills required for travel photography and for location photography are substantially the same, many travel photographers do some of this kind of work. I personally find it interesting and challenging to make beautiful pictures of industrial scenes; much of this kind of work is assigned by graphic design firms who are exacting but appreciative people to work with. Location photography at the top level of corporate annual reports is well paid (and highly competitive because of this). Lower-budget location work includes public relations photography, special event and party photography, all of which are good ways for up-and-coming photographers to gain experience. I started on that route.

Travel Photography Courses and Workshops

If you want to polish your skills, the schools listed below are well known and offer short courses in travel photography and related subjects, from basic to advanced and professional

levels. Famous photographers participate from time to time. Call or e-mail the schools for specifics of subjects, names and credits of instructors; and locations, dates, and prices.

- The **International Center for Photography** (ICP) in New York City offers courses year-round. Phone (212) 860-1777; e-mail: <code>edu@icp.org</code>.
- The **Maine Photographic Workshops** are held in the pretty seacoast village of Rockport, Maine, in New York City, and overseas. Phone (207) 236-8581; e-mail: *info@meworkshops.com*.
- The Nikon/Nikonos School of Underwater Photography courses are given yearround in Florida and the Caribbean. Phone (800) 272-9122; e-mail: phototours@ aol.com.
- The **Palm Beach Photo Workshops** are held in Florida year-round. Phone (561) 276-9797.
- The **Santa Fe Photographic Workshops** are held in and around New Mexico's capital. Phone (505) 983-1400; e-mail: workshop@sfworkshop.com.
- The **School of Visual Arts** (SVA) in New York City is where I give workshops. For a current SVA catalog showing all they offer, phone (800) 366-7820; from overseas (212) 592-2000. Web site: *www.schoolofvisualarts.edu*.
- Shaw Guides publish a continually updated online listing of photography workshops, schools, and tours offered in many locations in the United States and overseas. The site can be accessed on the Internet at www.shawguides.com.
- **Lisl Dennis**, a friend, operates well-regarded workshops and tours in Santa Fe, New Mexico, and overseas. Phone (505) 986-1106.
- Photo magazines carry ads for other workshops led by individuals.

luency in photography comes, as it does with everything else, with much practice. Sometimes you will hit a plateau and seem to make no progress, but if you persist you will sooner or later find your own style.

Finding Your Personal Way of Looking at the World

Photographically literate people can often recognize the work of famous photographers, because their work is distinctive. If your pictures have a "look," it will contribute to your personal and professional success. How do you acquire style, a signature as it were? Photographic style is a combination of technique, taste, and point of view; things that come from childhood and family, from where you grew up, and from whatever other important influences you have been exposed to. Innate talent and education are also major factors.

Your visual point of view and "eye" for a picture can be improved with training, especially if you gave up early on art studies. Because it's fairly easy to record family, friends, and impressions, photographic beginners are encouraged to go further. Creating anything well is one of the truly satisfying pleasures that life offers and the camera makes this relatively accessible. Just how much desire you have to carry your photography to its limits will determine how far you will ultimately go. But once you get good, even on a nonprofessional level, once you've sampled that creative joy for a while, you will never want to give it up.

Refining Your Photographic Style

In any type of art, including photography, there is a big difference between being inspired by a master or someone you admire and working in that spirit (which everybody starting out does to some degree), or copying someone else's work exactly. A few rather desperate photographers try to copy successful photographers because they think this makes their work more salable. This is a horrible pitfall. At best, such work is boringly derivative, at worst it's plagiarism and can lead you into problems—even lawsuits—over copyright infringement.

STUDY ART FOR BETTER PHOTOGRAPHS

Looking at great paintings as well as photographs is a way of refining your seeing. I don't mean that you should photograph in a highly pictorial style, or try to copy paintings. Look at art just to develop visual knowledge and sense of what and why something is beautiful. Consider Brueghel's harvest scenes, Vermeer's interiors and seventeenth-century Dutch landscapes. To learn more about lighting portraits, look at Rembrandt and Leonardo da Vinci. For light and landscape, there are golden studies of Italy by Turner; and the work of just about any Impressionist painter (but especially Monet's series of the cathedral at Rouen and of haystacks). To study weather, and people in a landscape, as well as color at different times of day and in different seasons, enjoy Hokusai and Hiroshige's woodblocks of their travels in nineteenth-century Japan and see how relevant they are to travel photography today.

When I travel, my relaxation is to go to as many art museums as possible and see originals, but of course you can also look at art books. And today, more and more artworks and collections are available for viewing and study on video and CD-ROM disc.

Guidebooks, of course, list major museums in the United States and other countries.

Travel stock landscapes that rely on the heavy use of color filters for instance, are almost all only a very poor imitation of the work of the renowned photographer, Pete Turner, who originated the concept in his traveling days and has long since stopped using it. If you want to make a real mark you must be original. Of course if you can find truly new ways of using color filters or gels (like the photographs with colorful flash painting by the talented Chip Simons) then of course do it.

Try all kinds of new and even crazy things. Some will fail, others seem promising. Shoot and reshoot the promising things until something succeeds. Don't forget to play, to break the rules, to risk the improbable or impossible, and recognize and seize the occasional marvelous lucky accident when it happens. And if you do come up with something new, don't despair if you are ahead of your time. It took Simons several years of shooting in his special style to catch on and get offered a lot of work.

It is helpful to most people's development to study images carefully every few weeks. Pin forty or fifty work prints (or minilab prints) to a wall or lay them out on the floor. Leave them there for a while. Projecting the same number of slides enlarged onto a white wall every few days has the same effect. Sort the slides or prints you are studying into groups, sets, or categories, as you might a deck of cards. Can you see any affinities? Perhaps a leaning toward people? Humor? Moody landscapes? Complex arrangements of shapes? A preference for black-and-white or monochromatic color? If you see a trend emerging (you will after you have been photographing for a while) trust your instincts and follow that lead. The best and most important thing you can do for your photography is to nurture your unique viewpoint.

To be a practitioner or artist of any kind you must both know about and be sensitive to the past and be aware of what present masters are doing, yet at the same time insulate yourself from those things. You should be like a racehorse wearing blinkers so that it can only see to the front and doesn't get distracted or scared by what's happening to the sides.

Some people worry that every photograph, especially every travel photograph, has already been taken. It is unhelpful to think that way, because although pretty well everything has been photographed (or written about, or painted, or composed), there are always

new ways of doing the same thing. We all have unique sensibilities, training, and values. New technology affects the way things are recorded, and how they look in print. If you gave Polaroid cameras to two hundred photographers, who then all aimed at that great travel cliché, the Eiffel Tower, no two snaps would be taken from exactly the same angle or distance or show precisely the same thing. Some photographers would include people, some go for design, others wait for beautiful light, others photograph tourists photographing the tower, others still notice the clouds between the iron work or the mechanics of the elevators. Some people would scribble on the print, peel and transfer it onto paper, melt it, immediately scan it to computer and alter it, or invent something that hasn't yet been tried.

Necessary Technical Skills

A mastery of photographic tools is always a requirement for a highly developed personal photographic style. This takes work. Shoot every day if you can. It is the only way to acquire fluency. If your film budget is tight, practice seeing photographs in your head, but actually shoot as often as you possibly can. It's also good to keep up with trends. Polaroids, laser copiers, hand coloring, digital cameras, defocus lenses, cross-processing, and computer retouching all affect the "look" of still photography today. Advertising and editorial travel clients have rediscovered black-and-white, which is now beautifully reproduced in top magazines and books by the four-color process method formerly used only for color pictures. But, tricks and trends fade. Ultimately, creative and honest seeing—starting your own trend—will get you the most work and recognition.

When working to acquire style, don't constantly compare your achievements to other people's; this can inhibit you seriously if you do it often. Measure your present photographs against those from years or months ago, and let your feelings tell you if you are making progress.

On the other hand, be realistic in deciding when you are "ready" to compete in the travel assignment marketplace, to market your travel pictures as stock, to exhibit your photographs. If you do technically good, original work and respect it, it is very likely that others will admire and use it. Don't expect instant gratification or success. Photography is a crowded field, and even if your work is truly excellent, it still takes time to get your pictures and name around and to carve a niche for yourself. If you want to succeed commercially you will need a lot of drive and the ability to accept rejection at first. If you do get stuck in a blank period, or if work isn't coming in and you are depressed, shoot your way out of it. Pictures that you force yourself to take will not be your best, but they may lead you in a new direction and will contribute to your development. Dry periods almost al ways pass, unlikely as it may seem at the time. Believing in what you are doing is also important. Remember the law of the self-fulfilling prophecy!

Composition, or Filling the Picture Frame

I meet students who worry a lot about composition. This just means filling the picture area in an interesting or powerful way. Can good composition be learned? Up to a point, absolutely. Some compositional sense is probably intuitive. To improve composition, always compose your picture when actually looking through the lens. This sounds elementary, but you probably will have to school yourself to do it at first.

What you see with the naked eye (and what you feel) when you stand on a mountain top is most likely not what the film will record, even if you have a panoramic camera. You have to choose (or compose) the part of the view you will use, but that alone is not enough. You must also select the best time of day to express your feelings about the physical look of the mountains and about the space, light, height, and the effort it took to get there, so that at least some of these feelings are conveyed to the viewer.

Varying Composition for Creative Pictures

To photograph a mountain panorama, for instance, don't just stand and aim the camera straight in front of you from eye level. You may want to get down low and have foreground rocks loom large in front of distant peaks to give depth, or prefer to show just a thin rim of mountain at the bottom of the frame and have nine-tenths of your picture clouds and sky. Or, shoot down onto jagged peaks or rolling receding domes and show no sky at all. Perhaps you can include distant climbers or hikers or skiers, which would give scale, in some of the mountain views. If you are very lucky, or patient, or in the right area, you can include a wild animal. Maybe there is a cairn or marker at the summit of your climb to put in the foreground of your composition. Silhouette someone against the low-lit mountains—sunrises and sunsets are usually the best times to get any dramatic landscape pictures, but the movement of clouds obscuring and revealing the sun any time of day is important too. Of course, if you can allow enough time, you can try all of the above approaches to the mountain scene; that would be my way of getting the best out of it.

Negative Space in Your Photographs

It is often helpful to think about what you're not going to include in your picture. Negative space—anywhere the main subject isn't, such as blank sky, concrete, water, grass, etc.—can be used as a design element. How much of it you use, compared to your main subject can make the background either very important or insignificant. Usually, keep backgrounds uncluttered. Think about the shapes between shapes, behind shapes, or in front of other shapes. Shapes, composition, and positive/negative space relationships can be altered by moving your angle of view, and by using different focal length lenses. Wide-angle lenses make the foreground large in relation to the background, giving an appearance of great depth and space. Telephoto lenses have the opposite effect, often causing a flattened, posterish look and making the background appear closer to the foreground than it actually is.

To help you to think about the negative space, or backgrounds of scenes, which have a great effect on your final picture, make a habit of using the "stop-down" or depth-of-field preview button, which manually reduces the f-stop (lens aperture) to the opening which you have chosen for the picture so that you can see the actual depth of field (zone of sharp focus). This is important, at least until you are accustomed to thinking about backgrounds, because modern lenses focus at the widest, brightest aperture for easy viewing and sharp focusing, stopping down automatically only when the shutter is fired.

That soft golden blur you ignored when viewing red tulips at f/2 may actually be a rather ugly broken fence. It will show up all too clearly in your elegant flowerbed composition on film exposed at f/11, which has great depth of field.

Inexperienced photographers tend to see or mentally focus on only the most impor-

tant thing in a picture. The camera records everything dispassionately, so consider backgrounds carefully, use aperture and depth of field creatively, and check the edges and corners of your picture area as well the main subject. Think about what you may want to leave out of a shot, by changing your angle or moving the subject. Block or mask something ugly by putting something between your lens and the offending object. If you try all these things your photographs will rapidly improve.

What Makes Good Composition?

Composition, as I have said, is the arrangement of everything in the "frame" or picture space, and there are no hard and fast rules or guidelines. Anything pleasing is okay. But to be specific, you usually want to keep horizontal and vertical lines as straight as possible, or lean them so they look decisive, not accidental or tentative. It usually isn't interesting to divide a land or seascape exactly in half; try a picture with more cloudy sky and less green field, or more stormy sea and less rocky shore. If you center a person in the picture area, which beginners often tend to, the subject can look like a target; try moving yourself (or him or her) so that they are to the right or left of the frame's center, or mostly in the top or bottom half of the photograph. Diagonals are strong and lead the viewer into a picture.

The Qualities of Lenses

Different lenses alter composition. Wide-angle lenses give a great feeling of space while emphasizing close foreground subjects. Telephoto lenses tend to flatten and make distant background elements important. Looking through a lens while changing your angle to the subject, trying different focal length lenses for different perspectives, and not being afraid to ask your subjects to move to a better location will all help you get graphically exciting images.

How to Fill the Frame Elegantly

Elegance is almost always very simple. Think about very expensive clothes, made of beautiful material, well crafted, perfectly fitting. Or the unfussy lines of beautiful cars. The best designers in all fields say "form follows function" and leave out a lot. Try and keep your compositions clean and spare, with beautifully arranged subject matter and light. Less is better than more for me, but I would be presumptuous to try to teach you elegance; study the masters and develop your own.

Breaking Rules

Experienced photographers can and frequently do ignore basic compositional guidelines. Having someone exactly in the middle of a shot, glaring straight at you, may convey their personality exactly. A tilted horizon might say everything you want to about sailing, skiing, or the view from a cathedral, looking down from its spire. Disembodied arms and legs emerging from the sides of a Manhattan streetscape could capture the nervous energy of a great city to perfection. Once you know the rules, dare to break them!

Professional Compositional Skills

When composing for assignments remember the needs of the art director, who will need both verticals and horizontals. Book and magazine covers are almost always vertical, with

clear uncluttered space where the magazine logo or book title goes. If you know that a given publication's style is to run most pictures on the left-hand side of a two page spread, make sure you have plenty of shots that face right, into the spread.

As a general rule, don't put faces or other important picture elements into the exact center of the frame. An art director won't usually use such a shot as a double-page spread because part of the faces will get lost in the "gutter" (space lost in binding).

Try using unusual lenses for any subject. I have made interesting portraits and still lifes using a 500mm lens, for instance. The flattened effect is somewhat like a Japanese print.

Things Art Directors Don't Ever Want To See in Travel Photographs

Garbage—even little bits can ruin a beautiful picture (pick it up if you have to); litter containers; graffiti; ugly or too many street signs; public toilets; junk cars; overhead wires, utility poles and antennas; anything you don't want to be there. Back views and rear ends of almost everything and everyone are awful. Never photograph lots of footprints, crowds, or brown seaweed on a beach; discarded towels, wet chairs, and empty drinks at poolside; cigarettes in general (except if your client is a tobacco company!). Don't photograph full ashtrays, the remains of a meal, dirty plates, or cluttered dining tables, ever. Brand names and advertising signs should be avoided wherever possible.

Avoid people wearing casts or bandages; people carrying plastic bags (just count how many there are on any street!). And avoid Elvis or any inappropriate tee shirts in places where colorful local costumes still predominate. Especially avoid T-shirts with revolting slogans or dominating designs (ask nonprofessional models to put them on backwards if desperate). Tight shorts do nothing for most people and almost nobody looks their best from behind.

Dirt and clutter of any kind is always out as far as commercial travel photography is concerned, as is scaffolding on major monuments if possible. I say if possible because a few years ago Big Ben, the Eiffel Tower, the Colosseum, and the Acropolis were all in heavy scaffolding at the same time that I was shooting a European tourism brochure for a new client. Luckily I had plenty of pictures of these "must" tourist icons in my stock files.

Demolition and messy construction sites should be avoided. I always remove, or ask people to remove, all those horrible little notices, cards and other visual clutter that people unthinkingly tack onto walls in hotel lobbies, restaurants, classrooms, and offices, not to mention all the junk they keep on their desks, computers, and workbenches.

Poverty, overcrowding, disease, and unhappy people are always out for commercial travel photography, even if they exist at your destination. If you want to photograph those things, be a photojournalist. Of course, if you shoot fine-art pictures, or for personal mementos of a trip, you can be as all-encompassing as you like. But, know that the poorest and saddest people everywhere usually hate being photographed, and they may let you know that in no uncertain terms. Local and national authorities in many regions do not like any depiction of their country that is deemed unflattering, and you may be asked, told, or even made to leave if you persist in taking such pictures.

Today, annoying, overlooked, or inappropriate things in otherwise good pictures can be retouched by having the image scanned onto the computer screen, and manipulated in a program such as Adobe Photoshop. This is expensive and time consuming. If possible, avoid the need for it.

Computer retouching or manipulation of photographs is considered dishonest by most users of photojournalism. For advertising it is routine.

SOLVING VISUAL PROBLEMS

To mask a small unwanted element in a scene, such as an immovable trash can (when you can't lose it by shifting it or you), block it by shooting at a low angle through flowers or foliage out of focus in the foreground. If there aren't any flowers or leaves right there, pick some elsewhere, and hold them very close to the lens, placed to hide the ugliness. The plants will dissolve the unwanted object into a blur of color. You can often angle a shot to mask ugly telephone poles, or break up the line of a TV antenna by placing it in front of well-positioned trees. In cities, wait till a passing person or vehicle masks the offending sight. Look through the viewfinder while moving around. Dusk is very kind to cities (or any place that has less than marvelous maintenance).

Careful arrangement helps people problems too. Have a large person sit down behind a table with their arms on the table. Make older people smile or laugh, and semi-backlight them, or shoot them diffused, perhaps through something like curtains, flowers, or foliage. All these techniques soften hard facial lines.

Photographing Ordinary Things Beautifully

One of the most needed skills of professional photographers is to be able to make things look excellent, sometimes better than reality. Using appropriate lenses is one of the best ways of doing this.

To give a specific example: If you photograph a swimming pool with a 20mm lens from a low viewpoint and hang over the water to eliminate the near edge of the pool, it makes the pool look bigger than it actually is. Light is important too; backlighting especially is flattering to food, landscapes, and less than perfect looking people. See chapters 3,6, and 7 for more on equipment, light, and lighting.

How to Nail Down the Great Shot

For the best possible pictures, as well as to perfect your technique, don't be afraid of shooting too much film. Although expensive, the cost of film is not as high as the costs of a big trip. It may take two or three rolls to get just the picture you want of a shepherd and his flock—the first few from a distance showing him small in the surrounding hills, then closer, moving along with shepherd, sheep, and dogs; and finally a close portrait shot with the location behind him. When the shepherd is used to your presence, it should be easy to ask him (with words or gestures) to hold a lamb in one hand and his crook in the other. Never take your eyes away from the viewfinder and keep shooting. When everything comes together, you will know it, and you will have your definitive shepherd picture. Perhaps it was the moment when the lamb wriggled and he grabbed it, or the dog barked for attention and he laughed and patted it, or whatever. (More subtleties of people photography are discussed in detail in chapter 8.)

You'll need many exposures to get excellent shots of moving people and lights in a disco. It usually takes a whole series of pictures to get the peak moments of a sunset, because you cannot predict when the maximum effect will be, and sometimes because the afterglow is even better than the sunset itself.

To me, the physical act of taking several pictures, rather than one, especially of people, warms me up as well as the subject and often results in my seeing things and juxtapositions that I didn't notice at first.

Travel Skills

Professional and serious personal travel photography is demanding. It challenges your social and organizational skills and your physical endurance.

What specifically do you need to know besides photography to bring home fine images? You have to be able to think on your feet and improvise and be flexible and work fast. You should be able to wait patiently and be philosophical and resilient when something doesn't work out as planned. You must be comfortable talking to the great, the humble, and good plain people everywhere. You should be able to enjoy an occasional stay at the Ritz or tolerate a hard night's semi-sleep on the floor of a none-too-clean peasant's hut, not to mention making the best of countless nights in innumerable boring motels. Keeping pictorial goals in mind while coping with the minor problems that happen on most trips is a routine skill every traveling photographer needs.

A professional travel or location job requires meticulous advance planning, constant checking of details, and good management (and a bit of luck) to avoid expensive mistakes or photographic disasters on a difficult trip. Finally, professional photography is a business and you must be able to handle finances, both cash and credit. Keep immaculate records for yourself, your clients, and the tax authorities.

Traveling Alone

Because it is usually difficult to photograph professionally while traveling with anyone other than an assistant who is being paid to do exactly what you want (and sometimes even with them!), I usually prefer (or the budget dictates) that I go by myself. I keep maximum sensitivity to my surroundings, have freedom to make last minute changes to the itinerary, and keep a low profile to be as unthreatening to the local people as possible. I'm not usually lonely if the shoot is going well, and if I have a good book for company. When needed, I get local assistance—from people who speak the language, know the area, have good contacts, access, and, especially, knowledge of local driving conditions. Sometimes, a "local" becomes a good friend. You are much more likely to make such friends when you travel alone.

Traveling With an Assistant, Loved Someone, Friend, or Client

The best travel is done with an assistant who is trained to anticipate your every need; is quiet, pleasant, and unflappable; doesn't ever complain about the food, the climate, the job or the boss; and who always gets up at dawn and works late without complaint. Obviously such paragons are rare. To have a spouse as an assistant is not easy, but there are some successful travel photographers who habitually work with a spouse or friend as partner or assistant. I think they too are rare. Perhaps it is the clash of egos. Some location specialists travel with a crew. (They then have a lot of logistical problems to contend with.)

If you do travel with someone else it helps to discuss thoroughly what has to be covered before you leave, but this does not always guarantee that you and he will work well together on the road. A good traveling companion or assistant is a joy on any trip, enhancing it, and making it much easier in most ways, but he is hard to find. An incompatible assistant or traveling companion is sheer misery, which is why (I think) many travel photographers are essentially loners.

I personally prefer not to travel with a writer—not that I don't like these usually nice

CONSIDER THE EGG

To practice making the most of whatever you must photograph, try this self-assignment in imagination and composition that I've given to photo students: Take six plain white eggs, cook them, and take them for a walk with a wide-angle and telephoto lens. I've seen some creative solutions—including eggs waiting to be killed on a busy highway, huge eggs in a nest in wide-angle close-up near an airport runway with Boeing 747s taking off behind them, and eggs being used as golf balls on a seaside putting green.

people—but their agenda is often not related to photography. The same thing applies to clients. Art directors are fine, as long as they don't want to shoot all the pictures themselves (it has been known to happen). If you must travel with someone else, agree in advance that you cannot spend all your time with him en route.

If you are a dedicated amateur photographer who travels with a spouse or partner, consider the solution of a former student of mine. He bought his wife a tiny, advanced, video camcorder and now she is almost as enthusiastic about her kind of photographic recording of their travels as he is about his!

Traveling in a Group

Group travel is often convenient and comfortable, and may offer big savings over individual trips; sometimes tours are the only way you can visit a country or region (as it was when I went to China with a group just before the United States and China had resumed diplomatic relations). Group travel, however, is never ideal for serious photography, because most tours adhere to a timetable. Some have extremely tight schedules. If you are in a group and photographing for yourself, your main problem will be finding ways to separate yourself from everyone else. Even if you get up very early every day and go out shooting before breakfast, you will probably have to skip some or most planned activities or sightseeing visits to have sufficient photography time. Choose a tour that doesn't have a lot of one-night stopovers for better picture-taking opportunities.

I have photographed professionally while traveling with a group; the biggest no-no is keeping the paying passengers waiting. Even if you are a passenger yourself, keeping a number of people waiting more than very occasionally will make you highly unpopular with the tour manager and with the other tourists on whose goodwill you depend!

If you are photographing a group for a tourism client, the best arrangement is to have your own car available. You can be with the group when you need to be but are free to wait longer somewhere for that special shot, catching up with the tourists later, or at the planned evening stop.

Small group tours specifically planned for photography and instruction are popular with serious amateur photographers (see chapter 1).

Researching a Photo Trip or Assignment

To make the most of your time and maximize your photography opportunities, to get the best value for your and your client's money, and to be considered polite by the locals, find

out ahead of time as much as you can about your destination, and what you will be photographing.

Through research, you'll learn, for instance, that you won't want to go on safari in Kenya in May (it's the rainy season) or travel by train in France the first or last days of August (the French government subsidizes vacation travel for its citizens and trains are packed solid). People present business cards everywhere in formal Japan, and it's courteous to hand them back—you can get yours printed in English and Japanese overnight at good hotels. Take your turn buying a round in a British pub, or you will be considered stingy. When you go on a shoot for business clients, read the previous year's annual report (as well as any relevant guidebooks) to find out as much as your can about the company and the location in advance. National and regional tourist offices, guidebooks, the AAA and other auto associations, and, now, the many travel sites on the Internet, are all great research tools. See also chapters 11, 16, and the resource listings at the end of the book.

Business Skills

Business know-how is essential if you are to make it in professional photography, including stock photography. Not everyone realizes this when they start out! Those photographers soon learn, if they survive, the very hard way. Foreign travel makes business, record keeping, and communicating more complicated because you have to deal with different languages, currency, social mores, and even varying electrical systems. If it's a professional trip, you will probably have to make a bid and submit a cost estimate to get the job. Sample bid and estimate forms are published in a monograph, *Forms*, by the American Society of Media Photographers (ASMP) and the Advertising Photographers of America (APA) also has bid/estimate forms. (See also chapters 11, 15, 16, and the resource listings at the end of the book.)

Business courses for photographers are offered by photo schools, and the major photographers' associations have frequent seminars on such business subjects as taxation, insurance, and "paper trails"—necessary business paperwork. You can often attend these even if you are not a member. Community colleges and schools and other places have small business management courses. My own publishers, Allworth Press and Amphoto, put out useful books on various aspects of business and legalities for established and aspiring professional photographers.

When you travel on assignment, you will need to negotiate the terms of the agreement with the client. You must understand the financial terms and the photographic requirements of the assignment clearly, and have them in writing, before you go. (See also chapter 16 and the bibliography.)

Social Skills

Professional photographers today work in a very competitive business. In a way, it's related to show business. It is a given after a certain point that you are highly competent at what you do, can deliver a job that meets the client's requirements, and add a certain unique vision to the project that marks the work as your own. In the current marketplace that is not usually enough to get you a lot of work. Clients of all kinds like to work with photographers whom they like. Nice guys and gals don't finish last in this business, they finish first if they also have talent. You don't have to be handsome or beautiful to be a success-

TWO ALMOST ESSENTIAL PHOTO BUSINESS TOOLS

The Computer

Computers have become an integral part of most professional photographers lives and are also influencing how many photographs "look" in general. Rather than skim over the whole subject, I have written about it in detail in chapter 11.

PDN (The Photo District News)

Photo District News is a monthly publication for professional photographers edited in New York that has contributors nationwide in the United States, and also overseas. It is high-end business oriented, with plenty of trendy pictures also. Each month has a theme, with annual travel, stock, lighting, digital, and self-promotion issues among others. Ads are for professional equipment and services, with a strong classified (small ad) section also. Buy PDN at photo dealers and magazine stores, or subscribe. In the United States call (800) 745-8922. From Canada and overseas call (614) 382-3322. You can visit PDN's Web site at: www.pdn-pix.com.

ful photographer (but it never hurt anyone in any occupation!), but you should strive to be as physically attractive and well-groomed as you can be.

You must also be able to talk fluently on the phone, know how to research a subject, write a reasonably literate business letter, and be able to "sell" your ideas and yourself on a face-to-face basis. Most travel and photo editors are reasonably well-educated people. Quite a few are cultured. And when you travel you will meet people of all social classes. I still remember a lunch on my first big job, an audio/visual shoot for a Latin American airline. I traveled with a writer and a director. We ate with about twenty house guests seated around a long table in the formal dining room of a beautiful *estancia* (estate or ranch) in the pampas south of Buenos Aires. The conversation was in Spanish, English, French, and German. A handsome silver-haired dowager said to me, "Oh, you've come from America. Do you know Winthrop Rockefeller?" Needless to say I didn't, but managed to ask a reasonably intelligent question about Argentine gauchos; horse-related subjects are usually a safe bet for conversations with the super-rich!

You should be able to handle different social situations gracefully; good conversational skills will help you get assignments and will always help you get better pictures, because you often have to talk people into helping you when you are shooting.

Of course there must be some mean, unattractive, unkempt, or very boring photographers who are successful. I personally don't know any.

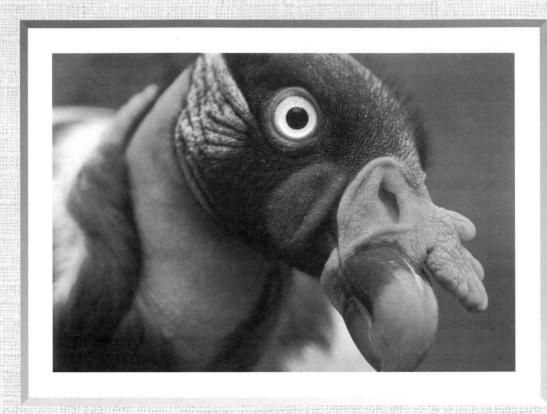

oday's traveling photographers, from beginners to experts, have arrays of camera formats, systems, lenses, and accessories to choose from, in all price ranges and degrees of sophistication. Films are being improved all the time. Digital cameras have made big strides. Their storage capacity (a current limitation for travelers) will only get better.

Photo manufacturers imply that to select their product, no matter what it is, will instantly transform you into a terrific photographer. Sadly, that's not true (you knew it anyway, deep down). Good photography today is convenient but not much easier than it was in the nineteenth century. It's still the photographer's taste and point of view that count, not the equipment.

Inspirations

My mother was my earliest influence in photography. She often snapped away at my sister and me growing up with a large, black box Brownie originally bought to photograph the great adventure of her life—two years touring South America with an English theater company before World War II. When I was a child I loved poring over her albums of faded black-and-white prints of Pernambuco and Valparaiso, Montevideo, and Buenos Aires, and listening to stories attached to the pictures. I could never get the snaps I made with her camera to come out well; I frequently cut people's heads off. My family all traveled; I suppose those things got me started photographing when I started traveling professionally at sixteen (as an assistant stage manager with a third-rate touring theater company in England). I took a plastic Ansco camera with me, got a few good snaps, and was hooked. It was not until I was twenty and in art school that I got a proper camera.

"Pointing and Shooting"

Today's good "point-and-shoot" electronically controlled cameras are fun and you can get nice snaps with them, even if you're a beginner. They are almost (not quite) foolproof. If Aunt Minnie is going on the trip of her life and asks you for advice on a camera to take,

WHY SERIOUS REGINNERS SHOULD TAKE PHOTOGRAPHY COURSES

If you want more than good snaps, advanced equipment alone is not the answer. I can and will recommend equipment in this chapter, based on my experiences as a travel photographer, and as someone who has taught photography majors, professionals, and enthusiastic amateurs. But if your vision outruns your skills, this book cannot teach you basic photography. You will save time and frustration by taking a class if you don't know what an f-stop, depth of field, or sync speed is. (They are all important for creative control.) The way to learn photography is to take pictures, but having someone at hand to guide those first steps is helpful. Introductory photo courses are offered at high schools, art schools, colleges and adult education centers. Take a course or two!

tell her to buy one of the many point-and-shoots made by name manufacturers (see later in this chapter for a few suggestions). Aunt M. will come back with pictures, memories, and no hassles because the camera was not too complicated for her to use. (Aunt M. might find Kodak's *Pocket Guide to Travel Photography* helpful.) Some point-and-shoots are so good you can do professional work with them.

Skills Beyond "Pointing and Shooting"

If you are serious about travel photography, going on your first great trip, and want to bring back more than good snaps, you'll need to know more than just how to "point and shoot." You must understand effective "framing" of pictures; you should have mastered exposure, metering and bracketing techniques (needed for the best possible pictures even with clever cameras), and should know why filters are needed for best results in some situations. When do you need fast lenses, and when are moderate aperture or slower lenses adequate? Which film is best for what? How can you photograph a minaret without cutting the top off or leaning it back?

This chapter will suggest equipment from the intermediate level and up. Keep up-todate by looking at photography magazines.

Good Basic Equipment

Aunt Minnie should stick to the point-and-shoots. Serious amateurs (and photo students) should aim to travel with a 35mm single lens reflex (SLR) camera plus at least two lenses. One good 35mm SLR plus one good 35mm point-and-shoot camera for backup will do for first paid travel shoots in an absolute pinch. Ideally, both camera bodies should be identical and take the same interchangeable lenses. That way, fingers won't fumble for unfamiliar controls, which can cause missed shots.

If you carry two camera bodies when traveling it will prevent disaster if one malfunctions or is dropped on the trip. I know a writer/photographer who went on a walking tour in England and came back crying. She had taken only one of her Leicas to cut down on weight. It jammed and she was reduced to using the guide's point-and-shoot for the rest of the trip, and lost some good photographic opportunities as a result.

Besides being safer, and letting you work with two lenses simultaneously, carrying two camera bodies permits the use of color slide and color print film, or color and black and

white film at the same time, which is sometimes needed. I always stick to the same speed films (100 or 400 ISO) when I have to do that, to avoid potentially disastrous mix-ups under pressure. Another reason to use two (or more) bodies at the same time is to shoot with different focal length lenses, and also to rotate cameras and lenses to minimize chances of loss if one camera fails or malfunctions.

Choosing First Lenses

Unless you photograph exclusively outdoors in bright daylight, I recommend buying the fastest possible (largest f-stop or aperture) lenses made by your camera manufacturer. An extra f-stop or two can make all the difference between getting a picture or not getting one under poor lighting conditions. Two f-stops can mean the difference between shooting at V_{30} or V_{125} of a second under the same lighting conditions, or, between V_{30} and V_{30} . The slower the shutter speed, the more chance of blurred shots. So although fast lenses are heavier and more expensive than slower ones, they are well worth the difference in weight and money.

Good generic lenses are made by several companies with mounts for popular 35mm SLR camera systems. Some of these lenses are very good optically, but avoid cheaper zoom lenses especially; they tend to be slow and are susceptible to flare and vignetting (darkening at the corners).

Independent brand lenses are almost all somewhat less rugged mechanically than top camera brand lenses, and all have a lower trade-in or resale value than major brand lenses. But if your budget dictates, consider Sigma, Tamron, and Tokina lenses, all well-respected and well-priced. All are available with modules for popular camera systems; quite a few professionals use their fastest lenses.

Advantages of Fast Lenses

The faster any lens, the easier it is to make low-light pictures. You can't always use a tripod or flash. Even when you "push" fast film (increase the ISO speed rating and development time), an extra stop in exposure may make an impossible available light, dimly lit interior, or night shot possible. So, buy the fastest lenses you can afford. The only disadvantages of fast lenses are size, weight, and price. The lenses listed will handle most travel, tourism, or location situations you are likely to encounter—landscapes, location portraits, event and people photography, architecture, and the odd still life against an interesting background.

Lenses to Avoid

I do not recommend extreme range (four or five to one) wide-angle to telephoto zoom lenses. Extreme zooms are slow, clumsy, and mostly for casual use by holiday snapshooters in my opinion. The reason I don't like them or use them are:

- Extreme zoom lenses are clumsy to work with and many have barrel distortion (slightly curved straight lines) when used at the widest angle.
- Almost all extreme zooms have small maximum apertures, making a tripod a must for low-light shots, and flash photography at any but the closest distances difficult.

A BASIC TRAVEL PHOTOGRAPHY KIT

To begin, the following should suffice:

- One or two 35mm SLR (single lens reflex) camera bodies (of the system you like and want to grow with) with a built-in flash, or a small TTL (through-the-lens metered) or automatic flash.
- Or, one 35mm SLR and one point-and-shoot camera with a reasonably fast two-to-one zoom lens, and a flash ON/OFF switch. This may save you if something happens to your main camera. I suggest getting a water-resistant point-and-shoot, so you can use it at the beach and in bad weather. (The Canon A-1 Panorama is one I like.)
- A wide-angle lens and a zoom telephoto lens for your SLR. (See later in the chapter.)
- A lightweight, steady tripod (or at minimum, a tabletop tripod, or camera clamp, that attaches to fences, chairs, car windows, etc.).
- A midsized camera bag or photo backpack, or inconspicuous, military-style or student backpack padded with foam. (All backpacks save your spine and leave your hands free.)

The serious photographer will add:

- A second SLR camera body, ideally the same or closely similar to the first.
- Several more lenses (see later in chapter for suggestions).
- A handheld flash plus daylight/available light meter (see later in chapter).
- An automatic or TTL bounce flash unit and the correct cord permitting flash use off camera (for details see chapter 7).
- A stable tripod that extends to eye level (see later in chapter).
- A 36"-round folding fabric reflector, silver and white (see chapter 7).
- A folding luggage cart (for recommendations, see later in the chapter).

These items will be useful to almost any serious traveling photographer.

- Extreme zooms are prone to "flare" that causes light blips on film when shooting into, or close to, the sun or bright light source because of the complex optics.
- Few zoom lenses are noted for sharpness; most sharp zooms are in the two to one zoom ratio. Probably no zoom is as sharp as the best single focal length lenses.

Important Accessories

These are not frills—they make picture-taking in difficult to impossible situations possible.

Handheld Flash/Daylight Exposure Meters

Whether or not your cameras have sophisticated built-in light meters (almost all modern 35mm SLR cameras do), you will probably decide one day to own a handheld exposure meter. If you decide to do it now, you'll avoid deciding later the hard way. Built-in camera meters can fail, and probably will do so if a camera is dropped, or given a hard knock. Dust, humidity, extreme cold, and dead batteries can also cause meter failure. Today's handheld meters measure incident as well as reflected light, flash (and strobe) exposures, and more. A handheld meter is picture insurance. I always carry at least one. (See chapter 4 for much more on exposure and metering.)

MOST USEFUL LENSES TO TAKE WHEN YOU TRAVEL

I recommend.

- A fast (f/1.4, f/1.8, or f/2) medium wide-angle or "normal" focal length lens (35mm or 55mm). The fastest lenses are musts for low-light shooting, in- or out-of-doors.
- The fastest wide-angle lens you can afford. Wide-angle lenses have great depth of field (zone
 of sharp focus), are good to work with in crowds, and make the foreground look large in relation to the background. The 28mm is my favorite lens, a good focal length for people in a
 landscape, and for many interior, building, and view shots.
- A 20mm is what I usually use for sweeping landscapes, architecture, and interiors.
- The fastest possible medium-focal-length zoom lens you can afford (f/2.8 is best, but no slower than f/4.5–f/5.6) in the range of about 80–200mm. This lens is good for precise framing of distant outdoor scenes, for bringing distant cityscapes and landscapes closer, and for unposed people shots.
- A short zoom lens (35–75mm or 28–80mm range, no slower than f/4–f/5.6) will fill the gap between wide-angle and telephoto lenses. Short zooms are good for flash pictures too.
- A 1.4× or 2× tele-extender made for your telephoto lens (do not get a cheap generic brand). Tele-extenders increase the focal length of telephoto and zoom lenses by the factor stated, at the cost of one or two f-stops loss of light. I use my 2× extender with fast telephotos. It doubles focal length (a 200mm lens becomes 400mm and so on; an f/2.8 lens becomes an f/5.6).

Tripods

A sturdy, lightweight tripod that extends at least to your eye level is an essential for any serious travel photographer. Get one with a head that tilts from side to side as well as from front to back. I especially like ball heads, which are quick to level and have tension that can be adjusted to follow movement.

Low-light, dusk, and night shooting, the precomposing of location portrait backgrounds, wildlife photography, and architecture and interior pictures are all dramatically improved when you use a tripod. When shooting work with long lenses that are difficult to hold steady, a tripod will prevent blurred, lost pictures. A tripod is a must for time exposures at night, or when using a slow shutter speed with a small aperture in daylight for great depth of field.

A tripod is also indispensable for composing still lifes. Whether shooting a famous author's possessions arranged on a writing desk or a delicious lobster dish posed in a formal dining room with chef and waiters hovering behind, choose the point of view you want and precompose the scene with the camera on a tripod. When you've got that right, arrange the foreground objects by moving from camera position to the still-life setup, improving the arrangement until it all looks great through the lens.

Of course a tripod is needed for panoramic, medium, and large format work.

What Equipment Should a Professional Travel Photographer Own?

Professional assignments call for quality equipment, carefully selected for reliability, durability, and ease of use. Good tools make doing difficult things much easier. Which top brand camera system you choose is not so important (except perhaps for prestige purposes

RECOMMENDED TRIPODS

A tripod should be sturdy, extend to your eye level, but not be so heavy you don't want to carry it. Don't get a cheap tripod intended for lightweight camcorders. The following are all good:

- Manfrotto (formerly known as Bogen in the United States) offers a range of well-priced tripods made in Italy. I use their lightest 3001 model.
- Gitzo manufactures equipment for the French military, space, and aviation industries. Their tripods are precision made, popular with professionals and come in sizes from six-inch tabletoppers to humongous eleven footers. I have two Gitzos. My compact, lightweight Tota Luxe extends to five and a half feet, I use it with Gitzo's "Number Two" ball head. (Ball heads make very slight adjustments easy; get one sturdy enough for your heaviest lenses.) If I need more height or am using a heavy lens or a 6 × 7cm camera, I favor a Gitzo Reporter model that extends to over seven feet. I often use this tripod to shoot down onto food, but it's heavy. The carbon fiber Gitzo Mountaineer tripods are super lightweight but pricey. (Save by picking up your Gitzo in France; I got a bargain at a FNAC discount chain store in Paris.)
- Germany's Linhof makes precision tripods for medium or large format cameras.
- The Japanese Slik amateur tripod line is well made, budget priced; professional Sliks are tough and come in different heights and weights.
- The American-made Tiltall tripod is a classic design, quick to set.

and resale value) as sticking to a system and building on it, buying classic lenses and most useful accessories, and not loading yourself down with unnecessary gadgets.

To shoot assignments, you will need two or three camera bodies that accept the same interchangeable lenses. Start with a wide-angle (20, 24, or 28mm, as preferred), fast normal (f/1.4 or f/2), and zoom (80-200mm f/2.8) telephoto lens. A tripod and a flash complete a basic kit.

Mv Choice of Camera System

I have used Nikon cameras, lenses, and flash units since I got my first model F's and lenses in the late 1960s. I'm not being paid in any way to say this (nor are any of my other recommendations "commercials"). I use the Nikon because it is a rugged and very complete system that includes just about anything I'm ever likely to need. I treat cameras poorly, and my Nikons used over years, from Fs to N90s have always been repairable when dropped, banged, or otherwise maltreated.

I own two groups of camera bodies. I have Nikon FM2s (fully mechanical except for a built-in meter). This camera is small enough for my hands, the metering is extremely accurate, and the in-camera meter is the simplest to see and adjust that I have ever used. I now use my FM2s mostly in bad weather or when rugged conditions make me feel insecure about relying totally on electronics. I would certainly take them on any job where I thought electronic camera repair would be hard to find. For personal photography I walk around New York with a couple of FM2 bodies and two Nikon lenses—an excellent 28mm f/2 and, a lens I like for flash, an inexpensive 35–70mm f/4–5.6 zoom.

When I do a travel assignment, I take three camera bodies. These are all same-model Nikon N90's, so that I do not have to think about where my fingers go when I am actually shooting. If I fumble, I could miss the exact moment when a model laughs, or horse throws

up its head, or the flag catches a puff of breeze, or some other fleeting thing that can make the average picture good and the very good picture great.

My current N90s are considered to be in the mid- to upper-range. They are relatively small, motorized, fast autofocus cameras with all the program and manual options I want. All my cameras are black. I put black tape over nameplates so they are inconspicuous and don't say, Expensive camera: Steal me.

I have found that the N90 TTL metering system gives excellent exposures in fast changing light. I like the flash "fill" exposures I get with N90s combined with a dedicated/TTL SB26 or SB-28 flash (both bounce units) and the budget-priced SB23 (a simple flash unit). Nikon's accessory SC-17 cord joins Nikons to the hot shoe of their TTL flashes, permitting through-the-lens metered flash exposures off camera. I also use a manual flash, an AC-powered strobe, a flash meter, and test exposures with a Polaroid camera, when lighting large areas or critical subjects (see chapter 7). The N-90 and N-90S both have an outlet for a sync/PC cord (flash synchronization cord) for use with high-powered professional AC-powered portable strobes/studio flash units.

Nikkor lenses, in my opinion, are unsurpassed for sharpness, and, important to me, Nikon has kept the same lens mount for years. I can still use favorite older lenses (some had minor adaptations) with my newest electronic camera bodies. All Nikon SLR bodies, new or used, from basic to top of the line, take the same lens mounts, so if you start with an inexpensive model, you can move up later.

And that's a good thing, because Nikon cameras continue to evolve. The N90S model has faster autofocus than the N90, and the shutter adjusts in $\frac{1}{2}$ stop increments. I will switch when I need new camera bodies.

Why don't I use Nikon's top-of-the-line F5 cameras? Size, weight, and money; not necessarily in that exact order. Cameras are fine tools to me, no more and no less. The N90 does everything I need, and is easier for me to hold than the F5 (or its predecessor the F4). I usually work alone, for long days, so ounces and pounds that I don't need to carry are that much energy saved. The high price of the F5 is certainly a consideration. I don't want to travel with equipment that has to be protected like jewelry.

Why Several Camera Bodies are Needed

I usually work with three camera bodies at the same time, each equipped with different lenses. I rotate the cameras (especially when shooting something critical) to minimize losing all-important pictures in case of equipment malfunction.

Cameras are not fragile, but if you don't rotate, that will be the day a shutter starts to act up or you have an accident. I have dropped several cameras in my career. If you do that, set them aside immediately, and don't risk lost pictures.

Some photographers, including the marvelous travel photographer Jake Rajs, use and rotate four, five, or six bodies at a time. People who shoot sports, like top photojournalist Ken Regan, work with several cameras, because changing film in the middle of peak action would mean important shots lost. (And, have you ever tried to change film while riding uphill on a donkey? Or with numb fingers in a snowstorm? How about on a hurricane ride at an amusement park?)

THE VALUE OF A SMALL FLASH

By adding to your kit a small flash and a cord so that it can be used off camera, you will increase your versatility considerably. Even a tiny, simple flash can help you get good pictures in low or no light and can "fill" ugly shadows in bright, contrasty light. Once you've learned how to use a flash well, you'll carry it everywhere. (For much more, see chapter 7.)

Top 35mm SLR Camera Systems

35mm SLR cameras are used by the great majority of professional and amateur travel photographers and many photojournalists. Lightweight, and with an unmatched range of lenses and accessories, they have probably accounted for 90 percent of all professional travel pictures taken since they first came on the scene in the late 1950s.

The most popular and complete 35mm SLR camera systems used by professionals are unquestionably Canon and Nikon. These companies woo beginner and intermediate photographers with budget and mid-priced cameras, as well as offering state-of-the-art models. Minolta is respected and favored by some pros and many serious amateurs, and Pentax is widely known as a good budget system especially popular with photo students and amateurs.

Leica, of course, is famous for both rangefinder and single lens reflex cameras. The former, which are whisper quiet in operation are beloved by many news photographers and photojournalists. Contax, too, is a great German system with superb lenses.

I feel that the ease of viewing makes SLRs infinitely preferable to rangefinder cameras for travel/location photography, where you often want to preview depth of field and are usually working in places where somewhat noisy camera shutters are not a problem. You can rent a "blimp" that encloses a camera to deaden sound if somewhat noisy SLR shutters are a problem (during performances, for instance).

All the above systems include a range of lenses, tele-extenders and close-up attachments, flash units, boosters, and specialist accessories. Some systems have underwater housings, close-up and photomicroscopy attachments, and more. All top camera manufacturers have support services; some loan equipment to professionals in emergencies or for special needs, all provide detailed literature on their products, as well as technical advice. (To locate manufacturers, see Resources, in chapter 20.)

Investigate Different Brands Before Committing to a System

A camera system represents a major investment, which you will have for a long time. Once you have bought a few lenses, you are generally locked in, because each system (regrettably but understandably) has different lens mounts. I suggest that you do as much research as possible before you buy. Read manufacturers' literature, talk to other photographers about what they like and don't like about their system, visit a photographic trade show, shop at a few different camera dealers, and ask questions. Rent camera models and lenses you are considering. Find out how a cameras feels, in terms of ease of operation, weight, size, and "fit" in your hands. Some cameras are simpler to operate than others. You may love or hate digital readouts as opposed to traditional shutter speed dials. You may do 90 percent of your photography on "Program" setting, or prefer to make decisions about shutter speed, f-stop, and focus and depth of field yourself.

ESSENTIAL FEATURES AND OPTIONS FOR ELECTRONIC 35MM SLR CAMERAS, FOR PROFESSIONAL USE

- Depth-of-field preview button, to preview "flare" blips as well as zone of sharp focus.
- Hot shoe on camera for flash unit, for a slave "trigger" as well as for a dedicated/TTL flash.
- Self-timer (put self in picture; sets off long exposures without shake).
- Bulb shutter speed setting for indefinitely long exposures.
- High shutter flash/strobe "sync" speed (currently ½50 or ⅓00 of a second with top 35mm SLR cameras). High sync speed is important for daylight flash "fill" (see chapter 7).
- Internal TTL (through the lens) metering with a choice of modes: full-frame averaging, center weighted, or spot metering, for extremely accurate exposure.
- · Aperture priority operation, for creative control of depth of field.
- Shutter priority operation, for creative control of movement and for long exposures combining available light and flash "fill" (see chapter 7).
- Program operation, for very fast changing or contrasty lighting conditions, or slow sync flash program for good foreground flash plus background exposures at night. (Note that dedicated electronic cameras require a special cable release for long exposures.)
- Fully manual operation, for creative variations in exposure and depth of field. (I use my program cameras on manual more often than not.)
- · Autofocus, this is especially useful in poor light.
- Manual focus, which is important for subjects moving in different directions and for portraits, still lifes, and close-ups.
- Double exposure provision, for creative effects.
- Built-in motor drive with optional booster. This is a requirement for sports and other fast action photography.
- A "sync" or PC cord outlet for strobe shooting (see chapter 7).
- A full line of lenses and compatible accessories for special work.

Cameras with all these features are at the top, or close to the top of each manufacturer's line. All features will contribute to making the best possible photographs and are not just "gimmicks."

If your budget is tight, you can start with a lower price camera model of a system you want. Make sure, though, that you will be able to use the same lenses when you add high-range cameras with more features later. Consider getting a good used second or third camera of your preferred model. (First have it thoroughly checked by a good repair shop!)

Buying Equipment

At one time, traveling photographers could save big bucks by buying cameras and lenses in Japan, Hong Kong, or Singapore. This is no longer true. At the time of writing, the cheapest places in the world to buy most camera equipment (to the best of my knowledge) are deep discount dealers in New York City, with professional dealers not much higher than discounters because of intense competition. Many good New York stores have toll-free phone and fax numbers, and e-mail. The stores where I buy are listed later in the chapter. In over twenty-five years of traveling professionally, I have never found that buying at

duty-free airport shops in places like Saint Thomas, Schiphol, or Shannon saved me money over New York dealers.

Choosing a Dealer

I recommend paying a few bucks more and acquiring your equipment from a full-service professional photography dealer. Building a long-term relationship with a good dealer can be very helpful. You may get loaners, first shot at a hard to find "hot" item, a good trade-in, good used stuff, or just good advice on what's available for a specific need. The U.S. warranties you get with authorized dealer purchases are valuable if you have equipment problems, although I personally have never needed to use one in my thirty years of serious photography. (Note: Discounters who sell so-called "gray market"—imported without U.S. warranties—equipment offer their own store warranties. Check warranties and be sure when buying from such stores that the merchandise is returnable.)

Top professional stores offer the chance to browse, handle, and compare equipment, and many give outstanding service. A few deep discount stores are also good, but check out discounters carefully, particularly as to their return policies. If dealing with discounters, know what you want before you buy, and don't accept substitutes. Find out what warranty the store offers to replace the warranty offered by authorized dealers. I have dealt for years with B&H Photo, a discounter that caters to professionals in New York, and have returned items to them with no difficulty. (I have never, though, dealt with them by mail.) Find professional photo dealers by looking at advertisers in photographers' association bulletins, ads in the *Photo District News* (*PDN*) classified phone books, and photographer referrals.

Let the Buyer Beware

I'm sorry to have to say I do not have the highest opinion of some camera store salespeople. Certain mass-market camera dealers and electronics store salespeople take the short-term view of getting the highest possible commission, without thought to the advantages of building up a long-term relationship with a customer. Also, some photo store salespeople are past, future, or part-time photographers, and they have preferences for their own equipment, which may or may not be right for your needs. Don't automatically take what any salesperson says as gospel, don't let them intimidate you with their use of a few abstruse technical terms, and don't get talked out of a system, camera, or lens you really want or need.

If you should decide to come to New York for the Photo Expo (usually held in November each year) to buy equipment, shoot, or take a class or vacation, stay well clear of tourist trap, rip-off, combined camera, electronic, and luggage stores. There are quite a few here, many on Fifth Avenue between 34th and 57th Streets and also around Times Square.

Because there may not be a good professional dealer within your easy reach, it may be a good idea to contact manufacturers' direct for the latest literature and suggested list prices. (To contact manufacturers, see the resources list at the end of the book.)

My Choice of Basic Lenses for Travel Photography

I take the following lenses wherever I go (all are Nikkor unless specified):

• 20mm f/2.8 autofocus. Indispensable for landscapes, architecture, and more.

- 28mm f/2. My favorite—I use it as a normal lens. It's the fastest 28mm autofocus lens I can get. Good for location portraits and many interiors.
- 35 to 70mm f/3.5–4.5 zoom. I use this budget lens for flash pictures; most manufacturers offer a similar useful zoom-range autofocus.
- 80 to 200mm f/2.8 zoom telephoto. Mine is a Sigma, bought at the time when Nikon's equivalent lens did not offer a tripod collar; the lens is very sharp. (Nikon's new 80–200mm f/2.8 zoom does have a tripod collar.)

Nikon

I have already talked about my preference for Nikon equipment earlier in this chapter (see "My Choice of Camera System," above). Nikon also makes the excellent Nikonos 35mm underwater cameras. They are great for wet, dusty assignments anywhere, when fitted with air-type lens, and indispensable on boats, and for snorkeling or going deep with a scuba outfit (I don't do that). The Nikonos V is recommended, it can be rented and found used.

Canon

Canon is a great and extremely complete single lens reflex camera system, rivaling (many say surpassing) Nikon. Canon cameras have high prestige and high resale value. Many photojournalists swear by the Canon EOS 1N model; autofocus with the longest Canon UMS lenses is extremely fast. All EOS camera models have identical lens mounts; the EOS mount is not compatible with old Canon AE-1 equipment. The EOS system has budget to pro bodies in all price ranges, so you can move up with those cameras. I'd kill for a couple of Canon lenses—the 24mm f/3.5 tilt and shift lens in particular.

Other Major Camera Systems

- The Contax 35mm SLR is part of a high-prestige system. Contax (now owned by Yashica) is a famous German-designed camera with superb lenses.
- The Leica SLR has fine workmanship and the lenses are legendary, but the price is high. Rangefinder Leicas are loved by many photojournalists.
- Minolta pioneered autofocus. Their current popular autofocus models work fast, and Minolta has added profesional lenses and accessories. Minolta is famed for top handheld meters and their in-camera metering is fine too.
- Olympus is noted for manual 35mm cameras that are compact and well crafted. The company now seems to be concentrating on point-and-shoot and digital cameras.
- Pentax was my first camera system. I used three bodies and four lenses hard and beat them up for about five years. Many photography students start by using budget-priced, all-manual Pentaxes. They are good for learning photographic fundamentals. Pentax also makes good point-and-shoots, program cameras, and medium format cameras too.

Polaroid Cameras

Polaroid cameras must have adjustable shutters and test lighting and exposure and setups. NPC makes Polaroid backs for most professional-level 35mm SLRs. Consumer Polaroids that

HOW TO PURCHASE PHOTO EQUIPMENT

Charge purchases to a major credit card whenever possible. This protects you in case there is any problem with the item. Some credit cards double the warranty of the equipment and may replace accidentally damaged, lost, or stolen goods for a limited time after purchase. You can add to frequent flyer mileage with some credit cards. (Check with different credit card companies for up-to-the-minute details of what they offer.) When buying anything, of course save packaging until you are sure everything works. File receipts permanently. They are needed for returns, warranty repairs, insurance purposes, and tax deductions if you are professional. Mail in warranty cards.

do not have adjustable lenses and shutters cannot be used for testing lighting setups; but Polaroid prints of any type make great "thank-yous" in exchange for posing, especially for people who may never have had a picture of themselves.

I find 35mm Polaroid prints hard to read and prefer to use an old, folding Polaroid 110B that has been modified, for my tests. (For more on using Polaroids for testing lighting, see chapter 7 and the resources.)

35mm Panoramic Cameras

The Widelux is a 35mm panoramic camera that utilizes the full film area. Amateurs may like the point-and-shoots that come with built-in panoramic masks, or even Kodak or Fuji's inexpensive throwaway panoramic cameras. These all utilize only one-third of the 35mm negative area but can result in good moderate-size prints.

Medium Format Cameras

 6×4.5 cm, 6×6 cm, and 6×7 cm cameras make big negatives, which many professional corporate and stock photographers favor today. Medium format is used for much advertising photography.

I find that the one "people" thing that 35mm does not do well is group portraits. I use a 6×7 cm Pentax for formal group shots (and occasionally for landscapes too).

- Bronica SLR's are well priced and favored by wedding shooters and students.
- Fuji makes innovative medium format SLR and rangefinder cameras, and professional panoramic cameras too. The Fuji GA 645 is a fully automated medium format camera that I have rented. It is extremely easy to use but does not currently offer interchangeable lenses.
- **Hasselblad's** 6 × 6cm cameras are legendary and available for rental worldwide. Hasselblads went to the moon, and would be my medium format choice for travel.
- Mamiya 6 × 7cm cameras with revolving backs are popular with advertising professionals. Mamiya makes fine medium format rangefinder cameras as well.
- Pentax makes a great budget 6×7 cm; I own one, the lenses are very sharp. Pentax now offers a fully automated 6×4.5 cm camera also.
- Rolleiflex now makes medium format SLRs, but their classic twin-lens reflex cameras, still available used, are highly priced collector's items.
- Polaroid backs made by NPC are made for most medium format cameras. Polaroid no longer markets professional cameras. Used professional Polaroid cameras includ-

ADDITIONAL LENSES FOR SPECIFIC SITUATIONS

For available and low light, particularly in factories, etc., and sometimes for indoor parties, or events where I will be shooting a lot of quick TTL flash pictures in dim light:

- 50mm f/1.4
- 80mm f/1.8 autofocus

For landscapes and architecture:

- 15mm f/5.6 rectilinear super wide-angle lens. A very nice lens; it does not distort if carefully
 used.
- 28mm f/4 PC (perspective correction) lens. (I wish Nikon made one with a wider angle).
- 55mm f/3.5 macro. An old manual lens; it's very sharp and still works fine.

For close-ups, nature, copying art or off a computer, TV, etc.:

- 300mm f/2.8 Tamron telephoto autofocus lens. This lens was bought as a demonstrator model. It's great for nature and wildlife photography.
- 2× tele-extender. This doubles the focal length of telephoto (and zoom) lenses at the cost of two stops in exposure. It's lightweight—I carry it almost everywhere.

ing 110A, 110B, and the 185 and 195 models (which take Type 42 roll film, or $3" \times 14" \times 14"$ pack film, if adapted) can be found used. Polaroid's discontinued press-type 600SE model is bulky; it, and a folding Minolta press camera with a Polaroid back, can also be found used.

For shake-free results and sharp pictures, use all medium format cameras on a tripod unless shooting at a high shutter speed or with flash/strobe.

Large Format Cameras

My first job in photography was as an assistant to a man who didn't like doing still life, but took those jobs when they came in for obvious reasons. I spent three months on a tall ladder looking down into an $8" \times 10"$ camera, arranging watches for catalog pages. I got good at moving tiny bits of black, silver, and gold paper around, and learned I could never be a still life photographer. Perhaps if that hadn't happened, I'd be keener on view cameras than I am. But I admire the people who care enough to travel with large format cameras. They are a hardy breed, many today are fine art, landscape, or stock specialists.

In the spirit of Maxime du Camp and Francis Frith and their successors, I salute the dedication and strong backs of all of you who are thinking about large format, and list some well-known makes. You who like the idea of large format will be pleased that recently, some makers have introduced lower-priced models of excellent quality.

- Calumet's rugged $4" \times 5"$ and $8" \times 10"$ view cameras have been studio favorites for years, they now offer a compact, budget priced $4" \times 5"$ model.
- Horseman has been making folding flatbed metal 4" x 5" cameras for ever.
- **Linhof** is famous for superbly crafted folding technical rangefinder cameras, and panoramic cameras too.
- **Polaroid** markets 4" × 5" and 8" × 10" camera backs for view cameras. These are used for lighting and exposure tests and also for fine art Polaroid prints. (See also chapters 4, 5, and 7.)

WHAT TO LOOK FOR IN A 35MM "POINT-AND-SHOOT" CAMERA

For Aunt Minnie, backup, fun, and some professional uses too, the Canon (which has a neat water-resistant model), Chinon, Contax, Fuji, Konica Nikon, Minolta, Olympus (their Stylus model is a worldwide bestseller), Pentax, and Yashica all make nice little cameras designed to slip into shirt pocket or pocket book.

It is essential to get a model with an adequately fast lens for shooting in low light, and with no more than a two to one zoom range (or the lens will be slow at the long end of the zoom—trust me on this one). Be sure that the built-in flash has a flash on/flash off switch so the flash can be turned on to fill (lighten) close shadows in bright daylight, and turned off for shots of distant land-scapes, or other subjects far beyond flash range.

Expect to pay a minimum of \$125 for a basic point-and-shoot and about \$200–300 for a model with a fast lens and more features. A top point-and-shoot can cost over \$1,000.

- Toyo makes rugged, metal flatbed field cameras in the popular $4" \times 5"$ and $8" \times 10"$ formats, and in the (rare today) $5" \times 7"$ landscape format too.
- Zone VI of Vermont markets classic wooden $4" \times 5"$ and $8" \times 10"$ flatbed cameras.

Roll-film backs in many sizes are made for panoramic shooting $4" \times 5"$ and $8" \times 10"$ cameras, especially by Mamiya. There are too many large format lenses made to discuss here, but Schneider optics are renowned. For more information on technical, view, and panoramic cameras, backs, and lenses, see a professional photo dealer, study Calumet's catalog, or contact manufacturers direct (see Resources).

Gyrostabilizers

A little-known photo accessory is the gyrostabilizer. A camera can be mounted on one when low light means long exposures are needed for sharp pictures, but tripod and/or flash use are not possible. Gyrostabilizers are valuable for photography from moving planes, boats, horseback, etc. and permit sharp handheld exposures down to about one second. They are very expensive but can be rented from professional photo dealers. When you first use a gyrostabilizer, be sure to practice before you shoot that job; the things are tricky to get the hang of initially. Ken Labs manufactures Kenyon gyrostabilizers for different types of cameras.

Caring for Cameras and Lenses

Cameras and lenses are precision instruments and, without being ridiculous, should be protected as much as possible when traveling. I don't use leather lens cases (they are heavy and take up too much room in my kit), but I travel long distances with lenses protected by "photo wraps"—squares made of padded material with Velcro closures—that come in different sizes and are great for wrapping cameras, and flash units too. Cara Gear and Domke make wraps (you can find them at good photo dealers); or, make your own.

Filters protect lenses from dust and rain as well as scratches, and protect the filter threads from being bent out of shape by sharp knocks. I've dropped lenses several times and smashed only the filter, which absorbs some of the impact. I use colorless UV filters on all

MEDIUM FORMAT PANORAMIC CAMERAS

For serious panoramic photography, very popular today, Fuji, Linhof, Noblex, and Widelux are the best-known brands of cameras. I suggest renting and trying out expensive panoramic cameras before buying.

Some photographers use a Mamiya $6 \times 9 \text{cm}$ or $6 \times 12 \text{cm}$ roll-film back on large format cameras, for panoramic effects plus full control of perspective via swings and tilts.

For more on this subject, read and see Joseph Meehan's thorough book *Panoramic Photogra*phy. A specialist panoramic camera dealer is Ken Hanson of New York City.

my lenses instead of lens covers. (I never use lens hoods, they get in my way.) Rear lens caps should be used whenever lenses are carried off camera. A scratch on a rear lens element is even worse than a scratch on the front.

I pack fragile gear in a backpack that fits under plane seats. For rugged conditions, hard cases that seal shut with O-ring closures, made by Pelican, are recommended (see below and chapter 16).

Bags, Travel Cases, and Luggage Carts

When traveling, it's better not to advertise that you are carrying photo gear. I use different bags for different purposes. For walking around New York or other cities, I often carry an old NATO backpack. This is shabby looking, but safely holds a camera, flash, and a couple of lenses, plus film and batteries, even my smallest tripod when disassembled. When I have an assistant, and want easy access to several cameras and lenses, I use a big canvas Domke bag. Mine has a waterproof lining.

When traveling by plane I have a Tenba backpack that fits under the plane seat. Tenba will do custom modifications; I had spacers made so the pack takes a tripod or long lens in a compartment down the center. This pack is smart enough to take to posh places. I have removed the logo so it doesn't advertise "camera bag" to the knowing. In this bag I can carry a small Gitzo tripod, two or three 35mm SLR camera bodies and four lenses plus a flash, a flash meter, batteries and charger, a few rolls of film, a sweater, and my courier-style flat document case.

For passing through airports, I now carry all film out of boxes, but in the cassettes, sealed in clear Ziplock bags, placing all inside a lightweight nylon bag. I always ask for a hand search. (This must be granted in the United States.) In countries where authorities refuse hand searches of film, I put my film into Sima lead bags, let it pass through the scanners, and pray a lot. Never put film into checked baggage. (For more on traveling with film, see chapter 16.)

My document case is black canvas, slim, $4" \times 6"$ and has a wrist strap and zippered compartments for passport, tickets, travelers checks, business cards, glasses, pens, and foreign currency. I bought it at the airport in London.

I put clothes and personal things into a round canvas stuff bag. If carrying lightstands and umbrellas, I put those into a tripod bag, and put it and my clothing bag into a large padlocked army-type duffel bag. This looks inconspicuous. (Check weight limits with your airline before leaving; baggage requirements change often.)

A wheeled luggage cart is essential if you want to avoid major back problems. In many

A SERIES OF GREAT CATALOGS

The Chicago-based photo equipment manufacturer/dealer Calumet puts out illustrated catalogs that are a treasure trove of information. They cover most camera makes, models, and formats; lighting equipment; accessories; filters; films; darkroom accessories; photo books; and more. Calumet sells their own brands plus just about everyone else's too. Get the catalog from Calumet at: 890 Supreme Drive, Bensenville, IL 60106. Phone (800) 225-8638; e-mail: sales@ calumetphoto.com. Or, visit their Chicago, Los Angeles, or New York stores.

places, luggage porters are an extinct species. I favor the Remin Kart-A-Bag. It is smooth rolling, strong, lightweight, and folds up small. As it costs over \$100, I hand carry it onto planes.

I ship strobe equipment by air in a custom-made, metal-framed wooden Anvil case, bought used years ago. It will outlive me. I use Lightware cases for packing strobe for taxi or car trips. I have a round fiberboard case that I use (stuffed with work clothes or foam) for shipping tripods and lightstands. I sometimes use a canvas Domke tripod/lightstand bag. (See also chapters 7, 16, and resources).

Maintaining and Repairing Equipment

However tenderly you care for your cameras (I don't), travel is rough on equipment, and camera bodies should be checked out once every six months, and immediately after working in dust, damp, extreme heat, or cold for any length of time, or of course if you drop something. If you use mechanical cameras, be aware that shutters can slow down or vary. Camera repair services can give you a chart of the actual shutter speeds on each mechanical camera body, which will save a lot of bracketing exposures. It is a good idea to have each body notched on the film plane so that you can quickly identify a malfunctioning camera; your repair service can take care of this. (Electronic camera shutters are stable, no need to have them checked unless there are obvious exposure problems.)

I use Professional Camera Repair Service, and also Flash Clinic (for flash and strobe repair), both here in New York. (See resources.) Authorized repair services nationwide advertise in *PDN*, overseas repair stations can be recommended by manufacturers.

Work With Mechanical Cameras for Ease of Repair

If you are going to a remote place for an extended stay, consider taking along mechanical camera bodies (like my Nikon FM2s). It has been my experience that good repair shops for mechanical cameras can be found in the most unexpected places. In emergencies ask local photographers and camera stores for advice.

Repairing electronic cameras and equipment can be a problem outside of major cities; to fix them, it's best to use authorized repair services. Ask your camera manufacturer for their worldwide list before you travel. In our global economy it's not too hard to ship malfunctioning equipment from almost anywhere. Mark packages "Optical Equipment for Repair." FedEx, DHL, TNT, and UPS are worldwide air shipping services that should help take care of paperwork. (See also chapters 15, 16, and resources.)

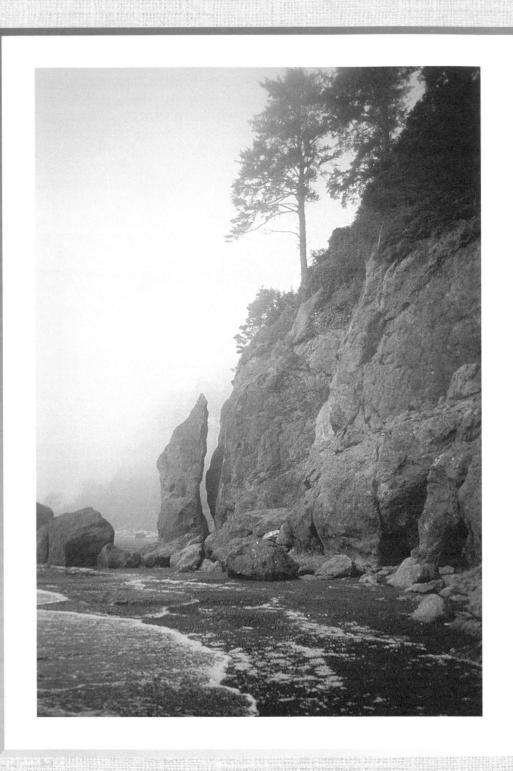

espite the clever cameras and excellent meters made today, getting the precise exposure you desire is not always easy. You must be aware of the range of contrast that films can record; of the direction of the light; and, occasionally, with the actual, rather than the manufacturer's rated ISO speed. Fuji Velvia, for instance, is rated 50 ISO, but most photographers prefer to shoot it at 40 ISO. Bracketing, or varying, exposures slightly from indicated "normal" will sometimes give several good exposures with slightly different moods.

Exposure

Good exposure normally means allowing an optimum amount of light to reach film in order to produce a negative or transparency that captures a subject as accurately as possible on film. Exposure is controlled by the lens aperture (f-stop); the camera shutter speed, and, sometimes, by the amount of flash, strobe, or tungsten light the photographer adds to a given subject or scene. The aim of good exposure by an advanced/professional photographer is to reproduce colors and/or tones as desired, or to express mood, in which case the photographer will probably break some rules.

Black-and-White Exposures

Most photographers' ideal black-and-white prints are fine to moderate grain, with deep blacks; all tones of gray and subtle details in the almost-white highlight areas. Negatives of course are reversed, and should not be too dark and dense, or too thin and washed out, or quality will be lost. A black-and-white print made from a good negative by a skilled printer can reproduce a tonal range of almost five f-stops.

One of the greatest of photographers in terms of technique alone was Ansel Adams, whose "zone system" for exposing and developing black-and-white film to place gray tones where he wanted them is widely taught in photo schools. With profound respect to the achievements of Mr. Adams, some lesser practitioners have made mastery of the zone system as an end in itself, which it should not be. You can make fine black-and-white nega-

ISO, ASA, AND DIN

Film speeds are rated by the International Standards Organization (ISO). The ISO rating (film speed index) has replaced the old (equivalent) American Standards Association (ASA) ratings. In Europe, film speed was formerly measured by the DIN scale, which is why you see DIN scales as well as ISO scales on some film boxes and on many older cameras, exposure meters, and flash units.

tives and prints without knowing a thing about the zone system as long as you expose and develop accurately.

I often bracket black-and-white film when I want particularly subtle effects (including the slide film mentioned below). I sometimes "push" and "pull" black-and-white negative films (increase or decrease ISO speed ratings and development time) about 20 percent in very harsh or flat light to reduce or increase contrast; I call that the poor man's zone system.

With the renewed interest in black and white, photographers can now shoot transparency films or films that can be processed as black-and-white slides. There are several options. Exposures for these films also can be adjusted to some degree. (For more, see chapter 5.)

Color Transparency (Slide) Film Exposure

Accurate exposure is essential with all color transparency films, although some adjustment of seriously over- or underexposed transparencies is possible by having custom labs pull or push film, and by duping and conventional retouching. Today's scanners and computer programs like Adobe Photoshop make considerable adjustments possible, but all such corrections are expensive, and clients don't want to pay for them unless the pictures are otherwise truly great or unique.

Electronic scanners used for color separation and reproduction today can add color to an image more easily than they can subtract it, which has changed the exposure habits of some photographers, including myself. I used to go for deeply saturated, about one-half to one stop underexposed pictures. I now go for a picture that is perfectly, "normally" exposed. Some photographers, especially fashion and beauty specialists, like a "high key" look—a one-half to one stop overexposed effect. (Truly overexposed slides look thin, pale, and washed out; badly underexposed transparencies look dark, greenish, and dense.)

Color transparency films have the capacity to reproduce a range of highlights to dark shadows of only about three f-stops. If you are shooting pictures that contain both shadowed dark tones and white hot spots, you had better decide which is more important to you, highlight or shadow detail, and concentrate on that, because you won't get both without adding light to the shadow area. Regrettably, just about all of today's color transparency films are very contrasty. Ideally, I like to expose color film in soft "bounce" sunlight, or on hazy sunny days, where the highlight-to-shadow ratio is no more than about two f-stops. (Reflectors and flash or strobe "fill" light can be used to reduce contrast in daylight; see chapters 6 and 7.)

Color Negative (Print) Film Exposure

Color negative has more latitude than transparency film—a good color negative can make a print that will give about a four f-stop range. Underexposed color negatives are very thin;

even when printed by clever automated machines, the darks will look green rather than black. Overexposed color negatives are dense and difficult to print. Color in amateur negative (print) films is largely corrected by automated processors. Professional color negative films may need correction with filters for optimum color. If you make your own color prints, minor exposure errors and deep shadows or hot spots can be "dodged" and "burned in" when printing. Accurate exposure is always necessary for optimal quality color prints.

If you have a difficult mixed light source or contrasty lighting problems to solve, using negative film may be your best bet; some newsmagazines and newspapers are now using negative film extensively, and reproducing from prints rather than transparencies. For jobs, be sure to check with the art director first, though; many publications and location clients still use only color transparencies. There are fast color negative films in the 1000–3200 ISO range, so there is often no reason to "push" film (increase the speed index and development time). If you need to, professional labs can push professional Kodak's Ektapress 3200 high-speed negative film two or more stops.

How Exposure Meters Work

Until you know a film or films very well (as I do with Fuji Provia exposures made outdoors in sunshine) you will almost certainly rely on a built-in camera meter, or a handheld meter to determine exposure. (If meterless for any reason, you can look inside the film box for exposure guidance, or use the old "sunny f/16" rule outdoors—use the closest shutter speed to the film speed, and a lens aperture of f/16.)

As I have met some not too experienced photographers who have problems understanding exactly how meters work, here is a capsule description:

All types of meters (both reflected and incident types, see below) contain a light-sensitive cell, and are designed to give correct exposure with "average" photographic subjects. In fact, most meters are very slightly biased on the side of underexposure, so as to not overexpose color transparencies.

An average photographic subject is usually defined as including some sunny sky with clouds (but not the sun itself), some grass and trees, and some people. It reflects back about 18 percent of the light that falls on it. If this scene were faithfully painted in oils, and all the wet colors were then quickly mixed together, they would come out a middle grayish shade.

Reflected-Light Meters

Reflected light meters all measure the light that reflects off the subject back to the meter. Absolutely all meters built into cameras, including those of electronic, dedicated/TTL (through-the-lens metered) cameras are reflected-light meters. Reflected-light meters are aimed at the subject, normally from the position you choose to frame the composition, but from close to the subject when lit from behind, or backlit.

Because the color or tone of the subject influences the amount of light reflected from the subject to the meter, you have to think when metering very light or very dark subjects with any reflected-light meter. For instance, you should close down your lens one to one-and-a-half stops (or use a faster shutter speed) when metering reflected light off a black or very dark subject, or you will not get a true black, but a tone close to 18 percent reflectance middle gray. You must open up your lens one or one-and-a-half stops (or lower the shut-

ter speed the equivalent amount) when metering reflected light off a white or extremely light subject like snow or bright sand, or the white will reproduce underexposed, also somewhere close to 18 percent middle gray. Note that this rule also applies to dedicated/TTL flash units and automatic flash units, both of which are designed to render subjects as close as possible to middle gray. Even the cleverest dedicated/TTL meters and TTL and automatic flashes have trouble exposing high-contrast subjects, such as small light-skinned faces or objects against large dark backgrounds, or small dark-skinned faces against large bright or white backgrounds. Then the photographer has to make decisions about what is most important, and probably make exposure adjustments. (For more, see chapter 7.)

Reflected-Light Metering with an 18 Percent Gray Card or Gray Card Substitute

If you take careful reflected-light readings off a standard 18 percent gray card (made by Kodak and others for a few dollars and sold at all good photo stores), you will get good exposure no matter what the color or tone of the subject (with this method you are in effect turning your reflected meter into an incident meter, see below). Be sure to place and angle the card in the same light as the subject. Meter off the palm of your hand as a substitute for a gray card (correlate your palm with the card by testing; skin tones vary). My palm gives one-half stop under exposure compared to a gray card. You can take reflected meter readings off any reasonably "average"-toned subject and use them to get good exposure. Use a favorite midtoned jacket or a midgray rock to meter a snow scene, not the snow itself. Use the gray sidewalk, not streetlights or neon signs to meter a brightly lit city night scene.

Exposing for Backlighting

Backlight (from behind your subject; see chapter 6) is very, very pretty but can fool inexperienced photographers. Go in very close to take reflected-light meter readings off brightly backlit subjects, such as people against sunsets or indoors against windows. If you meter from the point you plan to make the picture, you run a big risk of underexposed, even silhouetted, main subjects—even with modern electronic cameras that offer multipoint TTL metering.

Use the memory lock button if available (see your camera instruction manual) to meter up close for backlighting with program cameras.

Wide-Area, Center-Weighted, and Spot Metering

Modern dedicated/TTL cameras, when used with lenses designed for them, offer sophisticated "matrix" (or similar name) wide-area metering, plus center-weighted metering and narrow-angle spot metering (see below) as options. Personally, I use wide-area metering for most subjects. With long lenses, the spot metering option works well for theater work, wildlife, etc. But even the highly sophisticated metering available today, that gives excellent exposure for most subjects, is not totally foolproof. If the main subject is very light or very dark, or very contrasty (such as the always difficult small light-skinned face in a large dark room), using judgment to decide on the most important element in a scene, and "bracketing" exposures (increasing or decreasing light reaching film by altering the lens aperture or shutter speed or both) are still advised.

DEDICATED/TTL METERED EXPOSURES

Electronic cameras with through-the-lens metering measure all light hitting the meter sensor located close behind the film plane. The light from dedicated/TTL flash units used with compatible cameras (and used in TTL "fill" mode) is also taken into consideration. This makes "flash fill" exposures in daylight, low light, or night scenes simple, and for average-toned subjects, very accurate. Care must still be taken and photographer controlled adjustments made when exposing for high-contrast subjects (see chapter 7).

Some high-end cameras offer automatic bracketing, either built-in or as an option. If a contrasty outdoor subject is within flash range, using flash to "fill" (lighten) dark shadows will help. (See chapter 7.)

Incident-Light Meters

Incident-light meters are handheld and measure the light that falls on a subject. They are not influenced by the tone of the subject. Incident meters can be identified by their opaque white dome. To use one, the meter is usually aimed from the subject position and aimed at the camera. Incident meters were originally designed for use in studios with controlled light sources; the meter was aimed at lights to measure lighting ratios, or relative brightness of one light to another. Incident meters are still mostly used by studio photographers.

When used out-of-doors, particular care must be taken to align the incident meter's dome correctly. In a landscape, for instance, the meter should be held vertical so it receives light from both sky and ground. Overexposure will result if the dome is aimed down at dark earth; film will be underexposed if the dome is aimed up, including too much light from the sky. (Flat, white disks replace the domes when incident-light meters are used for flat copy work.)

Never use an incident meter when photographing distant subjects in light different from that where you are metering. If you are in shadow at the bottom of a mountain, and your subjects are skiers on a distant sunlit slope, an incident-light meter cannot give you an accurate reading. Use a long lens and the camera meter set to spot meter option, or, use a handheld spot meter (spot meters of all types are reflectance meters).

Many good incident meters offer reflected metering adapters, either standard or as an option.

Spot Meters

Spot meters are reflected meters that measure a very narrow angle of the subject. Built in meters in TTL cameras, used on spot meter option with a telephoto lens, provide extremely accurate exposure readings for distant subjects.

Many sports and news photographers and people who photograph rock shows, theater, dance, and similar events where one cannot get close to meter with TTL equipment also carry handheld spot meters as backup. Manual camera users require them.

WHY YOU SHOULD CARRY A HANDHELD EXPOSURE METER

A handheld meter is insurance in case an in-camera meter fails, or even (horrors) several built-in camera meters all read differently—it has happened to me. In-camera meters can easily be damaged if the camera is dropped or knocked sharply. Handheld meters can do some things that incamera meters can't. Those that can be used in either reflected or incident mode are useful if you are photographing the light filtering through stained-glass windows one day and a white-on-white still life in a restaurant the next. The most versatile incident meters measure daylight, flash, and strobe and have reflectance options. Flash meters are almost essential if you work seriously with flash or strobe.

Flash/Strobe Meters

Flash meters are incident meters (some offer reflectance adapters, see above). They measure the short burst of light from any small flash or large strobe unit. The most versatile flash meters can be used as incident meters to measure available light also. Depending on the features offered by the flash meter you choose, it can be used with or without a sync cord to measure available light, or flash/strobe light, or both combined. Some flash meters measure cumulative flashes, and available light, at all shutter speeds. They can also be used for calculating combination flash and time exposures. My handheld meter of choice is a Minolta V, a top-of-the-line flash meter that measures the ratio between flash/strobe and daylight/available light, all shutter speeds. I also own a Sekonic Digi-Lite F flash meter that is quite versatile. The Sekonic L-508 flash meter incorporates a reflectance spot meter. The Sekonic Flash Mate is tiny, accurate, well priced, and favored by students.

Color Temperature Meters

Minolta makes a three-color temperature meter that is a valuable research tool. It can be set for use with daylight or tungsten film, or with films of slightly different color (Kelvin) temperatures. It measures the amounts of red, green, and blue light reaching the meter and advises the amount of orange or blue light balancing, and/or magenta or cyan color compensating filtration needed to balance the light source with the film type being used. (Note: This color temperature meter does not measure exposure.)

Color meters can't replace filtration tests, because films have different inherent characteristics, and color variations of film are caused by many things in addition to the film emulsion and the color temperature of the light source. For instance, lenses have very slightly different colors and labs vary and run differently on different days. Long exposures can cause color shift, so color temperature meters cannot eliminate careful color testing.

If you use a color temperature meter without advance film emulsion, lighting, filtration, and processing lab tests, you should get acceptable to good, not perfect, color. Color meters are most popular with location specialists who must almost daily deal with difficult mixed light sources in factories and industrial locations.

To use a color temperature meter, you must own a set of blue, orange, magenta, and green gelatin light balancing/color compensating filters in different percentage strengths. (See chapter 5.)

AVOIDING COMMON EXPOSURE ERRORS

- Dead meters can't read exposures. Check meter and camera batteries before starting any
 important or long trip. Always carry spare batteries; many meters use hard-to-find sizes; common batteries like AAs are often expensive at tourist sites.
- Remember that all built-in camera meters measure the light that reflects off the subject, that
 all meters are designed to reproduce average scenes, and that they can't think. Bracket (vary)
 exposures, especially when light is contrasty.
- When using an incident-light meter (which measures the light falling on the subject) take care to align the white dome correctly. (See earlier in this chapter and the meter manual.)
- Avoid photographing people and scenes in partial bright sun and partial deep shadow. Color transparency film especially can't handle those extremes of contrast. Move your subject or angle to full sun or open shade for better results. If possible wait for the light to change or use a reflector or "fill" flash to lighten close shadow areas.
- Remember that meters are designed to avoid overexposing transparencies. If your camera shutter speeds are accurate, you can save film by only bracketing for a half-stop over-exposure for the most flat-lit of subjects.
- Electronic camera shutters are very accurate, you can trust the marked speeds unless your exposures are obviously way off. Mechanical camera shutter speeds should be checked before you go on a big trip, or every six months or so. (They can be slow, which can give you consistent overexposure.) A good repair shop can give you charts of your cameras' actual shutter speeds. Meters and camera shutters are somewhat fragile. Have your camera or handheld meter checked out immediately if you drop it or bang it hard.
- Don't forget to set film speed correctly on meters, manual cameras, and flash!
- Check all film speed (ISO) settings regularly even when shooting with electronic cameras and dedicated flashes that read film cassette DX codes. (The automatic film speed index can be accidentally altered too easily on some cameras; I have taped the DX over-ride buttons on my Nikon 8008s for that reason!)
- Allow for filter/gel factors (see chapter 5) when using handheld meters.
- Use the same film outdoors consistently; you will soon learn how to expose it correctly under normal conditions without being dependent on a meter.
- If shooting slide and print film, or color and black and white with two cameras at the same time, use identical speed films for both!
- Set the camera shutter on sync speed (or any speed below sync) when exposing for flash pictures with any manual camera, or part of the image will be blacked-out.
- Choose S (shutter priority) setting and slow shutter speeds to include some background detail in low-light flash pictures.
- I recommend using rear-curtain sync setting to minimize "ghosts" with flash "fill" at low shutter speeds (slow sync) only if the subject is traveling in a predictable direction.
- Study camera, flash and meter manuals whenever in doubt. (See also chapter 7.)

Film "Clip Tests"

"Clip tests" are used to get desired exposure, either when the film speed has been rerated up or down, or to get optimum exposure when the subject is fast moving and bracketing exposures would cause missing important shots. When you deliberately (or accidentally)

"BRACKETING" EXPOSURES AND "PUSHING" AND "PULLING" FILM

Despite knowing my preferred films and flash/strobe units well, checking camera shutter speeds periodically, and metering carefully, I "bracket" (vary) color slide exposures whenever possible. I don't feel there is any other way to get the most beautiful pictures possible. Some color subjects may look best with saturated rich tones, others need a slightly overexposed or "high-key" effect.

I sometimes even bracket black and white, by one-half or even full f-stops, to regulate contrast, for mood, and because over- and underexposed black-and-white negatives lose quality.

Bracketing costs film and money, certainly, but not as much as lost pictures. Especially with color film, the difference between perfect and almost perfect exposure can make a huge difference to a photograph.

I use "normal" exposures, plus one-half stop over- and underexposure brackets in average light conditions when shooting color, because I like rich, saturated color. In very contrasty light I add a half stop overexposure bracket. (Some top cameras offer one-third-stop brackets.)

I bracket an additional half-stop in each direction with very dark subjects, and very light subjects. Most of these pictures are good, and are perfectly usable. (In many shots I'm the only one that cares about the subtlest differences in exposure.) When shooting in very contrasty light (with 100 ISO Fujichrome or Ektachrome films, which can be pushed or pulled to a moderate degree), I sometimes overexpose by one-half or even, in desperation, one stop, and have the film "pulled" (first developer time decreased) to reduce contrast a little. "Pulling" color film in development does not reduce contrast much before the color goes very blue. (Try "pulling" if you wish, using a half-stop or a full stop overexposure. Tell your lab to "pull" or reduce time in the first developer—they will know how much—when they process the film.)

It is easy to increase contrast in E-6 transparency films (but they are all, without exception, inherently too contrasty for my taste) by increasing the speed rating and having the film "pushed" in development by a professional lab. This can be useful on flat, overcast days.

Please, Agfa, Fuji, or Kodak, make a lower contrast film for when one must shoot in bright sunlight!

expose a roll rated other than at the marked ISO speed, mark "Clip" and the speed used on the roll with a label or Magic Marker. Clip tests are done by professional labs (they cut off and develop two or three frames from the beginning or end of designated rolls) and then you or they judge the clips to determine developing time for the best exposure for balance of the roll. Clips can be done in one-fourth—, one-third—, one-half—, and one-stop increments. I have clips made when pushing or pulling film or when I'm not sure I have good exposures. Clips cost the same as processing a whole roll of film, but are obviously worth it when you need them!

Note: Most Process E-6 films (developed by the E-6 process) can be pushed a full stop, or pulled a half stop without noticeable loss in quality. Fast E-6 films (400 ISO) can be pushed a stop or two, although you may get some shift to brown. The Fuji and Kodak 400–1600 ISO transparency films designed to be pushed have masking that reduces color shift to brown when pushed one or two stops; they can in fact be pushed three, four, or more stops, with increase in grain, contrast, and color shift.

In my opinion, slow films are best not pushed, though it is technically possible up to one stop. Fuji Velvia (50 ISO) is best exposed at 40 ISO. Kodachrome films require the Process K-14, and the 25 ISO and 64 ISO versions were not designed to be pushed, though in

an emergency it can be done. Kodachrome 200 takes a one-and-a-half stop push to 500 ISO (but there is a perceptible shift to magenta.) Kodak Ektapress Professional color negative films of different speeds were designed to be pushed.

Talk to film manufacturers and good professional labs to learn more about color clips and pushing and pulling film. (See also chapter 5.)

Using Polaroid Films for Measuring Exposure

The professional Polaroid or equivalent cameras you use for Polaroid tests must have adjustable lens and shutter speeds, and provision for a "sync" (flash synchronization) cord to connect it to your flash or strobe. (Spectra and other nonadjustable, simple Polaroid cameras will not do.)

Polaroid backs for most 35mm and many medium-format cameras are made by NPC. Polaroid makes backs for $4" \times 5"$ and $8" \times 10"$ view cameras. With those, of course, the camera shutter speed and lens f-stop must be adjusted.

You can measure exposure, refine lighting setups, and preview compositions with color or black-and-white Polaroid tests. (Because Polaroid films do not reproduce color exactly the same as transparency or conventional color negative films, any color tests are only approximate.)

To test with color or black-and-white Polaroid films, you must compensate for any difference in the speed of the Polaroid film you are using with the speed of your transparency or negative film, either mathematically or with neutral density (ND) filters (which reduce the amount of light reaching the lens in one-third-stop increments).

Polaroid tests are used by a majority of professionals to measure strobe exposures and fine-tune studio lighting and composition. For the most accurate exposure with color or black-and-white Polaroids, include a large Kodak gray scale (which runs from black to white in nineteen steps) in the picture. If all the shades are separated in the Polaroid print, exposure is perfect. If the light end of the scale runs together, the film is overexposed. If the dark squares start to blend, the film is underexposed.

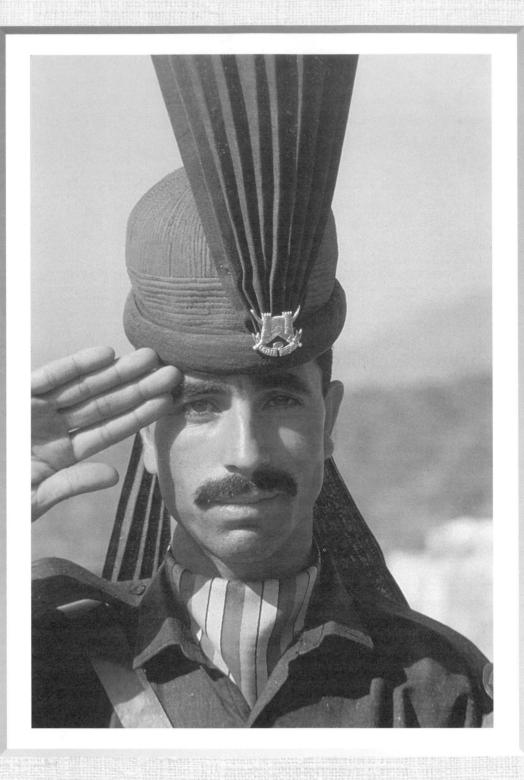

mateur photographers don't think too much about film, or the filters and gels that can modify or change the "look" of a subject on film. For professionals these things are critical; for mood, precise color control, or for the recording of tone on blackand-white film exactly as desired.

Film

Maxime Du Camp and my mother had almost no film choices available when they went on their great trips. Maxime, in Egypt in 1849, had to sensitize and develop his paper calotype negatives on the spot; the required exposures often were minutes long. Mother carried bulky rolls of Kodak black-and-white film on her pre–World War II travels in South America; the film speed was probably about 25 ISO by our standards.

In the 1960s, when I started shooting professionally, Kodachrome 25 was the standard of everybody who shot 35mm color for reproduction. (This film is still made, though Kodachrome 64 and 200 are more popular today.)

Until the mid-1970s, the introduction of any new film was rare. For color there was Kodachrome or Ektachrome, plus a couple of European films, period. When the first Fujichrome was introduced to the U.S. market in the early 1970s, photographers liked the bright colors; Fuji salesmen were efficient, and soon Fuji sales took off. The resulting competition between Fuji, Kodak, and others now means that there are many choices within film brands, and new film types are introduced quite frequently.

Slide films and negative color and black-and-white films now come in speeds from 25 to 3200 ISO, with higher speeds possible through push processing. Slow films have superfine grain quality, superfast ones give pictures a graphic, grainy look.

Photographers can choose between brand K, brand F, brand A, and others; then must weigh the advantages of professional versus amateur emulsions for long trips, and have the option of shooting slow, fast, or "push" film for that voyage up the Amazon or down the Colorado. They must decide whether to carry instant film to Borneo, or if they can replenish film supplies in Bordeaux, or dare process color at an unknown lab in Buenos Aires.

WARNING: AIRPORT X-RAYS

As travel security becomes ever tighter, protecting film from damage at airport and other security checks is an increasing problem.

CTX-500 scanners designed to foil terrorists are now being used at more and more airports worldwide. They specifically scan checked baggage, and can penetrate the lead bags recommended to protect film. Kodak, Fuji, and the other film manufacturers all say that CTX-500 scans can harm film even through lead bags (the scanner automatically increases penetration if it cannot "read" something in baggage).

In the first edition of the book, I said that when carrying a lot of film, I packed some in lead bags and checked it in my baggage. This is absolutely no longer an option.

The only safe way to carry film now is in your carry-on luggage. At all U.S. airports, you can legally ask for hand inspection of film carried as hand luggage. (Arrive early and ask pleasantly.) For the many foreign countries that refuse hand searches, I still carry Sima lead bags (available at professional photo dealers) and put film in them if I must allow the film to pass through low dose X-ray scanners used at passenger check in facilities. (See also chapter 16.)

Choosing the right film for your desired effects is a part of making good travel (or any) photographs whether photographing for an assignment, stock, personal pleasure, or fine art. I suggest testing films to settle on a few you like; and when you go, taking films you have used before.

My other film advice is to carry all film you will need for a trip, and bring or send it all home to your favorite lab for processing (if possible). Film is expensive in most places overseas and at tourist sites; the film you prefer may not be available where you go. Film sold in supermarkets, drugstores, and tourist shops may not have been properly stored. Blackand-white films are not used by snapshooters, so you may not find it everywhere. If you must buy film on the road, buy only at photo dealers recommended by film manufacturers. Avoid bargain, repackaged, and so-called free films everywhere; you get what you pay for. Problems, most especially bad color, are what you usually get with such films.

With unknown lab processing, you may get bad color also. Of course on a long trip it's okay to shoot an occasional test roll and have it processed on the road to see if equipment is functioning correctly.

I will discuss digital cameras and "media" briefly in chapter 11. Digital cameras and the media equivalent to 35mm film cameras currently give lower than 35mm film quality. Limited or expensive image storage space in most digital cameras are problems for travel photographers at present.

Films for Personal and Fine-Art Travel Photography

A majority of amateur and fine-art photographers want prints, so they shoot negative color or black-and-white films. Color negative films usually have the word "color" in the title—Agfacolor, Fujicolor, Kodak Vericolor, etc. (Kodak's professional Ektapress negative films are an exception.)

For personal and album prints there are "one-hour-photo" labs and do-it-yourself machine prints. Fine-art photographers often need enlargements. If your aim is to exhibit and sell on a regular basis, save money by learning how to print yourself. If you become

proficient, the quality of enlargement you make will be higher than those made by all but the best custom labs.

If you shoot color slides, excellent color laser copies (thermal heat transfer prints) can be made from slides by quality labs (but negatives don't reproduce well on laser printers). Quality laser copies are used in portfolios, as mailers, and as "drop-off" pieces by quite a few professionals, including myself.

Any type or size of film can be scanned to disc, by Kodak or by a computer service bureau. The digitized image can then be imported to a computer, printed, or, with an appropriate program such as Adobe Photoshop, can be retouched, reversed from negative to positive, or otherwise manipulated. Moderate-size to huge digital enlargements can be made, on a home or service bureau digital printer. Altered images can even be copied back to film. (See also chapter 11.)

Good Amateur Color Negative (Print) Films

Kodak's amateur Royal Gold comes in 100, 200, 400, and 1000 ISO speeds. Fujicolor Reala (CS; 100 ISO) is a widely used color negative film aimed at the consumer market. Fujicolor Super G Plus 800 (CZ) is good for low-light shooting. Agfa and Konica 100 and 400 ISO print films are fine.

Brand name negative films are sold at photo dealers. If you use one and have the film processed at a quality one-hour-photo lab you should be happy with the results. When shooting consumer color print films don't worry about light source variations or filters. Color corrections are made by the lab. Fine tune filtration if printing enlargements yourself.

Professional Color Negative Films

Kodak Ektapress Gold color negative films are designed for photojournalists; they do not require refrigeration (a consideration for extended trips in hot climates) and come in 100 (PPA), 400 (PPB), and 1600 (PPC) ISO speeds. Ektapress films can all be pushed. PPC film can be pushed two or more stops to 6400 ISO or higher (Kodak recommends filtration for this). Ektapress comes in 35mm size only.

Kodak's Pro 100 (PRN) and PRO 400 (PPF) give good skin tones; PRO 1000 (PMZ) is for low-light shooting. PRO 100T (PRT) is a tungsten-light balanced color negative film that replaces Kodak's long exposure Vericolor/VPL. Kodak Vericolor III Professional, Type S (VPS; 160 ISO) is the latest version of this popular daylight/flash/strobe balanced film. Kodak recommends it for exposures of one-tenth of a second or shorter. All these films come in 35mm, medium, and large format.

Fujicolor NPS 160 Professional (NPS) is a fine-grain color negative film designed for general daylight use. Fuji's fast daylight negative film, Fujicolor Professional 800 (NHGII) comes in 35mm and 120–220 formats. For tungsten-lit exposures of longer than an eighth of a second, Fuji offers Fujichrome NPL 160 Professional (NPL). This films comes in 35mm, medium, and large formats.

Black-and-White Negative Films

I like Kodak T-Max Professional films, which come in speeds of 100 (TMX) and 400 (TMY). Both can be pushed in T-Max developer. A push film, T-Max P3200 (TMZ) can be exposed

at 800, 1600, 3200, or even higher ISO. (Inform lab of speed used at the time of processing.) T-Max films are sharp with a long tonal range. TMX and TMY films come in 35mm to $8" \times 10"$ formats; TMZ in 35mm and 120 size only.

Kodak still makes Tri-X (TX; 400 ISO) and Plus-X (PX; 125 ISO) which have been professional standards for years. Other good black-and-white films are Fuji's Neopan (in 100, 400, and 1600 ISO speeds), Ilford's HP, and Agfa's Pan, which come in ISO speeds that compete with the Kodak films. You can choose any of these three with confidence.

Free professional film data sheets are available from manufacturers. They detail specifics for best uses, and give filtration recommendations too.

Black-and-White Slide Films

Kodak's T-Max 100 film can be processed conventionally as negatives; or expose it at 50 ISO and develop with Kodak's T-Max 100 Direct Positive Reversal Developing Outfit (Kodak catalog number 812-8188) to get rich-toned black-and-white slides. (A chemical reversing agent is involved.) T-Max reversal developing service is offered by a few professional labs.

Agfa makes Scala, a nominally 200 ISO reversal black-and white film (I shoot it at 160) that produces beautiful rich black-and-white slides with a long tonal scale. Scala film can be bought at professional dealers, and pushed and pulled, but, special processing is involved, so only a few big city labs offer processing in the United States. Duggal Labs is the processor in New York; professional labs or dealers in other cities will send Scala to the closest Scala lab.

Polaroid's Polapan is a 125 ISO 35mm black-and-white slide film you can develop your-self almost instantly, or have a lab do it, with the appropriate Polaroid processor. I like the slightly warm tone of this film; it's great for a warmish period look. Caution: Polapan scratches easily; allow to harden for at least half an hour before handling.

Chromogenic Films

Ilford's XP2 (400 ISO) and Kodak's Professional Black-and-White T400CN are fast monochrome films with good latitude, that are processed in C-41 (color negative) chemistry, and can be developed and printed by any minilab. Enlargements, if printed on color paper, with filtration can be toned sepia, blue, or any way you like, or printed on conventional black-and-white-papers.

Color Slide Films

These are the workhorse films for professional travel photography.

Kodak Color Transparency Films

Kodachrome 25 Professional (PKM), Kodachrome 64 Professional (PKR), Kodachrome 200 (PKL) are all quality color transparency films. Kodachrome 25 is still the finest-grain color transparency film made and is beautiful shot under optimum conditions—low or bounce sunlight. All the Kodachromes are contrasty and require very accurate exposure (also see chapter 4). Kodachrome processing is currently available from only three labs in the United States: Kodalux in Fairlawn, New Jersey, A&I Labs in Los Angeles, and BWC Labs in Miami Beach.

WHAT FILMS SHOULD YOU SHOOT FOR SALABLE TRAVEL PICTURES?

Fashions in films change—new offerings come and old ones go—but a high percentage of photographs that are assigned or sold as stock are still shot on fine-grain color transparency films. Some trendy photographers and travel publications, and a few stock agencies, are now featuring pictures with a moody, grainy look. Films with ISO speeds of between 25 and 100 are considered fine grain; 200 and 400 are moderate grain. Films with ISO speeds of 800 or 1600 and up are somewhat to very grainy, especially if enlarged beyond a quarter page from 35mm format.

I use mostly Fuji Velvia and Provia, and sometimes Ektachrome 64, 400, or P-1600. For personal black-and-white pictures I like Agfa Scala and Kodak T-Max films.

Ektachrome is Kodak's color transparency film standard bearer, with most professional Ektachromes available in all film formats. I shoot Ektachrome 64 Professional (EPR) for portraits. It has delicate neutral skin tones, grays, and whites. Ektachrome 100 Plus Professional (EPP) gives excellent blues at twilight and bright general color. Ektachrome 400X Professional (EPL) is my choice of moderate-to-fast film, and I love Ektachrome P1600 Professional (EPH) when I need or want superfast film and grainy effects. EPL is a 400 speed film designed to be pushed one, two, or more stops to 1600 or even 3200 ISO by professional labs; you must specify the speed rating chosen to the lab. I love this film for its grain and subtle, bluish color mood; it's great for the right subject. Surprisingly, it works well in sunlight if the sun is low and frontal and the subject not too contrasty.

Kodak's S (E100S) and SW (E100SW) Ektachromes, both rated 100 ISO (some rate them at 80), are comparatively new at the time of writing. I have not used more than a few rolls, but the color seems good. Kodak Ektachrome Elite film is a consumer (amateur) film, has good color, and is well priced—a possible choice for a long hot trip. All these films are color balanced for 5,500K daylight, flash, and strobe.

Kodak makes three so-called Tungsten Ektachromes balanced for 3,200K photoflood lights. These films have speeds of 64 ISO, 160 ISO, and, my choice, Ektachrome 320T (EPJ; 320 ISO). I use EPJ under hot lights because I like the speed. You can push this film one stop without much color shift to yellow.

Fuji Color Transparency Films

Fujichrome Provia 100 Professional (RDPII) is now my preferred film when I travel. Fujichrome Velvia Professional (RVP, 50 ISO; I shoot it at 40) is my choice for landscapes. I love both films for excellent grain and great color. Provia is good for almost anything shot in daylight; but like most Fujichromes it is warm, and renders faces and skin tones in general as too red for my taste.

Fujichrome Velvia has extremely fine grain and vibrant color. Velvia gives superb greens and blues, yellows are good, but reds are a trifle "hot" for my taste. I find Velvia a little slow for fast moving wildlife. RVP is quite contrasty and doesn't look great shot under high overhead sun. I never use it for people pictures unless skin tones are unimportant.

Fuji Astia 100 Professional (RAP) is Fuji's neutral toned film; it is pleasant, with clean grays and whites; people shot with this film to me look slightly tanned, so I still prefer EPR's skin-tones.

All daylight slide films have a color temperature of 5,500K, and balance with flash and strobe.

Choosing Color Films for Travel

Whatever brand(s) and/or type(s) of film you like, I suggest you take mostly rather fine-grain, slow- or medium-speed film on any trip. Medium-speed film (200–400 ISO) is a compromise, offering moderate grain, and is good if you don't own the fastest lenses. Always take at least a few rolls of ultrafast film (1000 ISO) or push film (400–1600) for those times you must shoot in low light without a tripod or additional lighting. (Take more if you like grainy, moody effects.)

If your personal style and convictions call for something other than the above, and you have done your homework, of course you can break the rules.

What is Good Color in Photography?

Good color is pleasing to the eye, and most photographers want it to look on film the way our eyes see it. The color should not be too light or washed out; it should be rich and fully saturated but not so dark that important details are lost. Color transparencies tend to darken slightly in reproduction, so I and many professional photographers "bracket" (vary) their color slide exposures slightly in order to get optimum color density (see also chapter 4). Color can be corrected with filters, see below.

What is Good Black-and-White in Photography?

Good black-and-white prints should reproduce a full, rich range of tones from black to white, with details readable throughout the tonal range. Grain should usually not be obtrusive. Black-and-white prints for reproduction are usually made slightly less contrasty, and slightly lighter, than prints for exhibition (to compensate for darkness and contrast added as an inherent part of most printing processes). Black-and-white slides too should reproduce a full tonal scale.

Getting to Know Films

Make comparison tests of two or three similar ISO speed films on similar subjects, under similar light conditions, and have the film processed at the same good lab. When testing professional film (and filters), shoot under daylight, tungsten light, and fluorescent light conditions, and with flash/strobe and hot lights (if used). Use the filters recommended (if any) in the data sheet included with the film (see later in this chapter for details on filters). Then look at the film projected or on a light box to compare pictures and see which film "look" you prefer. When you have selected a slow- or medium-speed film and a fast film that you like, work with them until you get to know them. Write down what you do. Soon, you won't be totally dependent on a meter, for outdoor exposures anyway. When you get to know a film very well by shooting with it often, and by testing it under different contrast and weather and lighting conditions, you will know if you prefer exposing the film at the manufacturer's ISO speed rating, or at slightly higher or lower exposure indexes.

Not all photolabs do equally good work. Saving a few pennies on processing is usually a false economy that could result in off-color pictures. Having a good relationship with a professional lab is a big help almost always. It can be a lifesaver if you have exposure problems.

THE FILMS I TAKE ON MY TRAVELS

Fujichrome Velvia Professional (RVP; nominally 50 ISO; I rate it at 40) is fine grain and has beautiful saturated color. I rely on it for most landscapes and nature pictures. Velvia is especially good where greens and blues are important. Like some other Fuji offerings, this film is way too warm (reddish) for portraits or close-ups and "people pictures" where natural skin tones are important. Velvia is also quite contrasty, and never at its best in bright overhead sunlight.

Fujichrome Provia Professional (RDPII; 100 ISO) is now my bread and butter film. I like the color for everything except close ups of people; the grain structure is excellent even for big enlargements and contrast is excellent; even tolerable in overhead sunlight.

Ektachrome 64 Professional film (EPR) is a classic that has been made for years, but after experimenting with several newer films, I cannot find better for neutral flesh tones and portraits, and always carry some with me. Ektachrome 400X Professional (EPL) is my choice for low available light; I prefer using it to pushing slower films; the grain is very moderate. Ektachrome P1600 Professional (EPH) is now a favorite film, I love it for grainy, moody, bluish effects; I currently shoot quite a bit of it in low light. The film is designed to be used at 400, 800, or 1600 ISO without color shift; speeds of 3200 or even 6400 are possible, then the color shifts lightly to yellow/brown. You must indicate the speed chosen to the professional processing lab. To my surprise, when I tested this film in low, flat, frontal sunlight at 1600, it looked excellent.

Kodak T-Max 100 and 400 Professional (TMX and TMY) are my favorite black-and-white negative films. Agfa's Scala (200 ISO) is a great black-and-white slide film.

Free Data on Professional Films

Kodak and Fuji put out handy, diary-sized booklets giving detailed information on all their professional films; both include filtration recommendations for different light sources, suggestions on compensating for reciprocity failure for long and short exposures, and other helpful information.

The Reference Data Book for Kodak Professional Photographic Products and the Fujifilm Professional Data Guide can be obtained from the Professional Relations Departments of these companies direct, or, sometimes, at professional labs and photo dealers.

Comprehensive data sheets on individual professional films are put out free by Kodak and Fuji (and other film manufacturers); get these from film dealers and labs or direct from the manufacturers. These recommend filtration for different light conditions and exposure times; and can save you quite a bit of testing.

Caring for Film on Long Trips

For optimum color, professional films must be refrigerated before and after exposure (frozen if kept for longer than a few months) and processed as soon as possible, or the color may shift. For a trip of a month or so to a cool climate I wouldn't worry much about color shift, but for a year-long trip to a hot climate test to find the best available amateur emulsion of Fujichrome or Ektachrome. Then keep the film as cool as possible in hotel minibars or refrigerators, or in an insulated bag or wrapped in newspaper while traveling.

If you must buy color slide film in a remote place overseas, first test a roll and have it developed to judge if color is at least acceptable. If you must process film overseas, ask lo-

cal photographers to recommend labs, or airfreight film to a Kodak or Fuji or Agfa designated lab.

Processing Film at Home and Overseas

I am not crazy about processing film away from home, and I've occasionally had problems with professional labs even in large North American cities (including New York it must be said). When you have a lab you like, have them process all your work if possible.

If this not possible, ask Kodak and Fuji for their recommended lab lists before you travel; or see the ads from professional labs in *Photo District News* or ask local photographers' advice. Also locate professional labs in classified phone books overseas.

If you must process on a long trip and you know that the labs where you are shooting are not up to scratch, send or hand carry film to the nearest city with good labs. Alternately, ship film home periodically for processing. Of course, today, it cannot be 100 percent guaranteed that film won't be subject to x-ray, but if you mark the film package "Exposed Film for Immediate Processing" and "Keep Cool and Dry and Away from X-rays," and ship only by one of the well-known airfreight services, you will probably be just fine.

Minimize possibilities of processing problems by sorting a big take into two or three batches, and shipping them on successive days. Include detailed instructions about your clip tests, etc., and label each roll in the package.

Worldwide companies like FedEx, DHL, UPS, and TNT will help you handle paperwork. As an example, current FedEx rate for a five-pound package from Buenos Aires to New York is about \$112; with liability \$100. Insurance is extra, in the above case 40¢ per \$100 of valuation. The service takes two days (longer if customs clearance is a problem). You can ship to a customs broker who, for a fee, will take care of this for you. FedEx and the others ship from most places in the world to most other places.

It's a good idea to check before you leave home with the consulate(s) of the country(ies) you will visit and the closest United States or other customs office, about possible problems, such as required censorship or customs fees. Censorship is not an issue, and duty is not normally charged, for exposed film returned for processing to the United States.

Why Filters Are Used for Color Pictures

Our eyes are amazingly efficient, and can see detail in the deepest shadows and the brightest highlights at the same time. Our eyes also very quickly "correct" color. Skin tones appear natural under the bluish-white light of a sunny beach or ski slope, the warm red glow of a sunset, or the yellow or greenish cast of street lighting.

Indoors, our eyes adjust to make the light of fluorescent and household lamps, and even the orange or red flickers of candles or firelight, seem "normal" or naturally colored to us. Color film can make no such adjustments. It uncompromisingly records the light that is actually there, which is why faces photographed with daylight film in a lamplit room turn out looking orange. Faces exposed under the fluorescent lights common in offices, schools, stores, and factories look sickly green on daylight film. In daylight, scenes taken on very overcast days, or at high noon on the beach or sunny ski slopes, often look too blue, or sometimes too warm for our taste, because variations in time of day, weather, season, and latitude affect the true color of daylight.

As I described above, different brands of film have different color qualities, which are

HOW TO TEST FILMS

Here is how to "test" films to find those you prefer. Test slow fine-grain films, and also a medium-speed or fast film or two.

Arrange some objects on a neutral gray or beige background outdoors on a clear day with blue sky, sun, and clouds, between about 10 A.M. and 3 P.M. Place the still life in even light well away from trees or colored walls (shade the subject with a white umbrella if needed). Include red, yellow, green, blue, and pastel-colored objects in your setup, as well as a black-and-white photograph (or a Kodak gray scale). Photograph people (or your own hand) to test critical skin tones. Note all exposures and filters/filter packs used. Compare results to find the films with the speed, color, and grain characteristics you prefer.

Test high-speed films (400–1000 ISO and up) under low-light conditions, and bad weather out-doors, and under different lighting indoors. Compare color, grain structure, and contrast. Compare ultrafast films "pushed" one or more stops if you wish.

Testing Film Emulsions

Today's professional films are manufactured to very close tolerances (plus or minus 10 CC of filtration), but you may wish to check variations in color slide film emulsions (batches) before you buy any large quantities for a long trip or important assignment. (Film emulsion numbers are printed in computer type on film boxes.)

Tests for emulsion variations need subtle subject matter. A test setup should include a Kodak gray scale, a few bright colors (or a Kodak or Macbeth color scale), some shades of white (try eggs or china), tones of gray and beige, soft pastel colors (use toilet paper rolls or Kleenex), and people with light and dark skin. Test two or three different emulsions. Use the same lens for all the tests (lenses can vary slightly in color). Write exposures used on cards and photograph them into each shot. Use the same processing lab for all tests. Judge test results on a light box, using a Kodak or Calumet color-viewing kit for the most accurate results, or ask the lab to help you judge color. Check subtle skin tones especially. They should never be green or magenta. You will find after testing that no one film does everything equally well, but that two or three will take care of most travel subjects.

usually recognizable by anyone who knows color photography. Each film batch (called the emulsion) varies by a tiny amount from those that precede and follow it, just as paint, yarn, and fabric dyes vary from batch to batch. Even professional film emulsions, carefully chosen and stored at optimum temperatures, can vary very slightly from normal color. Some inexpensive, small, and older, large, electronic flash units emit a light slightly higher in color temperature than the 5,500°K daylight film is balanced for. Processing lab colors vary slightly too.

Still life, fashion/beauty, and product photography require extremely accurate color reproduction. Merchandise reproduced in the wrong color in a catalog especially might be returned in large quantities. Travel and location requirements are less stringent, but there are many situations where the color must be very good (in food photography for instance).

Filters (and gels) are used to modify, correct, or balance color for all these situations and can also be used to change mood. Most professionals own several blue and orange, red and yellow, green and magenta gelatin filters in different strengths, plus a technical filter holder. It is important for serious photographers to become familiar with at least the basic filters. Professionals need to know much more.

FILTER AND GEL FACTORS

All but the very palest filters (and gels) reduce the amount of light transmitted (reaching the film). The amount of reduction is called the filter factor. A filter or gel in front of a lens, or a gel in front of a light, may reduce the amount of light reaching the film plane by 10, 20, or 50 percent, or even more for certain filters/gels. Manufacturers supply information on filter factors with their products. In practical terms, do not worry about the factors when using in-camera meters. The factor for filters on lenses must be taken into account when using handheld exposure meters, including flash meters and spot meters, or you will get varying degrees of underexposure.

Filters for Black-and-White Photography

Black-and-white films are filtered for different reasons than color films. All black-and-white films, of course, convert colors and shades into tones of gray, but even today's panchromatic films that are sensitive to all colors are not equally sensitive to all colors. Some colors look darker, some lighter than they actually are when translated into black-and-white prints. Filters for black-and-white films correct this and alter tonal relationships for a normal or exaggerated range of tones, for faithful translations from color, or artistic variations of normal tones.

Types of Photographic Filters

Filters can be round or square; glass, plastic, or made of optically flat gelatin sheets. Get those filters that are most important to you in the form of round screw-in filters in glass; they fit unobtrusively in front of lenses. Be sure to get filters large enough for your widestangle lenses; the corners of pictures taken with filters that are too small will "vignette" (go dark), especially at small apertures. (Three-inch square plastic or gelatin filters are cheaper but a lot less convenient than glass for the filters you use a lot; they require the use of special filter holders and sometimes a lens adapter ring.)

Color-compensating (CC) filters alter or add color to a greater or lesser degree (they can correct minor color bias in film emulsions). Light-balancing filters (called LB on color meters) change the color temperature or color of the light source to balance with the film being used, or to balance several different types of lighting in the same scene; so that they all can be rendered on the film as our eye sees them.

Neutral density and polarizing filters reduce light and glare/reflections respectively but do not change the color of what is being photographed. Diffusion filters soften, special effects filters can produce starbursts, multiple images, etc., and may or may not alter color. Graduated filters are used by landscape photographers especially; they can be used to reduce contrast between skies and dark foregrounds. Some are color tinted.

Gels

Gels (or gelatins) come in sheets or rolls, and were originally used in the theater, and then movie and TV lighting. Rosco and Lee both manufacture gels in sheets and rolls. They are used by many still photographers in front of strobe and flash and tungsten lights, to bring light and film into balance for best possible correct color rendition. They can also be used to alter colors, slightly or considerably, for creative effects, "mood;" and fun. They come

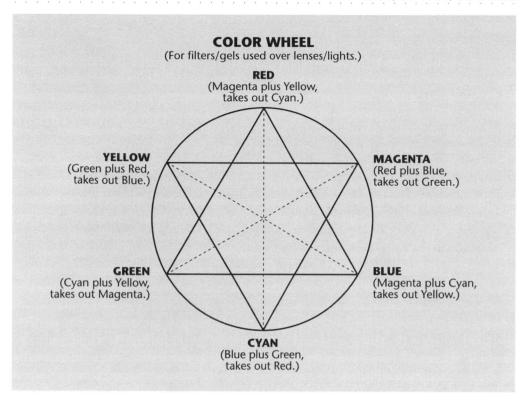

in light-balancing and color-correcting shades, neutral density increments, and just about every color you can think of. (The same manufacturers also make several kinds of diffusing and reflective sheets, which have many uses in still photography.)

Small pieces of gel can substitute for filters in front of lenses in many cases (where optimum color is not required). Because gels are cheap compared to photographic filters, and because a large number of colors are available, they are increasingly popular with still photographers.

A Basic Color Filter Kit

- *UV (ultraviolet)*. This filter is virtually colorless, and theoretically reduces the bluish color of haze (but very minimally in my experience). I use one on all my lenses instead of covers all the time.
- 30M and/or FLD. These filters compensate for the green effect you get when photographing with daylight film under cool-white fluorescent lights, the cheapest, and most commonly used fluorescents. (Both these filters can also be used to liven up dull sunsets.)
- 80A. This filter converts daylight film to balance with 3,200°K photolamps. (This is deep-blue and can also be used for blue "mood" or "moonlight" effects.)
- 85B. (Optional; not recommended except in an emergency, but those emergencies do arise.) This orange filter converts tungsten, 3,200°K color film for use in 5,500°K daylight. (It can also be used with black-and-white film to darken blue skies and enhance clouds.)
- Polarizing filter (or Polarizer). This rotating gray filter eliminates some light waves and

reduces the amount of light reaching the film by up to two full f-stops. It is most useful for cutting glare on water and it darkens blue sky to varying degrees when used with the sun behind it. Use this filter with caution, some people overuse the Polarizer, which to me often looks unnatural. (The Polarizer can also double as a two-stop neutral density filter.)

Get all the above filters in glass, large enough for all your lenses, you will use them frequently. I recommend the Tiffen and Hoya brands. *Note:* All the filter designations given are the photographic standard Kodak designations, which are also used by the Tiffen and Hoya brands among others. Some filter manufacturers (like Nikon and Cokin) use different designations.

Useful Filters for Black-and-White Photography

All filters for black-and-white photography darken opposite colors and lighten similar colors (in the print or slide).

- A #12 or #15 (yellow/deep-yellow) filter is indispensable for darkening blue skies (light blue does not record on black-and-white film).
- A #25 (red) filter makes dark blue skies look black; paler red or orange filters lighten lips.
- A #87 (red) filter is used with black-and-white infrared film for scientific and artistic purposes.
- A #21 (orange) filter makes blue skies look very dark.
- A #11 (yellow/green) filter lightens foliage, and darkens blue skies.
- An 85B (orange) color light-balancing filter can be used with black-and-white film to darken blue skies.

Black-and-white filters can be used for extremely strong effects with color film, if you like that sort of look.

Kodak Professional Filters

Kodak filters (also called Kodak Wratten) have been the standard in photography for over a hundred years. Kodak gelatin light balancing and color compensating filters are used for balancing light source and film; and for very slight changes of color. Kodak filters are still the standard of professional photography.

Other Filters

Tiffen Industries makes all its filters to Kodak color specifications, they make custom CC and LB filters in glass, and many special effect and black-and-white filters in glass, plastic, and gelatin. They make oblong glass graduated filters that permit reducing contrast in landscapes.

Hoya is a top Japanese filter maker with a very complete line. Singh-Ray makes filters formulated for use with different film brands and types of fluorescent and industrial lighting, and also graduated, underwater, and special effects filters.

Cokin filters, made in France, are especially popular with people who like a lot of added

PROTECTING LENSES WITH FILTERS

I recommend using clear UV on all your lenses as protection from scratches, dust, and fingerprints. With a filter as a lens cover, you are ready to shoot at all times; and even your lens mount is protected to some degree if dropped. For me, a filter used in this way has saved a lens dropped a couple of feet more than once. And, a few of years ago, a woman I know went to Switzerland with a new long zoom lens. She was so thrilled by her first views of the Alps that she left the new lens on the roof of the rental car when changing to wide-angle. She and her husband drove off slowly to snap some goats. Of course there was a horrid clink as the zoom hit the road, and they feared the worst. Fortunately, she had installed a filter. It was smashed to smithereens but the lens survived undamaged!

filter effects; Cokin uses a different numbering system for standard filters than the Kodak system. They offer inexpensive, square, graduated filters.

Nikon and Hasselblad are among camera manufacturers who market filters under their own brand names. These tend to be expensive and have other than standard filter numbers or designations. I personally don't think these filters are worth the extra cost.

Color-Compensating (CC) Filters

Color-compensating filters come in .025, .05, and then in .10 increments to .50, of the photographic additive colors red, blue, and green, and subtractive colors, yellow, cyan, and magenta. They are designated by color (R, B, and G, and Y, C, and M) and strength. A common filter pack for fluorescent lights is a 5Y or 10Y plus a 30M, for instance. Kodak gelatin CC filters are the professional photography standard for use in front of lenses. They are dyed to extremely precise specifications and sold individually wrapped. Most lenses take three-inch square gelatin filters; five-inch filters are available also. Most studio pros own a full set of each color. A metal gel filter holder and adapter rings to fit different size lenses are also needed.

Light-Balancing (LB) Filters and Gels

Light-balancing filters (and gels) are various strengths of blue and orange. Filters are available in glass, plastic, or gelatin, and are used (along with magenta and green CC filters) to balance the color of the light source to the film being used. A set of LB filters, along with a color temperature meter, is almost indispensable for the location photographer who must reproduce color accurately.

Light-balancing filters are used in front of the lens; gels are used in front of lights, for the same reason as light-balancing filters, to modify the color of the light reaching the film.

Blue filters bring tungsten light up in color temperature (make it bluer) for use with daylight film. They include the 80A (3,200°K to 5,500°K daylight), 80B (3,400°K to 5,500°K daylight), and the pale blue 82 A, B, and C filters which are used when a slight increase in color temperature is needed. The 82B filter is used to bring household lamps from 2,900°K to 3,200°K to balance with Tungsten film, for instance.

Orange filters reduce (warm) the color temperature and are used if tungsten film must be balanced with daylight. The most useful one is the 85B (5,500°K daylight to 3,200°K).

The very light orange 81A, B, C, and EF series of filters are often used for a slight warming effect in combination with flash/strobe light (for artistic effect or because some units have slightly higher color temperatures than 5,550°K). Of course they can warm overcast or rainy day bluish light too, and they make average sunlit scenes look warmer, resembling early or late light.

Kodak CC filters currently cost about \$11 each, in New York, at discount; a complete set of thirty-six different three-inch CC and LB gelatin filters will therefore cost you about \$400. Note that CC filters can be combined to produce the same effects as LB filters, if you have all the colors and strengths; the LB filters, though, reduce the number of filters required in a filter pack.

Filter Packs

A combination of two or three CC and LB filters used together is called a filter pack. Packs may be needed to correct difficult mixed lighting situations. Photographers who specialize in location work where difficult lighting conditions are the norm usually use a color temperature meter. (I use Minolta's; see later in this chapter, and also chapters 4 and 14. When using it I carry a lot of CC and LB light-balancing gels.)

Use fewer CC/LB filters of deeper intensity to avoid degrading images with thick filter packs. Never use more than three gelatin filters in a pack.

Special Effect Filters

Diffusion, graduated, starburst, multi-image, etc., filters are quite popular today. The French manufacturer Cokin popularized these filters. In my opinion they should be used with great caution; they can too easily become clichés, especially when bright color is also added.

Moderate diffusion filters with clear centers are flattering to older subjects, and people with skin problems.

Neutral Density Filters

Neutral density filters reduce light without affecting color. A square neutral density–to–clear graduated filter can be extremely useful for cutting the light from the sky in backlit landscapes. I carry these filters in gray-to-clear, muted blue–to–clear, and reddish/orange–to–clear.

Polarizing Filters

Polarizing filters work (in very simplified terms) by filtering out some scattered light waves and passing others on in a specific direction. Polarizers are rotated so you can actually see the effect this has when looking through the lens. They are used for darkening blue skies and reducing glare, as they are neutral gray, and reduce exposure by up to two stops (see manufacturers' directions for specifics). Polarizers can be used in place of two stop neutral density filters. I like sparkle, and use Polarizers extremely sparingly; to me they often give a somewhat flat, drab effect.

Always use circular Polarizers with TTL metering cameras, or the exposures will be incorrect.

Filters/Gels and Color Temperature Meters

Corporate photographers, who must often work quickly under difficult mixed light situations, rely on color temperature meters to tell them what filter packs to use as a basis for tests. Then they test the film and slight variations in filter packs in advance under the same lighting conditions, using the same emulsion, lighting and processing lab as they will for the job.

When viewing test film to decide what additional filtration (if any) is needed, use the CC and LB gelatin filters you have singly or in combination. Alternately, use a viewing kit (a set of filters of different colors and densities mounted together). Calumet's viewing filter kit can be used for color transparencies or prints (about \$60), as can the more limited but inexpensive Kodak color print viewing filter kit (about \$13).

Balancing Foreground and Background Color and Light with Gels

Location photographers often use gels in front of lights aimed at dull gray backgrounds in industrial areas. A red gel on a background light will make the background red, for instance, but will not affect the foreground if the light is properly directed (and masked with "blackwrap"—black aluminum foil—if necessary).

To balance a flash or strobe-lit foreground subject with a time-exposed background area (when using a glass or gelatin filter over the lens to correct a fluorescent-lit, time-exposed huge factory floor, for instance), use the opposite color gel on the lighthead; for example if you use 30 Magenta on the lens, use a 30 Green gel on the flash/strobe. If you don't correct the flash/strobe-lit area, the foreground (your main subject) will come out magenta. (See the Color Wheel diagram earlier in the chapter.)

Using Gels as Substitutes for Kodak Filters

When I started in photography, three-inch Kodak gelatin filters were very inexpensive. I still have some bought in the mid-seventies, with their price stickers of \$1.25 each attached. These filters now cost around \$11 each at discount dealers. (Kodak photo mechanical [color-printing] filters, which are cheaper than the camera filters, come in the same shades, are extremely accurate in color, and may also be used in front of lenses.)

Calumet makes Kodak compatible filters that are less expensive, but still by no means cheap.

Filter and Gel Sets

Rosco's Jungle Kit is a set of fifteen $10" \times 12"$ sheets of their light balancing Cinegels cut to fit Lowel Light, Smith Victor, and other gel holders. (The Jungle Kit contains most of the gels listed in the comparison table on the next page, and costs about \$35 at photo dealers.)

Individual Rosco and Lee gels come in $20" \times 24"$ sheets, and in tubes for use over fluorescent light fixtures (these are used by some architectural still photographers). They also come in wide, long rolls for use over windows.

Calumet makes a useful set of fifteen Kodak-compatible LB and CC filters for use with color temperature meters; about \$60 for the set (see chapter 3).

USEFUL KODAK FILTERS AND APPROXIMATE ROSCO GEL EQUIVALENTS

(For specific filtration recommendations for all types of fluorescents and industrial light sources see film manufacturers' professional data sheets.)

Color-Balancing Filters and Gels

When magenta filtration is used over a lens to correct background areas lit by cool-white fluorescent lights, or if foregrounds are lit with flash or strobe then green gels must be used over flash/strobe lightheads or the flashed area will record as magenta on film. If some daylight is present, reduced percentage strengths of filters/gels are needed.

- Rosco Tough Plusgreen #3304 gel is opposite the .30 Magenta filter.
- Rosco Tough 1/2 Plusgreen # 3315 gel is opposite .10 + .05 Magenta filters.
- Rosco Tough 1/4 Plusgreen #3316 gel is opposite .05 + .25 Magenta filters.

KODAK CC FILTER AND LIGHT SOURCE	ROSCO GEL NAME, NUMBER		
.30 Magenta (full fluorescent light)	Tough Minusgreen #3308		
.10 + .05 Magenta (about 50% daylight)	Tough 1/2 Minusgreen #3313		
.05 + .25 Magenta (about 75% daylight)	Tough 1/4 Minusgreen #3314		
	Tough 1/8 Minusgreen #3318		
25 Magenta (almost all daylight)*	N/A		

Cooling Filters/Gels

Blue filters and gels raise the color (Kelvin) temperature of light. They are used to balance daylight films to tungsten lights, household lights to tungsten films, and for general cooling effects. ("Gels" were measured under 3,200°K lights.)

KODAK FILTER	ROSCO GEL NAME, NUMBER		
80B (3,400°K to 5,500°K)	500°K) Full Blue #3202		
80A (3,200° K to 5,500°K)	Full Blue #3202 plus Eighth Blue #3216*		
	Half Blue #3204 (+900°K)		
	Third Blue #3206 (+600°K)		
	Quarter Blue #3208 (+400°K)		
82C (2,900°K household lamps to 3,200°K Type B film)	N/A		
82A (cools; +200°K)	Eighth Blue #3216 (+200°K)		
82 (cools; +100°K)	N/A		

Warming Filters and Gels

Orange/amber filters and gels lower the color (Kelvin) temperature of light. They are used to balance tungsten film to daylight; to balance cool flash/strobe units to daylight film, and for general warming effects. ("Gels" were measured under daylight.)

KODAK FILTER	ROSCO GEL NAME, NUMBER
85B (5,500°K to 3,200°K)	Roscosun 85 #340
85C (5,500°K to 3,800°K)	Roscosun 1/2 #3408 (warms; -1,700°K)
81C (warms; –800°K)	Roscosun 1/4 #3409 (warms; -1,000°K)*
81A (warms; –200°K)	Roscosun 1/8 #3410 (warms; -200°K)
81 (warms; -100°K)	

*Note: My tests were made using a Minolta color temperature meter. For precise color nothing beats doing your own color tests. Different light sources record differently on different brands of color films.

Care of Fragile Filters and Gels

Apart from glass filters used as lens covers (which should be replaced frequently), keep filters in a leather or fabric filter case or they can get scratched and will fade eventually. I keep mine in a fabric case designed for three-inch Macintosh computer floppy discs. Store filters and gels in the dark when not being used. Gels used in front of hot lights should be replaced frequently.

Where to Learn More about Filters and Gels

Filter manufacturers (Tiffen, Hoya, Cokin, etc.) put out free or inexpensive leaflets about their products. Many now have Web sites. *Using Filters*, a Kodak Workshop Series book, is useful. As previously mentioned, film manufacturers supply free professional data sheets listing filtration recommended for their products.

Rosco and Lee sample booklets showing their Cinegel line and all their other colors are available from professional photo and theatrical lighting dealers, or from the manufacturer. They are sometimes free, sometimes sold for about a dollar. The booklets are interesting to look at and read. Lee sample books are a bit harder to come by; try specialist film/television/theatrical lighting dealers.

Note: The individual samples of gels in booklets are just the right size $(1\frac{1}{2}" \times 3\frac{1}{4}")$ to tape onto a standard-size bounce flash head. (See also resources.)

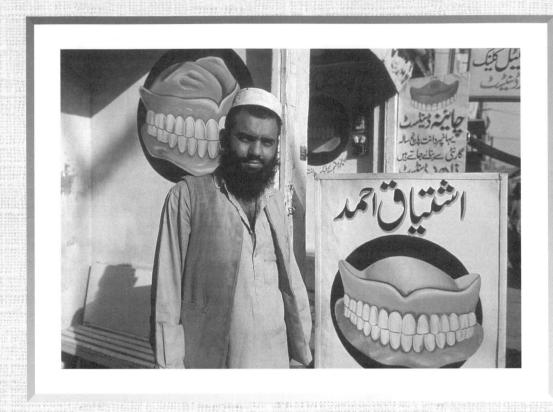

o two travel (or any) photographers use light in the same way. Some advertising illustration specialists go on location with almost the same equipment they would use in a studio, carrying powerful strobe packs and flash heads, big lightstands, large soft boxes, and reflectors and diffusers originally developed for movie location work.

A few photographers specialize in natural light. They have mastered the use of daylight, take advantage of color variations in the light at different times and in different weather, and carry only a camera, a couple of lenses, and a tripod. Most travel photographers can use photographic lights but prefer to work with daylight and existing light, supplemented with flash or portable strobes (studio flashes requiring a source of AC power) where needed. You must decide your own approach to using light.

Developing a Lighting Philosophy

Most professional photographers can use daylight, existing light, and photographic lighting equally well.

My photographic background is editorial or editorial style. My philosophy of lighting is to work with the least added light than I can and still get good photographs. This chapter is about daylight, and low available/existing light. The next chapter will deal with photographic lighting.

Using the Qualities of Daylight and Existing Light to Convey Mood

Beginning photographers, and some who are not beginners, take pictures outdoors, or indoors with available light, or even use flash, strobe, or tungsten lights without giving much thought to the light except to worry if there is enough of it to get an exposure.

But light quality is one of the most important elements in any photograph; sometimes it is the reason for the photograph. The ordinary can be made beautiful, and the beautiful made truly extraordinary, in the right light. Light can be soft and flattering from a diffuse or large, close source; hard or harsh from a single small or distant source; or bright and

sparkling from a multilight source. All of these kinds of light are useful, depending on the mood you want to achieve.

Light from the sun and direct artificial light looks hot when it shines down from right overhead, directional light from the side brings out texture. Diffused lighting from clouds or indoor fluorescent lighting give even, often flat, illumination. Such light is reasonably pleasant on people. Indoors, in factories, hospitals, and schools it may convey cleanliness, efficiency, etc., or it can read as grim and institutional. Soft pinkish lamplight is used in department stores and restaurants for a warm, flattering, relaxing effect. Lots of bright lights can convey fun and entertainment (the Las Vegas strip, for instance) or danger (flashing lights at an accident).

To learn how to really see and to use even daylight well, you must look at light at lot, especially at first. To augment existing light, or create your own, you must learn at least the basics of photographic lighting. There are courses and books solely devoted to lighting. Remember, anyone reasonably intelligent can plug in lights and use them safely after a ten-minute indoctrination, it's creating with light that's hard.

Looking at Light

To master both daylight and available light, and to get a head start on achieving effects you want with photographic light, study daylight and think about light quality wherever you go. Look at lighting effects you like and hate. Do this even when you don't have a camera with you.

Analyze the quality of light in large dark spaces with tall windows like churches, court-houses, and railroad stations. Look at faces in small dark spaces lit with a few high bulbs, like elevators or mom and pop stores. Watch the sun rise. Stand a friend under a tree in bright noon sunshine. What does the light look like? Note the effects of low afternoon sun glittering on lakes and rivers. If you live near the ocean, think about the best light effects. Are they in the morning or the evening, in summer or winter? Take photographs of interesting light as often as you can.

Daylight

The quality and color of daylight is not the same at different times, different seasons, in different weather, or even different places. With the aid of a tripod, you can photograph from the first glimmer of dawn to the last afterglow of sunset. Color records on film differently than as our eyes see it; by photographing the same view at different times of day and year, in different weather, you will learn a great deal about light.

Imagine noon on the desert of Nevada with the sun vertically overhead. June nights in Alaska or Scandinavia where you can read a newspaper outside at midnight. Think of a drizzly fall day in the caverns of New York, London, or San Francisco's financial districts. Visualize mist coming off Pacific Ocean surf early in the morning, making the cliffs recede in ever paler bands of blue. Remember a Minnesota wheatfield glowing against deep blue sky with the sun behind you on an August evening. Or perhaps look at stripes of morning sun slanting through kitchen window blinds, painting a still life of dishes, coffee pot, and fruit with bands of gold.

Light at Night

In real life on TV, you've seen the neon-lit bustle of Las Vegas, or of Times Square. Everyone has watched fireworks illuminating crowds on the Fourth of July, or yellow truck headlights flashing by on an interstate highway or motorway. Think of a lit up outdoor stadium, lights in a huge mall, a glimmer in the windows of a lonely prairie farmhouse. If you can capture these effects on film you can probably take fine photographs, and have come close to mastering the use of available light.

Time of Day

The single most important outdoor photography commandment is to choose the time of day you shoot. The variation in the color and quality of daylight over a few hours can make the difference between a mediocre or average picture and a great shot. Professional travel and location photographers spend a lot of time waiting around for the light to be just right.

Low, warm early morning and late evening sunlight is almost always best for photographing landscapes, architecture and any outdoor scenes. Sometimes this means getting up at four in the morning, because you must be where you want to shoot before the sun comes up—the predawn glow and then brilliant color of a good sunrise may only last from five to fifteen minutes. In Cumberland Island, Florida, one August I rose at five every morning to get long pink and blue shadows that revealed the texture of rippling sand dunes and hundreds of birds' footprints on the beach. That beach became a flat, blinding white at noon.

Many cityscapes and building pictures are morning rather than evening shots because they face east or north. Work out the best time to photograph important things in advance, and plan your schedule accordingly. Popular tourist attractions are best photographed early, before crowds arrive, and before litter has accumulated. Try to get permission to go in before the public, but if this is not possible, the first half-hour or hour in the morning is usually fairly quiet.

Many activities, like the return of a laden fishing fleet, the setting up of fresh displays of produce in a market, or the start of harvesting are also definite "morning shots."

Sunrises, Sunsets, Dawn, and Dusk

Sunsets and sunrise are often spectacular on film. The color temperature of the light is lower than the color balance of daylight film, exaggerating warm red and yellow tones. Sunsets last longer and look redder than sunrises, mostly because of the dust in the air. To shoot sunrise or sunset, scout the location you want (with the aid of a compass if necessary) and be there well before the sun rises or sets. If you photograph for an hour or so before to an hour or more after sunset you will get a wide range of sky, landscape, or water colors from yellowish to orange to red. After sunset the sky will fade to pink, then to pale blue at dusk. A royal blue middusk sky is the ideal for cityscapes with lights, the buildings are silhouetted and separated from the sky. Again, this magic time lasts for only a few minutes, because the sky quickly darkens to navy blue and then black, which usually records as either slightly brownish or greenish on film. Sunrises give reverse effects of course, with deep blue skies warming as the sun gets higher.

Low Sunlight

I have photographed landscapes, animals, and birds in parks and wilderness areas of the United States, Alaska, and British Columbia; on the plains of East Africa; the desert of Australia; and the hot, cindery Galápagos Islands. In all those places, when the sun was out, the best photographs were made within an hour or so of dawn and dusk. Most wild-life feeds early or late. Creatures that are around at midday are spotted or striped or otherwise camouflaged to be almost invisible in bright overhead sun.

When photographing people outdoors, warm early morning or evening sunlight, or light diffused by clouds, is infinitely more flattering than harsh noon glare. When the sun is low from behind a person, you can "bounce" light back into your subjects' faces with a portable reflector. I prefer white or silver reflectors; gold gives a look that is too yellow for my taste. Collapsible round reflectors stretched over thin wire are easy to transport, or for a couple of dollars, invest in a silver Mylar space blanket (found at camping stores).

Winter sunlight is low and warm during daylight everywhere outside the tropics; you can shoot at noon in Switzerland or Scotland, New Jersey or Nice, and still get interesting color and texture.

If You Must Shoot in Overhead Sun

Sometimes you can't choose the time of day or year you photograph (or can't wait) and must shoot in overhead sun. Then use reflectors, flash "fill," and your picture-design skills to minimize harsh effects.

If you shoot a lot of outdoor sports (such events do come up in travel assignments), remember if it's sunny to save plenty of film for the second half of the baseball game, tennis match, bullfight, or the last few horse races. The light will be infinitely more pleasing at 4 or 5 P.M. than it is at 2 P.M.

For portraits and close-ups of peoples' faces, especially those with dark skin, deep shadows caused by overhead sun are not acceptable for reproduction. Use reflectors or a small flash to "fill" (lighten) shadows.

Light and Bad Weather

The quality of light caused by weather is important when shooting landscapes. Bad weather can mean awful or beautiful light. On assignment in Northumberland, on England's harsh Northeast coast, I hit an uncharacteristic spell of brilliant sunny days and cloudless blue skies. I shot interiors, and was much relieved when great black-and-white cumulus clouds blew up and let me take the moody castled hillsides and white-capped seascapes I visualized.

I wait for fine weather in the damp English Lake District; lakes in the rain are not appealing and are useless for editorial, tourism, or stock photography. Just before it rains, mountains and distant views are a sharply delineated, deep blue. You can photograph in fog, rain, or snow (protect your camera with a clear plastic bag). Blue dusk is a great time to shoot mountain vistas. You can shoot cities in any weather, and if you shoot at dusk, you can salvage a rainy day because the rain itself will only be noticeable if it reflects on shiny streets, and it won't show up on long exposures of skyline views. In the country, you can make long dusk exposures of damp landscapes too, I've done it very effectively in Ireland, New York State, and the Orient. It is my experience that weather often improves at dusk, the rain may stop as you start shooting.

A stable tripod with vertical and horizontal adjustments is often an absolute must for shooting in low light or poor weather. The light in bad weather is low, requiring exposures too long for handheld shooting. This light is high in color temperature and looks bluish on film. Use this color to effect mood, or correct it if you prefer.

Time of Year

Some pictures are not just "morning shots," or sunset shots, they are summer shots, or fall, or winter, or spring shots. I'm not just talking about the color of the leaves, but about air quality, and the specific position of the sun on the horizon at different times of year. For instance, the famous view of the Statue of Liberty with the sun setting right behind it (it looks great taken with a 500mm lens) can only be done for about two weeks in December when the sun sets almost due south of Manhattan. The spectacular cloudscapes of New Mexico are at their peak in August; in northern Europe, it gets dark at around 4 P.M. in November; most mountain ranges are hazy in midsummer; and so on. Buildings can't be moved, but the sun moves around them. An architectural photographer may wait months for the sun to illuminate the north side of a building. Rainy seasons are to be avoided. If you can plan a fall or spring trip, these are the best photography seasons almost everywhere, with clear, angled light. (Remember, seasons reverse in the Southern Hemisphere!)

Types of Daylight

The quality and the direction of daylight at any time and any season is always important for photography. Here is a brief description of some daylight situations, and their photographic advantages and disadvantages:

Side Light

This directional light from the low-angled sun early and late in the day is beautiful, and the first choice for most landscapes, panoramic views, and cityscapes. For buildings and architecture the direction of the sidelight at different times of the day (or year) is important. Sidelight can be a strong portrait light. It emphasizes facial planes, and is excellent for showing up textures of all kinds.

Backlight

Light from behind the subject (sometimes called rim light) is very low morning or evening sunlight, aimed at the lens but masked behind a person, scene, object, or building. Sometimes it can shine directly into the lens. When properly used, this can be the most interesting light of all. Long shadows come towards you, heads are haloed with sunshine, translucent leaves and flowers take on a new beauty, and portraits are supremely soft and flattering when the sun is low and right behind the subject. And low backlighting is often spectacular over water. This lighting takes quite a bit of practice; use your exposure meter carefully, bracket exposures, and meter up close on people's faces to avoid silhouettes. Flare caused by the sun's direct rays hitting the lens and bouncing around can cause little blue blips, or orange "spaceships" on the picture, and can degrade or destroy the image. Use the stop-down preview button on your camera; you can see any problems caused by too much flare. Sometimes flare effects can add excitement to a shot; sometimes you must change your angle to the sun, or use your hand (or a tree branch or other object) between

you and the sun to block excess flare. Meter off the sky, not the sun itself for a picture of the sun at sunset, or the sky will be too dark and underexposed. Also, meter off the sky, not brilliantly backlit water, or sand or snow, or you will again get underexposure.

"Bounce" Light

Light "bounced" onto a shaded subject is beautiful; it is a soft, glowing light that is reflected from a nearby white building or other large white or light surface. If you photograph someone on the shady side of a sunny building or street or under a white porch with the sun hitting a white building opposite, you can get flattering "bounce-lit" portraits in bright sun. Light that is kicked into people's faces from snow and white sand is effectively "bounce" light too. Create flattering bounce light with a portable white or silver reflector. Place the subject in shade and angle the reflector so the sun hits it and "bounces" light back to the subject.

Flat Light

Low sunlight from behind you that hits a subject directly in front of you is flat light. Use this warm light early and late all year everywhere, and throughout sunny winter days in northern climates (when it is very yellow). Flat light can be dramatic in a posterish kind of way, especially when using long telephoto lenses. It is the only way to photograph long reflections on water, and is great for sunlight landscapes (especially red western landscapes) with storm clouds brewing. It is dramatic for cityscapes, city crowd scenes, traffic, markets, etc., though it can be a bit harsh for people (they tend to squint), and looks rather like direct on-camera flash. When the light is flat, you can deliberately underexpose scenic shots for deep blue skies without the need for Polarizing filters.

Three-Quarter Light

Old photo manuals recommended shooting with the sun coming over your left shoulder because light from a high three-quarter angle easily defines almost any subject and is an almost foolproof way of getting good pictures with the simplest camera.

Soft Light

Soft light can come from different sources. It can be low daylight before sunrise, or after sunset, or light diffused by clouds or mist or even drizzle outdoors. Rainy or snowy days are softly lit, and can convey much emotion. Misty soft light can be lovely for land- and seascapes; thin fog gives oriental effects of receding planes of color getting paler and paler. You may need slow shutter speeds and a tripod to record low, soft light. Indoors, soft light filters indirectly from a window, especially from a high north window, or a window diffused by translucent curtains. It is the light chosen by many classic portrait and interior painters, and by the early portrait photographers. The direction of the window light to your subject varies the light quality of course. Experiment with moving the subject and your camera angle in relation to the window.

Use gentle and flattering soft light for portraits and people studies outdoors even on sunny days, by moving your subject into the shadow of a building, or onto the shaded side of the street. (You can also shade them with a translucent white umbrella.) White reflectors made of fabric stretched on collapsible frames can be used outdoors to soften light. In the movie business they are called "silks" or "flying silks," and are hung above the subject/set, or angled from the side on stands.

USING REFLECTORS TO SOFTEN HARSH OR CONTRASTY LIGHTING

The most convenient reflectors to travel with are the round, collapsible fabric ones made by Photek and others. Using a motorized camera, or a camera on a tripod, I can shoot with one hand and use the other to hold and angle a thirty-six-inch reflector to bounce light and fill dark shadows for a people/portrait subject. If you must shoot from further away, ask someone else to hold and aim the reflector, close to the subject, but out of your frame of course. (You can also use a stand and a reflector clamp, see below.) White reflectors work well up to about six feet from the subject; shiny silver and gold ones "bounce" light further.

Top Light

This hard light comes from overhead summer, midday or tropical sun, and is to be avoided as a rule. It causes ugly shadows under peoples' eyes, noses, mouths, and chins. Indoors, top light comes from overhead, unshaded lights. (It's a good light for conveying harsh or primitive living conditions.) On the beach, if someone is lying looking upwards, the top light in effect becomes side light, and can be used for conveying a feeling of heat. (Some light is always bounced upwards from snow or white sand, opening up shadows to a degree.) When photographing dark-skinned people under top light, always add bounce or fill light to prevent shadowed eyes from disappearing into black holes. Use an angled white or silver reflector, or flash fill for this.

Top light from overhead sun is almost never good for landscapes. Sunlight at noon hits only the roofs of buildings, leaving too dark shadows below. In general, go "location scouting" (see also chapter 16), shoot indoors, or take a short rest in the middle of sunny days.

I make it an almost inviolable rule not to shoot outdoors if my shadow is shorter than I am. The only exceptions are if I need to show heat, broiling beaches, tropical languor, etc.

Contrasty Light

"Spotty" light—where part of a scene or subject is very brightly lit and part is in deep shadow—should be avoided because film, especially color film, cannot record the same extremes the eye can see. About five f-stops difference between the lightest and darkest areas is maximum to avoid black underexposed areas and bleached out highlights (check lighting ratios with a meter). Reflectors and flash can help fill confusing shadows when used close-up; but, be aware that noon sun filtering through distant foliage and grassy land-scapes causes patches of dark shadows and bright highlights and the image may look so spotty that the totality is very hard to see (the principal behind camouflage). Take nature photographs early and late; look for clearings under trees.

Be aware of color casts you can pick up under foliage. Early in my career I was photographing a Southern resort. A grand outdoor wedding took place beneath oaks covered with Spanish moss. Everyone was in "Gone With the Wind" costumes. I shot behind the official wedding photographer, and was pleased with myself until I got bright green pictures back from the lab!

Wide-angle lens shots of contrasty big-city street scenes half in sun and half in deep shade are a problem, because if you expose for the sun side, the shadow side will go almost black, and if you expose for the dark side the light side will be too light to record detail. Change your angle, come back later or earlier, or wait for a cloudy day to minimize contrast, especially in cities like New York, with high buildings. Flash fill can help.

Extremely Low Light

You can take pictures at any time you can see. Use time-exposures and a tripod, or fast film. (Be aware of possible reciprocity failure and bracket by adding extra seconds or minutes to time exposures of over, say ten or twenty seconds.)

Professionals may use a gyrostabilizer when a tripod can't be used. Cameras can then be handheld without blur at shutter speeds as low as one second. These devices, made by Kenyon, can be rented. (See resources.)

Fleeting Light, or Magic Light

Fleeting moments when the light is truly extraordinary come rarely, and you must seize those moments when you can. Extraordinary light often comes in conjunction with awful weather. I can think of a couple of examples: I went to Cambodia to photograph the famous temples of Angkor Wat with some difficulty. I had a visa for a week. The year 1969 was not too good a time to be in that part of the world. I spent three of those days in Phnom Penh, then flew to Angkor. I was trapped in the hotel facing the temple complex by a torrential downpour for two and a half days. On the evening of the third day, just as I was getting nervous about having to leave the next morning, the rain slackened. I ran out with cameras wrapped in plastic. After a few moments, as I photographed a gold-colored cow munching on the acid-green grass in front of the gray temple, the sun crept out from a crack in the black clouds and the whole scene was suffused with a watery lemon light. The effect was so extraordinary that I almost wanted to just watch and not take pictures. Almost. In ten minutes the sun was gone.

If you have that kind of pure pictorial luck, shoot your heart out! And never quit because of bad weather. It will change, and when it does, you will get great light. I'm a native of England and I know! I've lived in the same lower-midtown New York east-facing sixteenth floor loft for twenty years now. The light is always changing, but the best effects come before or after storms; winter and summer, spring and fall.

Window Light

This usually beautiful light is best when diffused; on a cloudy day, or by thin white curtains, or when light comes from a high north window (the light beloved by classical portrait and still-life painters). You will often need to use a tripod for slow shutter speeds and longish exposures. Use a reflector or a white sheet or white illustration board to bounce some light back into the dark side of the face in a window-lit portrait. Interior shots of even dimly window-lit churches, historic homes, etc., can be made with time exposures and a tripod.

Available Light and Mixed Light

Available light is the photographic term for existing light from lamps of any kind in streets, stadiums, stores, offices, schools, etc., or any mixture of daylight and existing light. Get good results photographing by available light using a long exposure and a tripod, or fast film, or both.

Mixed light is where several different kinds of light exist in the same area. A fluorescentlit office or classroom may be near a window, or a shop may have both warm tungsten

SUNSETS AND SUNRISES

Sunsets usually last longer and are more colorful than sunrises (because of heat and dust raised in the day). Effects vary; the peak may last seconds or half an hour or longer. Meter off the sky around the sun, not the sun itself, or you will get a well-exposed sun but a dark or black sky. I bracket (vary) exposures of sunset/sunrise pictures.

Best sunsets are when there is a lot of pollution or haze, making the sun deep orange or red, or after storms. Some places I've been where there are fantastic sunset cloud effects are Arizona, New Mexico, Miami, Bermuda, and the west coast of Scotland. On clear days anywhere there is too much contrast for great sunsets or sunrises.

Photographs of sunsets can be clichés, and often disappointing if shot with normal or wide-angle lenses. (The sun will look like a pinhole in the frame.) Sunsets are not worth doing in my opinion unless the overall scene is worth recording, or the color or cloud effects especially good. A silhouetted person or interesting object shot in front of the setting (or rising) sun will improve most shots but should have a graphic shape.

To get a reasonable-sized image of the sun rising or setting you will need at least a 200mm lens; a 300mm or 500mm is often better. My favorite pictures of the Statue of Liberty with the sunset behind it are made with a 300mm lens plus a $2\times$ tele-extender. If you use a $2\times$ tele-extender with a 300, 400, 500, or 600mm lens, you can make a very nice large sun with the doubled focal lengths that results. (Don't look through the lens directly into the sun for more than a few seconds.)

To illuminate someone or something in front of a sunset/sunrise, set exposure for the background, then use a flash to "fill" the person or object. The flash should be close—within four to ten feet of the subject, depending on its power. (See chapter 7.)

lights and greenish fluorescents. In general it is better to use daylight film for most mixed light situations. Daylight film looks warm or orange with nonphotographic lights and green with fluorescent lights. If you don't like these effects there are a couple of useful filters that will give good (not perfect) color under such conditions. If very accurate color is essential (it often is on a job), film testing in advance with one or more filter packs is necessary.

Shooting at "Blue Time" (Dusk)

Manufacturers recommend using most films for exposures of no longer than about four seconds because of color shift, but outdoors at dusk there is so much natural color shift toward blue in the sky that any shift in the film color is barely noticeable.

With ultra fine-grain Velvia and an f/5.6 aperture, I start shooting in pale blue dusk at one-fifteenth, then one-eighth, one-fourth, and one-half a second. At royal blue dusk, I use exposures between one, two, four, eight, and even sixteen seconds at f/2.8 and f/4. Usually all of these exposures are all good to excellent, with moody blue color variations.

I sometimes use exposures of several minutes with slow film, or when I want a very small aperture, or when I use long telephoto lenses with tele-extenders that cost two stops in exposure. I then bracket extensively. Try one-, two-, four- and eight-minute exposures with ISO 50 film and f/8, f/11, or f/16 apertures.

If long exposures at dusk make you nervous, use fast "push" (400–1600 ISO) Ektachrome or Fujichrome films to reduce the time needed. Meter off the twilit sky when shooting at

dusk. Experiment with time exposures, until you don't feel afraid of them. Expose tungsten film also just to see what it looks like. Evaluating all results carefully but not destructively will help your travel photography.

Shooting at Night Outdoors

Problems to consider in night photography are accuracy of exposure, contrast, the law of reciprocity, and color shift that occurs with long exposures. Meter carefully when using either an in-camera meter or a handheld meter under lights at night. (See also chapter 5.)

The best outdoor "night" pictures in city or country are usually taken at twilight—I call it "blue time"—after sunset, before it gets completely dark. Dusk in any weather starts off pale blue, like faded denim, then darkens to royal blue (the peak time for great "night" shots), quickly turns navy blue, and then black. I usually shoot the whole sequence.

Totally black night pictures are often not so good. Time exposures at night come out different colors according to the film used and emulsion. The night sky can look greenish (with some Fuji films), brownish (with Kodachrome 25 and 64), and purplish (with some Fuji films and Kodachrome 200). My preferred film for long exposures is Ektachrome Professional 100 (EPP). It holds a very true blue and black.

At night, in Times Square, or the Las Vegas strip, or on the Ginza, don't aim your camera or handheld meter directly at the bright lights but at something midtoned, like the sidewalk; then reframe for your desired composition. Use the memory lock (or similar name) button on a program camera, or you will get a picture of only the brightest lights, with a totally black background. Use the spot meter setting on an electronic camera, with a telephoto lens carefully aimed, or use a spot meter for distant night views.

Night exposure and filtration guidelines come packaged with film (or printed inside film boxes); also see manufacturers' data sheets for professional films. Kodak and Fuji don't recommend extremely long exposures because of color shifts, but try them anyway, the results can be marvelous and more interesting than "correct" color. (See the table below, which is based on my tests.)

Why a Tripod is Needed for Almost All Night Photography

Many pictures can be made at night, but they require slow shutter speeds (long exposures). A good tripod will hold the camera steady so that no jiggles or blur occurs. (Caution: inexpensive tripods designed for camcorders do not hold heavy still cameras steady.)

- To shoot fireworks, use a tripod and choose 100 ISO film. You can't meter fireworks, but I have found that a lens aperture of f/5.6 and varying shutter speeds between eight, fifteen, and thirty seconds works fine. Focus on infinity. Use B (Bulb) setting on older cameras and count off times. A cable release will minimize camera shake. Try and find a viewpoint that includes more than just black sky.
- Laser displays vary considerably in intensity, but you will need a tripod for all of them. For bright laser light displays use 100 ISO film, apertures of f/2.8 and f/4 and bracket exposures. Try two, four, and eight seconds.
- A tripod is a must for photographing floodlit buildings. As floodlighting intensity and color varies widely, meter off lighter and darker parts of buildings or monuments (not the night sky) and average the exposures. With 100 ISO film, try bracketing

NIGHT PHOTOGRAPHY EXPOSURES

Bracket these exposures in one-half to one f-stop increments when possible. Note: "s" stands for seconds

	25 ISO	50 ISO	100 ISO	400 ISO
Amusement parks, dusk	1/15 f/2	1/30 f/2	1/30 f/2.8	1/60 f/4
City skylines at "blue time"	½ f/2	½ f/2.8	1/4 f/2.8	1/8 f/4
City center signs at night	1/30 f/2	1/60 f/2	1/60 f/2.8	1/60 f/5.6
Country—pale blue dusk	1/8 f/2	1/15 f/2	1∕30 f/2	1/60 f/4
Big firework displays	30 s f/2	30 s f/2.8	30 s f/4	30 s f/8
Floodlighting at dusk	½ f/2	1/4 f/2	1/4 f/2.8	1/8 f/4
Sound and light shows—night	1 s f/2	½ f/2	½ f/2.8	1/4 f/4
Laser light displays	15 s f/2.8	8 s f/2.8	8 s f/4	8 s f/8

Photographing the Full Moon

Aperture of my 1,000mm lens was f/16. With 100 ISO film I used exposures of $\frac{1}{30}$ – $\frac{1}{60}$ at f/16. With ISO 400 film I use exposures of $\frac{1}{125}$ – $\frac{1}{250}$ at f/16.

This is based on three tests, because the brilliance of the moon varies. I used an old 500mm f/8 mirror telephoto lens plus a 2× tele-extender for moon pictures, to get maximum moon size. Remember, you want good exposures of the surface of the moon itself, not the surrounding sky (which may vary from pale blue to black). Don't use slow film to photograph the moon unless you have a very fast telephoto lens—the moon moves during long exposures.

around half a second at f/2.8. I sometimes use both tungsten and daylight film in different cameras for floodlit scenes and sound and light shows (which alas, never start at dusk but wait till pitch darkness) for the best possible interpretation of colors. I bracket exposures at least a half and a full stop in either direction, more if the lighting is very contrasty.

• Make Polaroid exposure tests of all these situations for a guarantee of good exposure. (See chapter 4.)

Photographing By Available Light Indoors and Outdoors

A tripod is usually impractical indoors at crowded events (but use one if you can). Flash may or may not be permitted. Use the fastest possible lenses, and fast or superfast film. A program camera is unsurpassed for rock shows and other presentations where the light is constantly changing. I use my N90s in S (shutter priority) mode with 1600 ISO films to avoid blur if the subject is moving. Use at least a 200mm lens and the spot meter option with a built in TTL meter, or use a spot meter.

Bracket contrasty situations. Remember that an acrobat in a white suit may be overexposed if he or she is small on a large dark background. Remember too that all meters are designed to reproduce average subjects.

"Sneaking" Pictures

I sneak the occasional picture in theaters and concerts. (Photography is forbidden on Broadway and in London's West End unless you can get invited to the preopening night photo call, for which the whole company—Actor's Equity members, musicians and stagehands—are paid.) I am cautious "sneaking," and have never had a problem, but remember: you try it at your own risk! The safest time to sneak pictures is during bursts of applause, loud scenes, and the big production numbers that come at the end of the acts in musicals, operas, and concerts. You can photograph final curtain calls in theaters quite openly if you do it quickly and move out. I have not been thrown out of a theater yet; I've used the technique in concert halls and opera houses too. I'm told this is not advisable in the less genteel atmosphere at some rock concerts and shows, where cameras are sometimes confiscated!

Reciprocity Failure and Color Shift in Long Exposures

Reciprocity is the correlation between lens aperture and shutter speed. If you open a lens one full stop (from f/5.6 to f/4 for instance) twice as much light will reach the film. At average shutter speeds (in the range of about one-thousandth of a second to about one or two seconds), if you want the light reaching the film to remain constant, double (increase) the shutter speed when you open the lens one stop, or halve (decrease) the shutter speed when you reduce the aperture one stop. But at very high speeds and very slow speeds these correlations no longer apply exactly. This phenomenon is called reciprocity failure. You must give a slightly longer exposure, or use a slightly bigger f-stop than you thought you needed.

With 35mm cameras and lenses, I have found that bracketing extensively with the shutter speed takes care of any possible reciprocity problems. (I use a tripod of course.) Film manufacturers do not recommend using exposures of over four seconds for most films. In practice, however, the color shift that occurs at very long exposures is of more worry to studio and product photographers than to travel/location photographers. The warm shift you get with long exposures in low light produces interesting colors. (Think in terms of exposures of at least a minute or longer, with the smallest f-stops.)

See manufacturers' film data sheets for more on reciprocity failure with both very long and very short exposures.

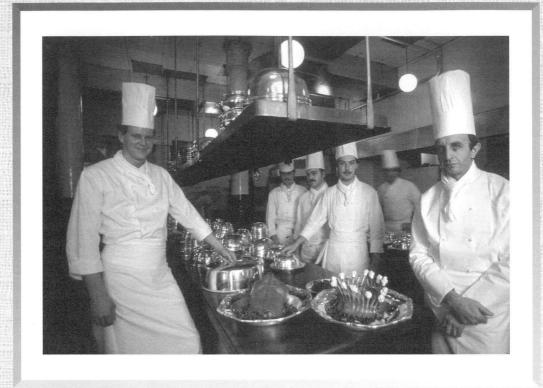

he biggest differences between amateur and professional photographers may be that most professionals are comfortable using photographic lighting and most amateurs are not. Lighting adequately is not hard once you have learned a few fundamentals; but evolving a lighting style takes practice, and looking at light effects you admire and trying to recreate them, and refining your inner vision of how a scene should look.

Lighting Fundamentals

To progress quickly, take a lighting workshop. These are offered by many photo schools, photographers' associations, and individuals. (I give occasional courses myself at the School of Visual Arts in New York.) Assisting a professional who is good at lighting is also a great way to learn.

There are three types of photo lighting: tungsten (or hot lights), flash, and strobe. Photographic tungsten lights are similar to the bulbs burned in homes, but brighter and balanced for Tungsten-type 3,200°K color films. "Hot lights" require a continuous supply of household electric current, and are quick to set up and use.

Portable flash units of all sizes are powered by disposable or rechargeable batteries, can be used on or off camera and can easily be combined with strobe use. Most flash units are lightweight; portable flash is my favorite lighting method.

There are two inviolable basics to remember about flash:

- 1. The light from any small flash (or any single point light source) falls off rapidly according to the square of the distance from the subject. In practical terms, don't waste flash on anything out of maximum range. Range can be six, ten, twenty, or forty or so feet, depending on the power of the flash and the film speed and lens aperture used.
- 2. Never exceed maximum flash sync speed with the camera shutter when flash is used, or part of the image will be blacked out or dark. Today's top electronic cameras sync at ½50 or ⅓500 (and will not permit exceeding sync speed when flash is turned on).

Midrange cameras sync at about $\frac{1}{125}$, old SLR manual cameras with focal plane shutters sync at $\frac{1}{120}$. Cameras with leaf shutters sync at up to $\frac{1}{120}$ 00 of a second.

Portable strobes (sometimes called studio flashes) are powerful flashes that run off 110 volt (v) electric current (or 220v current in many foreign countries) so they recycle fast. Power is usually supplied by a "mains" electricity source, but in remote places can be from a gasoline-powered generator, or current stored in a car-type battery via a device called a power inverter. Strobes incorporate a low wattage tungsten modeling light, so visualizing effects is simple. The light burst from a strobe is short, freezing much motion. A tripod is not necessarily needed.

Tungsten or "Hot Lights"

Tungsten lights are the perfect way to learn or improve photographic lighting techniques. Hot lights burn continuously, so lighting effects are easy to control. Many photographic tungsten lights are inexpensive, and some are small and easy to pack. Hot lights are in style again with portrait and fashion/beauty photographers. The tungsten lights used today are balanced for use with 3,200K Tungsten film (formerly called Type B film). As mentioned earlier, only Kodachrome Type A film, 40 ISO (rarely used today), is balanced for 3,400°K lights.

Photoflood bulbs used in polished metal reflectors and mounted on lightstands are inexpensive and easy to use. A garage light from a hardware store plus a ceramic insert and a 250 watt 3,200K photoflood lamp will cost you about \$15. A reflector made by Smith Victor and a 500-watt 3200K photoflood bulb will cost about \$50. Add a lightstand for about the same amount. With one 500-watt tungsten light plus a collapsible reflector, or with two photofloods in reflectors, you can make excellent portraits. With four tungsten lights, you can illuminate fair-sized rooms.

The disadvantages of tungsten lights are that photofloods are clumsy to transport; also, slow shutter speeds are often needed, so fast subject motion cannot be "stopped," or frozen, and a tripod must be used.

Tungsten quartz lights, with bulbs the size of peanuts or cigarettes and used in small professional fixtures, solve the size problem. Smith Victor makes good reflectors and a tiny 600 watt model 700SG quartz video light. Lowel makes the excellent Omni and Tota quartz lights that I favor. The Omni can be used with different bulbs in different countries. No transformer for foreign voltage is needed.

To work with tungsten lights, set up any patient human or reasonable-sized still-life subject. Think about what I wrote about types of daylight and the angle of the sun in chapter 6, and practice moving lights around and up and down till you get effects you like. Use thin white fabric for light diffusion, umbrellas and reflectors to bounce light, and gels in front of lights to alter color balance. Lowel's Omni lights can be fitted with optional barn doors (metal flaps), snoots (metal tubes), or metal honeycomb grids to concentrate light, and a holder for sheets of color gel.

Handle all "hot" light bulbs and fixtures with care; they can burn you badly. Weight the bottom of lightstands (and tape cords to the floor) when using hot lights around models. Allow all bulbs to cool before changing them, and prolong the life of bulbs by wearing cotton gloves or using tissue when touching them.

WHAT IS NOT PHOTOGRAPHIC TUNGSTEN LIGHT

Household lights, flashlights, and car lamps are all low-wattage tungsten lights, they will give warm, orange color used with tungsten films. Blue filters or gels can correct this. Street and industrial sodium vapor and mercury vapor lights are tungsten lights, often with a heavy green cast, requiring magenta filtration. All such special purpose lights when found at a location are called "available" or "existing" light.

HMI or "High-C" lights are tungsten lights that burn at extremely high temperatures and are balanced for daylight 5,500°K film. They are not very portable, so they are of little concern to most travel/location photographers. I won't mention them again.

A BASIC TUNGSTEN SETUP FOR LEARNING LIGHTING

The following items complete a basic tungsten-lighting kit:

- Two 250 or 500 watt 3,200°K photoflood bulbs (under \$5 each at most photo stores). They
 are for use with Tungsten-balanced (formerly Type B) color slide film.
- Two ceramic inserts for use between bulbs and lighting fixtures; they cost about \$2 each. For
 safety, use these ceramic inserts between all high-wattage bulbs and photographic lighting
 fixtures. (Caution: Even with ceramic inserts, 250 watts is too much wattage for household
 lamp fixtures and wiring for anything other than a very short period.)
- Two garage-type light clamps and reflectors (about \$10 each in hardware stores). Secure these clamps to stands with gaffer tape.
- Or instead of the above buy two portable Smith Victor 700SG Quartz lights (about \$75 each, see below).
- Two portable six- to eight-foot Pic or Manfrotto/Bogen lightstands (\$10 up, used; \$50 up, new).
- One or two thirty-six to fifty-inch white umbrellas (\$20 up).
- One or two umbrella clamps from a photo store (\$10 up).
- Two twenty-foot standard three-prong grounded extension cords and two three-to-two-prong outlet adapters.

How I Use Tungsten Lights

The quartz lights I use and recommend are the Smith Victor 700SG (a tiny video-light, which takes up no room in a bag; about \$75); and the professional Lowel Omni and Tota lights. The Omni is excellent for travel. It has many light-modification options like barn doors, snoots, and grids (all concentrate light) it takes 110v or 220v bulbs without a transformer (about \$150, accessories extra). Tota Lights have a broad spread, good for lighting rooms (about \$140). All these come with a 600 watt bulb. Buy spare 3,200°K bulbs.

I usually use tungsten light with umbrellas; for people pictures I often work with only one Smith Victor or Omni Light plus a reflector opposite the light to fill shadows. Sometimes I use a second light as fill. Four Tota Lights will illuminate most rooms if spaced out carefully. I tend to aim them up, to bounce off ceilings.

Quartz lights draw a lot of power and burn very hot. When using more than one be sure not to use more than a total of 1,200 watts on any one electric line—make sure no other lights or appliances are operating when you plug in your lights. If the wiring at a

QUICK TUNGSTEN LIGHTING TIPS

- Use a tripod for sharp pictures when shooting under tungsten lights, because you usually have to use rather slow shutter speeds.
- When learning how to light, don't forget to try photographing very light and very dark subjects as well as average-toned ones. Bracket such exposures.
- Shiny surfaces present special problems; you may bounce the light or angle it very carefully
 to avoid unwanted reflections, or do as studio photographers do and aim your light(s) through
 a translucent "tent" (of opaque plastic or paper).

location looks old, use one 600 watt quartz light per circuit as a maximum, or you may blow fuses, or overheat the wiring.

Battery-Powered Flash Units: Advantages of Small Flash

Battery-powered flash divides into built-in or detachable units; then into manual, automatic, and dedicated/TTL (through-the-lens metered) flashes that must be used with appropriate cameras.

Carefully used, even a tiny manual flash can be an asset to a traveling photographer. Often, the trick is to use a tiny flash to supplement existing light. Do this in low light by working with your camera on a tripod. Then, use long enough exposures and wide enough lens apertures to give correct exposure for the background—for instance a large room. Then add just enough flash to illuminate the main, foreground subject.

I once had to photograph poet William Wordsworth's Dove Cottage for a story on the English Lake District. There were no wall outlets in the eighteenth-century cottage; tourists were tramping through constantly; the ceilings were too low to set up lights on stands; and I had to shoot whenever the rooms were empty. These rooms were minuscule, with small windows, and the weather and interiors were very gloomy. (It rains a lot in the English lakes; how Wordsworth managed to write great poetry cooped up in there with his wife, three children, and sister I'll never know.) I took half-second exposures with 50 ISO film, at about f/4 and f/5.6 with my camera on a tripod and a 20mm lens. The day was bright when I started, and I was carrying only a cigarette pack–sized manual flash.

With a necessary P.C./Sync cord joining camera and flash, I aimed the flash at the ceiling. It gave just enough light to render the whites as white, rather than bluish in the low light. The tiny flash worked especially well in the kitchen where a black iron stove dominated the room. I aimed it directly at the stove from about ten feet away. The flash made the old stove gleam so the details on the ironwork could be seen.

Outdoors, a small amount of flash used as fill can lighten facial shadows caused by overhead sun. Flash used as fill can warm or give natural-looking skin tones to subjects within flash range in poor weather (when the high Kelvin temperature of the light makes everything look bluish). Bigger, more powerful flashes can be used singly or in combination for sophisticated effects.

SOLVING FLASH PROBLEMS

Aesthetic problems encountered when first using small flash seriously are caused by the fact that you can't preview flash effects. Hard shadows and dark backgrounds mar beginners' flash pictures, and the "red-eye" in many flash people shots is ugly too.

Learn to previsualize how flash pictures will look by practicing popping off the flash test button in low light, and studying after images. This is far easier than it sounds—try it, and you will soon see improvement in your flash pictures.

To reduce hard flash shadows on backgrounds, stand subjects well away from walls, and use a bracket or remote cord to raise the flash. To minimize the chance of red-eye in people caused by the flash reflecting off the retina, mount a detachable flash on a bracket. (The red-eye reduction mode offered on many cameras does not help much.) To soften the "look" of flash, expose at slower than maximum flash sync shutter speeds.

For manual cameras, use maximum lens aperture, and set the camera shutter so the background is about a half-stop underexposed. The shutter speed may be very low, so a tripod will help avoid blurred backgrounds. Then add flash as fill or emphasis to the foreground of your picture.

Many program and top dedicated/TTL cameras offer a "flash fill" or slow sync mode, sometimes called the "night portrait," or "museum" mode. (On Nikon N90s, use the Ps mode.) Dedicated flashes add just the right amount of fill in low light, whether the camera is set in program, shutter priority, or manual mode. Also use slow sync flash fill with a Vivitar 283 or other good automatic flash; the sensor does take low available light into consideration.

For manual flash, use a flash meter to calculate needed flash fill.

Manual Flash Units

Manual flashes can be tiny and cheap; midsized; or big, powerful, and professional. A manual flash (if fully recharged) always puts out the same amount of light. A photographer must use a scale on the flash, or a flash meter for accurate exposures. (To learn about achieving good flash exposures with the old Guide Number system, see later in the chapter.)

All strobes currently made are manual units also.

Automatic Flash

Automatic flashes, invented about thirty years ago, are moderately priced, and all have a sensor on the front. They are intended for use with manual cameras. The photographer must set the film speed on camera and flash, then choose among three or four indicated lens apertures or distance ranges. The chosen lens aperture must be set on the camera, then the flash exposures will be good to very good within the given distance range. Automatic flashes can cost from about \$40 to \$200, discount, in New York. Do not buy any unknown brand of automatic flash—you may save a few bucks, but I have seen no-name flashes that melted and fell apart!

Recommended automatic flashes are made by Metz, Sunpak, and Vivitar. I use Vivitar 283s (see diagram on p. 94). Automatic flashes are midsized and can be used on camera, off camera in automatic mode with optional automatic cords, or as remote flashes when equipped with a "slave" device to fire it. They make excellent supplements to TTL flashes. To do this, equip each with a slave unit; position them further from the subject than the

HOW TO USE FLASH FILL WITH A POINT-AND-SHOOT OR PROGRAM CAMERA

Good (but not all) electronic point-and-shoot cameras permit you to fire the built-in flash in any light, via a flash on/flash off option. Using flash on mode, the built-in flash will fire in bright day-light and deliver enough light to "fill" or soften close shadows on faces caused by overhead sun. In low light, use flash on mode and stand close to the subject. The flash will deliver sufficient light to fill faces silhouetted against sunsets, or brighten nearby objects at dusk or on gray days. Entry-level 35mm SLR cameras with pop up flashes, or even top SLR camera set to P (program) mode(s) with on-camera flash can be used in exactly the same way.

For best flash fill effects use slow- or medium-speed film (ISO 50, 100, or 200) and stand close to the subject—no further than ten feet away, maximum, in low light; five or six feet away in average light. For very bright backlighting, you may have to come in as close as three or four feet. Avoid placing a subject in front of glass, mirrors, or reflective surfaces, those will fool the flash into underexposing.

TTL flash, and set the remote flash for an f-stop the same as, or smaller than, the lens aperture you are using.

Automatic flash exposure is controlled by a thyristor (an electronic switch in the sensor) that cuts off the flash when it deems enough light has reached the film. Automatic flash can be used to fill (lighten) shadows. In bright daylight maximum shutter sync speed must be set. (For flash fill in low light any speed lower than flash sync shutter speed can be used.) See camera and flash manuals.

Dedicated/TTL Flashes

The newest electronic, dedicated/TTL cameras and flashes became popular in the early 1990s. They are computerized and designed to interact with each other. Detachable dedicated/TTL flashes used with appropriate dedicated cameras give extremely good to superb exposures when you understand how to use them. (It takes most people about an hour of studying manuals for camera and flash to understand the settings.)

Tiny dedicated/TTL flashes are built into good point-and-shoot cameras. Be sure to get a model that incorporates a flash on/flash off switch, to give you control. Pop-up dedicated/TTL flashes built into some entry and midlevel 35mm SLR cameras are activated with a button close to the flash. Simple detachable dedicated/TTL flashes that aim forward only are moderate in size, and cost about \$100.

Bounce dedicated/TTL flash models are more versatile, with heads that can be angled for varied effects. Top models permit varying the amount of flash fill to suit your own taste, via a set or select button on the flash. Manufacturers' TTL flash models for just about all the top electronic cameras cost between about \$300 and \$450, depending on power and features. Dedicated/TTL flashes can be used off-camera with appropriate dedicated cords.

Modular dedicated/TTL flashes are made for all popular electronic cameras. These can cost from as little as \$100 for consumer models to \$600 and up for professional units, including a rechargeable battery.

Detachable Bounce Head Dedicated/TTL Flash Units

These are the most versatile small flashes made, the kind I use on my travels. My flashes bend in the middle and rotate; the head can be aimed straight up, straight or diagonally forward, or to the side. These options permit bouncing light off low white ceilings or nearby walls, diffusing and softening the light. Since white ceilings and walls aren't always handy, many homemade and commercial "bounce" flash accessories are available. They include the simplest: angled white $3" \times 5"$ file cards attached with a rubber band; folding plastic bounce devices like the popular LumiQuest; white umbrellas; white, silver, or even gold reflectors; and even white plastic bags suitably placed.

Large flash units of the "potato-masher"-type mount the flash head on a handle, and are designed to be used on a bracket attached to the camera tripod socket. They are big and heavy, so I don't use them.

Dedicated/TTL Flash On- and Off-Camera

Dedicated/TTL flash is one of the major benefits of choosing a dedicated/TTL camera. The combination permits achieving many sophisticated flash lighting effects with relative ease. Dedicated/TTL camera/flash combinations measure the light from all sources reaching the camera film plane. Computerized circuitry cuts off the flash when there is sufficient light for a good exposure. Dedicated/TTL flash units are easy to use (after you have studied the manual carefully!) and have their own lighting aesthetic. They can be set on the camera hot shoe, or used off-camera, connected by a compatible "dedicated cord" between hot shoe and flash.

At the time of writing, only Minolta makes dedicated camera/flash combinations permitting remote flash (not connected by a cord) in full TTL mode (usable at rather close distances only). Ikelite (known for underwater flash) makes the LiteLink slave for remote Nikon and Canon dedicated flashes, that "sees" when a camera connected flash turns off, and switches off the remote flash. I have used this with my Nikon SB-26; it works well when the remote flash is further from the subject than the main flash on or close to the camera.

Metz, Sunpak, and Vivitar all make modular dedicated flash units for popular 35mm and medium-format electronic cameras. Quantum makes an excellent, easy-to-use high-powered professional model. You must get a modular unit with a dedicated module for your particular brand and model of camera.

Using Dedicated/TTL Flash for "Fill" Light

I normally use my Nikon N90 cameras with SB-26, SB-28, and SB-23 TTL flash units. (I will buy Nikon's new SB-28 when I need a new flash; it offers no special advantage over the SB-26 except that it is slightly smaller and cheaper.)

I prefer to use my N90 electronic cameras set on M (manual) mode. This permits me to choose any shutter speed or aperture I want and prevents me from exceeding ½50 of a second (maximum flash sync speed) when the flash is turned on. When I add dedicated/TTL flash with the camera in manual mode, flash output is still fully TTL controlled. I often choose a low shutter speed (½15 or ½ or ¼ of a second or longer) in very low light to record background lights beyond flash range, outdoors or indoors. (Of course, I get blurred backgrounds if the camera is not used on a tripod.)

Using slow shutter speeds with flash or this "slow sync" technique means that any area

of a picture lit solely by flash is sharp, motion is "stopped" (frozen) by the speed of light. The duration of the light from a small flash is about is ½350 of a second at full power, or higher—the speed of the light increases as flash power is reduced. The mixture of sharpness and blur resulting from this technique is currently a fashionable lighting "look."

Top TTL flashes have a select (or set) option, permitting you to vary the amount of flash fill to taste. I like to set -0.3 (minus $\frac{1}{3}$) or -0.7 (minus $\frac{2}{3}$ of a stop underexposure). Sometimes (for people shadowed under awnings in a bright scene for instance) I use +0.3 or +0.7 options. The fill still only affects shadow areas.

Rear Curtain Flash Sync

If your camera has a rear shutter curtain flash option (as my N90's do), you can choose it to minimize "ghost" effects (of a daylit part of the exposure overlapping with an area exposed by flash). Rear-curtain (rear sync, sometimes called Second Curtain or Second Sync) flash fires at the end of the shutter exposure. I use this setting only when "panning" and adding flash at slow shutter speeds, and only then if the subject is moving in a predictable direction. (If I use flash with rear curtain sync and unpredictable motion, I can miss peak action.)

The Versatile Vivitar 283 Automatic Flash

The Vivitar 283 automatic flash unit is the one I use and recommend—in fact, I own six of them. This pioneer automatic flash, originally designed for amateurs, has become a classic lighting tool. The unit is powerful for its size; is lightweight, inexpensive, and simply and strongly made. (The current price is still around \$75 at New York City discount photo stores.)

Use the 283 on-camera, direct, or bounced. Use it slaved as a second flash—for instance, as a hair light behind a portrait subject, or "gelled" and aimed at a dull background behind a subject. Combine a slaved 283 with strobe, or even with a dedicated flash as the main light. (A dedicated flash will not take the light from the 283 into account, and the 283 must therefore be set and placed so it is weaker than the main light.)

Two 283s can be joined as a pair and bounced out of an umbrella, or they can be aimed through a small- or medium-sized portable light bank. Several 283s can be slaved and scattered around small or large areas to augment existing light. You can also tape 283s (with "gaffer"—film electrician's—tape) to walls, ceilings, pipes, or fences; and use them indoors or outdoors. Because the 283 is so popular, Vivitar and other companies make accessories and modifications for it.

Two useful 283 accessories are made by Vivitar. Get them if you take a lot of flash pictures. The SC2 off-camera sensor-adapter has a six-foot coiled cord and is threaded for a standard flash bracket/lightstand (or tripod) screw, (¼-20 size) permitting easy automatic use of the flash within six feet of the camera (about \$30). The VP-1 Vari-Power module replaces the 283's removable automatic sensor, and permits firing the flash manually at full, ½, ¼, ⅓, ⅓16, and ⅓32 power, making it very easy to bracket flash exposures, and making subtle lighting ratio adjustments possible. When the power is cut back the resulting very short flash duration is useful for stop motion photography at close distances. At quarter-power, the flash duration is only about ⅓,000 of a second, for instance. (The VP-1 Vari-Power module costs about \$35.)

WHEN TO USE "SLOW SYNC" MODE WITH DEDICATED/TTL FLASH

When a dedicated/TTL camera/flash combination is set to P (program) mode and the flash is turned on, the camera program always chooses a $\frac{1}{200}$ or $\frac{1}{200}$ shutter speed (depending on the brightness of the daylight/existing light). This means that in low existing light or low daylight, the area out of flash range will often be under exposed. That's the cause of yawning black backgrounds or greenish underexposed backgrounds, in many flash snaps. It can even make daylit pictures look like night pictures.

To avoid this, use S (shutter priority) or M (manual) mode on the camera, and select a shutter speed and aperture for normal or slight underexposure of the background. Then add flash to fill or accent the foreground subject.

If you are a beginner, in low light select slow sync, or museum or night portrait modes (if your camera offers them) for flash fill. These options set slow camera shutter speeds ensuring good background exposures. The TTL flash fill will highlight the foreground subject, but not overpower it.

With either technique, use a tripod to minimize possible "ghost" (double-exposed) images or blurred backgrounds.

Some Modifications for Vivitars

- S.A.I. Photo Products makes a unit based on Vivitar 283s. S.A.I.'s NVS-1 flash unit doubles the basic 283's power output by installing an extra capacitor in the battery chamber. (It must then be used with an external battery pack.)
- Holly Enterprises and Paramount both make replacements for Vivitar feet (which are rather fragile). You can install them yourself. Both include a standard tripod thread and a female socket for twin-blade sync cords or slaves in the flash foot.
- Lumedyne, PermaPak, Sunpak, Quantum, and Underdog make recommended rechargeable gel-cel battery units. Most come complete with a battery-to-flash module and cord. All vary somewhat. The Underdog is my favorite. It is small and unobtrusive, and screws under a camera. It requires a Quantum battery to flash module.
- Cougar Design makes a plate that replaces the fragile Vivitar 283 foot. It has a ¼ 20 screw receptacle for mounting the flash directly on a flash bracket, tripod, ¼ 20 threaded lightstand stud, and, most especially, onto Cougar's own T-Bar mount.
- Domke Enterprises makes a fixture to join two bounce flash units with standard feet, so they can be used in tandem.
- Chimera makes a ring adapter that fits two flashes to its soft fabric light boxes.

How to Find and Use Flash Guide Numbers

The guide number (GN) is a combination of the power of the flash with the film speed being used. If you know the guide number you can calculate accurate flash exposure without a flash meter if you must. To find the GN for any flash, look in the flash manual; it is almost always listed for 100 ISO film. For 200 ISO film, double the guide number for 100 film and so on. A typical guide number for a good bounce head flash is about 120 with a 50mm lens. Simple detachable flashes often have GNs of 56 or 80; built-in flashes are usually rated at a GN of 28. (These numbers mean that the lens aperture needed for a good exposure at ten feet with the above flashes would be f/12, f/8, f/5.6, and f/2.8 respectively.)

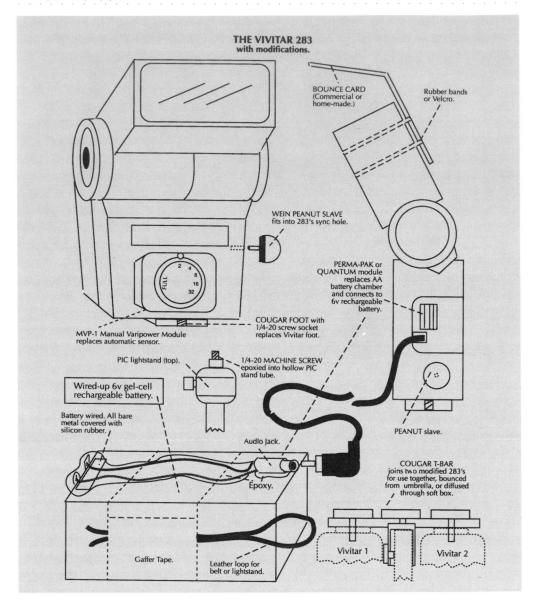

Finding the Aperture Needed with the Guide Number

Divide the distance from your subject into the guide number to find the aperture needed. If you stand twelve feet from your subject, and the GN is 80, divide 12 into 80, which equals 6 plus 8 remaining. This is two-thirds of a stop over an f/6.3 exposure $(6 \times 12 = 72)$. An f-stop between f/6.3 and f/8 is thus called for. Bracket with the f-stop if the main subject is small and light-colored against a large dark area (close down) or small and dark-colored against a large light background (open up the lens slightly).

Finding the Distance Needed with the Guide Number

Sometimes you want or need to use a certain f-stop. When this is so, divide that f-stop into the GN. The resulting number will be the distance from flash to subject required for correct exposure.

THE PROFOTO FLASH MOUNT/UMBRELLA TILTER

To mount almost any flash with a foot to any lightstand (or a tripod) so the light can be bounced out of it via a white umbrella (not included) buy this lightweight, handy tilter made by Profoto. It costs under \$20, weighs nothing, and works with flashes fitted with dedicated and automatic remote cords.

P.C./Sync Automatic, and Dedicated Cords

A flash not mounted on the camera hot shoe is "remote." Any remote manual or automatic flash (or any strobe) can be fired with a P.C./sync cord that physically connects it to the camera, transmitting an electric signal when the camera shutter is fired. These cords are inexpensive; most cost under \$20.

Some automatic flashes, like the Vivitar 283 and 285, can be used remote in automatic mode with an optional automatic remote cord. (The above Vivitars take SC-2 and SC-3 cords respectively.) Dedicated/TTL flashes can be used off-camera in full TTL mode if connected to the camera by an appropriate dedicated cord that transmits electronic signals between camera and flash. Such cords cost from about \$55 to \$75. Two dedicated cords can be combined for greater distance. Nikon SB-23 and 26 flashes take the SC-17 Power Cord. Consult dealers or manufacturers for information on other brands.

Today many photographers have replaced P.C. cords with slave and trigger combinations (see below), but carrying a sync cord might be wise insurance.

"Slave" and "Trigger" Units

A "slave" unit is any device that fires a remote flash/strobe by responding to a "trigger" signal from the camera. Most slaves are light-sensitive cells that sense flash or strobe light set off from the camera, or by an invisible infrared light "trigger" mounted on the camera. Other slave/trigger devices are radio controlled. Any number of slaved flash or strobe units can be combined. Use them close together or widely spaced to light a large area. When the on-camera flash or trigger is fired, all slaved flash/strobe units go off almost simultaneously because of the speed of light.

Infrared and Radio Slaves and Triggers

Light sensitive slaves cause your flash to respond to any flash nearby, obviously a problem for those who work in crowds. To solve that problem, you have three options:

Some highly sensitive slaves respond only to an infrared light trigger. This combination is very "secure" against casual flashes. A big advantage of infrared triggers is that their light does not show up in photographs. Two- and four-channel infrared systems are widely used by news, public relations, and those who must work with lots of flashes popping off around them. Wein and Quantum make two- and four-channel infrared setups.

Some slaves and triggers are radio controlled. They are favored by photojournalists, news photographers, nature and scientific photographers, and anyone who must work long distances from the subject. Flash Wizard makes sixteen-channel radio trigger/receiver setups that are extremely secure. But even the best radio-controlled slaves are not totally safe against being accidentally set off by stray radio and other signals.

The only truly interference-proof method of firing multiple flash or strobe lights to-

RECOMMENDED SLAVE AND TRIGGER UNITS

I use a WP SSR IR Trigger Model XT (around \$100) on my N90 camera hot shoe. This emits a weak infrared signal that triggers my slaved remote flashes and strobes, but does not show up even in close-up photographs. I sometimes use tiny Wein Peanut slaves on my Vivitar 283s (around \$18 each, they snap into the unit's sync cord hole), and I also like Wein's Hot Shoe flash, it mounts under any footed flash and has a threaded hole so the flash can be mounted on a lightstand or tripod (about \$40).

I have three of Wein's Ultra-Slaves; these are sensitive to my infrared trigger out to about 100 feet, even in the brightest sunlight, and are said to be effective to 500 feet in low light (about \$120).

Calumet Universal Flash slaves have twin blades, are inexpensive (about \$30), and can be used on any standard modern strobe, or with flash units fitted with household-type receptacles like the Quantum Q-Flash, S.A.I. modified Vivitars, and Norman and Lumedyne professional flashes. Flash Wizard makes universally recommended multichannel radio systems.

gether is by connecting them with "jumper" cords (long electric cords with two male plugs joining the strobes' sync outlets) to a sync cord connected to the camera.

Disposable Batteries

Disposable batteries have a short life, don't recycle the flash fast, and soon become expensive. (Realistically, allow about one battery pack per roll of film.) If you rely on batteries for flash, always carry enough! I have seen tourists almost weeping at missed photo opportunities when batteries went dead. Start trips with fresh batteries in cameras and meters. I carry a couple of spare Vivitar flash battery chambers as an emergency backup for my rechargeable 6v gel-cels, plus several packs of alkaline AA batteries (they fit Nikon flashes too). I buy Radio Shack batteries. Eveready Energizer, Duracell, Kodak, and Vartan are reliable brands also.

Carry spares of batteries for meters, slaves, and triggers too. In cold weather, keep all batteries warm; they are less efficient in temperatures below freezing.

Rechargeable Batteries and Battery Packs

External rechargeable and disposable battery packs that can be attached to flash units will save you money in the long run, and—very important—they shorten recycle time and permit at least a couple of hundred flashes without stopping to change batteries (more if the flash power is reduced). Flash manufacturers offer their own rechargeable packs of different types; Jackrabbit, Lumedyne, PermaPak, Quantum, and Underdog make rechargeable units for most makes of flash. (I do not care for Ni-Cad batteries.) Measure battery voltages with a Micronta battery tester from Radio Shack.

You will get faster recycle time (useful for light "painting"), and short flash duration (useful for stopping motion), with battery packs set on half, quarter, and lower power settings.

To keep flash capacitors and battery packs in good condition, recharge used packs as soon as possible after each use. I travel with six batteries and two dual-voltage chargers. Remove disposable batteries for stored units. Charge unused gel-cel batteries at least every three months.

Light Modifiers for Flash: Bounce Cards, Diffusers, Domes, Umbrellas

The light from a direct flash on camera is harsh. White walls and ceilings are not always available, or may be too far away. When working within about 10 feet of the subject, soften the effect of on-camera flash by aiming it at a card or reflector, diffusing it with white plastic or translucent cloth taped over the flash head.

All such light modifiers cost about $1\frac{1}{2}$ to 2 stops in exposure when the flash is aimed at the subject. The difference in exposure is compensated for by both dedicated/TTL and automatic flash sensors (but flash range is reduced by at least 50 percent). Sto-Fen Industries makes a neat, tiny, correctly angled white plastic bounce card and a diffusing dome that fits over many small flash units. I use the dome quite often.

LumiQuest makes a folding white vinyl Ultrasoft bounce device (about $4' \times 7'$) that attaches by Velcro to flash heads and folds flat when not in use. It gives quite a pleasant, soft light and is favored by news photographers.

A small translucent white umbrella from Calumet can be used for both bouncing and diffusing flash. Tape the umbrella to a reversed flash head, or simply place the umbrella where the flash can hit it.

Bouncing Flash in an Emergency

You can use any $3" \times 5"$ white file card, or even a stiff envelope, angled and taped or rubber banded to flash heads to bounce light. I often use my left hand cupped over my angled TTL/dedicated flash head as a bounce device when using an autofocus lens (or with a prefocused subject). There is minimally less light than with a white card and the light is a trifle warmer—which I like. I discovered this technique when I had to photograph a formal ball in a huge hall and had failed to pack a bounce card. It worked so well that I now use it often.

Reflectors

A collapsible round Photek (or similar) reflector is easy to carry, and use, and is a flattering surface to bounce flash from. Thirty-six–inch and forty-eight–inch sizes are both useful. The reflectors come in white, silver, and gold. White, silver, and gold artists illustration boards cost about $2 \text{ per } 24" \times 36"$ sheet. Fashion photographers often use them as huge bounce cards. Make reflectors out of virtually anything white or silver—from Mylar to plastic shower curtains to sheets. (See also chapter 6.)

Professional Reflectors

Thirty-six—inch and forty-eight—inch round folding reflectors made by Photek fit neatly into my luggage. They collapse to twelve and fourteen inches, weigh little, and are especially useful to fill shadows opposite an umbrella setup in portraiture. They are handy for bounce light; fill in contrasty light outdoors, especially at the beach; and can be clamped, hung, or gaffer-taped from lightstands, walls, or ceilings. They come in white (soft), silver (harder, more directional), and gold (warm, directional).

On-Camera Soft Light Banks for Small Flash

The smallest Chimera soft box of folding fabric is designed to be used with a flash mounted on sturdy camera/flash bracket. These soft boxes are white in front, black behind, and give a soft, directional light. You may like them; I prefer bounce cards.

Umbrellas and Portable Light Banks

Always remember, the larger the light source, and the closer it is to the subject, the softer the light. Therefore, I generally use the largest umbrellas and soft boxes I can carry easily. I use fifty-inch Calumet umbrellas (about \$40, a bargain) in my studio or when I take strobes on location. I take twenty-four-inch Calumet or thirty-six-inch Photek folding umbrellas (which collapse to fourteen inches) when traveling light.

Portable light banks are now offered in both black-backed and lantern style. I favor Chimera banks. They are well priced, easy to assemble and disassemble, and come in all sizes, from a 16" \times 22" model, designed for use with a flash on a bracket, to huge ones used to light cars. I have a medium-sized (36" \times 48") Chimera and a narrow striplight (9" \times 36"), which I use for portraits. Both fold easily into my tripod or lightstand cases and weigh little. I use them with my Vivitars and a Chimera flash mounting ring.

The Plume Wafer is a shallow light bank, designed with an internal baffle, that sheds a very even light and is great for use with strobes.

Concentrating Light

Snoots (black tubes) and honeycomb grids (black grids in various sizes) concentrate light. While none to my knowledge are made for small pro or amateur flash units, those made by Quantum and Norman for professional flashes, or those made for strobe units, can be used—attached perhaps with gaffer tape. Black Cinefoil comes in rolls and can be used to mask flash heads to reduce the spread of light. Make a snoot with black cardboard.

Lightstands

Bogen, Lowel, and Pic make portable lightstands and clamps in different sizes. I own several Pic stands, two large Lowels with separate booms, and assorted, handy Bogen clamps. I often take two Pic PP68SU stands on location. They fold to seventeen-and-a-half inches and extend to about eighty inches.

Cougar Design also custom makes the ultimate in lightweight stands with extensions for getting light up high. Modular Cougar "Sticks" extend these and/or can be used as light poles, or as a monopod.

Advanced Small Flash Use: Multiple Flash Setups

Small flash is not just for use on the camera. As many flash units as needed can be used together if each is equipped with a slave unit and triggered from the camera. Mount modified Vivitar 283s or other bounce flash units singly or in pairs on a tripod or lightstands; bend them and stand them on the floor aimed into dark corners; hide them behind furniture or equipment; or fasten them with gaffer tape to walls or ceilings. Use

TWO INDISPENSABLE LIGHTING AIDS—GAFFER TAPE AND BLACK CINEFOIL

Gaffer tape is made of adhesive cloth that can be torn or cut. It is sold by photo lighting dealers in silver, black, and a few colors. Gaffer tape was developed for movie electricians ("gaffers") to hang lights and tape electric cords to stands, floors, and more. It will not take off paint when removed within reasonable time. In gray, it costs about \$12 for a hundred-foot roll. With gaffer tape you can repair equipment temporarily, tape luggage locks shut, fix a torn hemline in an emergency, and more. I roll a few feet around a Magic Marker and carry it in my camera bag at all times.

Don't confuse gaffer tape with duct tape sold in hardware stores. Duct tape *does* take off paint, and *doesn't* hold things to walls.

Cinefoil—heavy black or white aluminum foil in rolls—is made by Rosco. Cinefoil can be cut, torn, folded, molded, and taped. I use the black foil to hide small lights and light leaks, and to improvise flags, gobos, snoots, barn doors (these are all light modifiers), and more. It cost about \$35 for a hundred-foot roll; I always carry a few feet in my lighting kit.

Lowel's scissor clamps to hang small lights from metal ceiling frames common in offices and factories. Add color gels over flash heads if it pleases you. (See chapter 5.)

For location portraits, people pictures, and even food shots and still lifes, I often use two joined Vivitar 283s, bouncing them out of a white umbrella or aiming them through a small or medium portable Chimera soft box. Both these methods give me soft light, as well as control of the height and angle of the light. A flash meter and/or Polaroid camera or back will make such lighting setups much easier. (See chapter 4.)

Lighting Large Spaces with Small Flash Units

Several slaved small flash units triggered from the camera can be used to light large areas. Because the flashes all go off simultaneously, you can use this technique when people are in the room.

Time and Flash

Flash/strobe light can be combined with a time exposure of any length to record daylight or available light and bring indoor and outdoor light into balance. You will need a flash meter. Meter the outdoor light, set the camera shutter at sync speed or below, and add enough flash/strobe indoors to bring the light into balance. You need less strobe/flash indoors at dusk when outdoor light is low. Of course, use the camera on a tripod. Polaroid tests make this technique quite easy.

Cumulative Flash

Still-life photographers who need more power sometimes use cumulative strobe exposures with an open camera shutter in a darkened room. (Firing a strobe several times permits photographers to use the extremely small f-stops needed for greatest possible depth-of-field with large format cameras, especially when long bellows draw is required for close-ups.)

Use this technique with cumulative flashes on location when you need a small f-stop,

or when there is no other way of lighting with the power at your disposal. Hold the camera shutter open on B (Bulb) setting with a locking cable release. Then, flash as needed, releasing the shutter immediately when you have finished.

The calculations are quite simple. Each time you want to decrease the aperture one f-stop you must double the amount of light reaching the film. If f/8 requires one flash pop, f/11 will require two pops, f/16 four, and f/22, eight pops. (Of course you can do the same thing with strobe also.) After about eight flashes, the light becomes less efficient, and you will have to more than double the number of flashes to double the light output. (You will need seventeen, eighteen, or even nineteen flash pops for f/32, for instance.) It's the same principle as the law of reciprocity. (See also chapter 4.)

To paint a totally dark room with light, set the camera on a tripod with the shutter locked open. Then cut the flash to quarter-power, and try walking around flashing all walls and the ceiling as evenly as possible. About 40–50 pops from a Vivitar 283 does my $12' \times 18'' \times 12'$ studio quite well.

Balancing Indoor Flash/Strobe and Outdoor Light

First use the camera on a tripod. Then measure the outdoor light and set the camera aperture for the highest possible sync speed and widest possible aperture. Then add enough light indoors to equal the outdoor light. You can use either slaved multiple flash units, or better, one or more strobe units (these are more powerful) and several heads. Outdoor and indoor exposures are most easily balanced when the outdoor light is comparatively low, at dusk or on a very gray day.

A Polaroid camera and a sophisticated flash meter are a big help for this technique.

Multiflash Exposures

With a black background indoors (black velvet is best) in a darkened room (you can also work outdoors in the country at night against a completely black sky), you can do multiple portraits or record movement on one piece of film. Try it for yourself by setting your camera on a tripod with the lens locked open on "bulb" setting. Use a lens aperture of f/5.6 with 100 ISO film. Set a dedicated/TTL flash to manual mode at $\frac{1}{32}$ power, and then set Multi mode and choose the number of flashes you want per second. Shoot the moving subject.

With an automatic flash like the Vivitar 283, set minimum flash power, and pop the flashes off yourself. Experimentation will determine exact exposures needed. Of course, allow for the cumulative exposures. (If you want four poses on one frame, underexpose each by three stops.) Be prepared for a lot of experimentation.

Professional Battery-Portable Flash Units

Battery-powered strobes, as these units are often called, are popular with travel, corporate, industrial, and fashion photographers, all of whom must often set up lighting outdoors in places with undependable electricity. Chargers for battery-portable units are available in 110–220v dual-voltage models.

Midpower battery portables are made by Balcar, Dyna-Lite, Lumedyne, Norman, Quan-

tum, and Sunpak. Prices start around \$450 and rise to around \$600–\$800, depending on power. High-power battery-portable units (1,000 watt seconds and up) are expensive (\$1,000 to \$2,500 and up) but worth it if you need the light where electricity is unavailable.

Disadvantages of high-power battery-portable units are slow recycle time (some units take up to twelve seconds on full power) and relatively small number of flashes obtainable from one charge. At least one spare battery is therefore a must.

It should be noted here that two Vivitar 283s joined together and used as a unit on full power with two 6-volt rechargeable gel-cel batteries, 100 ISO film, and bounced out of a white umbrella, have a guide number of 40 and recycle in about five seconds. A popular 200 watt-second battery portable strobe puts out only about 50 percent (half a stop) more light than this.

The Quantum Q-flash is an excellent professional dedicated/TTL modular flash. Buy it with modules for popular 35mm and medium-format cameras. Light modifiers and various battery options are offered. Lumedyne flashes are considered highly reliable and come with different power options. Norman portable flashes have been around for a long time. Some people love them, and some hate the batteries. Comet and Henschell are top of the line, high-power, high-priced pro flashes offering many accessories.

Strobes

Electronic flash (popularly called strobe in the United States) was invented by the late Dr. Harold Edgerton of the Massachusetts Institute of Technology (M.I.T.) in the 1930s and since the 1950s, strobes have been the workhorses of professional photographic lighting. Strobes continuously draw electric current, usually from a main electricity source. Devices inside the strobe raise the voltage; the high-voltage current is stored in capacitors until used. Strobes deliver a lot of light and they recycle for use again extremely fast. The duration of a strobe burst is short and can stop much motion. You do not need to use a tripod for many strobe-lit situations. Strobe power is measured in watt-seconds (ws) in the United States, Canada, and some other countries; in Europe and other places the rating is in equivalent joules. Maximum power of studio strobe units is about 20,000 ws/joules.

Studio Strobes

Studio strobes are not at all portable. They transform main AC power to very high voltage (about 4,000v) and store this energy in oil-filled capacitors, which are extremely heavy. Studio strobes are almost never taken on location. I won't mention them again.

Portable Strobes

Portable strobes need a continuous 110v AC power supply (or 220v in those countries where 220v is standard) which is usually drawn from "the mains"—a main electric power outlet. In remote spots, a gas or diesel-powered portable generator, or a 12v DC to AC power inverter can be used. (See later in the chapter.)

The AC input is transformed in the strobe to higher-voltage AC power, then rectified to DC and stored in electrolyte capacitors. (Portable strobe voltage varies from about 350v to 900v depending on the model and make.) The power range of portable strobes is from 200 ws/joules to an average of about 2,000 ws/joules (a few higher powered AC portable units are available).

Portable strobes are inherently low-voltage; the flash duration on full power is typically about ½50 of a second, higher if the power is turned down. "Stop-motion" portables with very short flash duration are available, for a price.

Travel/location photographers often use 1,000 or 1,200 ws/joules units; these units are of a convenient size and weight, and give a reasonable f-stop. Even the smallest portable strobes are bigger and heavier than flash units, which usually prevents them being used on camera. The heads of Lumedyne, Norman, Comet, and similar lightweight battery-powered strobes can be mounted on a camera bracket if desired.

AC-powered portable strobe heads, however, are used on light stands and often aimed through soft boxes, or bounced from white ceilings, walls, and umbrellas.

Advantages of Portable Strobe

AC-powered strobe is much faster recycling than most battery-powered flash (or strobe) units; average recycle time is about one to two seconds to reach full power. Portable strobes that use power from the mains or a generator have the advantage over battery portables (and of course small flash units) in that they have built-in tungsten modeling lights that burn continuously, which makes controlling lighting effects fairly easy. Strobes are very cool in operation, unlike hot tungsten lights. Many strobe-head designs, accessories, and light modifiers are made to vary the quality of strobe light output. Literally hundreds of different reflectors, screens, optical snoots, scrims, barn doors, umbrellas, soft boxes, and more can be selected to get your desired lighting "look" with strobe.

Disadvantages of Strobe

There are truly only three disadvantages of strobe. First, strobes are expensive. A good 1,000 ws/joule unit with power pack and two heads starts at around \$1,700. Second, strobes all require a continuous electric power supply. Finally, strobes are heavy (but thank goodness, they are getting lighter all the time). Balcar, Broncolor, Comet, Dyna-Lite, Elinchron, Henschell, Norman, Profoto, and Speedotron are top AC-powered portable strobe brands. Some of these manufacturers offer dual-voltage (110–220v) models and compact monoblock (one piece) models. Both are extremely practical for traveling photographers.

Which model strobe you choose will depend on your lighting needs and budget, and on local service facilities available. I strongly suggest you compare strobes and features by renting a few times from a professional lighting dealer before investing in any strobe system.

The Strobes I Use

I use lightweight Dyna-Lite portable strobe units. I have two power packs, a 1,000ws pack and a 500ws pack. I use these with three heads. (I sometimes use any or all of these with the addition of slaved Vivitar 283s for accent lights.)

Packing Strobes for Travel

Get a good bag or case to take your strobes on location. Tenba and Lightware make strong, lightweight shock-absorbing fabric bags. Anvil cases are lockable, rigid (and heavy) for

SAFETY WITH STROBE

All types of AC-powered strobe units store high-voltage electricity (enough to kill you in many cases). It is therefore imperative to learn how to use strobes safely.

- Read the manual first when you buy or rent any strobe.
- Always attach heads and sync cords to the strobe power pack before connecting it to the main electricity supply.
- · Never work with strobe in a damp or wet area, or outdoors in rain or snow.
- Never use a strobe head with frayed wires, or cracked flashtubes.
- Remember that high-voltage electricity is always in the wires of the strobe tube, so never, ever stick your finger into the ventilation holes of the tube.
- Strobe heads/monoblocks are heavy; light stands should be weighted at the bottom. Portable weights that can be filled with sand/dirt or water are available.
- Fasten strobe cords to light stands and floor with gaffer-tape to avoid tripping.
- When a shoot is finished, switch off the strobe right away, and immediately bleed out the stored high-voltage electricity by firing the strobes test button. Then you can safely disconnect the unit from the main electric power source and disassemble it.
- Allow all tubes and bulbs to cool for several minutes before touching or disconnecting them
 from strobe heads for packing. Always use cotton gloves or Kleenex when handling them. This
 will minimize the chance of burns, and prolong the life of the expensive strobe tubes and
 modeling light bulbs. (Oil residue from fingers is bad for them.)

shipping equipment as freight. Strobe tubes are fragile and very expensive. Always handle them with care and wear gloves to avoid transferring skin moisture and oils that are on even the cleanest hands. Touch strobe tubes (and photo lamps) as little as possible; it will prolong their life.

When shipping strobes, many people take removable strobe tubes out of the heads, and pack them and the modeling lamps separately. Wrap tubes and modeling lamps in bubble pack, then in cardboard, and tape them tight. I hand carry fragile tubes and modeling lamps with my cameras. For car travel, it is usually sufficient to put the strobe heads in a good case without removing the tubes.

Tip for Using Strobes

Strobes permit very fast shooting to catch fleeting mood and motion. The higher power the unit, the smaller the minimum f-stop that may be used. Most studio portable strobes permit the use of several heads at a time, but I use two or three heads as maximum (otherwise setting up can get complicated). The duration of a burst of light from most strobes is about 1/350 of a second at full power; as with small flash, when the power is turned down, the duration of the flash decreases, permitting motion-stopping. (Multitube heads are available for some strobes; using them decreases flash duration.) Scrims, gels, screens, snoots, and barn doors are used by many location photographers, especially fashion, architecture, and interior specialists, to modify strobes for different lighting effects. I try to light as simply as possible, and usually photograph with one main light, using the strobe head bounced out of an umbrella or diffused through a translucent umbrella or a portable soft box. I keep the light about six feet high, fairly frontal, and as close as possible to a seated subject. I

sometimes use a reflector to add a white, silver, or gold "fill" to open shadows on the dark side of a subject. If I am in a small, light space with too much light "return," I darken shadows with a black reflector opposite my main light.

For portraits, I may use a direct light, aimed slightly down on my subject as the main light, "filling" with a reflector or second diffused strobe shone through an umbrella on the opposite side. That is very close to the classic Rembrandt portrait light! A small (slaved) flash directly behind the head as a rim light gives a "halo" hair effect; aimed down it can be a subtle hair light; a flash/strobe head aimed onto the background separates front and background planes and gives an illusion of depth.

Determining Strobe Exposure

Strobe exposure can be measured with a flash meter, (top brands are Minolta, Sekonic, and Gossen; I like the Minolta V) and by the use of Polaroid film tests, with a professional Polaroid camera or camera back. The disadvantage of relying on Polaroids when traveling is the additional weight and bulk of camera/back and film that must be carried.

Make tests for critical color when using rental strobes, to determine if filtration is needed or wanted. Some strobe and flash units can run a touch blue.

Strobe on Location

There are a few pitfalls to watch out for when you travel with strobe. In American towns and cities, 60 cycle (Hertz) 110v power is standard. Note: Nominally 110v power is never 110v but usually around 120–125v in the United States. Modern 110v and 110–220v dual voltage strobes are designed to cope with minor voltage fluctuations, but you can never be too careful. Find out from your dealer or the manufacturer exactly what your strobe's operating tolerances are. Play it safe, check line voltages with a meter (see later in this chapter) before you plug in your strobe in strange places.

Note also: Never plug European 220v strobes (or dual-voltage strobes used on 220v) into American/Canadian 220v outlets; 220v strobes are meant for use in Europe and the many other countries in the world where 220v is standard power. In the United States and Canada, 220v outlets are designed for running air conditioners, stoves, and machinery, and single-phase 220v outlets may deliver an actual 250 volts of power which may be excessive for your unit. (Europeans traveling in the Unites States/Canada with 220–240v strobes should acquire a stepup 220–110v line voltage transformer.)

Portable Generators

Generators (gasoline- or diesel-powered) are frequently used as an alternate power source to run strobes where there is no electrical power. Professional lighting dealers rent generators. Homelite and Honda are well-known generator manufacturers; contact them for more information if you are thinking of buying. You must use only voltage-stabilized generators with strobes (auto-regulated generators are not suitable), and you must use a volt meter to assure that the power output is regulated to within about a 2–3 percent tolerance. The frequency is also very important. A good check before you rent or buy any generator is to plug in an electric clock (before you plug in your strobes) and check the second hand against your watch to see if the clock (and the generator) is running fast or slow.

Power Inverters

Power inverters convert current from 12v DC (golf-cart type deep cycle) batteries to 120v AC inverters. They can be shipped by air or UPS, unlike generators, which UPS won't take. According to Ken Haas in his invaluable book *The Location Photographer's Handbook* (see chapter 15), Federal Express will ship generators if they are emptied and sealed.

Power inverters are mainly used in RVs and campers, cabins and boats, and by emergency squads and fire departments. They can also be used to power strobes. Inverters are used by photographers who go into remote areas a lot; most have the inverter wired into a car or van, so it can recharge from the vehicle's alternator. (Alternately, charged, heavyduty truck-type batteries must be carried.) Lighting guru (and maker of my favorite Underdog flash batteries) Jon Falk recommends Excel Tech Inverters as being lightweight and reliable. Vanner and LTM are two other well-known manufacturers of inverters. (See resources.)

Power inverters are usually more expensive than generators. A. J. Nye, another electronics guru, says that if you can transport a generator and gasoline or diesel fuel to your location, you will get a great deal more power (and shooting time) for a given weight than you will with an inverter.

Warning: Never, ever rent any generator or inverter or use it for a job without having time to test it out first with your volt meter and under actual working loads with the strobes you will be using. Not everything is compatible with everything!

Strobe Overseas

If your 120-volt strobe is not a 110–220v dual voltage unit, you will need a transformer in Europe and the many other countries where standard power is 220–240v. Be sure and get a transformer with a high enough volt-amperage (VA—equivalent to watts) rating for your unit and the modeling lights combined. A 500 watt 50–60 cycle step-down (110–220v) transformer should cost around \$50. They weigh about seven pounds. For high-powered portable strobe units (1200ws and over, plus modeling lights), a step-down isolation transformer of the proper capacity is the safest way to go. Signal, Stancor, and Triad are all very reliable brands of line-adjusting, auto-step-down transformers (which can also be reversed and used as step-up transformers for European equipment used in the United States/Canada). Again, consult a professional lighting dealer, wholesale electronics dealer, or manufacturer for specific recommendations for your strobes and modeling lights.

I carry a Stancor 120v/220v auto transformer, 50–60 Hz, rated for 150 VA. It can be used with 60 or 50 cycle power (which is common in Europe). It is $4\frac{1}{4}$ " \times $3\frac{1}{4}$ " \times $3\frac{1}{4}$ ", weighs only three and a half pounds, and I have used it for many years with no problems (I don't shoot particularly fast), either with a 1,000ws strobe (with modeling lamps turned off to shoot). This is because any strobe draws full power only for a second or so while recharging its capacitors. If you want to leave all your modeling lights on when you shoot, or if you shoot very fast, you will need a transformer rated for the highest combined voltage of strobe rating and modeling lights. Check with strobe manufacturers and professional lighting dealers for specific recommendations for different strobe models.

Caution: I also use my transformer with my 6v battery chargers for my small flash units when overseas. I specifically do not recommend using the small transformers, which are fine for hairdryers, etc., with any strobe or battery recharging device or any other lighting equipment. If these small transformers fail while in use because of a surge (spike) in the

(often unreliable) local electric current, your strobes or chargers and batteries could be ruined. Use heavy-duty transformers.

Foreign Electric Pitfalls

There are three main problems to contend with when you travel with lighting equipment: DC power, line voltage, and electrical plugs.

DC power still exists, especially in India and other third world countries, and will destroy your strobes if you plug them into it (if they are not protected by correct fuses). Carry a tiny neon tester (available from electric stores) and check everywhere before plugging in. Both electrodes will glow for AC power, but only one if it's DC. Don't even think of plugging in if it's DC!

Too high or low a line voltage can affect your strobe recycle time and maybe power output. A volt meter such as a Micronta Digital Voltmeter from Radio Shack stores will not only tell you if your disposable and rechargeable flash batteries are okay, but will also tell you if the main power is AC or DC and the line voltage is within the tolerance limits of your strobe equipment. The meter I recommend costs about \$30. Mine has long since paid for itself by telling me when disposable batteries are still good.

The shape and size of electrical plugs and receptacles varies considerably in different parts of the world. Rather than try to explain all this in words, I created some diagrams on my computer!

"Pigtails"

You can carry a foreign plug adapter kit (sold at electrical dealers and airport shops) for common foreign outlets, but, if you go off the beaten track, in my native England for instance, you will find some plug shapes still around that Thomas A. Edison would recognize.

Therefore, carry a pair of wire strippers, a set of small Hama's screwdrivers, a roll of 3M electrical tape, and a couple of "pigtails" (different type power plug connectors) with you overseas, and save grief. Make the pigtails about twelve inches long, with a North American female connector wired to one end. At your destination, buy the appropriate male plug or plugs from any electric store, and wire them in. Insert your strobe plug to the female connector in the transformer, the male transformer plug into the female pigtail connector, and the male pigtail plug into the wall outlet. Plug a dual-voltage strobe (check that you have set it to the correct voltage first!) directly to the pigtail, and connect the pigtail to the wall outlet.

In desperation, when photographing in an ancient Stately Home or Palazzo, you can always unplug Milord's or Commendatore's TV set or lamp, disconnect the exotic plug, wire it to one end of your pigtail, and then connect the North American end of the pigtail to your transformer or dual-voltage strobe to take his portrait. Of course, you'll restore everything afterwards.

Renting Strobes on the Road and Overseas

Portable light banks, 220–240v strobes, and other photographic equipment can be rented in many major North American and foreign cities. It may be cheaper to rent than to carry

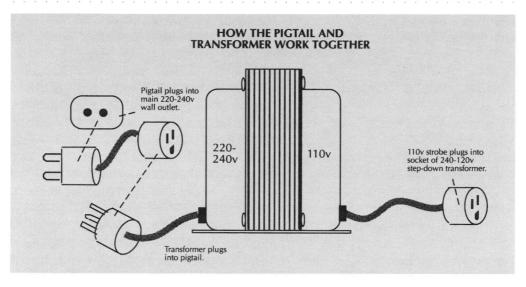

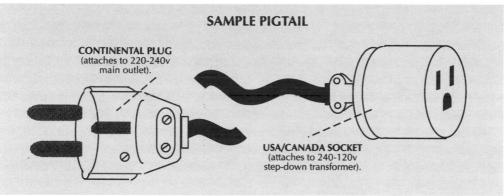

your own equipment plus transformers, plugs, etc. But, call first to see what is available and to reserve what you need, and be sure to test any rental equipment thoroughly before you depend on it for a job! Balcar strobes, made in France, are available for rental even in surprisingly remote places.

The commercial department of many foreign consulates may be able to give you the names of professional photo equipment dealers in their country.

Buying Lighting Equipment

I suggest renting strobes a few times before deciding on what you want. In the long run, it pays to invest in quality equipment. Lights are no exception and good stuff has a high resale value.

When ready to buy or lease, first visit a few reliable local photographic lighting dealers (you may need help later). Preview most equipment I have discussed by studying free, illustrated catalogs from mail order houses, or by visiting manufacturers' Web sites. (See resources.) Pay for equipment with a credit card or check. Keep all packaging and guarantees until you are sure everything works fine.

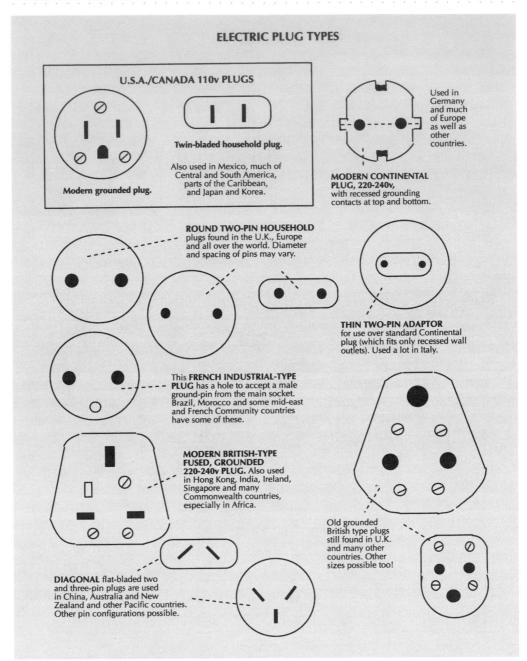

Recommended Specialist Reading on Lighting

- · Light, by Michael Freeman
- *Mastering Flash Photography,* by Susan McCartney (My own book, of course, fully illustrated in color, and I'm told, good.)
- Matters of Light and Depth, by Russ Lowell
- Secrets of Location Lighting, by Bob Krist
- Secrets of Studio Still Life Photography, by Gary Perweiler
- Also see the bibliography

f your travel photographs are intended for personal/fine-art use, what you choose to photograph is of course entirely up to you. Some people take only landscapes, wild-life, and natural scenes; others like to make "people pictures" of locals in exotic places; or abstract mood pictures. Few nonspecialists think seriously about architectural photography, but for balanced coverage of a place serious travel photographers should be able to photograph buildings and interiors at least competently.

What Professionals Need to Shoot

Professional travel photographers must be able to handle people, landscape, and architecture equally well; they are the backbone of most travel features, illustrations for travel stories, and travel stock. (For top professional work you should be able to handle sports, events, and location still life too.) Check any issue of Condé Nast *Traveler*, the *National Geographic Traveler*, *Travel Holiday*, or *Travel and Leisure* magazines, and look at Sunday newspaper travel supplements to see the varied subjects covered.

I have discussed light for photography of people, landscapes, and architecture in chapters 6 and 7 and composition in chapter 2. Now I will list musts and techniques for professional-level travel shooting.

People Pictures and Model Releases

In reply to the question I am most often asked about people photography: Yes, you should get model releases for people pictures if you intend or hope to sell them for stock. All pictures of people used for advertising and promotion must be released. Pictures of identifiable property and pets also require releases for such uses. (See chapter 14 and the English and foreign language releases in chapter 20.)

You can sell people pictures for editorial uses (inside magazines, newspapers, and many books) without model releases. Current news photos do not require model releases. And, I do hope that even if you are a professional photographer you sometimes photograph

people for personal or fine-art reasons, because you think them handsome, interesting, or beautiful, or just for the joy and fun of it. Selling isn't everything.

Photograph People for Complete Travel Coverage

In my opinion, to understand a place you should get to know some of the local people. For many personally shy travel photographers (I am one) the best way meet people is to photograph them. Sometimes you get great opportunities because of your camera. For instance, I spent a marvelous day at a peasant wedding in El Salvador when their photographer didn't show up; and I was invited to a marvelous party later. Though not a news or celebrity specialist I have made portraits of famous painters in China, Poland, and Haiti, top singers at the Covent Garden Opera House, and famous actors in London and Stratford-upon-Avon. I've also made pictures of the presidents of two of Japan's mightiest corporations and of three amiable mayors of New York, among many other notables. Also in New York, where I take pictures continually, I have photographed bicycle messengers and bus drivers, sculptors and bakers, real estate tycoons, philanthropists, chefs, Wall Street whiz kids, and the president of the Coney Island Polar Bear Club. (He invited me to the clubhouse for hot tea one frigid day in January after I took pictures of him and six other shivering fanatics braving a 42 degree Fahrenheit dip in the Atlantic!) People are as much a part of coverage of a place as landscapes and monuments.

People are People, Everywhere

It seems to me that some photographers approach people, especially "native" or "exotic" people, with the same spirit they would use in hunting an elephant. They "bag" the person from a distance with a telephoto lens, often showing the head without any background or landscape. They display the picture head later as they would an animal trophy, and make no attempt to record the person's inner qualities.

I am a people photography specialist, and I always strive for a feeling of intimacy in my travel pictures of people. However colorfully someone is dressed or however superficially different a person seems to be from me, I am always conscious that they probably have kids, spouses, and occupations, and joys and problems that are not so very different from my own. I almost always start by asking people, by word or gesture, if I can photograph them, unless they are part of a large crowd. You can usually sense people's reaction to you, if you stand nearby holding a camera very obviously without taking any pictures. After a few minutes you will see who is open to being approached. Then, ask permission to photograph verbally, or by pointing at your camera and smiling the request.

Of course, some people don't want to be photographed, and show this by turning away; occasionally someone actually refuses a request with words, a shake of the head or even a rude gesture; I always respect the refusals, and peoples' right to privacy (I'm not a photojournalist, remember), smile and just approach someone else. Even if you are more of a "candid camera" type that I am, I still suggest that you always ask parents' permission to photograph kids, and ask very poor peoples' permission everywhere.

The most important thing to remember when you ask a stranger about photographing them is that if you are comfortable about it, they are much more likely to respond positively. Polaroid prints make wonderful thank-you gifts for people who pose, especially in remote places. I do not normally pay for picture-taking, and never give candy

to kids—not wanting to turn them into beggars. I will buy small things from market stallholders, etc.

Work Close for Intimate People Pictures

Permission for photography secured, I usually work close to people, using moderate focal-length to wide-angle lenses for portraits. (I like showing people in their environment.) I often end up as close as two or three feet from the subject, so getting their cooperation is obviously absolutely necessary. Once you have a good subject, don't take just two or three frames. It takes time for people to warm up, and unless you are in peak practice, it will take you a few frames to warm up too.

Talk to Your Subjects When Photographing Them

I usually keep my left eye open when shooting (this takes some practice), so I can watch for intrusions into the background and I talk to people, even people whose language I don't even attempt to speak, all the time that I am photographing them. (I'll try a few words in any language, however badly pronounced. If I know any, this often causes gales of mirth.) If people understand, they respond; if not, I talk in English, which usually amuses them too, and always takes their minds off the discomfort of having a lens pointed in their face.

Think about it, do you feel comfortable when someone is photographing you? If he or she doesn't talk to you, and walks around studying you while muttering about f-stops and apertures, you feel stiff at best and wonder where to put your hands and feet, and worry about pimples (if young) or wrinkles (if middle-aged) or how you hate the way you look now (if old). My mother, who was good-looking, told me that she felt like a very old turtle in front of the camera. I'll bet that Annie Leibowitz's mother—or Herb Ritts' have to be talked into letting their kids take their pictures!

So, empathize with peoples' private agonies about their appearance, and talk to them about almost anything while you take pictures. Even in the street they will be distracted and relax after the first few clicks; they will probably settle into more comfortable, natural positions, and may smile or laugh, or even come up with creative poses themselves. After the initial clicks of my shutter—the warm-ups—I feel free to ask people to move or to put something down (a plastic shopping bag for instance) or to pick something up (some fruit or beads in a market; a tool for a worker, artist, or craftsperson; a book for a student). After a while, I will ask someone to take off a jacket or reverse a tee shirt with an intrusive design, or to repeat an activity that's sometimes difficult to capture on one frame (like the peak of a dive, or a kiss between young lovers). My rule is never to be embarrassed to ask anyone to do almost anything. People will immediately let you know if you are overstepping their limits of distance, time, or propriety.

Be Aware of Clothing

I like to take pictures of people in national, regional, or traditional costumes. These are often good as symbols for a place or a way of life. In America, cowboys wear blue jeans, western shirts, and broad-brimmed hats; lumberjacks wear thick red-and-black wool shirts; New England fishermen yellow slickers and rubber boots; and farmers overalls, check shirts, and long-peaked caps with mesh tops. Relaxing yuppies of both sexes favor polo shirts,

QUICK TIPS FOR PORTRAITURE

- Ask men to shave an hour or so before you take the pictures.
- Be sure women don't wear too much makeup, and have a soft hair-style, not one that looks
 as if they emerged from the beauty parlor ten minutes ago.
- A filter with a clear center but slightly soft at the edges flatters many middle-aged and older people. Women especially prefer to have wrinkles played down.
- · Soft, diffused lighting is flattering to almost anyone.
- Talk to your subjects when photographing them formally, just as you do when working with people on location. Pay compliments and tell them they look nice. Never say anything like "Oh, that angle makes your nose look big"—that will kill a portrait session stone dead, instantly. It's your job as a photographer to solve the nose problem, not to make your subject worry about it. For the big nose, use a moderate telephoto lens (in the 80, 105, or 135mm range) and photograph the person looking directly into the camera. Use shadowless lighting.
- If you want to try different poses to improve any portrait, say, "Could you please try so-and-so, I think it would look nice" or to an executive, "I think it would look appropriate if . . ." or for an unusual pose "Is it possible? . . ."
- If any pose doesn't look right in the viewfinder, take a couple of shots without comment, then try another variant.
- Remember that photographing two or three people, or a group, is much more difficult than
 photographing one person (because they all must look good at the same time); shoot plenty
 of film.
- Finally, and most importantly, if you ever promise to send prints in exchange for posing and signing model releases, always send them, and as soon as possible.

tan pants or skirts, and loafers; old hippies wear headbands, denim, and tie-dye. Even if reality is not quite that, these stereotypes have some truth, and are especially useful for tourism pictures and stock, because they don't date quickly. Austrians in dirndls, Britishers in tweeds or pinstripes and bowler hats (or alternately dressed as punks or mods), Germans in lederhosen or checked shirts and hiking knickers, Indians in kurtas and saris, Africans and Arabs in beautiful robes, and similar classics will all last longer for picture sales than shots of people in trendy clothes that are soon dated.

The Vagaries of Fashion

Ten years ago everyone in southern French resorts (where many upscale fashion trends start) was wearing bright green and purple bathing suits, tank tops, shirts, shorts, dresses, even shoes. For a few years, those two colors together were everywhere in the United States. They look awfully out-of-date now. In spring 1998 here in New York (where many young fashions start), teens are wearing either the skinniest or the baggiest of clothes. Don't bother to photograph people wearing such stuff. Ten days after you've taken the shot it looks dated. Look at last year's fashion magazines to see what I mean. (Of course, you may want to make personal photographs that comment on the vagaries of fashion, but that is altogether something other than plain travel photography.)

When photographing someone in traditional or national costume, carefully check to see if some discordant modern element could be removed to improve the shot. Fancy wrist-

watches, fancy eyeglasses, sneakers, and visible tee shirts with slogans or superbright designs are my pet hates. People are often willing to remove or change a discordant element if you ask nicely.

Formal Portraiture

Formal portraiture is of course people photography too. Preplan your backgrounds and lighting to a large extent before your subject comes on the scene. Use a substitute or standin to refine lighting if necessary. That way a subject won't have time to sit around and get nervous before you start. Work with more than one camera and lens so that you won't have to break the rapport and mood you achieve with your subject because you must change film. Ask your subjects to avoid extreme or trendy clothes and bright colors or jewelry that will compete with their face for attention in the picture (unless that's part of their basic personality, or style).

Landscape

We live in a crowded and stressful world, and most of most people's lives today are spent in suburbs, towns, or big cities. Almost everyone, even a dedicated city dweller like myself, has a deep-seated need for space and light. Green, unspoiled countryside, wilderness areas, high mountains, peaceful lakes, untouched seashores, and even beautiful empty desert lands satisfy that hunger. Therefore good photographs of these things are very popular, and can be big stock sellers in the United States and Canada, and especially in crowded, highly organized countries like Germany and Japan—both top-paying markets for photography. If you photograph for stock, landscape has the merit of being timeless; good pictures of redwoods or rain forests, mountains or moorlands, should be as salable in twenty years time as they are today.

Some Problems of Landscape Photography

Photographing pristine landscape is not as easy as taking off to a national park or sparsely populated area. Signs of civilization (or sometimes, lack of it) intrude in even the very remotest places today. I'm told that scientists and increasing numbers of tourists are causing litter problems in the Antarctic; we all know about the depredation of various forests in just about all nations. Oil drilling, mining, hydroelectric production, as well as population increase, tourism, building development—even recreational diving—are leaving ugly imprints on more and more once unspoiled places. Exclude signs of such things in your landscapes, unless driven to make protest pictures (those in fact may well sell as stock).

Pleasures of Landscape Photography

I am not a landscape or wildlife specialist, but I have photographed in North, East, and South Africa, in the American desert states, the Pacific Northwest and Alaska, New York's Adirondacks. Also in English national parks, Norwegian fjords, and the French, Swiss, Italian, and Austrian Alps. I have camped in unspoiled West Virginia, by the roaring tide of the Bay of Fundy in Nova Scotia, and on remote beaches in the Greek Cyclades islands. I love to look at clouds, the changing play of light on water, the movement of leaves in the

wind, and tumbleweeds and sand blowing in the desert. I have risen before dawn to catch animals feeding in the Serengeti; and photographed migrating birds at wildlife refuges at Brigantine, New Jersey, Chincoteague, Virginia, and in the Farne Islands off England's Northumberland coast. One of my favorite places to vacation and photograph is the remote island of Ouessant off the coast of Brittany, part of the land and sea Armorique National Park in northwestern France.

Beautiful scenery exists everywhere, even in densely populated countries like my own dear England, and surprisingly close to even very crowded areas like my adopted home in New York City. The closer to population centers, the more the landscape photographer has to watch for things that can intrude, break the mood of peace, solitude, and oneness with nature.

Emphasize the Positive

I am not, as I have said before, a photojournalist. There is pollution, overdevelopment, overpopulation, exploitation of the land, and destruction of natural beauty everywhere. Some wildlife is near extinction, and much is endangered. I do not usually make photographs that emphasize these things. I think that people respond to positive messages as well as negative ones. We all see so much horror on the small screen every night between 6:30 and 7:30 P.M. that we want the other side of life also. I believe that showing the very many beautiful things that still exist will make people more likely to want to preserve them, even at the cost of jobs, convenience, and money. Man does not live by bread alone. So, I don't apologize for showing landscape and nature at their best. If you feel moved to make photographs that show how our planet is being ravaged, I salute your efforts.

What I Don't Include in My Landscape Photographs

In many areas of the world lines of electricity towers are a problem for landscape photographers. They run down beautiful Alpine valleys, meander smack through the middle of bucolic New England vistas, slice through many scenic western views, and intrude in many, many other places, usually on the wrong side of the view as far as photography of the landscape is concerned. (England is, I think, the world capital of electric pylons, as they are called there.) Local electric wires, TV transmitters, oil derricks, and ski and other cable car towers are related problems. All the photographer who wants unspoiled landscape pictures can do is angle the camera to avoid such things. (But take a few pictures showing them for stock or protest purposes only!)

Railroad lines and highways should be avoided for pristine landscapes, but for tourism photography especially, a distant road or railroad with a well-placed train (or tourist bus!) or a distant single car in the scene, imply that the viewer can be there also to enjoy the vista. I photograph such landscapes whenever I see them, as well as empty ones. Sometimes I specifically search for scenic overlooks, and arrange to be there when a train or bus is due below. With buses, if you are working for a tourist client, arrange with the driver to go extremely slowly along a previously chosen stretch of road, so that you will have plenty of choices of pictures for the client. Dirt roads look romantic in landscapes too, if they are not too bumpy.

Local electric poles and wires, TV antennas and satellite dishes, advertising billboards, gas stations and highway directional signs, even road stripes, are also problems for the land-

scape photographer. I usually leave those things out if it's possible, but again, a few shots for stock purposes are sometimes useful. Some road and other signs are unintentionally funny, and worth photographing for their own sake.

Garbage, litter, and related containers are always out. So are most picnic tables, camp and RV sites, and beachfront shacks. The occasional mountaineer's hut, shepherd's shelter, or fisherman's cottage can give scale. I take shots of mountains, green landscapes, and beaches with and without these things. (I'll also photograph the climber, the fisherman, and the shepherd close-up in their landscapes if I can.)

Giving Scale to Landscapes

Sometimes one small sign of human life adds to a grand scene and gives it scale. If you go on the Great Wall in China and walk up to the right from the main entrance, it is crowded with people and looks ugly and unromantic. But if you climb to the left for a couple of hundred yards, you can see the wall rolling along, slowly diminishing for miles and miles over green mountains. If you wait for one tiny figure to appear, that person makes you fully appreciate the scale and immensity of the wall. (It is said to be the only man-made thing clearly visible from space.)

A distant small boat in a seascape, one or two people far away on an otherwise empty beach, or skiers carving trails down a snowy mountainside are useful variations on empty landscapes. Keep these people and objects very small; ski and bathing suit fashions change, so do hairstyles for both men and women; cars and trucks go out of date; even people on yachts need model releases for advertising uses if they are large enough to be recognizable in a seascape. (You will also need a property release for the yacht to use it for advertising.)

Show Geographic Features for Potential Stock Sales

Landscape photographs that show geographic and geological features of all types are used in many textbooks and encyclopedias. Look for strata and graphic shapes as well as more obvious things like famous rock formations, waterfalls, glaciers, and trees and dunes shaped by prevailing winds. "Generic" tropical beach pictures, clean green and blue lake and mountain scenes, beautiful sunsets, cloudscapes, rock formations, and bountiful farmland pictures are all popular stock subjects.

Take a Risk—Do it Your Way

Rules are always broken by talented people—Jay Maisel has made some great landscapes including utility poles in the west, and Richard Mizrach and Len Jenschel have done wonderful pictures of western landscapes showing the destructive hand of man. Look for their modern landscape photographs and also those of early masters O'Sullivan, Muybridge, and Watkins.

Architecture

Many photographers who aren't afraid of tackling people balk at architectural photography. They will take the odd snap of a skyline or church, probably tilting the camera to get

the tops of buildings in, and then, thinking they can't do any better without specialized equipment, will leave it at that. But the outsides and insides of historic and modern public buildings, hotels, restaurants, monuments, formal gardens, especially in Europe and Japan, and religious buildings and just vernacular housing everywhere all contribute to complete travel coverage. All are frequently requirements of magazine, tourism, and corporate travel/location clients.

Equipment for Architectural Photography

While architectural specialists almost always do use technical and large-format cameras with elaborate shifts, swings, and tilts, the well-equipped 35mm or medium-format photographer can take good architectural and interior photographs with the cameras and lenses she normally uses. It is just necessary to understand how to use 20mm and 28mm lenses (or the equivalent wide-angles for medium format), as well as moderate telephoto or zoom lenses, and to know how to place them correctly for good results.

A sturdy tripod that extends to about seven feet high or higher is indispensable for architectural and interior photography. I use a Gitzo tripod with a ball head which is very easy to level. (You may also find a small spirit-level handy to help you level your tripod and camera accurately.) You will need a stepladder to photograph very large interiors; usually you can borrow one at the site, but carry a lightweight aluminum ladder with you if you know there won't be anything to stand on at the location. If you wear glasses, or have astigmatism, a grid screen in your viewfinder will help line up horizontals and verticals so that perspectives of walls, ceilings, floors and furnishings do not converge.

Remember always in architectural/interior photography that if you tilt the camera from exact horizontal or vertical, the lines of buildings will tilt to the exact same angle. If you point your camera up, buildings and rooms will appear to lean backwards. If you aim the camera down, vertical lines will appear to lean toward you. And if you tilt the camera sideways, even a tiny bit, as well as up or down, the whole scene will lean sideways too; walls will tilt, and the picture will appear totally skewed for a *Cabinet of Doctor Caligari* effect—not recommended except for horror movies.

How to Photograph Interiors and Buildings without Tilting Lines

The answers can be simple for interiors:

- Shoot vertical pictures rather than horizontals
- Move further away, and shoot with a short zoom lens (28–80mm is good)
- Get up to a high viewpoint on a ladder or scaffold
- Use a wide-angle lens (a 20mm lens is often excellent)
- Try a combination of all these things

The secret of tilt-free exterior architectural photography with a 35mm camera is to always point the center of the lens at the center of the building. If you are going to photograph a thirty-story building, the very best place to do it from is the fifteenth floor of a nearby building. That way, equal parts of the building are above and below your lens. Providing it is of wide enough angle to include the top and the bottom of the building, there will be no tilting of lines if you level the camera exactly. There will be slight elongation at

the top and bottom of any vertical wide-angle lens picture (or at the sides of any horizontal one), but this is an inherent feature of these lenses and will be scarcely noticeable in your architecture shots.

Sometimes, you will have to move to some distance away, and photograph the building from a distance with a moderate telephoto or zoom lens. (Zooms are great for precise framing; I often use my 35–70mm and 80–200mm zooms for architecture and cityscapes.)

Special 35mm Lenses for Architectural Photography

Nikon makes 28mm and 35mm perspective correction (PC) lenses that shift vertically and horizontally to include the tops of buildings without tilting the camera. Canon has just introduced a 24mm tilt and shift (TS) lens for its EOS line of dedicated/TTL autofocus cameras, and has offered TS lenses for older models for years. Olympus has a 24mm PC lens. All these specialist lenses are expensive; but worth it if you need them. They can be rented for occasional jobs.

Approaches to Architectural Photography

Some things just cannot be done when photographing high buildings, even using view cameras with full swings, tilts, and shifts. It is impossible to photograph the famous 102-story Empire State Building here in New York from immediately below it, on 34th or 33rd Streets between Fifth and Sixth Avenues. You can't see the top. Most 35mm pictures of the Empire State are taken with telephoto lenses from the top of the RCA building on 50th Street looking downtown, or from the top of the World Trade Center, on West Street, looking uptown. From about ten blocks away (up or down Fifth or Sixth Avenues, or Broadway) you can shoot the Empire State from any building, on about the fifteenth floor. From twenty blocks away (near where I live) you can shoot the Empire State from ground level without tilting it, by using a short (35–70mm) zoom lens. The landmark looks its best at "blue time" (dusk) when colored floodlighting illuminates the top.

Take a PATH tube train across the Hudson River to photograph the Empire State from many parks along the New Jersey shore, for backlit sunrise pictures, and for the reflected light of sunsets which often stain it gold, sometimes orange, and, occasionally, blood red. (Weehawken, NJ is directly opposite 34th Street; the view from the Hudson riverfront park by the Exchange Place PATH station in Jersey City puts the Empire State in a classic New York skyline view that also includes the World Trade Center.)

From across the East River in Brooklyn or Queens get early morning light, or backlit sunsets behind the Empire State from a waterfront park in Brooklyn or piers in Long Island City, Queens. The Empire State Building is also visible from the Staten Island Ferry, the Statue of Liberty, and Ellis Island, to name just three of many interesting views. You will discover your own if you seriously photograph New York.

Apply the same principles to photographing skyscrapers, cathedrals—even quite small buildings—from Sydney to San Diego, Paris to Pernambuco. (Pernambuco is in Brazil. In case you remember my previous reference to it, I did follow my mother's footsteps and go there, but the city is now called Recife.)

Photographing Interiors

For interiors, again you must get your lens up to the midheight of a room, by standing on a stepladder if necessary. A PC (or I'm sure, a tilt and shift lens, but I haven't tried one) is especially useful for correcting perspective of interiors where it's not too easy to get up high. (Try to get permission to shoot church interiors from choir lofts, or other large spaces from similar high vantage points.) PC/TS lenses can't make enormous corrections, just appreciable ones. It's usually best to use a tripod when working with them.

You will probably need to make quite long-time exposures of interiors if you do not specifically light them. These long exposures may affect film color, and the laws of reciprocity failure may apply. (See chapters 4 and 5.)

"Light painting" with multiple flash exposures can be useful in dim churches or other public buildings (if the ceiling is not too high). About twenty feet high is probably the practical maximum with a Vivitar 283 or similar-power flash. Light painting takes practice. (See chapter 7.)

Architectural and interior photography, will reward you if you persist and learn how to do them well. They are requirements for professional travel photography.

Still Life on Location

The subject of still-life photography is so large that I won't attempt to tackle it in this book. Although I am no specialist, I have done quite a lot of still lifes on travel and location assignments; specifically of food, fine-art objects and paintings, precious relics in stately homes, and industrial tools. I approach the whole subject in the same way I do architecture; I always use the camera on a tripod and compose the subject through the lens. When photographing food in the foreground of a restaurant, dining room, market, or kitchen, I've found that 20mm lenses work well for me. Soft back-lighting is usually a good light on food.

When arranging precious relics of authors and other greats in a setting indoors or out, I owe a great visual debt to Arnold Newman, a master of location still life, as well as of portraiture. I once saw a picture of his in *Holiday* magazine. It was of two immense and frightening helmets, from medieval suits of armor, arranged on either side of an English castle's gates; the scene was photographed with a wide-angle lens so the castle looked small in the distance. The change in scale was very powerful.

A problem you may run into in photographing shiny or metallic objects is that they reflect everything, including the lights, you, and the camera. The really professional way to approach that is to either "tent" the still life—surround it with a cone or circle or even dome of translucent diffusion material (made in sheets and rolls by Rosco and Lee)—or to partially surround it with nonreflective black. Shine the lights into a "tent" from outside and just cut a tiny hole for the lens. (Set up the still life before "tenting" it of course.) An easy way to solve a glare problem is by liberally applying dulling spray (from photo stores), which I do myself whenever I can get away with it. Dulling spray requires solvent to remove afterwards and cannot be used on precious relics.

When photographing any complex still life, if you can work with an assistant or even a totally untrained helper, it will shorten your setup time considerably. You can then direct the placement of the small objects without constantly having to move from the camera position. For recommended specialist books on the subjects covered in this chapter, see the bibliography.

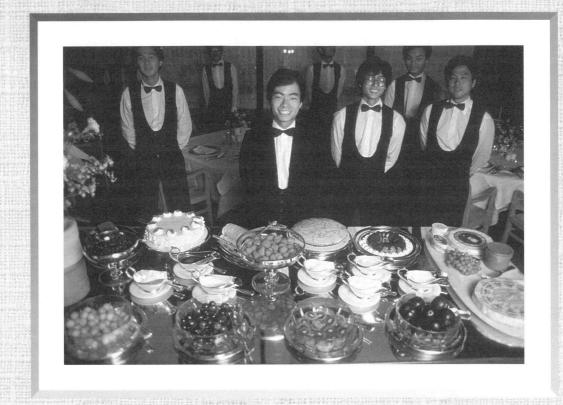

his "teaching" chapter of the book is intended for those who need practice in photography in general, and can be used as a guide for emerging professionals on how to approach travel, tourism, and location assignments. When you can shoot these subjects competently in a conventional manner, try breaking rules and experimenting as to style.

What You Should Know before Shooting Travel Assignments

Before a photographer can accept or solicit assignments (paid work) from clients, obviously he or she must be able to deliver what the client needs. The best way to practice is with self-assignments. You can go back and reshoot anything you don't like (more than once if necessary), make corrections, and sharpen your point of view. When you have done these self-assignments well, you will be able to handle just about any travel, or travel related, job that you are offered.

The self-assignments given are typical of working situations. Choose the subject matter carefully, so that the photographs will provide you with good travel/tourism/location portfolio material. Don't forget to approach people in a positive manner and get model releases, so the best pictures can be considered for stock. (See chapter 13.)

You should be able to market at least some of the pictures made for the self-assignments directly to "clients"—the subjects of the photographs. If some of these "clients" are businesses and corporations, you may well develop assignment clients who will use you regularly. Art directors give work first of all to people they know, trust, and like.

When someone does want to buy work from the self-assignments, be sure and ask for at least enough money to recoup your out-of-pocket expenses, even if you are a relative beginner. It took time, skill, and money to make your pictures good enough for exhibit or publication—don't undervalue them, or your skills.

If you are a photographer for fine art or pleasure, some of these self-assignments should help your "seeing" skills, and the practice should help you to refine technique and develop a personal style.

Style for the Self-Assignments

Your "look" is your signature. Be proud of it, and work to develop it. Photographic fashions change; a rather fine-art, impressionistic, grainy or soft-focus style with subtle color (or black-and-white) is currently in vogue. If this "look" is not your style, never mind. Your own particular look may become the next fashion.

Black-and-white photography is again being used by sophisticated travel clients. Corporate, tourism, public relations, and stock picture—users are usually conservative and like color. The assignments suggested for this type of subject are best approached in a straightforward manner. Be as creative as you wish, in your own way, with advertising/editorial subjects.

Assignment #1: A Working Portrait

Photograph someone in his or her working environment, outdoors or indoors. This is a frequent assignment request, and could be shot in either color or black-and-white.

The object of this assignment is to both make a good portrait, and show clearly the person's job, either literally or symbolically. Choose someone who works for a typical local industry or an outstanding individual. The "look" should be editorial, not too stiff or posed, for a magazine, newspaper, corporate brochure, or annual report.

Possible uses of the photographs: Sale to a magazine or newspaper; sale to the individual; sale to the company or corporation; stock (get a model release before you shoot).

Equipment: You will need as a minimum a camera with a normal lens. A moderate wide-angle lens and a medium telephoto lens are useful also. (I often use a 28mm lens for environmental portraiture, and include quite a bit of the surroundings.) A "normal" 50–55mm lens works for a waist-length portrait and an 80–105mm lens is good for a tightly framed head.

Very important is a tripod to precompose the background—a cable release for this is helpful but not essential. Carry a reflector, or improvise one (see chapters 6 and 7) to supplement available light.

Film: Use slow- or medium-speed slide or print film (25–100 ISO) outdoors; appropriate film and filters for the lighting indoors. (See chapters 5 and 7.) If the shot is being done indoors, you will probably need supplemental lighting (bounce flash, tungsten, or strobe). Take along a sync cord or trigger/slave combination if you use strobe; a long extension cord or two for tungsten lights.

Professional equipment: Color compensating (CC) filters and/or light balancing (LB) filters, or the approximately equivalent gels (see chapter 5) if using fluorescent or industrial lighting as the main source (make advance color tests for such situations).

Research: Finding a suitable subject, and the best place to photograph him or her. Choosing any tools, books, or other objects to be included in the portrait that best symbolize the person's job. When you have your subject, try to find out as much as you can in advance about her job, family, interests, or background, also her hobbies. If your subject is a writer, read some of her books. If you can get a portrait subject talking about herself or anything else, you will get better pictures (but keep shooting when she stops talking also).

Suggested subjects: A mayor, innkeeper, chef, craftsperson, technician, farmer, medical or legal professional, law enforcement or fire officer, factory manager, ordained member of any religion, writer, mother of large family, teacher, etc.

Possible locations: Inside or outside city hall (include flags, etc.), interior or exterior of a

pretty inn, hotel, or resort; a barn or silo or bountiful field of crops; a hospital operating room or ward; a classroom in a school or college; a police station or firehouse with action in the background; an interior or exterior of a church, synagogue, mosque, etc. Inside locations are usually better for portraits of business executives, managers, lawyers, computer programmers, teachers, nurses, homemakers, chefs, etc., because that is their normal working environment.

Variables: Availability of good location, the subject's schedule and clothing. (Ask him or her to wear quiet colors unless a special uniform or typical costume dictates otherwise. You may need to ask executive men to shave before a late afternoon shoot. Carry a comb and some flesh-colored face powder for any subject, just in case.)

Permissions: From a company, school, hospital, etc., may be needed to shoot on their premises. Get a model release from your subject, also from any other people you may choose to use in the background of the shot, so you can use the pictures for stock later.

Transportation: If you choose to take the person somewhere to best express personality or occupation, arrange for a car or taxi beforehand.

On the shoot: Before posing the subject (or before he arrives), choose the location, set up your tripod, compose the background, and approximately arrange any lighting where you want to place the subject. Of course, compose through the lens! You will then be free to concentrate on the nuances of the portrait. It is important to talk to the subject throughout the session so that he doesn't "freeze"! Be sensitive to your subject's personality, allow him to contribute to the portrait, but don't let him take over the shoot. Include your subject's face and hands, and some relevant background, in most shots. Think about feet. Do you want them in or not? Some people just don't notice feet, but the way they point or turn can be expressive.

Get the portrait subject actually working, not just pretending to work. Make some pictures with him or her looking straight into the camera also. Don't be afraid to ask anyone (tactfully) if it's okay to clean up a messy desk, move tools, shift an intruding piece of furniture. Watch out for ugly shadows on the face or intrusive objects in the background.

Take plenty of pictures (thirty-six shots as an absolute minimum). When you do this, you will find that most subjects soon get used to the camera and relax. You will warm up too, and achieve a relationship with the subject which is not possible when you take only a few shots. Classic portrait photographers sometimes spend hours or days getting to know a subject!

Results: An interesting photograph that tells a story about a person or way of life; also a salable portrait.

Look at: In the American West, by Richard Avedon; Portraits, by Bill Brandt; The Man Who Shot Garbo, by Clarence Sinclair Bull; and I Dream a World, by Brian Lanker—these books are examples of wonderful portraiture.

Assignment #2: Landscape or Cityscape

Choose a truly beautiful, unspoiled landscape (or seascape) or a very dramatic town or cityscape. Photograph it at different times on a sunny day. Start shooting just before sunrise to the very early morning, take a few comparison shots at noon, and photograph seriously again in the very late afternoon/sunset through "blue time"—dusk.

The object of this assignment is to show how changing light, color temperature, and sometimes weather, affect a scene; and, to make the most beautiful landscape possible.

Possible uses of the photographs: Part of an editorial travel story; a corporate promotion of a city or region; regional or national tourism promotion by airlines, etc.; stock pictures; postcards; calendars; portfolio pieces; fine art or wall decoration.

Equipment: You will need as a minimum two cameras to shoot fast in changing light; with wide-angle and telephoto lenses. (I like a 20mm lens for most landscapes, but sometimes use moderate zooms—say 43–80mm or 80–200mm—for precise framing and to bring, say, distant mountains or buildings closer.) A sturdy tripod for long exposures is a must (use one that extends at least to your eye level) and a camera cable-release is handy. Carry spare batteries, and a backup meter if possible.

Film: At least two rolls of 35mm slow-, medium-, or fast-speed film to your taste (or equivalent amount if you use medium or large format). I use Fuji Velvia (ISO 50; I rate it at ISO 40) and Fuji Provia (100 ISO) professional films for landscapes. I like Ektachrome P1600 for moody, grainy effects.

Research: Do some driving/traveling around and choose the most beautiful landscape you can find, or the best view you know of a downtown skyline. My definition of a pristine landscape includes no man-made objects.

Variables: Weather and time of year. Check weather forecasts and wait if necessary; a very clear day with sunshine and nice white clouds in a deep blue sky would often be ideal. Before or after storms you often get dramatic cloud effects. Check the position of the sunrise and sunset in advance. Fall is good for some landscapes; and winter especially good for many cityscapes; for instance, lights go on in Manhattan office buildings before sunset, making for great views toward the lit-up financial district with the setting sun behind.

Alternate approaches: You can include highways, railroad lines, small farms, distant hikers/climbers/sklers, a boat, a lighthouse; but all these should be used very small in the overall scene. For cityscapes, no single building should predominate—you are out to show the spirit of the city as a whole. Look for the best possible vantage points: bridges, hill-tops, cliffs, fire towers, scenic overlooks, rooftops, high office windows, observation towers, piers, river and lake fronts.

Permissions: Arrange in advance to arrive very early, return, and then stay late at a building observation tower; rooftop with a great view; national, state, or local park; private property; etc.

Transportation: A car is normally a must to "scout" locations (see chapter 15) and to move equipment, but city dwellers can sometimes manage using public transit.

On the shoot: Arrive at your chosen vantage point half an hour before sunrise, and well before sunset; set the camera on a sturdy tripod and be ready to shoot in the rapidly changing light very early and late. Make sure your horizon lines (and vertical building lines if a cityscape) are level. (If you have difficulty with this because you wear glasses consider getting a grid-style viewfinder for your camera; a small spirit-level is also helpful.)

Take all your landscape pictures from the same spot for maximum comparison of changes in light effects. (Mark your tripod position with tape, stones, etc., so you can find it again.) Of course you can also do variations on the theme for art purposes.

Meter off the nearby sky, not the sun itself, during sunrise and sunset or you will get underexposure. (Use a 135mm lens or longer on camera as a substitute for a spot meter.) Shoot from about half an hour before until about fifteen minutes after sunrise, and half an hour before sunset through the pink afterglow, and then the darkening blue sky of dusk.

Bracket your exposures. You need not bracket the midday exposures if you generally

get good daylight exposures. If fast-moving clouds are present, photograph different cloud effects.

Results: You should have a great variety of mood in these landscape pictures. The color range will be from reds, warm oranges, and pinks at sunrise and sunset, to palest blues at noon through royal blue and midnight blue before sunrise and after sunset without the use of any filters. That is because the color temperature changes from very low to very high at different times of day.

Note: The noon pictures are for purposes of comparison, only; very rarely are they better than the early or late ones, but there are always exceptions to every rule, so don't skip them.

Look at: All the landscape photography books listed in the bibliography.

Assignment #3: Architecture/Interiors

Make a series of five to ten carefully composed interiors and exteriors of any important historic public building or major new building you can easily reach. Include people in some of the shots.

The object of this assignment is to show off the architecture, important design features, and the building when it is in use.

Possible uses of the photographs: Sales to architects, contractors, developers, owners, municipal and other authorities, as well as the same uses as assignment #1.

Equipment: You will need a camera, sturdy tripod, cable release, and wide-angle, normal, and medium zoom or telephoto lenses. A small spirit-level may be helpful. Possible added lighting for the interior shots. Film to balance with principal lighting sources. Basic filters.

Professional equipment: Perspective correction (PC) or tilt and shift lenses for 35mm SLR cameras. Architectural specialists use technical and large-format cameras with shifts, tilts, and swings for correcting perspective.

Film: Slow- or medium-speed daylight or tungsten film, or both, as appropriate.

Research: Choose the building. Note: find out the angle of the sun, especially in relation to the main entrance. Select good viewpoints from other buildings and nearby sites, as well as more distant views. Avoid ugliness in backgrounds.

Permissions: Get permission from the necessary authorities to photograph interiors, and/ or from the owners of nearby buildings to use as vantage points.

Transportation: You will need a car or taxi to take yourself and your equipment to and from the location. Big-city dwellers can use public transit.

Variables: Weather, time of year, time of day, traffic activity in the area. If the main entrance to the building faces north, this usually means photographing early or late on a midsummer day, when the sun illuminates that part of the building, or choosing a cloudy day. Dusk shots from outdoors showing the warmth of lighted interiors are often excellent. Find out the time of the building's maximum use—people in architecture pictures bring them to life. Avoid parked trucks outside the building.

On the shoot: Design your photographs carefully, keeping lines level, etc. (see assignment 3). Watch the light. Try early and late shots. If tilting the lines of an interior or exterior is unavoidable, do so forcefully (a slight tilt looks accidental). Bracket indoor exposures, adding light when needed, and perhaps try light painting (see chapter 7). Use filters if needed for mixed-light or fluorescent-lit interiors.

Take pictures both with and without people. A new college library should show some students, churches need worshippers, a historic home usually has a curator, a few tourists, and so on. Take some (but not too many) close-up shots of special design features, ornamentation, lobby art etc. to finish your assignment.

Results: You should have well-designed pictures suitable for use in a publication, brochure, annual report, or to decorate an office or boardroom wall. Other possible uses are as fine art, covers of religious bulletins, and postcards as well as stock and portfolio pictures.

Look at: Architectural Digest, and "shelter" magazines for examples of top professional work. Photographing Buildings Inside and Out, by Norman McGrath is a truly excellent reference book.

Assignment #4: A Location Still Life

Create a carefully styled picture of food and drink with an appropriate scenic or interior background. Would-be corporate photographers can use products or industrial artifacts in suitable places instead. After you have made some sharp images, try variations on focus also.

Subject for inexperienced photographers: A simple picnic lunch or a formally presented outdoor luncheon setting. Anywhere with a nice view; a beach for seafood; a country garden, or pretty city park for a picnic; a restaurant terrace with a nice view, or formal garden for a buffet lunch.

Subject for the experienced: Formal food presentation in a restaurant or hotel, with lighting on the food for correct color. Use strobe (bounced out of an umbrella, or through a collapsible soft box) and daylight film, plus time exposure for the background if necessary. See if a local inn/hotel/restaurant/caterer will trade food and "styling" (food arrangement) services in return for pictures to advertise their business.

Possible uses: Summer feature on a local beauty spot (possibly using local produce) in regional magazine or newspaper; possible feature on a restaurant; stock. Of course, if you live on Cape Cod, or the bluffs of the Mississippi, or close to a great California beach, the picnic shot or series may have more than local interest.

Equipment: As a minimum, you will need a camera, wide-angle lens, tripod, and cable release. Indoors, you will usually have to add strobe or multiple flash lighting. Outdoors, a large white and silver reflector is helpful for bouncing light (see chapter 7). I use a 20mm lens for most location food shots to get maximum depth of field.

Film: Slow-, medium-, or fast-speed film, daylight or tungsten type, as preferred and/or appropriate.

Props for the outdoor shot: A picnic cooler and ice for carrying food if the shoot is far from the food source. For a picnic, as with most still lifes, you will have to "style" the shot. Choose a big good-looking wicker basket, a bright plain or check tablecloth (don't use white, or flowery designs that will clash with the food). Use contrasting or complementary napkins, china, or plastic plates. A universally appealing picnic spread includes bright fruit, attractive raw vegetables like tomatoes, carrots, scallions, and cucumbers. Use a ham or cold roast chicken for a centerpiece. Don't forget French or Italian bread, wine and glasses.

Picnic suggestions: A clambake or lobster dinner at a beach; a barbecue in the South or

Southwest; corn, steaks, and hamburgers in a city or suburban backyard; a poolside spread of cool salads; a campfire dinner in the mountains; a kids' picnic of hot dogs and cookies in a park with swings, etc., in the background. Use your imagination together with local culinary traditions and beauty spots.

Props for the indoor shot: Food prepared by the restaurant or hotel; it could be the chef's specialty or something very photogenic. A decorated lobster platter is almost always safe. The place should be styled to look elegant, rustic, Italian, etc., depending on ambiance and price range. Flowers and wine give a festive feeling everywhere. Little flags are fun props for casual "foreign" places. Guests used as models (or models you bring along) should be mostly couples—mix up the ages. Bear in mind that picnics are casual; very formal places call for very well-dressed guests. Ask models to wear appropriate, nonfussy clothes.

Permissions: From owners of private property outdoors; restaurants, chefs, etc., indoors. Get model releases from all models, chefs, waiters, etc., for possible later stock or advertising use of the pictures.

Transportation: A car (or taxi) is normally a must to scout locations, carry equipment, props, and models, etc., for this type of shoot.

Logistics: Buying and cooking food, and getting it and other props to your picnic site. Keeping food fresh; setting up the still life. Rearranging a room slightly for the camera; putting room back together afterwards. Cleaning up everything, outdoors or in. If you can take an assistant or helper, or best, a professional "food stylist" who knows how to arrange food for the camera, you will be able to work much faster. If you have only limited time to set up indoor lighting and position food/props/furniture, an assistant is almost a must. Direct the food arrangement and placement from camera position.

If you are going to include models as diners, arrange for them to arrive fifteen minutes before you plan to shoot.

Variables: Outdoors: time of day, weather, angle of the sun. Plan the shoot for about two to three hours before sunset on a pleasant day. Indoors: Chef's availability. You will have to set up, shoot, and get out fast. Chefs, kitchens, and restaurants have tight schedules. About one hour before the place starts serving lunch or dinner is usually good for photography.

On the shoot: Set up your camera with a 35mm, 28mm, or 20mm wide-angle lens on a tripod. Make a background composition, and light the food area if necessary, then place the food close to the lens so that it dominates the picture. Arrange the food and drink carefully by alternately looking through the lens and placing platters, etc., for best effect. I often mask holes in the table setting with casually dropped flowers or leaves; you can also use wine bottles and glasses, or anything else you like. The critical factor is always to get fresh, appetizing, beautiful food, with correct color. Shoot both horizontals and verticals.

Alternate approaches: Take some attractive people to enjoy the picnic and photograph them eating, after you have done the still lifes. Include the chef, owners, and waiters in formal indoor photographs.

Results: A useful and appetizing "location still life" and possible eating/dining pictures as well for your travel/tourism portfolio.

Look at: Magazines like Family Circle, Food and Wine, Gourmet, and Woman's Day. These will all help if you feel unsure about your food styling abilities, and they show current top professional work.

Assignment #5 — Abroad in America/Canada

This is a "picture story" about an ethnic or immigrant neighborhood. The object of this assignment is to practice for photographing in foreign countries, and to produce a feature (illustrated piece with no time deadline) for a local or regional magazine or newspaper (or for a foreign magazine or newspaper). The pictures might also be used as travel stock.

Equipment: A camera (two are better) and normal, wide-angle and moderate telephoto lenses. (Fast lenses are helpful.) A small flash for fill light is useful. Appropriate filters to correct color in indoor pictures.

Film: Slow- to medium-speed daylight film for outdoor shooting, fast daylight or tungsten film (400–1600 ISO) for available light indoor shooting.

Research: Select the neighborhood; try if possible to locate one or two members of the community to focus on. A family, who will let you photograph them is an especially good subject.

Suggestions: Try to find little-known or less-photographed ethnic groups. Enclaves of Afghanistanis, Iranians, Laotians, Koreans, Pakistanis, Portuguese, Romanians, Sikhs, Vietnamese, and West Africans are among those that are seldom photographed. Pictures of the life of these groups will sell more easily than those of larger, old-established communities like the Chinese and Japanese.

Try to make intimate pictures of the life of the people, not just a superficial "tourist" view. Visit homes if possible. Show people at work and in their leisure hours. Include the obvious, like storefronts and foreign-language signs and foods, and, of course, celebrations for special holidays, as well as lesser-known features of the life of the group. What sports do they favor? What religion do they practice? (Get a wedding if you can.) Try to include cultural contrasts between younger people and their parents and grandparents. Don't forget to take an "establishing" or overall shot that gives a feeling for the whole neighborhood. A busy crossroads, thriving market, etc., from a high vantage point, may be useful for this and will do if you can't find something original.

Variables: People's schedules, national/religious holidays, time of day, weather.

Permissions: Ask individuals and store owners, etc., if you can shoot up close or in home, store etc. Get model releases so the pictures will have value for stock. I suggest exchanging Polaroids or prints for releases, or paying a moderate modeling fee. (See the foreign language releases in the resources section of the book.)

Transportation: Public transit or a taxi may be best; parking is often impossible in old immigrant neighborhoods.

On the shoot: Smile, be patient, ask permission before photographing, and accept the fact that some people will not want to be photographed. You will almost certainly have to make several visits to get good coverage. Bring along prints on your second or subsequent visits, or carry a Polaroid Spectra camera and film, and give away prints as "thankyous" and in return for poses.

Professional tips: This is a travel feature; keep it upbeat. Aim for one or two strong pictures that sum up the place—a feature story today rarely runs more than four or six pages. A cover shot is almost always vertical with clear light or dark space at the top for the publication's "logo" or title. Covers are often, not always, of attractive people looking into the camera. A "spread" goes across two pages, and the center of interest should not fall into the "gutter" (the join down the middle). Important one-page pictures are often run vertically on the left side of a spread, therefore the center of interest usually faces right. If you shoot important pictures as both horizontals and verticals you give the art director

maximum choice. Detail shots only complement, but never replace, strong establishing shots. Evening shots are kind to cities.

Variation: A feature on one attractive member of the community.

Results: An editorial story that may be salable locally or nationally, even internationally; stock, portfolio material, fine-art.

Look at: Geo (in German, French, or Spanish), the National Geographic, National Geographic Traveler, or Travel/Holiday as examples of top current work and subject matter and places chosen by different travel magazines.

Assignment #6: A Tourist Resort

A motel, hotel, country club, dude ranch, or other resort with sports facilities—a nice pool, lake, or beachfront; golf course, tennis courts, horseback riding, etc. Alternatively, shoot a ski resort in winter. The object of this assignment is to advertise and/or promote the facility as a place for active vacations. The place should be attractive and upscale.

Equipment: A camera (two are better) and normal, wide-angle, and telephoto lenses. A tripod. A small flash and a collapsible reflector for fill light will be useful. Lights (if planning to shoot interiors). If this is a beach or lakeside resort, a water-resistant camera may be helpful for shots taken from water level. (See also chapter 3.)

Film: I take plenty of fast and slow, daylight and tungsten film for this type of assignment. You never know exactly what you will encounter.

Research: Locating the facility; possibly finding a good-looking young man and woman, or fiftyish couple, with sports clothes to use as models.

Permissions: From the owners/management of the resort. You may have to agree to show them the photographs before publication. (Promise to offer them a good price if they want to use any.) Agree that you will not photograph any guest without the guest's permission, or that you will take your own models and photograph early or late when no guests are about. Get all the people you use as models to sign releases in exchange for photographs.

Transportation: Car or taxi.

Variables: Weather, time of day, season. (Plan to shoot both early and late outdoors on sunny days; do any indoor shots at midday.) Timing is important; find out when the resort's facilities are busy or empty.

On the shoot: Wait for great weather, but shoot early and late, not at high noon! Don't forget overall views of the main building from a good vantage point, showing the surrounding landscape. Then show sport/fun against a background of the place. Have people actually diving into the pool (shoot from low down, with your camera over the pool edge; it will make it look larger). Show people actually playing tennis and golf, not just pretending to. If the place has extensive grounds or gardens show the space and peace of the natural setting. Views from a boat are great for seaside, lakeside, and riverside resorts. Pictures showing water are always very appealing. Low sunlight from behind you onto the subject is best for reflections and the bluest possible water. Do some "after" pictures of people relaxing with cool drinks, lying in hammocks, reading in a quiet spot, dancing on a patio, etc. Don't forget to photograph any special sports or unusual features offered. Always make dusk shots lit from inside of buildings, and romantic "mood" shots of couples in the evening (the one of people on the beach, barefoot but in formal clothes, is a cliché, but clients still seem to use it).

Possibilities for vantage points: On a horse at dude ranches, on a ski lift, on or close to a

diving board, on a boat for a waterside resort, low and close to the green at a golf course, at netside for tennis.

Professional tip: Consider showing a beautifully situated resort from the air. Have the pilot fly as low as is safe, use high shutter speeds and possibly a gyrostabilizer (see chapter 3) and work early or late when long shadows define the landscape.

Results: Coverage that can be used for advertising, brochures, public relations, and magazine/newspaper features and also (with releases from the property owners and models) stock. This is good portfolio material.

Look at: Up-market travel magazines and newspaper travel supplements, any issue. Aerial Photography, by Harvey Lloyd, is an excellent illustrated manual by a master of this subject. And if you can get hold of a copy of Splendid Hotels of Europe, by Nicholas d' Archimbaud, published in 1994, you will get a good overall feel for this type of photography.

Assignment #7: Bright Lights at Night

A disco, circus, amusement park at night, or downtown entertainment area. The object of this assignment is to improve your "available-light" photography. It will provide personal/fine-art pictures, a possible picture story, portfolio material, and stock.

Equipment: You will need two cameras, fast lenses of different focal lengths (or zoom lenses), tripod, cable release, flash. A dedicated/TTL camera, a dedicated/TTL flash, and a spot meter (or long telephoto lens on dedicated camera) are all especially useful in the rapidly changing light of such places. A dedicated cord for using a dedicated/TTL flash off-camera may be helpful.

Carry everything in a backpack, army-type, or other inconspicuous bag. I like to work with an assistant, or other companion, in big cities at night.

Film: Take plenty. For "available-light" shooting I use the fastest daylight films. (Use tungsten film if you wish also.) When using "fill-flash" I like 50–100 ISO film.

Permissions: Amusement park management will have to be approached for permission to take a camera on rides. Some will require you to furnish them with proof of liability insurance. You may need permission from artistes for circuses and similar indoor events. Carry model releases and a pen. Your best bet is to try not to be conspicuous—just shoot as a "tourist."

Transportation: Any way you can get there.

Variables: Lighting conditions can be extreme. The ideal time to photograph is at "blue time"—dusk before it gets dark. In midsummer in the United States this is between about 8 and 9 P.M. depending on location and exact date. If you wish, take a couple of models (boy/girl having fun never goes out of style; of course get model releases if you do this).

On the shoot: Take some conventional pictures to show the overall scene, using fast film and available light. Bracket exposures or mark rolls and plan for clip tests (see chapter 5), then use medium-speed film at longer exposures adding flash fill to stop nearby motion; or try "panning" (moving the camera with the action) while shooting at a slow shutter speed like ½5, ½6, or ½4 of a second. Use any other technique you like to try to capture the fun of the place rather than a literal representation of it. If you use models, have them run, laugh, play the games, etc.

Results: Exciting, somewhat abstract pictures to complement the factual ones in your portfolio. Editorial features; brochures; stock; postcards; fine art; pictures of family fun. Sales to management, performers, musicians. You may also use these pictures as wall art.

Look at: My book, Mastering Flash Photography should help. Existing-Light Photography is a good manual from Eastman Kodak.

Assignment #8: A Formal Event or Meeting

This is a very typical "meeting" magazine, newspaper, or public relations assignment. Make a series of about twenty color or black-and-white pictures on print (negative) film of guests and speakers, happenings, and audience at any formal indoor party, meeting, conference, or similar event.

Equipment: You will need two cameras and wide-angle lenses for quick "party" shots (preferably one should be a wide-angle zoom lens). Moderate telephoto or zoom lenses for pictures of speakers. A flash unit, with a bounce card. An external battery pack or plenty of disposable batteries (allow one pack of disposable batteries per roll of film for fastest recycling). A dedicated/TTL flash is very useful here, as is a flash meter. Many pros use an automatic flash like a Vivitar 283.

Film: Use 400 ISO print (negative) film for maximum depth of field. I would tend to do this assignment in color unless the client dictates otherwise; color negatives can be quickly processed at "one-hour-photo" shops, and speed is often important for this type of job. The color negatives can be printed as black and white if needed. Keep prints and negatives together in separate envelopes for each roll.

Professional tip: If you shoot Fujicolor 100 DX-coded film, some professional labs will number each print on the back, which can save you a great deal of trouble when reprints are ordered later.

On the shoot: Use the flash bounced if possible; use flash direct if distances are too great for bounce. Use flash together with a low shutter speed (about $\frac{1}{30}$ of a second is good with 400 ISO film) in order to record at least some of the background of the room. (See chapter 7.)

Talk to the groups as you photograph. Try to make them smile. Don't be afraid to ask people to pose or to arrange special groupings. Some may not wish to be shown holding drinks or cigarettes. Keep notes of names.

Be discreet when photographing speakers (best time for unobtrusive shots is at the beginning and end and during applause). Never interfere with a speech, or block the audience's line of vision. (You can always ask for a couple of extra shots after a speech is over.) Photograph every speaker, and groups of people together on the podium.

Results: Samples for a public relations portfolio, possible future assignments; probable sales of prints to individuals or event sponsors.

Look at: "Hospitality" (in-house and hotel) meetings, business and trade magazines (see chapter 12) to see the standards for "meeting" pictures. A friend of mine gets up to \$1,000 per day for taking top-quality ones!

Assignment #9: An Outdoor Tourist Event

Photograph the largest, most interesting "people-related" event you can easily reach. It could be a parade of any kind, a huge outdoor market, a boat race, local or national sporting event, a balloon festival, a concert, or cultural gathering. Use wide-angle, normal, and telephoto lenses for complete coverage. Include overall views, medium and clos-eup shots in both horizontal and vertical formats. Show participants and audience and the perfor-

mance, game, race, or whatever, from a good vantage point. Try to get pictures of key people and peak moments.

The object of this assignment is to produce a magazine or newspaper feature, personal pictures, travel stock, tourism promotion. (For very specific directions on how to approach this type of subject, see also the sample letter of assignment in chapter 12.)

Equipment: Ideally, at least two cameras, better three (to have different lenses quickly available at all times), and fast wide-angle, normal, and zoom telephoto lenses. A small flash for fill light. Plenty of spare batteries. Carry all this in a sturdy backpack or other inconspicuous bag.

Professional tip: A small, light aluminum stepladder is sometimes helpful to get above crowds (where permitted).

Film: Depending on weather, I use slow- or medium-speed daylight transparency film (fast grainy film breaks up small figures in crowds too much). If you want prints for personal or fine-art pictures, and don't care about possible future stock usage, use print film.

Permissions: In large cities, or for major events, you may need credentials from the police and event organizers to get close. Apply well in advance. Otherwise, get there very early. I once walked unhindered onto the middle of the Verrazano Narrows Bridge between Staten Island and Brooklyn at 6:00 A.M. to photograph the start of the New York City Marathon, because I did not have an assignment or a photographers' badge from the NYPD. The race starts at 10:00 A.M. I got great shots which sold well as stock later. It is not normally easy to get model releases at such events, but carry a few forms with you just in case.

Results: Portfolio, personal and possible stock pictures, or editorial feature. Possible print sales to event organizers.

Look at: Current newspapers, local and regional magazines, and top travel magazines for "event" coverage.

Assignment #10: Travel/Tourism Promotion

The object of this assignment is to produce an advertising-style feature about the most famous tourist attraction that is within your reach. Take models with you—have them sign a model release first, and reward them with pictures. Find models among your good-looking family, friends, and acquaintances, and at modeling schools, acting workshops, and little theaters. Consider paying actors, students, or retired people a small fee; or, promise them a percentage of any stock sales. The models could be a young couple (yes, boy/girl is ever popular) or a mature man and woman (who should be fit and active) to symbolize older tourists, a major part of that market.

If you go to a theme park, take a nice-looking family with kids. Models of any race are okay. Minorities are especially needed for stock.

Equipment: Two cameras; wide-angle, normal, and short telephoto lenses. A reflector and/or a small flash for fill light are helpful.

Film: Slow- or medium-speed film.

Permissions: Some museums and other attractions require a photography permit and do not allow flash. Suggestion: Offer a "first look" at the take and promise reasonable photographic use fees to management in exchange for privileges. You will almost always need permission to use a tripod or set up lights.

Variables: Know best times of day for posed shots, times of biggest crowds.

Styling: Extremely important today, especially if you are shooting for stock. Think care-

fully about what all your models will wear. Clothes should be your choice of colors, styles casual classic—a sportshirt, loafers, and slacks for the man; blouse and slacks or skirt for the woman. The colors of both should coordinate. Have kids wear plain tee shirts and jeans, or plain shorts or skirts. Look at TV commercials, in current catalogs like Lands' End or J. Crew, or check out any Gap or Benetton store to get clothing ideas. Ask all models to avoid wearing anything tight, fussy, or with strong patterns or black or white. Avoid tee shirts with slogans, or any extreme fashion that will go out of date quickly.

Transportation: You will need a car or taxi to get models to the site.

On the shoot: Show the couple or family together enjoying the facility, talking and laughing with staff, enjoying the sights, looking at souvenirs, etc. Buy them a few hot dogs and sodas to loosen them up! Take plenty of pictures. Your models will soon forget you and the camera and have fun. Don't have people stand stiffly and point at things. Feel free to direct subtly, looking through the viewfinder all the while. "Could you look over here for a minute please," or "that was great, could you try it again, but slower" are two directions I use a lot!

Professional tip: Pick up any litter that might show in your photographs, and visually eliminate anything or anybody unattractive. Make the whole feeling very lively and upbeat. Do some shots that look somewhat abstract—crop creatively, use pan and blur techniques, and variable focus.

For personal/fine-art photographs: Choose any point of view you like!

Results: Model-released pictures that can be used for advertising and promotion, for public relations distribution to accompany press releases, as well as for editorial features. Stock/portfolio material. Personal/fine-art pictures. Practice in directing (for those who wish to improve skills in working with models).

Look at: Ads and "advertorials" (editorial-style ads) in travel sections of newspapers, and consumer and trade travel magazines.

General Considerations for the Self-Assignments

Think carefully about where to do these self-assignments (which all are based on similar ones I have done). Check local tourist attractions, resorts, new hotels, etc., and study photographs they are currently using.

When you have done each assignment, edit it carefully. Did you get what you wanted or hoped for? Should you go back to improve the take? Are you honestly proud of the pictures? When the answer to that question is yes (it may take one or more reshoots to get there) show the take to the owners, managers, organizers, etc., and you will probably sell some work. Even if you are 100 percent unsuccessful at selling anything immediately, you will have gained experience, have good pictures for your portfolio and stock, and will have made some useful contacts that you may hear from later, especially if you periodically remind them of your existence, and show new work. (See chapter 10.)

Also see travel highlights chapters for suggestions on how to approach destination photography.

TEN QUICK WAYS TO IMPROVE YOUR TRAVEL PHOTOGRAPHS

- 1. Photograph as many different people as possible. If you are shy, start by getting family and friends to act as models; learn how to get them to do what you want (or "direct" them) before you leave on a trip. On trips, use your travel companions and acquaintances as models. Photograph them in natural positions, not just gazing at the camera or pointing at something. Don't be afraid to approach strangers; a smile that says "Please, may I?" will go a long way. (Look at any travel magazine to see how many "people pictures" are used.)
- 2. For sharp pictures of any fast-moving subject, and pictures taken from moving vehicles, use a high shutter speed to avoid blur caused by subject movement—1/250 of a second or higher is good. On program cameras, use the Shutter Priority setting to choose shutter speeds. Also use high shutter speeds with telephoto or zoom lenses, to minimize camera shake. A tripod is a necessity for consistently sharp pictures with long lenses (200mm and up), and with all medium-format cameras.
- 3. Be aware of backgrounds in all your pictures. Inexperienced photographers tend to overlook them, but a sign right behind someone's head, a garbage container or litter in a pretty park, or utility lines in a panoramic landscape can ruin an otherwise very nice shot. Stand on a bench and shoot slightly down, or hunker down and aim the camera up to avoid some background problems and provide a different point of view.
- 4. Be keenly aware of prevailing light conditions at all times and with all subjects. Especially avoid hard noonday light and subjects that are part in sun, part in shade. (Keep a manual camera set for prevailing light conditions, so that you are ready to take a picture without adjusting the f-stop.)
- 5. Take several pictures of any good subject, human, or otherwise. You need to make quite a few shots to get a human subject to relax and show her personality. Try several different angles or arrangements of people, landscapes, or architecture to get the most creative possible composition. Bracket (vary) exposures slightly whenever possible for optimum color. Vary lenses—a telephoto shot of someone in a landscape is very different from one taken from the same place with a wide-angle lens, and it's not just difference in the relative sizes of the main subject. Remember that labs—even the best—occasionally scratch or mark film, and extra frames may save the day. On really great subjects, take pictures with another camera, or at least on another roll of film, for extra "insurance."
- 6. Don't forget to take some "establishing" pictures that show the overall scene and give a sense of place. These are all too often forgotten by neophyte travel photographers in both city and

the countryside. Get up high, move farther away, and/or use a wide-angle lens. Try taking three overlapping shots to show a sweeping view or mountain panorama. Use a tripod if possible, and aim the camera to the left, center, and right, using something as a reference point where the pictures join. Professionals often use panoramic cameras (they are expensive) to do the same job in one picture. For amateurs there are surprisingly inexpensive Kodak and Fuji "throwaway" panoramic cameras. (See chapter 3 on equipment.) Pictures of signs help pace a slide show, and caption an album of vacation prints. Shots of people looking at foreign language signs can sell as stock.

- 7. Don't be afraid to photograph in bad weather for your own travel pictures, even if these are not always wanted by editorial or other assignment clients. Gray skies, mist, fog, rain, and falling snow can make evocative personal and fine-art images, and overcast light is good for shadowless portraiture. Protect your camera from moisture with a clear freezer bag or dry cleaners' wrap. Poke a hole for the lens (covered with a Skylight or UV filter), and tape it tight, leaving a hole for your hands. Select a fast film if you are uncomfortable with slow shutter speeds (400 ISO is good), and fire away. Flash "fill" works well on overcast days, use the same technique as you do at dusk. (See chapter 7.)
- 8. Think about what you want to say. Travel pictures should do more than record "I was there." Normally, they are upbeat, but if a place is over touristy for your taste, placing something negative in the foreground of your composition can emphasize your point of view. You may love or hate New York City. It can be photographed looking glittery and glamorous or rundown and desolate; both approaches are valid and can make strong pictures. But, if you hope to sell New York pictures for stock, take the first approach.
- 9. Be very patient, especially when photographing people. Wait, camera ready, for a child to giggle, an old man to look up from his card game, a worker to change the angle of his hammer. Wait also for a sailboat to go under a bridge, ducks to settle on a pond, a distant skier to appear on a mountain, the sun to come through scudding clouds. The resulting pictures will be worth the extra time spent.
- 10. Compose all your pictures "through the lens." This sounds elementary, but many people view a subject with their eyes, then quickly put up a camera and take a snap, not stopping to look through the viewfinder, or move around and study what the lens covers or whether a different lens would be better or how a scene translates into two dimensions. Try to keep both eyes open when looking through the viewfinder (this takes practice) so you are aware of what's happening outside the picture area.

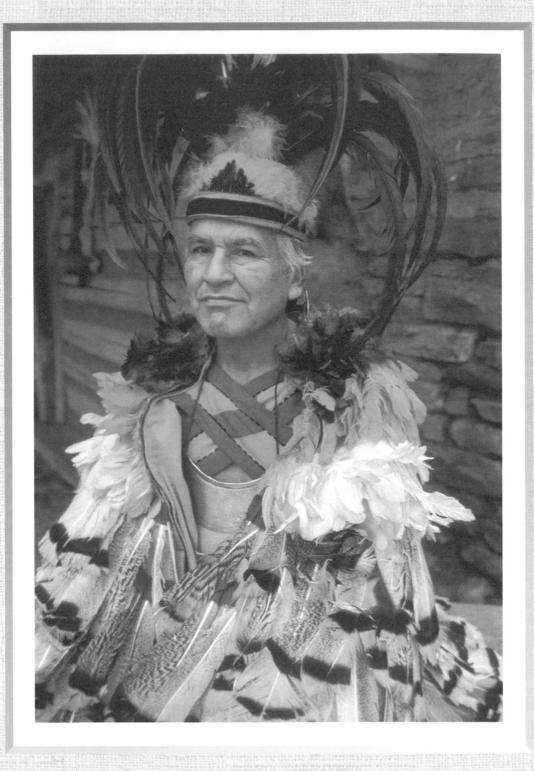

diting skills are important for serious amateur photographers, and critical for professionals and would-be professionals. Editing takes practice, but if you currently don't edit much you will be amazed at the difference serious pruning will make to your presentations. The inexperienced photographer, and even some professionals, often make the mistake of showing too much, which weakens the effect of their best work. Don't do this.

How to Edit Photographs

Whatever the final intended use, your work is incomplete until the pictures have been edited. Good picture editors are highly skilled, and can look at work with a dispassionate eye, while the photographer who made the shots cannot. However, since at the beginning of your professional career (or for your personal/fine-art pictures) you won't normally have access to the services of a trained editor, you should learn editing skills yourself. Everyone, including superb photographers, quite often takes dull or technically poor pictures. Professionals just never show them to anyone.

Whether you are making a professional portfolio, a school thesis, prints for an exhibition, or a quality family photographic album, carefully choose and limit the photographs you show to gain maximum effect. The best way to edit is to look at all your pictures a lot. Pin black-and-white or color prints to a wall and let them stay there for a while. Ideally, look at slides projected in a darkened room, where you can see them big. Study each picture carefully. (Use a Kodak Stack Loader to eliminate having to put each slide individually into a Carousel projector wheel.) Use a light box, illuminated from underneath, and a "loupe" (a small magnifier that fits the eye) to view medium and large format images. (See below for directions on how to make a light box inexpensively.)

When you edit, be realistically critical but not self-destructive. It is easy to start—just remove pictures that are unintentionally too dark, too light, too contrasty, blurred, or just plain boring. After studying your initial selection for a while the best pictures usually jump

HOW TO MAKE A LIGHT BOX

Commercial light boxes are expensive. Save quite a bit of money by making this one.

- 1. Make an open twelve-inch-high box of the right size for your space (and the fluorescent fixtures) from one-inch lumber (or use an existing box).
- 2. Buy two fluorescent lamp fixtures about six inches shorter than you want your box to be; and a sheet of quarter-inch opal true-white plastic of the correct length and width.
- 3. Paint the box white inside. Drill a couple of ventilation holes on each side of your box, put the fluorescents in and wire them together.
- 4. Drill holes, and screw the plastic down, use clips, or, rout out the lip of the box to fit plastic.

If possible, make your light box big enough to take a couple of thirty-six exposure rolls of 35mm slides, or long enough for uncut rolls of 120mm transparencies.

out, but sometimes, on a second or third look, one's choices change. For that reason, I never throw anything but bad mistakes away; I store pictures I don't choose to show.

Put your "selects" aside for a few days if possible, then look at them again. Then decide which of the photographs look the way you wanted them to look, and say what you wanted to say. If you have several very good but closely similar shots, study the exposure, small gestures, composition, and color of each, carefully. You will almost always find one that is just a little better than the rest, even if only you can tell the difference. Mark these special pictures on the mount. You may choose as I do, to save them for your "private stock"—photos that you hope to use for a book or exhibit one day.

Editing Transparencies on a Light Box

For the second stage of an edit, professional editors always lay out transparencies on a large light box. (Buy a professional Macbeth daylight-balanced light box if you wish.)

With a light box, it's easy to sequence slides and transparencies so that each relates visually in some way to those preceding and following them. This is essential for a professional portfolio where you must entertain and impress potential clients. Pacing is very important for audiovisual presentations and even good vacation slide shows too.

Editing Prints and Sequencing Your Edit

To edit and sequence prints for an exhibit, print portfolio, or a public relations or family album, lay out possible prints on a large table or clean floor. Take out weak pictures. Sequence the best in an interesting way. Arrange prints for albums as "spreads" of two facing pages.

If editing prints from an assignment or personal shoot in, say, Jamaica, you might start with beach pictures, then people shots, then show tropical landscapes, and finish with architecture and hotels. Or, group pictures by color or shapes that dissolve into each other or anything else cohesive. The next step is to arrange them in a logical sequence as interestingly as possible. The sequencing can be by subject, or by any other grouping that seems to work. (Turn off the sound on your TV to study commercials and see highly professional

EDITING TOOLS

- A loupe by Agfa (inexpensive) or Schneider (the best, adjustable to your eye) to view contact sheets and transparencies.
- White and red china markers (grease pencils) from stationery stores to mark black-and-white contact sheets.
- A light box (Aculite and Macbeth are standards; or make one yourself).
- A Carousel (or compatible) projector with autofocus. If you are fussy, Navitar makes fine lenses
 that replace the plastic ones that come as standard with Carousel projectors.
- An 80 or 140 slide Carousel wheel for 35mm slides.
- A Kodak Stack Loader for the Carousel projector (permits loading a stack of thirty-six slides at a time).
- A rubber stamp with your name and the international copyright symbol (it's easy to stamp
 the copyright on pictures while editing, and then you won't forget to do it later. (See also
 chapters 1, 2, and 13.)
- Plastic or cardboard sheets or sleeves that hold twenty 35mm slides, (or other format sheets/ sleeves) and individual, nonharmful plastic slide/transparency protectors; be sure they are archival quality. The stiff ones I use for individual 35mm images are called Slides Sleeves and marketed by Fotek. (See resources.)

editing where every second counts. After you have done that, you will know why no one today can sit through long disorganized presentations.)

The Professional Portfolio

You probably will need to have at least forty or fifty pictures that you are proud of before attempting to make a portfolio to solicit assignments for publication. When you have selected them, think about who will be looking at the photographs and choose fifteen or twenty pictures that are appropriate for individual potential clients. Pitching a portfolio to specific clients does not mean you have to change your individual style—that may be why you get hired—but that you use that style on subjects that a prospect can relate to. It is normally useless to show location portraits of children to an architectural client, for instance, but if a new school has to be photographed, you might add a few child pictures to your selected architectural shots. Pictures of children at play plus, say, Bermuda travel shots might be perfect to show to a company that operates family oriented tours. You get the idea. Think creatively, and vary the portfolio.

Portfolios for Assistants

People seeking work as a professional assistant in a big-city photo market need a sharp looking portfolio that demonstrates their interests, talents and, often most importantly, their printing and computer skills.

The strongest portfolios of any kind are done by photographers who show originality, passion, and conviction as well as technical skills.

Specialized versus General Portfolios

New York City photographers (and probably most Los Angeles, Chicago, Dallas, and Toronto area photographers, too) who are established in the profession are usually specialists and show portfolios that reflect this.

Advertising illustration, fashion and beauty, still life, travel and location, photojournalism, corporate/industrial, and portraiture are some specialties. Some photographers today are stock specialists. If you do more than one kind of work, make more than one portfolio—don't confuse viewers with too varied a portfolio.

Beginning professional photographers and those in smaller cities/markets can have more general portfolios, but it should still have a unified look—the prints should be the same size, and have the same finish and borders.

How Many Pictures Should Be in a Portfolio?

There seems to be a consensus that not too many shots are needed to show your style and what you can do. A limited portfolio does not tax the viewer or waste his time, and leaves you the option of returning with different good pictures if you are asked to keep in touch.

Slide Portfolios

Twenty to forty slides may be shown, either sequenced on a wheel that fits a Carousel projector, or mounted on black cardboard presentation sheets.

Print Portfolios

Show no more than fifteen to twenty prints. I usually show $11" \times 14"$ or $11" \times 17"$ prints in a "press book" (available at art and photo suppliers). Subject matter can be grouped in two or three related areas—travel to different parts of the United States or the world, corporate and industrial, or architecture and interiors for instance—and should flow from one section to the next. Color prints, black-and-white prints, and published tear sheets are usually shown in separate groups. Setup or posed advertising illustrations or stock pictures using models should be shown separately from photojournalist and editorial "real" people pictures in my opinion.

Today, because many clients do not want the responsibility of being responsible for valuable original work, I often show the best quality laser prints, unmounted. I show laser prints of tear sheets (published work) reduced to half size. Duggal Labs here in Manhattan makes excellent laser prints for about \$8 each. Other photographers have other types of portfolio, and may show original prints, large duplicate transparencies mounted in black mats, or laminated tear sheets enclosed in clear plastic. These are all widely used and professionally acceptable.

Fine-Art Portfolios

Fine-art prints may be of different sizes but almost always look best, in my opinion, if they are uniformly mounted and/or matted. Choose the color of the mount or matte carefully. Black or white isn't always best. I like the look of a medium gray mount for many color and black-and-white prints.

Print Albums

For a print album, edit and sequence carefully and don't make the prints (or the album) too big. Prints from $3\frac{1}{2}$ " \times 5", 5" \times 7", to a maximum of 8" \times 10" are good for meeting and party shoots, weddings, etc.; standard $3\frac{1}{2}$ " \times 5½" (snapshot size) prints for a personal family album are economical.

Choose only your best pictures for a personal vacation travel album; be strong and set bad shots aside. If you only have one picture of Aunt Minnie at the Taj Mahal and it's a poor one, store her away in a box if you want the album to look excellent. It's well worth the expense of buying an archival album; cheap ones discolor quickly, smell like plastic, and may harm your prints eventually.

Portfolio Albums, Boxes, and Cases

Whether for commercial, personal, or fine-art presentation, always get the best looking portfolio album, book, or box you can afford, with pages that won't harm your work. If you can't find one you like at your local photo or art supply store, try the mail order house Light Impressions in Rochester, New York, at (800) 828-6216 (they will send an excellent free catalog on request) or specialist portfolio maker Brewer-Cantelmo in Manhattan at (212) 244-4600.

Prints for Exhibition

I have said elsewhere that you should learn to print (at photo schools or workshops) if you want to exhibit. But if you have the funds for huge exhibit prints, I can personally recommend three New York labs who do great work and will ship anywhere.

Ken Lieberman Labs specialize in making box-mounted color prints for corporations, museums, decorators, and many top photographers. A $20" \times 30"$ box-mounted Type C print (which needs an internegative from a transparency) currently costs about \$260; from a negative about \$225. Lieberman also makes Fuji Super Gloss prints and chromogenic prints up to $48" \times 72"$ in size. Contact them at (212) 633-0500.

Clone-a-Chrome in Manhattan specializes in Ilfochrome (direct positive) enlargements from transparencies. The process is considered stable and fade resistant. Contact them at (212) 206-1644; or (800) 750-9127. Modernage Labs in New York City specialize in large-to mural-size black-and-white prints. Contact them at (212) 997-1800.

Locate professional labs in your own area through classified phone directories or the Internet.

Inexpensive Enlargements

Small prints from color negatives are made by one-hour-photo shops everywhere. Thermal transfer (laser color copier) prints can be made on the spot from prints or slides at "quick copy" shops just about everywhere. They cost from \$1 to about \$6–8 for an $11" \times 17"$ copy here in New York. You get what you pay for.

LONG-TERM FILING AND STORING OF PHOTOGRAPHS

Do not use inexpensive, thick polyvinyl chloride (PVC) sheets to store color or black-and-white slides for any length of time. (This thick cheap plastic can be identified by its strong smell. It will eventually adhere to, and damage transparencies.)

Sturdy DW Viewpak transparent archival storage sheets (available with dust covers and metal file hangers) are the best, and are used by many stock agencies including my own. They are made in England and sold (in the northeastern United States anyway) by the Sam Flax chain of art supply stores.

Thinner, less expensive but archivally safe plastic storage sheets for all slide and negative formats are made by Perma-Saf or Best File, and are sold by many photo dealers (these need metal hangers to hang them in file cabinets). Order them from Light Impressions, at (800) 828-62216, if your dealer doesn't carry them. This company will send an excellent free catalog of archival storage supplies if requested.

I put archivally safe, transparent, plastic slip-on covers on individual 35mm slides to protect them from fingerprints, scratches, and dust. Even in the age of Adobe Photoshop, retouching is a time-consuming and/or expensive business. I use the covers on every slide I send out, and on all my favorite stored pictures too.

All slides and negatives should be stored in a dark, cool, dry place. I keep my "super select" transparencies in covers, then in slide sheets hung in a closed storage box in my safe. I keep stock selects in individual plastic slide covers, then in DW Viewpak archival sheets, all hung in standard metal file cabinets. My filing is by country or by subject.

I store "outtake" (rejected or spare slides) in the original boxes in metal filing cabinets with shallow drawers. (I found mine very inexpensively; they were originally used for canceled checks.)

Framing Prints

In my opinion, photo frames for gallery exhibition or home or office decor should be plain, narrow, and all the same color. Choose light wood, brushed or painted aluminum, or frameless plastic or glass covers held together with clips.

Presenting Professional Assignments

For your final choice of pictures for any kind of assignment edit, my best advice is to rely on your instincts for what you want to show. Asking advice will only confuse you, as no two people, even professional editors, will choose alike. An assignment edit will probably contain hundreds of pictures to give the art director plenty of choice (don't forget to include horizontal and vertical versions of the same shots, except for audiovisuals, which use horizontals only).

Present edited shots in twenty-slide plastic sheets or in Kodak Carousel wheels, whichever the art director or picture editor prefers. Always number and copyright stamp all slide/ transparency mounts (or each print on the back). Include related numbered caption sheets with the take.

TWO ARCHIVAL STORAGE SUPPLIERS

Two companies that sell portfolio boxes and cases; albums, mounts, sleeves, storage boxes, and many other archival supplies which are used by museums, and that publish free catalogs with much information on photo storage are: Light Impressions, phone: (800) 828-6216; and University Products, phone: (800) 762-1165.

How to Start Showing Your Photography

Great pictures are at the heart of great self-promotion. Show only your best work, immaculately presented. Show your self-assignments (see chapter 9) at first, and mix it with the best of what you have done for clients as you get more experienced. The first step is to edit your pictures well; the second is to have a business card printed. This can be a simple card in tasteful type from a local printer at first.

Experts are unanimous that the portfolio size should be limited. A slide portfolio should probably contain no more than thirty to forty images. Show good color dupes rather than fragile originals, and slide copies of tear sheets or black-and-white prints too if you have any. Carry chromes in a standard Kodak Carousel slide wheel. (Take along your own projector if the client doesn't have one.) Transparencies of any size can be shown in black cardboard presentation sheets, available in all formats from art and photo dealers.

I repeat, keep all portfolios tight, prints can be any size you want. A print portfolio should have no more than fifteen to twenty black-and-white or color samples in a smart press-book type folder or zippered case with glassine sheets, or a box.

Some advertising photographers use $8" \times 10"$ duplicate chromes of original transparencies or tear sheets. These, while expensive, look great in uniform black mounts. Get the dupes made by professional labs, or, if you are skilled, dupe them yourself onto film made for that purpose. (Consult Kodak and Fuji about this; I have never done it seriously myself, and there are new duping films on the market.) There are even portfolio cases with built-in $8" \times 10"$ light boxes.

Showing Your Portfolio

The portfolio should be limited in size for three reasons. First, art directors are very busy—you don't want to bore or overtax them; second, any good art director can see what you can do by looking at very few pictures. And, most importantly, even if someone likes your work a lot, they may have nothing to offer in the way of jobs at the moment. Sometimes it may take several visits before work is offered, so you need some pictures in reserve for when you call back. Always carry your business or promotional card and a few photocopies of pictures to leave behind when you show work.

Stock photographers should keep a "Stock Picture Delivery Memo" (see chapter 13) handy when they see clients, in case someone is interested in holding work from the portfolio. (Be certain what you leave is copyright-stamped!) If you market stock pictures, make an alphabetical listing of them by subject and leave it with your card. Remember too, that stock clients can sometimes turn into assignment clients.

THE TRAVEL INDUSTRY PERSONNEL DIRECTORY

A travel agent friend told me about this useful directory, published by Business Guides Inc. It lists national and state tourist offices, tour wholesalers, airlines, cruise and ship lines, car rental companies, hotel and motel chains, and more. I use it both to locate possible clients and as a research tool when planning a trip. It currently costs \$30. To order, call (800) 252-9791.

Promotional Mailers and Cards

The first promotional tool a photographer needs is a business card. These can cost as little as about \$25 for one hundred all-type cards from printers or service bureaus. Resist the temptation to have cutesy "clip art" designs on this basic card!

Five-by-seven-inch photo cards with your name, address, phone number, e-mail address, etc., and a photograph can be produced quite reasonably. I send them out as mailers periodically, and as Christmas cards. Studio X here in New York does a nice job on such cards; they cost about \$200 for one hundred cards with a single photograph. Call them at (212) 989-9233 or (800) 959-9233. Other card printers advertise in the *Photo District News*. Also see classified phone directories.

If possible, mail out a different promotional card every six weeks or three months. A Christmas or Seasons Greetings card is a good way to keep in touch with old clients, and bring your name before new ones. Do not use family-type greeting cards unless the picture is a fine photo of generic holiday interest!

Mailing Lists

A good mailing list is an important promotional tool. Beginners should build up a mailing list with local contacts, local classified telephone directories (yellow pages) and/or the Internet (Yahoo yellow pages is good) as sources of possible clients. A good magazine store will provide much useful browsing for local/regional publications.

Two groups of professional directories are expensive but exhaustive, and may be consulted at good public libraries. The *Standard Rate and Data Guides* and *Bacon's Media Directories* list all U.S. newspapers and consumer magazines, business publications, advertising agencies, and more. Some overseas information is also included.

The Photographer's Market (published by Writer's Digest Books) is an annual directed (in my opinion) at photographers starting out. It lists many buyers of all types of photographs (these are often in the lower paying end of the market) and sells in bookstores for around \$25. (See also chapter 20.)

Commercial Mailing Lists

For the photographer with some experience and a strong portfolio, purchasing a mailing list may save time and provide valuable new contacts. Lists of photo buyers, including publishers, large and small advertising agencies, graphic designers, etc., are available on preprinted labels and broken down by region and specialty, from professional list brokers, including Creative Access, phone: (800) 422-2377; and Steve Langerman Lists, phone: (207) 761-2116. Other list brokers advertise in the *Photo District News*.

PROMOTING YOUR PHOTOGRAPHY ON THE WEB

Since the first edition of this book was published, a new promotion tool has evolved. Having your own Web site on the Internet is a great way to showcase your work. You can refer potential clients to it, and it's easy to keep current. If you have the skills to design and maintain the site yourself that will save you money. If not, have a specialist do these things for you—a bad Web site is worse than none. For basics of how to register a domain name, set up a site, and much more, see chapter 11. My site has not been up for long, I have not yet sold images directly from it. Time will tell if I will do so later. Meanwhile, a possible client can view my work without my having to drop off or ship a portfolio.

The American Institute of Graphic Arts (AIGA) has chapters nationwide (see big-city phone directories and the Internet) and sells lists of its 1,700 members (good sources of annual report and corporate work) on preprinted labels or computer disc.

Send out promotional mailing pieces fairly frequently. Every two to three months is probably not too often. There seems to be a consensus that it is more effective to mail (or hand deliver) a new promotional to one hundred carefully chosen people several times a year than to scatter one card to one thousand people once a year.

Photo Business Newsletters and Stock Want Lists

Most newsletters that I am aware of deal with the stock (existing) photo business. Stock request (want) lists, are also available on subscription. With at least one, you can advertise travel plans. Lists are a way of learning about what travel pictures are in demand, and a way of adding selected buyers' names to your promotional mailing list. (See chapter 13 for more and resources for listings.)

Promotional Directories

American Showcase, The New York Gold Book, and Direct Stock are color self-promotion directories published in New York. I have either advertised in, or know people that have used these directories, with good results. There are quite a few national and regional directories for both assignment and stock photographers (check local sources for regional photo directories covering California, D.C., etc.). Most color promotional directories cost about \$2,000 per page. They are worth it if you are moving into high-paying advertising and corporate assignments, or if you have very good model-released stock that may command high advertising prices. Such directories are distributed free to a carefully selected list of proven art buyers and most provide one thousand free reprints for their photographer advertisers. These of course make excellent mail and drop-off promotional pieces. Most promo directories are not for beginners or for those on a budget, but are generally considered by top experienced and established photographers to be part of a long-term promotional strategy that includes regular mailing pieces, ads in magazines read by art directors (Communication Arts, Photo Design, and Select are three), and extensive circulation of one or more portfolios, most often by the photographer's personal representative or "rep."

AG Editions of New York publishes two all-type promotional directories. The Blue Book

is for travel photographers and the *Green Book* is primarily for nature photographers. The fee to advertise in either is around \$750 per page. I have used the *Blue Book* with satisfactory results. Now, both offer a detailed online listing of your specialties. (See resources.)

Working With Professional "Reps"

A few photographers are lucky enough to have a dedicated spouse or friend who is able to carry their portfolios around and represent (or "rep") them to art directors and other art and picture buyers early in their careers.

Most photographers start by "repping" themselves, because it is difficult to get a good rep until you have an established business. Reps live on a percentage (usually, but not always, 25 percent) of the sales they generate for a photographer, so it is obvious that they either have to be paid a salary or have a large-grossing photographer in order to survive.

Repping is not an easy way to make a living, especially in these days of "drop-offs" (leaving the portfolio for a short time) and the fact that art and photo buyers in big agencies and magazines screen portfolios, making it more difficult for reps to establish relationships with art directors.

Competitive bidding for big-money advertising jobs is routine today, and only a few very well-established reps get to see top art and creative directors regularly, so the business is tough for new reps without contacts. But, as in any field, some people have the talent and persistence needed for selling, and if you are clever or lucky enough to find one, treasure him or her.

In fact, most top reps who stay in the business not surprisingly end up working with the photographers who make the most money, usually those who do high-paying corporate annual reports, or advertising or fashion work.

To try to find a rep, you can advertise in the *Photo District News* or in the Society of Artists and Representative's (SPAR) newsletter. Reps seeking talent advertise in both. (See resources.)

Working With a Professional Rep

To get on well with any rep, your understanding with him or her should be clearly spelled out in writing in advance, and the agreement should be to the satisfaction of both parties.

Edith Leonian, a good friend and a former board member of SPAR, says that it is very important for you and your rep to have similar goals for your career, and that these should include where you want to be working, and how much you want to be billing within a certain amount of time. She advises that photographers confer with their rep frequently.

If the arrangement does not work out after a reasonable trial period of about one year, you should be able to end the relationship without costly arguments.

Representing Yourself

Most travel photographers will almost certainly have to rep themselves, at least at the beginning. Don't think of this as boring; you can learn a lot from the people you meet. The three most important criteria in selling yourself are: great pictures, good follow-up, and a personal rapport with potential clients.

To start, make a list of publications, designers, or other clients you would like to work

NETWORKING—PROBABLY THE BEST WAY TO FIND CLIENTS

Your "network" is everyone you know—family, friends, people you know from work and social activities and professional colleagues. A great deal of photography work is given to someone the art director knows, likes, and trusts.

- If you go to any kind of art school or college which graduates future art directors, be sure to keep in touch with their careers.
- If a client moves to another job, keep in touch with him or her.
- Ask clients to refer you to other people who might use you.
- Remember everyone you meet potentially has a cousin who is an art director! Carry your business card wherever you go.

I went to art school at night and worked as a guide in the United Nations Headquarters here in New York, for two years. I did grunt work in the art department of the Scholastic Magazines group, and I was student travel officer for the British Tourist Authority before becoming a photographer. Contacts made at all of those places later resulted in assignments when I turned professional.

Knowing people will always get your foot in a door. You must have a good portfolio and skills, and do good work, to be hired more than once!

for, with whom your style "fits." Mail or hand deliver one (or several) promotional pieces, and follow up with phone calls a couple of weeks later. If you can't get in to see the person you hoped to, don't give up. While many magazines, design firms, etc., have a "drop-off" policy, they will call you for a personal interview if they like your work. Of course, if you can use someone's name to get in to see a potential client, do so. (This does carry an obligation to show only truly good work!) Don't sniff at seeing assistant art directors, associate art buyers, or junior editors; they will pass you along to the boss if they think you are good, and they, themselves, like to get to know new talent. In the fast-paced communications industry people move up quickly and assistants can soon be in a position to give out work themselves.

Making Sales Calls

When you locate a possible client, telephone for an appointment—you may have to be politely persistent. When you get in, it's good to remember a few points. Representing yourself is selling yourself, no doubt about it. This has nothing to do with photography of course, but you should dress appropriately when calling on potential clients (photography is after all an "image" business). You are always to some degree judged for yourself as well as for your pictures when you make calls, and you must usually impress new clients that you would be a good person to represent the publication, or company, as well as be the best photographer for the assignment. Dress more formally for a call on the corporate/public relations world (after all, they wear suits) than you might for a visit to a magazine, advertising agency, graphic designer, or book publisher.

Today is most emphatically not the sixties, when I for one went around in jeans and safari jackets. A good rule when seeing a client you don't know is to wear what you would wear to dinner at a good but not too formal big-city restaurant.

When You Get the Assignment

Once you have an assignment, you have the obligation to do it well, and on schedule no matter what it costs you in time. Art directors', sales directors', and picture editors' jobs (and repeat assignments) depend on your performance.

When you have done any job, always thank the client for the work. Top photographer Nancy Brown used to be a busy model. I used her two or three times some years ago. She was not only pleasant to work with but the only model I ever used who always sent me a note of thanks afterwards. I don't know exactly how she made the transfer to photography, but now she is a very good and very successful advertising illustration photographer. I am quite sure that she still thanks all her clients, and that this has contributed to her success.

How to Thank a Client

Send a thank-you note by all means. It never hurts to take a client who has given you a job out to lunch, or to send someone who uses you regularly a small gift at holiday times. (Unless they ask, clients don't normally want framed photographs!) Entertainment and small gifts are tax-deductible to professional photographers.

If at First You Don't Succeed

Be patient and keep showing and improving your portfolio. Never, never underestimate the importance of persistence. Many good people in all artistic fields don't make it because they don't hang in there. The people that do succeed in photography, as well as in every other art, do so because they are both talented and persistent.

I truly believe that if you do good, honest work, and love doing it, and don't get discouraged by a lack of easy success, eventually you will find enough people to hire you to make photography support you. Whether you will ever get rich is another matter.

Some Good Books on Self-Promotion

I have met travel photographer Cliff Hollenbeck and seen his huge studio in Seattle, and, judging by it alone, he is thoroughly entitled to use the title *Big Bucks, Selling Your Photography* for his professional business book. Worth the price, it contains a lot of hard suggestions.

The Photographer's Guide to Marketing and Self-Promotion, by Maria Piscopo, is sound. Sell and Resell Your Photos, by Rohn Engh, is a bestseller aimed at emerging stock photographers. It has good information on tax strategies. The Perfect Portfolio, by Henrietta Brackman, is also a bestseller; some images are now dated. Photography for the Art Market, by Kathryn Marx, gives a lot of information about the fine-art photography business, and should be helpful to those interested. Publishing Your Art as Cards, Posters and Calendars, by Harold Davis, is good too. (See bibliography.)

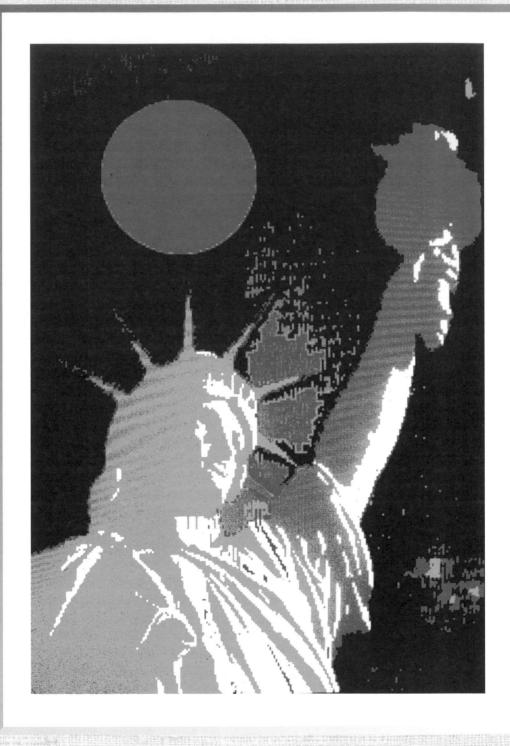

The Computer, Digital Imaging, and the Internet for Photographers

his chapter is an overview. I am deliberately not being highly technical, both because I'm not qualified and because anything too specific will probably be outdated in a few months. I have discussed the subjects with experts in detail.

How I Use the Computer

Ten years ago, I bought my first black-and-white Mac SE computer, with an eight-inch screen. I also had a noisy dot matrix printer and two programs: Microsoft Word, for correspondence, writing, keeping travel expenses straight, and invoicing; and Intuit's Quicken program for balancing my bank accounts. Soon, I added type fonts from Adobe and a graphics program called Freehand (now marketed as Macromedia Freehand) and learned how to design my own stationery and personalized business forms, create diagrams, and more. I still do all those things.

Now, I have a color Power Mac with lots of memory and a huge hard drive, seventeenand fifteen-inch color monitors hooked together (one monitor is used to display the complex palettes needed for Adobe Photoshop). I have an Apple black-and-white laser printer, and a modem to send and receive e-mail.

I now use Adobe's marvelous Photoshop program to retouch scratches and other minor flaws on pictures (first I have slides scanned by Kodalux to CD-ROM disc rather inexpensively for downloading the images to the computer). My local computer service bureau turns the corrected pictures back to film for about \$20 each. I can print scanned color photos up to $11" \times 17"$ in size on my Epson Photo Stylus 850 ink-jet printer, and am very satisfied with the results.

I have no plans to shoot digitally at this time, or to create computer-enhanced montages (which I tend to think of as photo-based illustrations, not true photography), but, I may change my mind later. The interview I did with Andrew Child (see the end of the chapter) has got me interested.

How I Use the World Wide Web

The Internet is a communications miracle that is also chaotic, with millions of separate sites all around the world, each with its own address, called the URL (universal resource locator). For the last couple of years, I have been on the Internet via a modem. I use Interport, a New York City and regional service provider. E-mail is marvelous for corresponding with clients and friends all over the world, and I belong to a professional photographers' newsgroup that is informative and occasionally extremely helpful. The Web can be an excellent source of travel information as well.

I now publicize my photography and books on the Internet via a commercial Web site—a friend who is a great designer created it; I am currently struggling with learning how to maintain the site with the GoLive's CyberStudio program.

Travel Research and the Internet

Today the United States and most foreign governments have official Web sites providing detailed, frequently updated travel information. Most airlines, national and regional tourist offices, and hotel chains and cruise lines have Web sites too.

If you love doing research on the computer, you'll have a ball. If you are like me, and find staring at a small screen for long periods isn't much fun, browse at night, when the Internet is less busy and information downloads faster. The downside to the Web is that the excellent sites and terrific information is mixed in with old, incomplete, and repetitive material; garrulous personal pages; crackpot junk; and rambling chat and newsgroups on just about any subject. The Web should clean house, or at least have periodic sweeps to get rid of outdated repetitions.

Search Engines

Search engines are directories. To research a place or subject not listed, start with one of the Internet's top search engine Web sites. These include: AltaVista (www.altavista. digital.com/), Excite (www.excite.com/), HotBot (www.hotbot.com/), Lycos (http://lycos.com/), WebCrawler (www.webcrawler.com/), Infoseek (www.infoseek.com/), and my favorite, Yahoo (www.yahoo.com/).

To find subjects via search engines, you must type in key words and set search perameters. For example, to find a subject that is defined by multiple words, you can use the plus sign (+), as in: Travel + cruises or Britain + travel or Mexico + Spanish + language schools or Aloha Airlines + schedules. The better you are at selecting key words, the more appropriate the suggested sites will be. At first, you may get thousands of listings from a query, many of marginal relevance. Practice will enable you to discard the dross quickly and find the sites and data that you want.

Useful Web Sites for Travel Planning

To save you much digging among dross to find the gold nuggets, I list below a few of the most useful travel sites. Be aware that some URLs will change during the life of this book.

U.S. Government Sites

- At the U.S. State Department site (http://travel.state.gov), you can, among other things, find places to get a U.S. passport issued.
- For up-to-the-minute travel warnings and advisories for American travelers go to: http://travel.state.gov/travel_warnings.html. Also check U.S. consular information fact sheets for all countries in the world.
- The U.S. Center for Disease Control site (www.cdc.gov/travel/travel.html) provides upto-date information on epidemics, travel health risks worldwide, vaccinations, and required and recommended precautions.
- The U.S. National Parks Service site can be found at: www.nps.gov/.
- To find foreign government sites, access the Yahoo search page at www.yahoo.com/ and enter the name of country plus "gov" (e.g., "Brunei + gov").

Airline and Rail Sites

- American (www.americanair.com)
- Delta (www.delta-air.com)
- TWA (www.twa.com)
- United (www.ual.com)
- Air Canada (www.aircanada.com)
- British Airways (www.british-airways.com)
- Amtrak (www.amtrak.com)
- European Railroads (www.eurail.com)

To find other airline sites on Yahoo go to: www.yahoo.com/Business_and_Economy/Companies/Travel/Airlines for the search engine's long list of U.S. and overseas airlines, complete with links to individual sites. For airfare bargains, try: www.reservations.com/Farefinder.

A Tiny Selection of Official Tourism Sites

Regions:

- Caribbean (www.caribtourism.com)
- Europe (www.world-tourism.org/europe.htm)

Countries:

- Barbados (http://barbadoes.org/btaoff.html)
- France (http://francetourism.com)
- Thailand (www.tourismthailand.org)
- United Kingdom (www.visitbritain.com)

States:

- Maine (www.visitmaine.com)
- Minnesota (www.exploreminnesota.com)
- Montana (www.travel.state.mt.us)

Cities:

- Charleston (www.charlestoncvb.com)
- New York City (www.nyc.visit.com)
- Santa Fe (www.santafe.org)
- Montreal (www.tourism-montreal.org)

Useful Commercial Travel Sites

- Avis (http://avis.com)
- Hertz (http://hertz.com)
- Sheraton (www.sheraton.com)
- Best Western (www.bestwestern.com)

Guidebook and Travel Magazine Sites

- Lonely Planet (www.lonelyplanet.com/). Site of the budget/off-the-beaten-track Lonely Planet guidebook series. Interactive travel info, good maps.
- Shaw Guides (www.shawguides.com/). Listings of photography workshops and tours are now only available online.
- Condé Nast Traveler (www.epicurious.com/). Site of the upscale magazine.
- National Geographic (www.nationalgeographic.com). This site is for both National Geographic and National Geographic Traveler magazines, and is illustrated.

E-mail

Send and receive electronic mail (e-mail) to/from anywhere in the world at the price of a local phone call. Both sender and recipient must have a computer, modem, and service provider. For those without computers at home, cyber cafes have sprung up in the United States, and all over Europe and South America, and there are increasing numbers in more remote places too. At those cafes, for the price of a cup of coffee plus a few dollars an hour, you can retrieve e-mail or send it, sometimes from highly unlikely places.

Hint: E-mail etiquette requires that you be brief and to the point, especially if asking questions. Personally, I use e-mail as a business tool. Of course I love to hear from friends, but find 95 percent of forwarded jokes boring, and 99 percent of unsolicited mailings an irritating waste of time.

Advantages of E-mail

As an example of how useful and interesting e-mail can be, here is an edited version of a correspondence I had with Craig Robertson, a generous New Zealand photographer. Quite obviously, such help is invaluable even if I didn't research all the sites mentioned.

From: Phanpho@nymailserv.net
To: WellInf@aukweb.nz
Subject: New Zealand Travel

Dear Well-Informed Photographer NZ:

I will be photographing in New Zealand, both North and South Islands, soon. How is May as opposed to August? Those are months when I can go.

I plan to rent a car to hit highlights and whatever else I like in three weeks, perhaps taking a few flights for long hops. Have no sense of what driving is like in your country. Specifically:

How long does it take to drive from Auckland to Wellington non-stop?

Superhighways or winding roads? Plenty of motels en route?

What about weather? Don't mind if its chilly, but don't want lots of rain for obvious reasons.

Thanks much,
Phantastic Fotographer NY
(Phanfo@nymailserv.net)
— END MESSAGE —

- REPLY -

From: WellInf@aukweb.nz

To: Phanpho@nymailserv.net

Reply: Re: New Zealand

Dear Phantastic Fotographer NY:

... Weather. Being a temperate climate it's difficult to give you accurate info for May and August—both are quite changeable. However this can mean fantastic light conditions. May is probably best—but don't hold me to it. . . . Early May you will get nice autumn colors in parts of the country—notably Otago/Queenstown area and maybe some light snow on the mountains. August you will get much more snow on the mountains, probably a little more rain as well but clear winter days are stunning especially on the west coast of the South Island.

. . . The link below is New Zealand's Meteorological Service Web site with key weather events from last year noted—it may be of some use.

www.met.co.nz/home/articles/index.html

... Travel. Roads are certainly not super highways but the main ones are of a high standard. Usually only 2 lanes wide, winding in parts. North Island roads are busier especially around Auckland. (Gridlock on the Auckland motorway between 7.30 A.M.–9.30 A.M. and from 4.30 P.M.–5.30 P.M.—avoid it!)

South Island roads are great, good surface and almost no traffic—not to mention the stunning scenery.

NZ Automobile Association distance calculator. . . .

www.aa.org.nz/map.html

Above site also includes suggested itineraries, booking of rental cars, accommodation and rates. AA offices provide regional travel maps.

To drive from Auckland to Wellington nonstop (and that means no stopping for quick snaps along the way) would take about 8 hours. There's plenty of accommodation around. Motels range from NZ \$70 to \$150 per night and there's an increasing number of bed and breakfast and "farm" stay accommodation around.

All normal rental car firms are here—Avis, Hertz, Budget, etc. as well as dozens of smaller firms often offering cheaper cars.

Current petrol (gasoline) price is NZ\$0.815c-\$0.849c per liter.

Domestic air travel—check out these links:

www.airnz.co.nz/index2.htm

www.ansett.co.nz/home/homefrm.asp

... Great things/lesser known spots to see include-North to South ...

Cape Reinga at sunset

www.newzealandnet.com/fullers/tours1.htm

Bus drive down/up (depends on tide) Ninety Mile beach Auckland boat trips to Rangitoto and Kawau Islands. Good views from new Skytower too.

www.akcity.govt.nz/

Giant kauri trees in Waipoua Forest

www.hmu.auckland.ac.nz:8001/gilchrist/matakohe/

Helicopter flight over Rotorua lakes and inside Mt Tarawera crater—

www.rotorua.co.nz/

Tarawera falls—near Rotorua —large waterfall cascading out of tunnels in a rock wall

White Island—active volcano off Bay of Plenty coast (would be better for thermal stock than Rotorua)—chopper flights and boat trips

www.wave.co.nz/pages/vulcan/wiva.htm

Hydro dams along Waikato river and geothermal power station at Wairaki near Taupo may make interesting stock shots

Hawkes Bay/Napier if you want to taste some great wines and photograph vineyards (would need permission)

Wellington—Cuba Mall for opportunities to photograph people.

Kapiti Island is great for shots of NZ wildlife.

Pupu Springs—near Takaka north of Nelson. Millions of liters per minute of the purest and clearest water flowing from underground.

Whale watching at Kaikoura—north of Christchurch. Go on early morning trip for best light.

www.whalewatch.co.nz/

Christchurch's Port Hills and Akaroa—very nice city too

http://nz.com/SouthIs/Christchurch/index.html

Drive via Arthur's Pass from Christchurch to Westcoast—alpine scenery + keas (sometimes). Good views of the Waimakariri River—a braided river

www.canterburypages.co.nz/explore/arthurspass/index.html

Westcoast of South Island—stop at Okarito Lagoon, 15 minute climb up to trig for view of Mount Cook, Mount Tasman and glaciers at sunset

http://onenz.co.nz/tourism/11/Index.htm

Drive over Crown Range from Wanaka to Queenstown—rough road through old gold country—try the bungy jump if game, jetboating is awesome

http://nz.com/webnz/Queenstown/Queenstown/DocRoss/index.html

Moeraki boulders on coast near Dunedin. Albatross colony on Otago Peninsula. Catlins coast south of Dunedin. Remote area, native forests. Drive from Lake Te Anau to Milford Sound, Fiordland—good walks, stunning scenery; excellent boat trips and light plane flights at Milford

www.nz.com/FiordlandTravel/

If you can get to Stewart Island—wildlife all around you

www.southland.org.nz/html/overview of stewart island.htm

These are off the top of my head and you won't get to all these places in three weeks but all offer good photographic opportunities.

Other NZ Web sites that you may find useful. . . .

www.searchnz.co.nz/ (a good starting point for finding NZ sites)

http://nz.com/infocus/index.html

http://onenz.co.nz/index.html

www.nztb.govt.nz/

http://channels.nz-travel.co.nz/Intro.asp

http://nz.com/webnz/tpac/nz/individual.html

http://photo.net/philq/new-zealand/index.html

www.us.discovernz.co.nz/discovernz/

www.yellowpages.co.nz/index.html—Telecom NZ Yellow Pages

www.doc.govt.nz/—Department of Conservation—responsible for national parks and wildlife

Photography/processing etc:

I highly recommend PCL in Auckland for all your processing. They're used by a vast number of pros in NZ and quality control is superb.

www.pcl.co.nz/

In Wellington I recommend: DAC. Phone: 64-4-385 3156

In Christchurch I recommend: New Zealand Photocorp. Phone: 64-3-379-7217

For NZ film price list:

www.photo.co.nz/photo/newfilm.htm

Photo Equipment

TA Macalister are the NZ Nikon distributors.

Film Facilities, phone 64-9-378-9493 (talk to Bob Pinker) hire Hensel lights and other bits.

CR Kennedy Ltd, ph 64-9-276 3271 hire a limited amount of Hasselblad gear.

Please let me know if you need any other specific info/costs.

Regards,

Well-Informed Photographer, NZ

WellInf@aukweb.nz

- END E-MAIL REPLY -

Displaying Photographs on the Internet/World Wide Web

If you want to display your photographs on the Internet, there are several possible approaches. One of the simplest for amateur photographers is to have Kodak display your work free on their Kodak PhotoNet online service. You can then send it to friends and family via e-mail. Learn more by visiting the Web site at: www.kodak.photonet.com.

Geocities.com offers free personal pages. The offerings are mixed in quality.

On the next level, some Internet service providers permit you to have a personal home page, either included in the cost of your monthly service or available for a small additional fee. These sites generally must not have commercial content or contain high-resolution images. (Ask your Internet service provider for information.)

If you have HTML (hypertext markup language) programming skills, design your own page. If you don't, have someone who does have those skills do this for you, and send the pages up to the Web. (Possibly you could exchange the right to use some of your photographs for Web site design and programming.) Many photographers on all levels of experience now have personal Web pages; some of them are beautiful.

If you are professional and want a commercial site like mine (www. susmccartneyphoto.com), the first step is to choose and register a domain name with InterNIC. If the domain name you want is available you then pay a registration fee to InterNIC and it's yours for two years. After that, you must renew and pay again every year. (Business sites have a ".com" suffix; organizations can have an ".org" suffix; some other sites have a ".net" suffix.) Learn more about the finer points of domain registration by contacting: www.InterNIC.net.

Your Web site must have a host, so you will need to choose a Web host service provider. The host site can be close to home or across the country. The important thing is that it permits fast access to your site, and does not go offline (rendering your site unreachable) frequently. I have been told by Web site developer Andrew Child that finding a good Web host is not always easy. I am pleased with the host he suggested to me, located in Maryland. I find their cheapest basic service adequate. You can contact this company at: http://proWeb site.com.

If you are a computer whiz, you can of course design your own professional Web site. If not a whiz, think of what you want, then have a professional design the site for you. I took this route myself. The designer should also take care of the technicalities of sending the site up to the Web host service you select. Web site designers' fees vary, depending on the complexity of the site, and of course the designer's reputation. Find designers on the Web. I am happy with my own site, its designer's URL is: www.DouglasProductions.com.

Photo Retouching on the Computer

As previously mentioned, I am a confirmed Mac computer user. Mine has 128 megabytes of RAM (random access memory). That much is required for the medium-level work I do with Adobe Photoshop, every photographers' favorite advanced photo manipulation program. High-end photo manipulation needs at least double that amount of RAM. My computer also has additional V-RAM (video-ram) needed for displaying millions of colors on the monitor. Of course I use the Mac versions of all programs.

I do not own a slide scanner. I send the pictures I want scanned, forty at a time, to Kodalux for scanning to CD-ROM disc. I use their basic scan service that is relatively inexpensive—about \$2.50 per image. (Kodalux makes higher resolution professional scans also.) With the basic service each photo is scanned to five different resolutions. The highest 18 megabyte resolution scans have the best definition and are good for turning back to 35mm film; the lowest resolution scans can be used to display pictures on the Internet. Scanning forty pictures per disc means that the disc comes back with thumbnails that fit on a neat 4.75-inch-square photo print. I have had these prints color laser copied to twice the size and used the laser copies as promotion pieces on occasion.

After the photographs have been scanned and transferred to the computer hard disc, simple retouching, like getting rid of dust spots and correcting red-eye, is easy with Photoshop. Read the Photoshop manual to learn how. I retouch the highest resolution scans. Then, I transfer the corrected photos back to disc (I use Iomega Zip discs) and take them to a computer service bureau for turning back to film. Find service bureaus in your area by asking photographers and graphic designers, and through classified telephone directories. The main problem to watch for on files turned back to film is that you often get dust spots on poor-quality slides—this is absolutely not acceptable.

The price of making film slides from computer files varies. Some stock photographers get $4" \times 5"$ enlargements from retouched or manipulated 35mm originals; the price for one slide or enlargement in New York City varies somewhere between \$10 and \$25 per image.

To learn a great deal about advanced image manipulation with Photoshop, read *Digital Wizardry* by Bryan Allen. It's a terrific book. (See bibliography.)

Digital Cameras and Photography

Consumer digital cameras are now quite popular, because of the World Wide Web and low-priced photo printers. Prices have come down and decent amateur digital cameras can now be had in the \$500–\$1,000 range.

For travelers, the main problem at present is storage of digital images. Media cards are expensive and hold only a few dozen to a hundred or so digital images. Of course, if you don't mind also carrying a laptop computer and downloading, that is not a problem. Most

people will want to choose a digital camera that offers reasonably inexpensive removable media storage devices, and carry plenty of them.

The Olympus D-320L has a 35mm equivalent f/2.8 lens, built in TTL flash, and a cord for downloading images to PC and Mac computers or a personal printer or TV set. More exciting, it has an optional floppy disc holder that solves the inexpensive image storage problem for travelers. This currently works with PC computers only, but Olympus tells me it soon will be offered for Macs. When this happens, I plan to get one of those cameras, for fun, and to keep personal and travel memories. I've seen fine snapshot-size enlargements from the camera. List price is \$499.

Epson's least expensive color printer currently costs about \$200; it works well on plain paper; their highly rated photo printer (that I recommend) needs special photo paper for best results, and sells for about \$500. For more, see consumer electronics and computer stores, and photo and digital imaging publications.

Professional Digital Cameras

Professional 35mm SLR digital cameras that are practical for travel remain very expensive to merely expensive. Kodak models that can transmit images over phone lines or modems can cost around \$30,000. Traditional users of such high-end digital cameras are news and sports specialists.

Recently, Web site designers have adopted digital cameras for convenience, and now some public relations, party, and wedding specialists who shoot a lot of film are saying that the initial high cost of a pro digital camera is offset by savings on film and processing, making the cameras economical in the long run.

The Fujix/Nikon SLR digital hybrid based on the F4 camera is well regarded because it accepts many Nikon lenses, accessories like TTL flash, and it gives full coverage with all lenses. The DS 505 feels comfortably familiar in the hand. With two batteries, a charger, and two media storage cards, it presently costs around \$10,000 (this doesn't include lenses and is mid-priced by professional digital camera standards).

To learn more about professional digital cameras in use and to keep up with changes, see *PDN*'s annual Digital Imaging issue, and read *Digital Imaging* magazine. Also consult manufacturers' Web sites, and digital equipment dealers (often professional photo dealers).

An Interview with Andrew Child

I wanted to know more about digital cameras myself, so I asked an expert; Andrew Child is a photographer, computer whiz, and the most digitally literate person I know. I share his answers below.

SM: What exactly do you do, or call yourself?

AC: I think of myself primarily as a photographer who specializes in new media—interactive CD-ROM and Web development. I am also involved to various degrees in the creative, technical, and business process of new media development for my company, G2G Productions.

SM: Do you shoot with both film and digital cameras?

AC: I bought a digital camera a few months ago, and don't ever want to shoot film

again. As of this summer (1998) I am shooting almost exclusively with a digital camera.

SM: Did you get one of those \$28,000 dollar cameras?

AC: No, my partner and I invested in a Fuji DS-505 camera. The body has come down to about \$8,000; that's through a catalog. Then you need optional items like batteries, data cards (media storage cards), lenses. . . . I had the lenses; the other things—two batteries and charger and two data cards—brought the cost to \$10,000.

SM: None of those things are options—but I suppose they are afraid of scaring you off if they tell you the real cost right away . . .

AC: Just like computer makers . . .

SM: Does that camera deliver what you see in the viewfinder, and give full lens coverage?

AC: Yes. I shoot a lot for industry in factories and so on. We got that camera because I wanted full coverage with wide-angle lenses. I get the full 20mm with a 20mm lens.

SM: It works with conventional Nikon lenses?

AC: The camera is basically a modified F4 system. There are some lens limitations related to the camera's internal optics (lenses must be f/2.8 or faster) but it otherwise works with the rest of the Nikon line of speedlights and accessories.

SM: For travel/location photographers, surely the limitation so far is storage of images, especially if you shoot at the highest resolution that the camera can deliver, for maximum quality. On a long trip, if you can't arrange to modem your stuff back home, there is the problem of storing a lot of pictures. . . . The storage problem seems enormous.

AC: It's true that with a professional digital camera, depending on how you've got your files set (or in terms of how much image compression you use) you can get only sixty to one hundred photographs onto one data card. That's only two or three rolls of film per data card, so you need a few cards for extended shoots. But I shoot with a laptop as part of my standard gear. When combined with a Zip or Jaz drive, this provides essentially unlimited storage space. A single Jaz cartridge holds around 1,500 frames (roughly the equivalent of forty rolls of 35mm film) and costs just over \$100. It's a pretty cost-effective solution for the kind of location work I do. If you carry a laptop, you can transfer all your picture files to a laptop at the end of each day or during a break in shooting. . . . That way you can see what you've got . . . you get proofing on site, and can reshoot if necessary. It's actually a terrific benefit; it's like having your film instantly processed, or having a Polaroid camera. . . . The weight of the laptop is offset because you don't need to carry film, or the Polaroid back, or Polaroid film. . . .

SM: They have laptops with a lot of memory now, I know that. About how many pictures at maximum resolution can you store on a 100 megabyte Zip disc? Say you have gone for a five-week shoot to Africa?

AC: About 150 frames with the Nikon/Fujix camera using high-quality compression—note that this is not "lossless" compression but is sufficient for print use. The Kodak cameras vary. But a better solution is to use a Jaz drive, which holds about 1,500 pictures on a 1 gigabyte cartridge. Picture for picture, it's much less expensive than film.

SM: So the storage problem is not as bad as one thinks. What about quality? If you want maximum quality for print, not for the Web or discs?

AC: Coming off the camera I have, with a moderately compressed image, I'd be comfortable going to a quarter of a magazine-size page for print. . . .

A general point I want to make is that digital cameras are not for everyone. Important

questions about cost, the number of pictures a photographer shoots, an individual's technical savvy, the final image size desired should all be answered before moving [totally] from film to digital....

SM: Do you have to worry about airport X-rays with data cards, Jaz and Zip discs, and other image storage media? If so, what precautions must be taken?

AC: To the best of my knowledge, airport X-rays do no damage whatsoever to computer media.

SM: Great! You've given me a lot of new ideas. Thank you so much for your help.

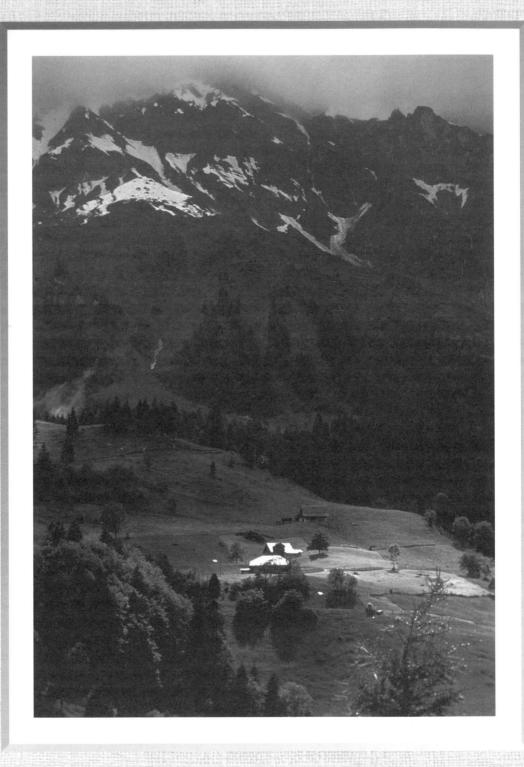

ravel magazine assignments are my favorite things to do. A photographer is normally chosen because the art director or photography editor likes his style and point of view, and while he is given a framework for a job, usually not much is too specific.

With editorial photography for books, assigned photography is fairly rare. Of course, you can shoot for your own book projects too. Photography for tourism is a specialty of mine. It's fun, reasonably well paid, and has taken me all over the world.

Magazine Photography

On most magazine assignments, the photographer must cover the main points of a story, but she is free to wander off and find things on her own. The ideal magazine art director wants photographs that complement, not merely illustrate, a writer's work, and appreciates what the photographer brings to a story. Occasionally, photographers originate travel essays, which are run as picture stories with short text captions. I have done this; it is obviously an ideal situation!

For top magazines, travel photography assignments are quite well-paid. Fees are to some extent negotiable, paid either per day or per page, normally with a minimum guarantee. The average editorial day rate for national magazines is currently about \$350–\$550. Rates depend on circulation and other factors, and well-established photographers may command somewhat more than that. Only a few stars command extremely high fees for magazine work.

Magazine photography is prestigious, as most publications give credit lines on the same page as the work appears, and it is a good way for an up-and-coming photographer to get name recognition, and for an established photographer to keep his name visible. Any nice layout of several pages in a good magazine makes a terrific portfolio piece.

For all the above reasons, magazine photography is not too easy to break into. Almost no magazines today employ staff photographers (except the *National Geographic*), though some have contract photographers, who are guaranteed a certain number of days' work, or published pages, or sum of money for the length of the contract. Freelance photogra-

phers do most magazine assignments. Therefore, good new photographers always have a chance, especially if they have a fresh and personal viewpoint, are pleasant and persistent, and most especially if they have good ideas for features and stories. Avant-garde and small magazines are most likely to take a chance with new talent.

Skills Needed for Magazine Photography

I will go out on a limb here and say that the skills needed for magazine photography are social as well as photographic. Most travel magazine readers are well educated, and quite sophisticated. Magazine editorial staffs reflect this, and want the people they hire on a freelance basis to be presentable, pleasant, and self-sufficient. They aren't there to hold your hand in Timbuktu, and although they will give you all the help possible before the shoot, a lot of the on-the-spot negotiations and persuasions are up to you. This is not the type of work for the inarticulate photographer who is only happy in old jeans. (Jeans are fine on some occasions but on others, more formal dress will help you "fit in" to the scene.)

If you would like to work for national travel magazines, realistically appraise your portfolio and skills. It is a given that a magazine photographer will be excellent technically, have a point of view that fits with that of the publication, and the "something extra" that will bring life to the story, location portrait, or whatever. If you feel that your work meets those standards, the next step is to do some research at a good magazine store or library. Art directors' and photo editors' names are listed on magazine mastheads (opening credits). When you have found a publication you think you will fit, and the picture editor's name, call to find out how to show work. Almost all magazines look at portfolios regularly, but "drop-offs" are the rule for people they don't know. You will get a call back if they are interested.

How to Find Travel Magazine Clients

Browse in a good magazine store. Most magazines today are part of a larger publishing group, for instance: American Express Publishing (*Travel and Leisure, Food and Wine, L.A. Style*) or Condé Nast (*Condé Nast Traveler, Glamour, Mademoiselle,* the *New Yorker, Vanity Fair, Vogue,* etc.). Publishers of both travel magazines and many books are the National Geographic Society (*National Geographic, National Geographic Traveler,* and *World*) and Reader's Digest Publications (*Reader's Digest,* Reader's Digest Books).

New York City and environs are still the nation's publishing capital. You certainly don't have to live here in this age of e-mail, fax, FedEx and UPS, but you will probably have to make periodic visits or get very good at shipping your portfolio of prints or duplicate slides if you want to work for top magazines. Los Angeles and California in general are the second publishing market in the United States (and the "hot" art center in the country), but almost every state has at least a few publishers. The publishing centers in Canada are Toronto and Montreal.

Don't overlook foreign publishers. In Europe, Germany's giant Gruner and Jahr of Hamburg is one of the biggest. They put out *Geo* magazine (in German, French, and Spanish editions) among many other publications. Most of the big European and Japanese magazine publishers pay quite to very well, and many have New York offices or representatives.

Where to Learn More about Magazine Photography

Read and look at plenty of magazines. This might seem elementary, but is often neglected by neophytes!

Attend meetings of chapters of the American Society of Media Photographers (ASMP). Phone (609) 799-8300 or fax (609) 779-2233 for membership information and a list of chapters nationwide. Get a list of their current books and monographs on the photography business via e-mail at *Info@ASMP.org*, or their Web site at: www.asmp.org.

Specialist magazine directories can be found in good public libraries (they are expensive to buy). The Standard Rate and Data Guide series of directories (called the "Redbooks") list all consumer and trade magazines that accept advertising. *Bacon's Publicity Checker* is a similar exhaustive list of publications directed at public relations professionals (Bacon's 1998 directory lists over sixty consumer travel magazines and over twenty major travel-trade magazines). These directories include magazine circulation figures. There are overseas editions too. (See chapter 12 for more details on these directories.)

The Smaller Magazine Market

Travel magazines break down into international, national, regional, city, and local. Specialized travel magazines exist for backpackers or RV owners or doctors, for instance. "Inhouse" magazines are distributed free to airline and cruise passengers, as are hotel/resort publications. Regional magazines serve a city, state, county, or popular tourist area. Local photographers have a good chance of getting published in well-known regional publications like Arizona Highways or Vermont Life. Even better opportunities exist in lesser-known regional publications, such as Down East, the Maine Magazine, or Wonderful West Virginia. (All of these use excellent photography.) There are regional magazines published all over the United States and Canada that are always on the lookout for good new pictures and especially for appropriate feature ideas and stories. Check your own state, province, or area to see what's published. In the region of upstate New York where I have a house, for instance, there are Hudson Valley Magazine, Kaatskill Life, and probably other publications too. Of course regional and local magazines don't pay what the big ones do, but working for them is good experience, gives you tear sheets (printed pages), and can serve as a stepping-stone. If you can write well too, you have an excellent chance for publication in smaller magazines.

Some major manufacturers have a natural interest in travel and publish glossy magazines that use travel features. *Ford Times* and *Amoco World* are two examples. Quite a few magazines of all types have regular travel features, with the picture emphasis towards food, wine, gardens, the outdoors, the mature person, or whatever is the focus of the magazine.

Combining Writing with Travel Photography

If you can write as well as photograph, or photograph as well as write, or can travel with someone as a writer/photographer team, and you are energetic about researching ideas, you have a chance of selling travel features for newspapers and smaller magazines. A friend of mine who is a commercial photographer has had success selling illustrated stories about Alaska and other places she visits on her vacations.

Travel features always accentuate the positive. Top travel magazines almost always use established writers, and mostly send photographers to illustrate stories already developed

SAMPLE LETTER OF QUERY TO A TRAVEL MAGAZINE (Print on photographer's letterhead)

Mr./Mrs./Ms. Trendy Editor High Flying Travel Magazine 200 Prestigious Avenue The Great Apple, NY 100?? [Insert Date]

Dear Ms. or Mr. Trendy:

"Carnival" is celebrated with enthusiasm in India's only predominantly Catholic state, Goa, a former Portuguese colony. It begins this year on (date) with religious parades by its Catholic population in the towns of Margao and Parlim and continues for three festive days. What interests me most is what people wear: elaborate embroidered silk saris and tunics with headdresses. There are statues of saints decorated with flowers, and much pleasant revelry.

I intend to be in India in (month) and will go to Goa to shoot the festivities in Margao, Parlim, and possibly Old Goa as well. I see this as a lively photo essay focusing on the traditions of the Goan people in which Portuguese and Indian traditions make a fascinating blend. Goa is also famous for beautiful unspoiled beaches, and has decent hotels. It is the burial place of St. Frances Xavier, who has an elaborate tomb at the Basilica of the Born Jesus, and there are many other interesting ancient churches, many of which have special feast days. I think the extraordinary customs and costumes and the traditional foods—specially decorated fiery vindaloo curries, cooling vegetable platters, and ornate cakes—would make a vivid picture story for High Flying Travel Magazine.

So that you'll have some idea of my work, I include tear sheets, and you might like to look at my Web site: www.phantasticfoto.com.

OR: I'm enclosing a promo piece that shows some of my more recent work (to editors who know your work).

OR: I enclose a few samples of recent work, and will be glad to bring or drop off a portfolio at your convenience.

I look forward to hearing from you.

Yours sincerely,
Phantastic Fotographer

by the magazine. A Guide to Travel Writing and Photography, by the writer/photographer team of Ann and Carl Purcell, might be a helpful resource for photographers who want to polish their writing skills and learn about finding feature ideas.

If you have worked with a magazine before, or have an unusual idea, or are going to a rarely visited place, you can try to get a photography assignment before you leave. If a magazine likes your idea enough, they may well assign a writer to the story.

Trade Magazines

Trade magazines are targeted at packagers, photographers, planners, plumbers, programmers, and almost any other trade, industry group, craft, organization, or profession you

SAMPLE LETTER OF ASSIGNMENT (Magazine's letterhead)

To: John/Jane Photographer Your address New York City/Suburb, USA [Date]

Dear Mr./Ms. Photographer (or John/Jane):

This letter will confirm *Gotham City Magazine's* assignment for you to photograph the Union Square Greenmarket near East 14th Street in Manhattan. We will guarantee you four pages at our customary rate of \$?.00 per page, plus film, processing, and location expenses for this local assignment.

This popular market has been in operation since 1985. Farmers from upstate New York, New Jersey, Connecticut, and Pennsylvania come in for the Wednesday, Friday, and Saturday market days and sell vegetables, fruit, flowers, and plants. Eggs and chickens, meat and fish are sold on the weekends. New York State gives a dispensation to its vintners, so upstate winemakers sell their wares also. As we have not scheduled when the feature will run, we would prefer that you avoid any highly seasonal pictures. (OR: this is for a fall issue, show pumpkins; Christmas issue, show trees and holly, etc.)

You will need to try for a colorful cover (vertical). Most of our covers are of people who are likely to appeal to our (upper-middle income) readers. An attractive young woman with a basket of goodies in front of a vendor in overalls selling appetizing produce, and with eye contact with the viewer, would be a good bet. Allow light or dark space on top for our logo.

We will also need a strong horizontal picture for the opening spread. It should say "farmers' market and Manhattan" at one glance. Allow for type on the top left quarter of the picture. We definitely don't want to see anything dirty or ugly. Make a few overall shots from a height or distance showing the whole market in its urban setting. This is the only place where it's okay to show cars, traffic, etc. Minimize these in all other shots. We want a "country" feel as much as possible. Show abundance and beauty. There will probably be families buying, sampling, and checking produce, the more attractive and sophisticated looking the better. If you set anything up, it should look candid and unposed. Not more than a couple of elegant close-ups of massed vegetables/fruit etc. Our writer likes cheese—he recommends Charley Cheesemaker in the piece—so try and get some good shots of him and his wares. If you find a subject that you think would make a great cover, shoot plenty of film on him or her, and try to get a model release. At least get the name, address, and phone number, so we can get a release later.

We don't like to crop pictures, except very slightly at the edges to make the shots fit the magazine's format. Needless to say, pictures with highly contrasty light, heavy shadows on faces, etc., are not acceptable. We prefer you to use (Kodachrome or Fujichrome Velvia) film where possible.

Keep notes for captions, especially note names. Keep all receipts for local expenses, film, and processing. We cannot reimburse expenses without receipts.

Enclosed is our letter of introduction. The market manager is Harry Smith, phone (718) 449-2122, evenings. You might want to call him in advance.

I very much look forward to seeing your take.

With kindest regards,
Jerry/Mary Picture Editor (or Art Director, Photography Director, etc.)

SAMPLE LETTER OF INTRODUCTION (Magazine's letterhead)

[Date]

To Whom It May Concern:

This letter will introduce Mr. John/Ms. Jane Photographer, who is on assignment for *Gotham City Magazine* to produce a photo feature on the Union Square Greenmarket.

This feature, which is planned for publication this fall, will be part of a special issue on the best places for families to enjoy Manhattan, and we think will appeal strongly to our readership of 1.2 million above average income New Yorkers, and another 300,000 New York lovers around the country and the world.

We would appreciate your giving Mr./Ms. Photographer any and all assistance that you can, so that he/she can show this delightful part of the city in the best possible light. If you have any questions about Mr./Ms. Photographer's assignment, please feel free to contact me at any time.

With thanks in advance for your help.

Yours sincerely, Jerry Picture Editor (or Mary Art Director, etc.)

can think of. They usually have smaller circulations and are lower paying than national magazines, but the biggest of them pay more than local or regional travel magazines.

Some trade magazines use travel features (especially those directed to affluent professionals); the travel story must always have a slant toward the magazine's audience. All trade publications need photographers with the skills of a good travel/location photographer from time to time. Don't overlook even small trade magazines. Working for them is a good way to gain experience and help you eventually make it to national magazines.

To find trade magazines, see the directories mentioned earlier in the chapter. Ask business and professional people you know what specialized magazines they read. Consider concentrating on one trade area that interests you: hospitality, transportation, or foodservice oriented publications, for instance, or some major industry you know something about. Some trade/company publications are: *Aviation Week, Ford Times, Food Technology, Travel Weekly.* You get the idea. They are all included in the directories.

Books

Book publishers use a lot of photographs. The biggest and best paying market is high school textbooks, because textbook print runs may be very large. Many of these picture needs are filled by stock and most are not particularly travel related except for social studies and language texts. The usual need is for shots of families, teenagers, workers, and professionals of all nationalities, ages, races and religions. Some assignments are available, and a good way to meet picture editors is to send in a stock picture list. Encyclopedias, guidebooks, and trade (general) books all use travel pictures from time to time.

Getting a photo essay or travel picture book published is not easy, especially if it's in color, as color photographs are very expensive to reproduce. The photographers that

succeed do careful research into the marketplace, and make and present well thought out "dummies" (physical mock-ups of the book). This is relatively easy to do today with Kodak and Canon color copiers. You might be able to improve your chances by working with a graphic designer. Possibly you can trade photography for design services. Even a student graphic designer today almost certainly has access to a computer, can set type, and can help you with your portfolio in general. And designers you meet that way are always potential clients. People like to work with those they know.

A few photographers publish their own books, which obviously is wonderful from the point of view of doing what one loves best. Equally obviously, this involves big risks and expense. Sherman Hines, perhaps the top Canadian travel photographer, is one person I have met who is very successful indeed at this.

"How to Self Publish" seminars are given by individual photographers and ASMP chapters from time to time. Check the photo trade papers and photo-school announcements. If you have a unique, terrific idea or access, or an in-depth marvelous collection of pictures for a specific travel picture book, and if there is nothing like it around, you should try and find a publisher. Search in libraries and good bookstores, and if you see something in the same general area as what you want to do, trying that publisher is a good bet. Publishers very rarely take books that come in unrecommended.

Try and find a picture-book agent or consultant (they advertise in the *Photo District News*), make some prints or even "dummy" (mock up) a section or chapter of the book, and start showing the dummy around. You may be able to find a sponsor. Kodak's Professional Photography Division now sponsors quite a few books it feels are important, as to a much lesser extent do other photographic manufacturers, as well as printers, paper companies, and major corporations. Books that involve art and culture, the environment and social issues, and that reflect positively on a business or geographic area, are more likely to be sponsored than others.

Newspapers and Travel Photographs

Newspapers of all sizes use local travel features and pictures illustrating places, events, and attractions within easy range of their readers. You might start by doing a picture story on a tourist attraction close to home. (See chapter 9.) A golf resort, a ski area, or an amusement park are good bets, or you might prefer a quiet scenic area, state park, or historic village or town. If you can produce a feature of about six to ten good photographs illustrating different aspects of the place, you have a good chance of selling it because the resort, attraction, or theme park is an advertisers in local publications. Most newspapers publish foreign travel pictures periodically; some have regular travel supplements. The biggest papers often use travel pictures and stories, though some may be supplied as a feature from a public relations firm or national tourist organization. Some major papers have regular travel supplements. The *New York Times*, to give just one example, uses black-and-white and color pictures every week to illustrate stories from around America and the world in its Sunday travel section, and has a biannual *Sophisticated Traveler* magazine.

Newspapers normally employ staff photographers, but use "stringers" (regular contributors on call) and freelancers as well. General newspaper work gives editorial photographers a tremendous variety of experience; many world-class photojournalists started that way, before going on to freelance magazine and other types of photography. Several young photographers I know started by shooting sport or "paparazzi" pictures on a part-time ba-

ADVICE ON SPORTS PHOTOGRAPHY FROM A NONEXPERT

I often have to photograph sports as part of travel/tourism coverage. I use my usual range of lenses (see chapter 3) but after taking overall shots, I rely mostly on telephoto zooms. I always use the widest apertures and fastest shutter speeds. (Specialists use superfast lenses in the 300–600mm range.) The aim as a rule is to bring your subjects close, separate them from the background, catch peak action, and, usually, stop motion. (You can also use slow shutter speeds—try 1/8 and 1/15 and "pan"—move with the action to show motion.)

You don't need to be able to ski to do good ski pictures (take cable cars and ski lifts and walk around to find good vantage points); but to do great ski pictures almost certainly requires at least good skiing skills. In fact, the more you know about any sport the better, because then you can anticipate action. Prefocus on places where you think you will get good shots. Autofocus lenses help sometimes, but not always. Motor-drives help a lot. Shoot a fraction before any peak moment to capture it on film.

Many sports events start in hard noon light, but continue for quite some time, so save film for later in the day when light is more interesting. Shoot high-speed film for all night games. To light sports events is for specialists, getting the lights up high enough is just the beginning. See Jon Falk's Adventures in Location Lighting for specifics.

I do not know of any major book on sports photography, but Kodak's *Pocket Guide to Sports Photography* contains many useful hints. Study *Sports Illustrated* magazine or specialist magazines about skiing, yachting, track, horse racing, etc., for a look at what top specialists do.

sis. Local papers need lots of local sports pictures, even including coverage of high school games. Newspapers are always interested in "picture feature stories" about their area. Call and arrange to show your portfolio to the photo editor. If you can come up with a few picture story ideas, you will probably get some work. Some newspapers offer photography internships to young photographers. Inquire if interested. You could also contact the National Press Photographers Association (NPPA) to see if they have any leads.

To learn more about magazine photography, rates, contracts, etc., read: ASMP's *Professional Business Practices in Photography*, 5th Edition, and the *Legal Guide for the Visual Artist*, 3rd Edition, by Tad Crawford. Both are indispensable. (See bibliography.)

Tourism Photography

I am a specialist in tourism photography. For twenty years I traveled around the world as the official photographer for a major tour operator, a contact originally made through my British connections. I have also worked for a big student tour company, and photographed cruises in the Caribbean, Aegean, and the Orient, and canal-barge cruises in Europe. I've shot national advertising campaigns for airlines, and promotions for national tourist offices.

Tourism clients often require specific pictures not available as stock. The best need very beautiful pictures to enhance their quality image, so there is nothing compromising about working for tourism. Tourism photography, however, is always commercial and not personal photography. This should not (ever) mean bad or hackneyed photography. What it does mean is that you will usually be working to specific guidelines, even to detailed "layouts" (art directors' sketches of what something should look like). You may have to show

technicalities, such as hotel rooms or golf course layouts, and must learn how to direct both professional and amateur models.

Requirements for Tourism Photography

The most important single skill for photographing for tourism is to be able to work well with all different kinds of people. It is possible to be a fairly reclusive travel photographer and make a living (you would have to shoot and sell a lot of travel stock landscapes). It is not possible to be a solitary photographer of tourism. You must not only be able to photograph people well, you must never forget that you are very often photographing your client's clients, and never get in the way of their enjoyment. I'm proud of the fact that none of my clients' clients ever complained about me. I have often asked tourists to pose, occasionally usurping a free day by asking them to return to a locale in better light, and had clients "model" in setup scenes. All this without payment, except for the odd drink or meal, and they signed model releases (usually limited to the tour company's use).

The secret is appearing relaxed, competent, well organized, and totally in control while having good rapport with the person running the program, and being pleasant, flexible, polite, up-front, quick, and patient with the clients on tour, all while bearing in mind the often tight schedules of organized groups. John Lewis Stage, a great people photographer, who shoots the rich and famous and powerful, once told me his magic formula for getting the poses he wants from important people: He always asks the aide, publicist, or assistant, etc., "Is it possible . . . for so-and-so to do so-and-so?" I've used the phrase ever since; it works with ordinary subjects too! And my English upbringing taught me to always say "please" and "thank you" and to "sir" and "madam" people at frequent intervals.

How Tours and Cruises Operate

If you have never taken a tour you might like to know how they work. On arrival, clients rest, and then on the first evening there is an introductory cocktail party (or Captain's cocktail party on ships) where clients dress quite formally. Events proper usually start (early) the next morning.

On cruises, days at sea usually alternate with days in port. On bus tours, there is a lot of riding around in a bus, with short breaks for meals and sightseeing en route, and about every third day, a full day or two in one important spot.

To do a really good job as a photographer, it is imperative to have your own car, or local transport, because what you need and the group needs are not exactly the same. The tour or cruise always ends with a gala farewell dinner where everybody gets dressed up. (To photograph this well, be there the day before to get acquainted if possible.)

I have found that three days is the perfect amount of time to be with a particular group—one to get to know people, two days to photograph them. I then leave to avoid "upstaging" or taking the limelight away from the tour director. The tour director or cruise host or hostess is your most important ally in this work—be nice to them always!

Working with Tourist Clients

I always ask the tour director/cruise host to introduce me to the clients as the "official photographer" (or photographer on assignment). I always say I'm photographing for the

client (or brochure or magazine), and that I will not take anyone's picture without asking them first.

I never, ever take "group shots" to sell on the spot. (There are photographers on ships who do this. Remember "Ace" on the *Love Boat* TV series?) There are also plenty of group photo specialists at major monuments around the world who bring back prints in an hour. I never promise to send tourism subjects pictures I have taken, but ask them to contact the client's head office for "outtakes" if they are available. I will give away the odd Polaroid print, or take people's picture on their own cameras if requested to do so.

Working with Tourist Staff

It is very important on any tourism assignment to remember, and be considerate of, the hardworking and not-very-well-paid people who work in the industry. Many depend on tips for a large part of their income. While tour managers are well-paid professionals and colleagues, if you are photographing groups, waiters, stewards, drivers, local tour guides, and many more should be well tipped. They are your allies and enjoy the fun and recognition of being photographed. You should explain clearly what you need in advance, respect their need for keeping schedules, and be aware of their problems. Be as courteous to them as you are to the clients and of course reward them at the end for their assistance. The amount to tip will vary according to the help they have given; if in doubt, be generous, you may need their help again!

I have learned a lot from professional tour managers in particular. Some of them have become good friends. The thing they are always concerned about is the dynamics and wellbeing of the group as a whole. Good tour managers do not show the overt favoritism they may feel, especially to clients who are more physically appealing than others. Therefore, when working with a group of tourists for a day or several days, it is important for the photographer not to cause jealousy within the group, and to pay attention to (and even make a point of photographing) the less attractive members of a group, even though you are fairly sure the pictures will not be selected. If a tour leader or manager asks you privately to single out a particular person, couple, or group-within-the-group, it is almost always for good reason, and you should do it.

The client too is always aware of the market base, and if they do good business with, for instance, older women (or older men) traveling alone, you must make a point of photographing such clients in pleasant situations, and with the tour director. Show friendly people of both sexes, and, where possible, show some younger people having a good time too.

Working with Professional Models

Find professional models through agencies (see the classified phone books again) and through actors' agents, modeling schools, etc. If you book through a big model agency, be sure that you (and the client) fully understand the financial terms. Top models are usually booked on a "weather permit" basis, which means some part of their fee is payable even if a shoot is canceled for poor weather. Travel time, makeup time, and more may also be charged for.

I often use actors as models. They are usually nice looking, or interesting, know how to move, act and react, and will work for quite reasonable fees. (You can sometimes find

aspiring actors who are willing to model in exchange for pictures. Theater groups are a good place to find them.) Before you start shooting, always get model releases signed by all paid (and unpaid) models if you have any intention of marketing the shots.

If you get to the very top of the still photographic tree, and shoot major advertising assignments, or produce stock designed for travel/tourism advertising, you will probably be working with top models, and will probably employ stylists to worry about the "look" of clothing, food, the room, or other setting. You may even employ hairdressers and makeup artists. (These specialists run ads in professional photography publications.) You won't have many problems to deal with. Experienced models know how to move and act, and can work quite well even with inexperienced photographers. Stylists will take care of the "look" of everything.

Working with Nonprofessional Models

Most travel photographers, at first anyway, use attractive people who are not professional models, and use a client's clients as models on occasion. They have to learn to do their own styling. Here are a few suggestions:

- Make sure that women don't wear too much makeup. If in doubt, less is better. Hairstyles are almost always best simple and natural.
- Men should shave before a shoot, unless a very casual laid-back look is what you and/or the client want.
- You may have to help models to choose clothes, which should be casual to dressy as appropriate, but unfussy. Sportswear, bathing suits, and nice dress clothes may all be useful on the same shoot.
- Clothing colors should usually be rather muted in my opinion—but some other travel photographers disagree with this! Avoid all visible brand names on clothes or shoes.
- Avoid photographing anyone whose body is not superb in shorts or miniskirts, tank tops, or bathing suits.
- Have models actually doing something, not just pretending to do it.
- If the subject is a sport, it is essential that the models be at least reasonably proficient at the sport. On a golf course, they must know how to hold the clubs correctly, and how to make real shots. (You can have them do the shots over and over in a certain place if needed.)
- If the models are supposed to be eating, drinking a toast, or jogging, have them really do so (but a bit slower than usual). Shoot a scene over and over again, if necessary, to be sure you have what you want. (I try to make the clients laugh about all this.) Many otherwise good commercial or stock travel/tourism photographs fail because the models are not quite believable. (Partly of course, all of this falls into the area of personal taste.)
- When you include people in pictures of rooms, or at poolside etc. be sure they are not just standing around, or sitting stiffly, pointing, or otherwise looking awkward.
- The best way to get people to relax is to talk to them the whole time you are shooting. I do this with the camera to my eye, but other people work with the camera on a tripod. I never take my eye from the viewfinder, because fleeting gestures can make all the difference to "people" pictures.
- Photograph rooms both with and without people, and have models look towards the camera, or ignore it, as appropriate or as called for in the layout. There are no

rules about this. I usually like eye contact but cover myself by shooting people looking away from the camera also.

Working with Professional Assistants

Professional freelance assistants, almost always to be found in the biggest cities through photographers' associations, ads in the *Photo District News*, photo schools, etc., in the United States and Canada and overseas, can be a big help. I usually hire assistants who have their own car or van, who are well dressed, polite, and intelligent. Assistants are human beings; treat them as such! If an assistant does foul up on a job, or you get very tense (which can happen) and you yell at him, apologize afterwards if humanly possible!

Assistants are paid by the day, and cost more if they are specialists in, say, lighting. (A few lighting assistants know more than some photographers who hire them!) Assistants get overtime after eight hours, extra pay for weekend work, and of course if you use their vehicle, that costs extra too. You must have Workmen's Compensation Insurance if you use models and assistants. (See also chapter 15.)

What the Client Wants in Tourism Photographs

There are a few points to keep in mind at all times when you are photographing people for tourism. One is that if they are guests who have paid for the vacation (on a tour, in a hotel, or on a cruise), then in those tourists' minds you represent the facility's head office. You must never interfere with their enjoyment. If you do, the client will certainly hear of it.

When you are photographing a tour group, you will probably be told about any large or small difficulties with the tour, hotel, ship, restaurant, or whatever. My way of dealing with that is to say to the guest, very politely, "I'm so sorry to hear about your problem, but I'm only a freelance photographer here and have no influence. Why don't you take it up with the head office?"

An extremely important thing to remember at all times is that no tourism client wants you to show that the client is a part of a herd or crowd. Your photographs should reflect this. People in pairs or congenial small groups is the effect you want to achieve. In the case of an extremely popular tourist site for instance, which can be packed with people during the high season, the best solution is to arrive as soon as it opens, when you usually have a half hour to shoot a few people enjoying the place before the big crowds arrive. This rule applies to beaches, pools, museums, etc., as well as monuments. Failing that, lunchtime or just before closing time are possibilities, though later in the day the site is usually not so neat or clean. In restaurants, clubs, etc. and at festivals, of course, you want a good crowd.

Another rule is that some people who are very willing to have their picture appear in a tour brochure are not willing to sign a model release authorizing unlimited use of their likeness. A release is necessary, or you can't use the image, so a simple limited release is needed. It can even be handwritten by the client if he or she prefers. (See also chapter 13 and the sample limited model release form in chapter 20.)

The last commandment for tourism photography of places—both landscapes and city scenes—is to remember that it never, ever rains in a tourism brochure. Probably not even in the rain forest! The late Barry Hicks, chief photographer for the British Tourist Authority (a government body), was for many years a generous mentor of mine. The first thing

he taught me was the importance of always waiting for the sun. As there are always plenty of interiors to shoot for tourism, you can do those in poor weather; or you can use the time to scout locations and note the exact spots and angles you want when the weather improves. The sun always comes out eventually, even in England.

Although this is not a commandment, the good photographer of tourism (and of travel in general) always remembers that travel is to some extent the realization of a dream or fantasy for everyone. It is an escape from the responsibilities, pressures, and realities of everyday life; it is romantic in both the literal and metaphorical senses of the word. To show ugliness, which exists alongside beauty almost everywhere, is to destroy the dream. One does not have to lie in travel/tourism photography, but merely to omit sometimes. Pollution and poverty exist almost everywhere and there are overcrowded spots in many countries. These are not what professional travel photography (as opposed to photojournalism) is about, and there is no point in including them in your views.

Capturing the "Dream" on Film

Tourism photography may be for international, national, regional, or local advertising or promotion. Tourism assignments are usually shot in color, but may occasionally be shot in black-and-white for newspaper use.

Major tourism brochures often use very high quality photography, but the style is not so important as showing lovely places, attractive people, friendly staff and locals, and good weather. Conferences, meetings, and parties are usually held in resorts and big hotels, and the organizers usually need good, sharp, clear photographs. Cruise and tour operators, airlines, car rental companies, large and small hotels, motels and resorts, and even the people who design, construct, and furnish new tourism facilities are among possible tourism-related clients who need good photography.

As to expressing mood in your travel photographs, that comes with a great deal of practice, with awareness of light and composition, and with your own sensitivity to your surroundings. Heavy usage of soft filters or other tricks to show romance are clichés and should be avoided. If you feel that a place is romantic and beautiful, it probably is, and if you trust your own instincts you will be able to convey that feeling of beauty and romance in your photographs.

Model Releases and Tourist Clients

Tourist clients who have paid a lot of money for a trip, or cruise may not be willing to sign a standard model release, but you must legally have a release to include any pictures of people in a tourism brochure, which is a form of advertising or promotion. A limited release, usable only by the particular travel company, is the answer for this one. Ask the travel companies' legal department to draft one. (A sample, limited "group tour" release is included in chapter 20.)

A Useful Directory

To pinpoint tourism companies, a good sourcebook is *The Travel Industry Personnel Directory*. It lists national, state, and regional tourist offices, air and cruise lines, hotel chains, wholesale tour operators, and more. I also use it to help plan trips. (See chapter 10.)

SAMPLE MAGAZINE ASSIGNMENT CONTRACT FOR PHOTOGRAPHERS

PHOTOGRAPHY CONTRACT

This agreement is between	(the Photographer)
and Super Terrific Publications, Inc. (the PUBLISHER),	for the acquisition of rights to photographs
to be used in Super Terrific Travel (the MAGAZINE).	
1. ASSIGNMENT. PHOTOGRAPHER agrees to photog	graph the subject
	for publication in MAGAZINE.
The due date for this assignment is	

- 2. RIGHTS. All photographs taken/created under this agreement will be considered as specially commissioned for use by MAGAZINE, subject to the following provisions:
 - (a) PHOTOGRAPHER grants PUBLISHER exclusive first worldwide periodical rights to the photographs, beginning with date of your signature and continuing until ninety (90) days after their first publication in MAGAZINE.
 - (b) Any photographs not selected for publication will be returned to PHOTOGRAPHER along with all rights to these photographs except that none may be made available to anyone for publication until 90 days after the MAGAZINE has first published its selections. PHO-TOGRAPHER will not authorize the use of any such photographs in any publication that could be deemed competitive without first notifying MAGAZINE in writing.
 - (c) In the event that any of the photographs are used on the cover of the MAGAZINE, the PHOTOGRAPHER agrees not to authorize such photos to be used on the cover of any other publication without prior approval of the PUBLISHER.
 - (d) PHOTOGRAPHER grants PUBLISHER the right to use PHOTOGRAPHER's photographs, name, pseudonyms, biography, and likeness in publicizing, advertising, and promoting the article containing PHOTOGRAPHER's work. There will be no reuse fee when photographs are used in the context in which they originally appeared.
 - (e) PHOTOGRAPHER grants PUBLISHER the right to use any of the published photographs for the advertising and promotion of the MAGAZINE, it being understood that such use shall be subject to a reuse fee.
 - (f) PHOTOGRAPHER grants PUBLISHER the right to select material from the assignment and use/reuse it in any of its other MAGAZINES, domestic or foreign, or anthologies or collections of magazine material for the full NINETY (90) DAYS of the agreement, subject to a reuse fee. (*Note:* Some publications may now require electronic rights. These too should command an additional or reuse fee, in my opinion.)
 - (g) PUBLISHER agrees to print PHOTOGRAPHER's credit line in the following manner:
 - (i) If PHOTOGRAPHER is author of all the pictures in the article, credit line shall appear on the first page of the article in a type size no smaller than writer's credit line. (Sometimes you may wish to defer to a famous writer and say 75 percent of writer's credit line. This is a negotiable item—you may wish your credit to be larger than writer's credit if this is a major essay originated by you.)
 - (ii) If the work of other photographers also appear in the article, PHOTOGRAPHER's credit line shall appear adjacent to each of his/her pictures, in type size of no less than 7 points.

 PAYMENT. In considerations of the rights granted by the PHOTOGRAPHER the sum of \$ upon a is an advance against the PUBLISHER's standard space can edition of the MAGAZINE. The balance of such republication of the photographs upon receipt of your until photographs with clear, accurate caption inform EXPENSES. PUBLISHER will reimburse PHOTOGRAPH travel, film and processing, lodging, meals, and misce 	cceptance of the photographs. This fee ce rates applicable to the North Ameri- ates, if any, shall be paid at the time of invoice. Payment will not be processed nation have been submitted. IER for reasonable expenses (including
as submitted in an estimate by PHOTOGRAPHER. (See	
If actual expenses exceed the estimate, only those ex	penses approved in advance will be re-
imbursed. All expenses must be itemized and substar	ntiated by receipts.
5. ADVANCE ON EXPENSES. PUBLISHER agrees to advance	ce \$ against expenses
(and/or day rate or space guarantee), provided PHO amount of the advance.	TOGRAPHER signs a receipt for the full
6. WARRANTY. By delivery of photographs to MAGAZIN	E; PHOTOGRAPHER warrants:
(a) that they are original;	
(b) that PHOTOGRAPHER owns all rights to them free	e of any prior assignment;
(c) that they have not previously been published in a	
(d) that they will not be published prior to the on-sale they are published; and	
 (e) that the publication or other use of your photograedge and belief, infringe upon or interfere with an right of any kind. 	
7. LOST/DAMAGED PHOTOGRAPHS. PUBLISHER agrees	to take every care of PHOTOGRAPHER's
work, and to use insured/bonded carriers to transpo	
able to loss or damage to photographs at any time th	
mediate possession or control. In the event the photog	
MAGAZINE's possession or control, the amount to be	
negotiation, but PUBLISHER's liability shall not exceed	
regulation, seek oblightens habitely shall not exceed	in the aggregate.
This agreement sets forth the entire understanding between	the parties. Please confirm by signing
and returning copies to:	(title), by:(date).
and retaining copies to.	(title), by (dute).
Signed for SUPER TERRIFIC PUBLICATIONS (Name and Title)	Date
Signature of PHOTOGRAPHER	Date
PHOTOGRAPHER'S SOCIAL SECURITY NUMBER	

SAMPLE EXPENSE ACCOUNT POLICY STATEMENT

Information for Super Terrific Travel Magazine Photographers (Note: Similar policies may be used by other clients.)

- 1. When you return the signed Photographer's Agreement to Super Terrific Travel Magazine, please send an invoice for an advance against the assignment guarantee as stated in the Agreement.
- 2. Expenses should be kept to a minimum. They should be reasonable and should be directly related to the story assignment.
- 3. Super Terrific Travel Magazine will pay for economy airfare directly related to the assignment. Upon accepting the assignment, contact the Super Terrific Travel Magazine photo department, and they may be able to make the travel arrangements for you. If not, you will make them and be reimbursed by submitting a photocopy of the original airline ticket.
- 4. Super Terrific Travel Magazine will pay for a single or double room, as appropriate. Lodging will be reimbursed by submitting the hotel invoice(s) for the days covered.
- 5. If a personal car is used the allowance is (.00¢) per mile, which includes gasoline costs. (This at time of writing is 27.5¢ per mile; consult your accountant for current standard IRS mileage deduction.)
- 6. Please submit all expenses promptly and include an itemized report for the dates involved. All receipts must be taped to sheets of $8\frac{1}{2}$ " \times 11" paper, and must be submitted with the expense report.
 - Note: The Accounting Department carefully scrutinizes all expenses and will not process those that are not properly completed or substantiated.
- 7. If the assignment requires more than _____ (often 10) rolls of film per day, approval must be obtained from _____ (name or title).
 (This restriction, which I do not like, has been added because some photographers shoot stock at a magazine's expense. When a magazine trusts you, they will relax this inhibiting stricture.)
- 8. Super Terrific Travel Magazine will pay (no more than) \$7.00 (currently around \$16.00-\$17.50) per roll for film and processing. Rush processing fees must be approved in advance. It is possible to make arrangements to purchase film through the Super Terrific Travel Magazine (or other client) photo department and have it processed at the lab they use.
- 9. You must submit complete written identification of the assignment photographs, sufficient to enable Publisher to write accurate captions and agree to verify all facts as stated in the written identification material. Additional space rate will not be paid until this information is supplied.
 - Note: Some publishers (and all commercial travel clients) may include a paragraph like this: "Photographer will secure model releases from subjects wherever possible on Publisher's or photographer's standard model release forms. He/she will in all cases obtain name, address, and phone number of people featured in photographs, in the event that Publisher later determines that a release is necessary before publication of subject's picture(s)."
- 10. Publisher may request photographer to bring back current material that will help their factcheckers, including menus, event lists, programs listing names of performers, ferry schedules, etc.

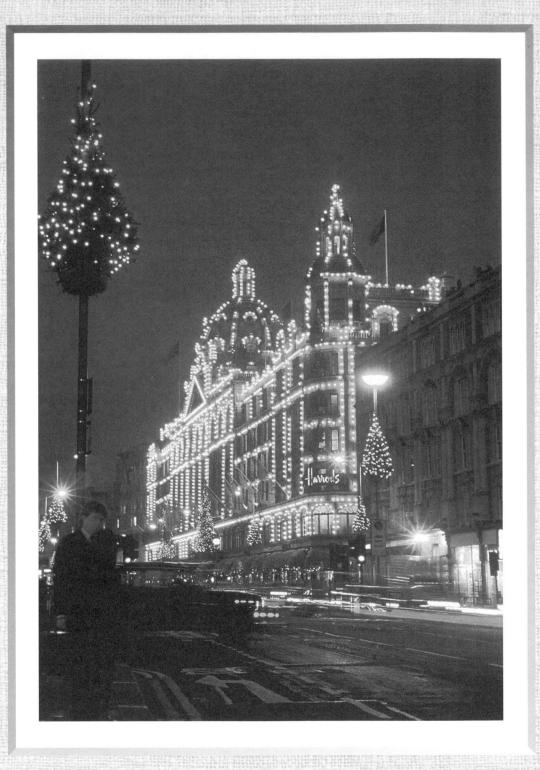

ot too many years ago, most of the photo magazines ran stories about the serious money that top stock specialists were making, and many photographers were inspired to start shooting stock.

Today the pendulum seems to have swung, with some professional photographers and magazines even bemoaning the end of stock. This is because of the advent of inexpensive, so-called "clip art," royalty-free photo discs.

Stock Trends Today

Stock experts I spoke to feel that low-end stock sales are being affected by royalty-free discs, but that those who shoot pictures in a fresh style on a regular basis will still make money. Some feel there will not be as much money made from stock as there was in the 1970s when the business first exploded and there was less competition than exists today.

I feel that any professional photographer hoping to make money from travel stock today should budget carefully, and if possible find assignment clients. Take almost any job that will get you to a location, no matter what type of photographs are needed. Once there, of course shoot the job you were sent for as well as possible. Then, on your own time and dollar, apply yourself to shooting the stock that you know or strongly believe is needed. Some good stock photographers have started successful careers by traveling for a business unrelated to photography; I know a couple who began their travels as airline flight attendants.

If you can travel and shoot on a regular basis—preferably with advice from a good stock agency—you should slowly build up a marketable file. Stock is emphatically not a get rich quick business, and it is no good burning up film shooting everything that appeals on your travels. (Make personal pictures for memories, fun, and art when you travel of course. I do this, and have used some of these picture for my books, Web site, and more. I've even sold a few as stock.)

You should be aware that the way stock photographs are marketed has changed in the last few years. Most picture agencies are no longer "mom-and-pop" companies—many are

large with international affiliations; a few are huge subsidiaries of global conglomerates.

Ten or so years ago, most stock photography was sold from slides stored in agency files. These files were kept current by submissions from assignment "outtakes" from travel photographers and photojournalists who were routinely sent overseas on assignment. Such shots formed the basis of most stock travel collections.

Today trained photographers live in most countries of the world, and magazine and advertising budgets are tight. Many stock sales (including travel stock pictures) are of pictures taken especially for stock, and most stock images are sold through catalogs. Many photographers now invest their own money shooting travel stock. To make a profit, they must be extremely careful. Most stock specialists today work closely with a good stock agency. Successful stock photographers and agents spend a lot of time researching future trends to stay ahead of the competition.

In the next five to ten years, it seems safe to say that more and more travel (and all) stock images will be marketed over the Internet, where buyers will find them on big sites using key words. These pictures may be shot on film as currently, or on digital media when quality and storage improves. (See chapter 14 for more.) But, not everything will be in a catalog or available on a Web site. Traditional agency files will still be used, especially for less generic images. (Remember that the advent of television did not kill either radio or the movies.)

I personally think that at some point photography will split into two camps, with the majority of photographers working digitally and manipulating images, and the minority choosing the traditional approach. There will be room for both kinds of photography in the marketplace, just as there is room for both fast food and fancy restaurants.

One thing is sure: No matter how shot or how sold, the basic need for excellent pictures made by excellent photographers with a tresh point of view will always remain. No matter how conceived, manipulated, marketed, stored, and distributed, photographs are almost all based on the creativity of one individual.

Also on the positive side, in this visual age the use of pictures is increasing. Talented, motivated, hardworking photographers who follow guidelines as to what sells can make big money, or respectable amounts of money, by shooting stock either full-time, or as part of their overall photo business.

If you are thinking of investing serious money in shooting travel stock, don't just rush in. First compare your work with that currently being published. If many of your travel and other pictures honestly look to be as good as shots you see in travel magazines, books, catalogs, and advertising, and if you have a fair number of such good pictures (say one hundred to five hundred to start), take my advice and try to affiliate with a good stock agency. It will save you a lot of detail work and free you for photography. Contact PACA (the Picture Agency Council of America) for their membership list for ways to locate an agency or agencies whose interests mesh with yours. (See resources in chapter 20.) Then contact a few agencies that interest you, explain what you have and what your ambitions are, and ask for an evaluation. If interested in your work and ideas, the agency will let you know how to proceed further.

How I Approach Stock

I have large stock files resulting from past assignments, some of which are still current, and others that are now classic. My present approach to travel stock is to go where I want

to go, and to shoot stock when and where it seems appropriate. I market almost all of my stock through a good picture agency. Mostly through them, I have netted about a quarter of a million dollars from stock in about twenty-five years. That's obviously not getting rich quick, but it's a decent sum nonetheless. I also shoot personal projects at home and overseas because I enjoy doing that; some of these pictures sell as stock also. My photographic style is more realistic and journalistic than that shown in many stock catalogs. I make most stock sales to the book market.

That's how the business works for me. Below I have summarized how the overall stock business mostly works now, and at the end of the chapter I've included interviews and current advice from stock experts. You will find that they are not at all gloomy about the industry, but that each has a somewhat different point of view, reflecting their interests.

You will have to choose an approach to stock (if any) that suits you.

What Exactly Is a Stock Travel Picture?

Theoretically, any travel picture that has already been taken is stock. In practice, for regular sales, stock pictures must be in an organized collection, accurately captioned, marked with the photographer's copyright stamp, and be easily accessible to photo buyers. (Anyone can sell an occasional picture with luck, if he has a good shot of a subject someone is looking for, and can get it to the buyer in a timely fashion.)

How Are Stock Pictures Sold?

Most photographers work with one or several stock picture agencies or picture libraries who, for an agreed commission, handle all the business chores of selecting and submitting pictures, negotiating fees, and taking care of paperwork, filing, and refiling.

A big change in the stock business in recent years is that almost all big and midsize picture agencies now print elaborate color catalogs each year. Many agencies are known for particular specialties. The catalogs reflect the specialties of course, but most also show selected pictures illustrating the most popular stock subject categories. These are currently lifestyles and leisure, business, transportation, people, travel, wildlife, scenery, and science.

The catalogs are distributed free to qualified art buyers; some catalogs can be purchased in professional art supply stores or viewed in public libraries. Art directors, designers, and picture editors are often under time pressure, and looking at images in catalogs is easy, so at this point in time it is estimated that somewhere between 70 percent and 80 percent of stock sales to the high-priced advertising and graphic design markets are from catalogs.

Buyers searching for unusual images may not find them in catalogs, but may go to agency files, individual photographers with known specialties or the Internet. Not many buyers as yet research the Internet, but that will change as more pictures go online, techniques for selecting key words improve, and the Internet itself speeds up. (For more on current practice and future trends, see the interviews with stock experts at the end of this chapter, and also see chapter 11.)

Other Methods for Marketing Stock

A few photographers set up as small stock agencies, sometimes with a few noncompetitors. They may rent office space and hire an employee or two, or use a home office and family members as staff. The photographer run agency must of course be able to respond promptly and professionally to requests.

Some individual photographers with stock know-how and/or large, highly specialized picture files advertise and promote their work in stock directories. Two that are well-known are *Direct Stock* (all pictures) and the *Blue Book of Travel Stock* (without pictures, subjects are listed and cross-indexed in great detail). (See later in this chapter and resources in chapter 20.)

A few commercial services market individual photographers' work on sites on the Internet. Such services are not cheap. They are open to professionals whose work is judged suitable. (See ads in *PDN* or other professional photo magazines.) Any photographer with a computer and skills and access to the Internet can set up her own Web site to showcase pictures. You can also have a computer expert do it. This can be a personal or commercial site. The problem is always how to attract viewers to the site. (For more on how computers, digital imaging, and the Internet can benefit photographers, see chapter 11.)

Networking

Getting to know as many photo industry people as possible is a very important and underestimated marketing tool for all photographers. The photo field is crowded, and art buyers most often give work to people they know and like. If an editor or art director must choose between equally good stock pictures, he or she will use the one by the agency or the photographer he knows. And, never forget that travel assignments can grow out of a good photographer/client relationship that started with stock sales—it has happened to me.

The best way to meet useful people is probably to join or affiliate with professional groups such as local Art Director's Clubs or the ASPP (American Society of Picture Professionals). Meeting other photographers through professional associations may not produce work, but it is certainly useful to people starting out in the profession. (See resources.)

Stock "Wants" Listings

Some stock photographers subscribe to photo buyers want-list services sent by fax or e-mail. These request subjects needed (usually not easy ones to fill). Even if you make no sales, the listings may help you learn about the stock business, and help you build your own mailing list.

PhotoSource International of Wisconsin is the best-known want service. The subscription fees are not high; I have a friend who is a semipro photographer who has made some sales that way. You can call PhotoSource for information and a free trial. (See resources.)

Some textbook publishers have in-house photo research departments. They mail out lists of wants to photographers with known stock files. Check any school or public library to see types of books, the sort of pictures used, and names of publishers. You can send your own list of subject matter direct to the publishing house if you wish. Address the list to the photo editor or photo research department. You then may get on the publisher's list of possible sources.

Who Uses Stock?

Almost every user of photographs buys stock at some time. Stock users at the top end of the market are advertising agencies and national and international corporations. Book and

magazine publishers also use stock in big quantities, and are in the midrange as far as fees are concerned.

Some small (and a few big) companies and publications quite frankly use stock to save money. They always try to get photographs free or as cheaply as possible, don't care all that much about quality, and today make use of the "royalty free" travel stock discs available. In my opinion, stock photographers should not try and compete in price with clip discs, or lease any stock picture at a fire sale price, or they will soon be out of business.

How Much Does Stock Sell For?

Stock pictures can be used for national, regional, or local advertising; television spots; corporate brochures and annual reports; by publishers of all kinds of magazines, books, catalogs, and more. Stock fees are based on the type of usage, such as different print runs, time cycles, size, and placement of images. Most companies will pay fair prices, but of course will try to negotiate to their advantage.

When starting out, you should learn what it costs to produce a picture, and add your profit, as an absolute minimum selling price. There are no fixed stock reproduction fees (that would be against the law), but there are accepted parameters that can be used as guidelines. Fees in fact are negotiated very carefully, based on how the picture is used. A photograph leased for a major print or TV national advertising campaign can command many thousands of dollars; the fee for same shot used small inside a textbook for one edition might be around \$125.

Pricing Photography: The Complete Guide to Assignment and Stock Prices, by Michal Heron and David MacTavish; Negotiating Stock Photo Prices, by Jim and Cheryl Pickerell (available by mail order for \$30 plus shipping from Pickerell Marketing); and PhotoQuote, a computer program by Cradoc, all list specific price ranges of stock for many different uses as a basis for negotiating fees. (See resources.)

How Exactly Are Stock Pictures Sold?

Stock pictures are almost never "sold" outright. They are leased, for specific and clearly defined uses and for limited time periods, either by an agency on behalf of the photographer (who retains ownership of the copyright) or by the photographers themselves. Some stock images are extremely valuable and are leased many times over. Very rarely, clients want a "buyout" (outright transfer of the copyright, ownership of the image). They can expect to pay a high price.

Royalty-free stock pictures on disc are, as implied, sold outright for most nonexclusive uses. The first royalty free stock discs were not good in quality, but today, some good photographers have sold large quantities of images for this type of use.

Where Do Stock Agencies Get Pictures?

Agencies get pictures from individual photographers (almost all of whom are under contract to the agency), from owners/copyright holders of specialized collections who don't market their own material, and from their affiliate agencies at home and overseas. Several major stock agencies have owners/partners/principals or staff photographers who produce stock images owned by the agencies.

What Travel Subjects Are Best for Stock?

Theoretically, travel stock pictures can be on almost any travel-related subject; from Anatolia to Zanzibar, anthropology to zoology, aardvarks to zebras. Most travel stock sales though, are pictures of popular places and famous "icons" (instantly recognizable symbols of a region or country). The travel photographer should probably shoot those icons as stock staples for her files whenever possible, remembering that they must be photographed in a fresh way, and be recent, to be salable.

Current cityscapes, pristine wilderness scenes, tropical beaches, and good wildlife shots are usually in demand; there is stiff competition for easy-to-find subjects. Pictures of remote places and of how people live all over the world are unlikely to be featured in catalogs or on CD-ROM discs; these may find sales in the textbook market.

Model releases make all pictures more valuable. To be considered for the high-paying advertising market, any and all people pictures absolutely must be model released. Also get releases for people photographed for possible use in books if you can. Pay amateur models with a small gift, or with Polaroid prints. Pay a moderate fee (\$2–5, or \$10–\$20 in rich countries) to an amateur model if you take more than a roll or two of film. It will help if a local can negotiate fees for you. (Model releases in twenty-nine languages that you can copy and use are in chapter 20.)

Where Should a Travel Photographer Go to Shoot Stock That Will Sell?

Uninformed photographers seem to think that by going anywhere they want to go and shooting a lot of film, they will sell a lot of stock pictures. Do not confuse your love of travel, or wish to see a remote place (I love those too) with shooting stock with a good chance of selling. For that, you must usually go to the places most tourists want to go.

Photographers who shoot professionally for stock are extremely selective about spending their travel dollars—they have to be, travel and film is expensive. Some specialize in a particular area, and carve special niches for themselves in stock. Others go where they can find symbolic photographs relating to the universally enjoyed pleasures of travel—gorgeous beaches, mountains, colorful markets, famous entertainment areas, and well-known shopping streets. Some photographers specialize in adventure travel, or "green" travel, and photograph hiking, camping, climbing, wildlife, or wildflowers.

You will have to decide what you want your stock niche to be. (My specialties, if any, are New York City, people, and famous tourist spots.) It's easy to say where not to go. Avoid wars, areas of famine and pestilence, civil unrest, and cities with high street crime (all the bailiwick of the photojournalist).

While I suggest going to major tourist areas, where you will probably find some new ways to photograph familiar things, it's hard to be original in smaller places that everybody with a camera goes to. I love Venice for instance. I have been to Venice about twenty times, taken thousands of pictures of it (some I think are beautiful), and have only sold three or four. But I went to Machu Picchu in Peru only once, for one day, and the pictures have sold again and again. (The ruins perched on a mountain are the major tourist attraction as well as the "icon" for Peru.)

Mexico and Central and South America in general are, I am told, still underphotographed. If you want to travel there, photograph obvious tourist icons, then perhaps look for situations that could illustrate Spanish-language textbooks. These might include direc-

tional signs, family interactions, attractive young people talking in cafes, people in stores buying things, people asking directions or catching trains, busses, or planes.

Watch Trends and Don't Neglect the Classics

Read a major newspaper or newsmagazine to keep abreast of international trends. They may give you ideas for places that are "hot" and those that definitely are not. Travel shots of the Middle East are not doing well at the time of writing! But, things change over time; Vietnam is once again a destination for the adventurous.

Foreign tourism to the United States is still booming. Western landscapes are what visitors want to see, but there is stiff competition for this market. Be creative. Golf resorts and holidays are bigger than ever. Alaska, Hawaii, and Canada's west are popular too. Australia and New Zealand are definitely "in."

Europe is the most popular tourist region in the world. Both tourists and experienced travelers will always go to London, Paris, and Rome—and magazines will always need pictures of them—for stock the trick is finding interesting corners and new ways to illustrate the tried and true. Eastern European cities and scenes are still in demand. There are plenty of wonderful safari pictures out there, but I'm told that pictures showing Africa's traditional and modern home-life, development projects, and more are sometimes needed for textbooks.

What Styles Work Best For Stock?

Travel stock should always have a positive approach to sell. Ugliness exists everywhere but is not wanted for travel stock. Apart from that, pictures can have the warm, upbeat "feel" of much television advertising, or be quite journalistic/editorial or personal in style. There are no absolutes. Currently, experiments and impressions are in demand.

Study stock directories, magazines, and textbooks to see pictures used. It's a poor idea to copy current catalog styles, because they will have changed by the time your shots reach the market. I don't think a photographer should alter his style to shoot stock; others may differ.

What Film Formats Are Used For Stock?

All formats are used for stock, with a majority of travel photographers shooting color transparencies in the 35mm format.

Stock agencies report a movement back to black-and-white stock, as four-color electronic scanners can be used to reproduce black-and-white transparencies as well as prints. Color prints (from negatives) are still only very rarely used as stock.

How Stock Agencies Function

Agencies get pictures from photographers and others (like scientists) and agree by contract to use their "best efforts" to market the images. The photographer retains the copyright.

Agencies usually ask their photographers to submit new work tightly edited, in twenty-slide plastic sheets for easy viewing. The agency's staff then further edits or selects pictures.

WHY COPYRIGHT OWNERSHIP IS BASIC TO PHOTOGRAPHERS

If you want to make residual "sales" of any kind, including stock sales, it is crucial to keep control of your copyright and ownership of your images. Income from residual sales, including stock, can exceed the fee for the original assignment; this is especially true for editorial photographers.

Only the owner of the copyright of a photograph (usually the creator), or his/her authorized agents, can lease, sell, or even give away the right to publish it (or reproduce any kind of other creative work from it) in any country that is party to the international copyright conventions. In the United States, violation of copyright is a federal offense.

How to Protect the Copyright on Your Photographs

Never sign any "work-for-hire" agreement transferring ownership of your pictures to a client. If a client needs outright ownership of your pictures badly enough, you may be able to negotiate a high fee that would make it worth while to transfer the copyright.

Sometimes, an agreement that allows me to retain copyright in some pictures is possible. I have negotiated this type of agreement when photographing clients of a client, on tourism shoots for instance; I keep the copyright where no client customers were involved.

Always Use a Rubber Stamp (or Other Imprint) to Help Protect Copyright

Although it is not technically necessary according to the copyright laws of the United States or Canada, you should physically protect your copyright (and identify ownership) by always marking your name and the international copyright symbol on the back of prints, and on the mount of all slides and transparencies. Get one stamp for prints and large format mounts, and another, small stamp to fit 35mm slide mounts. (You can use a computer program for this, and there are also in or out-of-camera devices that mark permanently.) The wording should read:

Photograph © copyright (add year)

Name of Photographer

All rights reserved.

Use Roman numerals for the date if you wish. Some photographers omit the date altogether, fearing to limit the life of the image. Many top photographers use a stamp requiring that a copyright notice be published along with the credit line.

The "selects" (and the rejects) are returned to the photographer, who must caption and copyright stamp selected images. There are computer programs that can be a help with stock captioning and managing chores (see advertisements in professional photo publications—I don't use them).

The selected, captioned, copyright-stamped pictures then are taken or sent back to the agency, where they are logged in, sorted, classified, and entered on the agency's computer or other retrieval system. Finally the pictures are filed, ready for inspection and possible selection by stock clients. Today, some pictures the agency especially likes may be selected for catalog or display on its Web site (if any).

How Are Photographers Paid for Stock?

Neophyte stock photographers are often disappointed to learn that photographers almost never receive money from agencies in advance, but are paid only after an image has sold. (Every rule has exceptions; I know of agencies that make payments to their high-grossing photographers when a large body of new work is accepted, and a few agencies underwrite the cost of big shoots by their top photographers. In the latter case, the photographer's commission rate is adjusted.)

Most photographers must invest in the expenses of shooting stock themselves, and may have to wait a year or longer before income from a shoot comes in. If and when, and only when, the images are leased for publication in some form, and the agency has been paid for the use by the client, the photographer will receive his or her share of the fee. This share, or royalty, is less the agreed commission (that pays the agency expenses and profit). Commission is often, not always, 50 percent of the fee. The photographer and agent should always have a contract spelling out commission, payment schedule, and much more. Model contracts are printed in the business and legal guides noted in earlier chapters and in the bibliography.

A Cautionary Note

Of course there are, and probably always will be, a few eager wannabe or semipro photographers who spend serious money traveling and shooting stock, but lose this investment. That can be because the pictures aren't up to today's stock standards, or because the photographers don't shoot subjects that are needed or stay abreast of trends. Stock is a fairly conservative business where quality counts, but it's not about fine-art or personal expression. Photographers must also know how to market their stock. Potential buyers must be able to find even the best stock pictures.

Can Part-Time Photographers with a Few Good Pictures Sell Stock?

Some serious amateur or part-time photographers may, if they are lucky or persistent, sell some stock pictures; the problem is always matching pictures to buyers. A few "semipro" and part-time photographers I know have sold some stock through services that advertise stock buyers' wants via fax or the Internet. (For more see later in the chapter.)

How to Locate and Approach Stock Picture Agencies

A few of the biggest stock agencies advertise in the *Photo District News, Communication Arts,* and other publications aimed at photography and graphic design professionals.

The Picture Agency Council of America (PACA) has high ethical standards and publishes an annual directory listing its hundred or so members, their specialties, wants, and overseas affiliations. To obtain a copy, contact PACA at P.O. Box 308, Northfield, MN 55057-0308. Phone (800) 457-7222; fax (507) 645-7066. The booklet currently costs \$15 plus postage, it is sometimes given away at major photo shows.

Many agents have told me that they never look at unsolicited work. The correct approach is to first telephone or send a letter to the submissions editor listing the approximate number of pictures you have and the range of subject matter covered. If interested, they will let you know how to proceed further.

It is not too easy to affiliate with a top stock agency today, though talent is rewarded if you are persistent. You may have to contact several agencies before finding a match.

How to Submit Work to a Stock Agency

If a sample submission is requested by an agency, each picture should be marked with your name and copyright stamp, and put in twenty-exposure plastic sheets for easy viewing. Never send slides loose in boxes. Send by registered mail or insured air express.

Smaller agencies may offer greater opportunities to new photographers than big ones. However, be cautious and check the reputation of a small agency before entrusting it with images. There have been a few small agency insolvencies in recent years, causing photographers to lose money and even pictures.

How Individual Photographers Can Offer Work to Picture Buyers

PhotoSource International, 1910 35th Road, Osceola, WI 54020-5602 is perhaps the best known "picture wants/needs" service, offering daily, weekly, or monthly want listings to individual photographers, for a fee. Subscribing to such a service may be a good way for some beginners to get a handle on what stock buyers are seeking, and of building a list (database) of stock users.

Stock Catalogs Accepting Ads from Individual Photographers

Stock agencies and individual stock photographers can pay to advertise their wares in stock directories distributed free to proven stock buyers.

Direct Stock, published in New York each fall, is one of the best known of such directories. It grows in size every year, so I assume that most of the photographers who advertise in it (many are well-known) find the fees charged (currently about \$2,000 per page—and always comparable to other promotional directories) worthwhile. You can be shown on their Web site also. Call (212) 979-6560 for detailed information and current rates.

Two almost all-type stock directories are published by AG Editions, 41 Union Square, New York, NY 10003. Phone (212) 929-0959; fax (212) 924-4796; e-mail: office@ageditions.com; Web site: www.agpix.com. A one-page, basic all-type ad in their Blue Book—The Directory of Geographic, Travel and Destination Stock Photography currently costs around \$700. Enhancements including picture display in the book or on their Web site cost extra.

Their *Green Book—the Directory of Natural History and General Stock Photography* is similar, designed for individual photograpers to advertise, and buyers to find these types of work.

Travel Stock Trends: Interviews with Experts An Interview with Bug Sutton

Bug Sutton is a partner in, and Creative Director of, Photo Researchers, a large New York City stock agency especially well known for its travel, science, and nature files. They have represented me for over twenty-five years.

MODEL RELEASES

Model releases (legal permissions to publish photographs) are needed for almost all stock uses today. Get them signed whenever and wherever you can; model-released pictures (of people, and even recognizable private property) are far more valuable than pictures without releases. (See the English and foreign-language releases in chapter 20. You may copy and use them freely.)

SM: What advice would you give travel stock photographers today?

BS: Shoot selectively. Travel has always been a stock staple, but the market is now extremely crowded. Many of the new royalty-free CD-ROM discs are of popular travel destinations and travel icons.

To be competitive, travel, and indeed all stock images, must be fresh (not more than two years old) and on the film stocks now preferred by art directors and designers. (Fuji Velvia, with superb sharpness; Fuji Provia with more grain than Velvia but more realistic color; Kodachrome 64 with unsurpassed stability, and the newest Ektachromes with excellent possibility are all good choices.)

There is a significant trend away from the brightest colors popular in the 1980s—the new favored "look" is for a muted, springlike, or autumnal color palette rather than the summer hues popular in the recent past. Black and white is back for travel photography for the first time in many years. It's now okay to show grain in many instances; in fact I suggest to our photographers that they carry several different film stocks with them on important shoots to get different "looks" of the same subject.

SM: What about needed subject matter?

BS: New interpretations of popular subjects will sell. For instance, today a salable picture of the Eiffel Tower will probably not be a sharp, straight on shot taken from a distance. The camera may be aimed up from underneath the tower and the photographer may use intentional blur and soft-focus effects along with unusual orientation techniques. Of course, the tower must be completely and instantly recognizable.

If a photographer has access to places where most people don't or can't go, he or she has an advantage. We do quite a bit of business with photographers who live in more remote countries. They can photograph places and events, in all seasons and weather, that short-term visitors can't get.

SM: Is there any value in older travel pictures?

BS: Most date rather quickly and are not useful to us. A very few may be classics. We dupe those onto newer film stocks on occasion. A new trend is that some of our photographers are now incorporating travel images into montages made on the computer—then the age of the original photos doesn't much matter. We even have some travel photographers collaborating with lifestyle specialists and graphic designers or computer imaging experts, to produce travel/lifestyle montages.

SM: How do you want those montages delivered?

BS: Currently, still on film. Film is what the clients want.

SM: It's expensive to convert digital files to film.

BS: There are a few service bureaus we know of that can produce a sharp image on 35mm film from high resolution digital files for a reasonable price (around \$10 or so). Those slides are sharp enough for us to have them duped onto 70mm film stock. In the future, perhaps within three years or so, we will be delivering some files on disc or online. At the

moment, it's still film for the majority of our clients, so for photographers who are working with digital files, the cost of conversion becomes a factor both to the photographer and to the agent.

SM: Thank you very much.

An Interview with Jim Pickerell

Jim Pickerell is a photographer, writer, agent, and publisher. He is author of the monthly newsletter Selling Stock; and the coauthor of the annual Negotiating Stock Photo Prices, widely used in the industry. He is vice president of the Stock Connection picture agency.

SM: I always talk to people that I know are honest, and ask the questions that I want answered. The stock business has changed so much in the last few years. In terms of travel stock, would you give any advice to photographers starting out? What they should do, and what they shouldn't do, in terms of stock?

JP: The travel subjects that are in highest demand are the generic clichés. . . . Paris, the Eiffel Tower; London, Big Ben; and so on. Those are pretty well covered by the stock catalogs and the CD-ROM discs. But, Stock Connection and other agencies are always looking for a new look at that same old location. We [Stock Connection] also might be interested in coverage of places we don't have. . . .

Photographers starting out tend to want to shoot the less well-known places. From an income producing point of view this is usually a waste of time. I would say that the opportunities for the photographer starting out would be in showing less well-known aspects of the most popular places. There isn't so much demand for secondary locations (of popular places) so the catalogs and discs won't have those. . . .

Certain off-the-beaten-path pictures work as concepts. For example, I recently saw a travel poster promoting France. It was of someone eating in a restaurant. While not a major icon, it works because one of the first things you think about when thinking of France is food. The OTBP [off-the-beaten-path] pictures need to clearly illustrate a concept that is at the heart of what the country or state, or city is all about....

Off-the-beaten-path type of travel destinations can be sold too, but I think that usually they are going to have to be sold with text. I advise adventure travel photographers to learn to write, or to travel with someone who writes. There's relatively little demand for those travel pictures if they don't come with a text package.

SM: How many pictures would you like to see, if you are trying to sell my travel story? JP: We don't handle picture/text packages. Most of those are sent to publications by individuals. . . .

For the less well-known destinations, I think the travel photographer is going to have to find an agency that specializes in selling to off-beat travel markets. For the most part, those are not the major agencies, but the smaller stock agencies.

SM: In terms of people and travel, do you want model releases?

JP: Of course pictures to be considered for advertising must have a release. In some cases now the editorial users are requiring releases too. The problem is we are becoming a smaller and smaller global village, and a more litigious global village. Pictures are used without releases, and people get away with it. But if that Masai warrior sees his picture used in a big ad and if his uncle is an international lawyer. . . . Photographers should get model releases. (I hope there was a release on the travel poster picture mentioned above because it

was shot from the street through a window. Using any picture for a major travel poster without a release is very risky.)

SM: But I say don't not take a beautiful picture because you can't get a release. There is still an editorial market, and also your own soul. . . .

JP: Absolutely.

SM: To change the subject, everybody is worrying so much about digital everything. As if traditional photography is going to disappear overnight. What do you know about online sales [sales over the Internet]?

JP: So far, very little is being sold online.

SM: What about worldwide online sales?

JP: Worldwide online sales? So far more agencies have lost money than made it. It costs a lot of money to put images online. Agencies have spent money scanning images, but haven't recouped it yet. Currently maybe 2 percent of the billion dollars in stock sales is online, but it's rising. Within the next two to three years I expect to see a lot more travel pictures available online. They will be located by using online databases....

The traditional agency filing cabinets are not dead yet, but I expect sales from these cabinets will start dropping off....

SM: Are the bulk of stock sales currently coming from catalog sales?

JP: I estimate that 70 percent of worldwide sales now come from catalogs. Alfonso Gutierrez, CEO of AGE Fotostock in Spain estimates that 80 percent to 85 percent of the gross money produced (globally) in stock photography today is coming from catalogs and that in a number of countries 97 percent of their sales are from catalog images. . . .

SM: Those are certainly things for all travel photographers to think about. Thank you very much.

An Interview with Richard Steedman

Richard Steedman is a photographer, and cofounder and president of The Stock Market, the largest independent stock photo agency in world. He is a noted authority on semiotics, the art or science of communicating through symbols.

SM: Everybody has been extremely gloomy recently about stock and the small photographer, and about travel photography in general. The idea seems to be that, well, there are already all the Eiffel Tower pictures anyone will ever need, so what's the point of taking any more. Do you share that gloom?

RS: It is true that royalty-free images are going to take away the easy part of the stock travel market. Once each disc maker has a definitive image of the Eiffel Tower, Big Ben, the Statue of Liberty, and so on, that have been scanned, color-corrected, and enhanced available on royalty-free discs, the small users will go for them because it's price effective.

So we have to go further. The individual travel photographer is going to have to find a way to make those images of famous places vivid and evocative, to add something to an Eiffel Tower photograph that would make it special, unique. It is getting harder.

Travel budgets and assignments are not what they once were. Only a few photographers now generate much stock from assignments, and travel costs are high. It's always valuable to find some airline or magazine or tourism company, or anyone to help finance the cost of travel. Local photographers have the best opportunities to get great travel pictures because they are there in the great weather, the right season, and so on. The Stock Market is

trying to encourage Europeans and others to concentrate on their own areas. There are still windows of opportunity. We are looking for local people to generate great stock.

You can look at something with gloom, or you can see opportunity. A lot of our travel pictures are used for advertising. There are still plenty of opportunities. Using local people as models and getting model releases for instance. There is a shortage of model-released travel pictures everywhere. They will always be special, and new ones will always be needed. A lot of travel photographers didn't want to do this [get releases] but now, I would say that they must. We don't want people pictures that are not model released.

SM: Should photographers pay for model releases?

RS: Yes. Small amounts, depending on how much time was involved for the model. Maybe as little as \$2 or \$5 in local currency (more in rich countries of course). Model fees make it cleaner. It is good if you are a visiting photographer to team up with an English-speaking local. They can be a huge help with getting releases signed, negotiating the price, and more. I like using taxi drivers to help me. I tip them well at the end.

SM: I like student assistants. What advice would you give American photographers about shooting travel in their own region, say, the Midwest?

RS: In order for a travel photographer to succeed, they are going to have to develop material that has a special look to it. Add evocative props to a beautiful scene. And the computer has come into this business in a big way. You can take any travel picture and enhance it. Photographers can learn to do this, or work with a computer expert or service bureau and split the commission.

The biggest area of stock is people, lifestyle. That can go for travel too, in the Midwest, or actually anywhere. People enjoying themselves in nice places. It calls for getting people together, getting them on a site, getting model releases. It's a production, it's not much about what so many photographers like, going off by yourself into the wild. More and more scenics will be available on those discs. Model-released people pictures at pleasant locations are almost disc proof.

SM: Some photographers would say that setting up shots isn't what they love about traveling or about travel photography.

RS: That's a dangerous way for a photographer who wants to make a living to think. It's not about your need to see the world. I spent a week in Burma once. It's incredibly photogenic and I got great pictures. Never sold any, because almost nobody can go there. . . .

Photographing for travel stock isn't about loving travel, or even about loving photography. It's about communicating. You have to look at where the need is for pictures. Cancún, Florida, Paris, all places where many people go and the airlines need to make a lot of brochures. It's not about where you need to go, not about your need to see the world. . . .

People have to understand why people buy pictures. They don't buy pictures because they are pretty, or exotic, they buy a picture because something in that shot is going to move people to go to that area. . . . Great travel stock pictures communicate the mythic qualities of travel. Travel is about freedom, escape, fulfillment. Romance. Luxury. Wellbeing. Joy. Meeting warm people who like you, that you'd like to know better. . . .

Travel photographers may not like this, but the most money [in travel stock] is made by pictures of places the airlines go, that everyone wants to go... Especially the beach places, the palm tree places.... A great picture of a palm tree hanging over a white beach with a perfect sky and an atoll in the background will make \$20,000–\$30,000 gross....

Certain travel subjects sell over and over, but they are not easy to get. Those perfect palm studded isles with dazzling white beaches surrounded by turquoise seas of course exist, but they are remote. In the Seychelles, the Maldives. The ultimate fantasy vacation spots. Very few people actually go there, but everyone finds them appealing. You just can't get those particular shots with a ticket to Jamaica or Puerto Rico. . . .

Of course you mustn't lie as to where a place is. An advertiser or travel magazine can never say a beach is somewhere when it's somewhere else. But if a picture can symbolize all beach vacations it's all right. . . . I have done a lot of work in the Caribbean. I always add props to my beach shots. I buy and carry big beautiful local shells, a hammock, an umbrella, a straw hat, maybe folding chairs, snorkel equipment, whatever seems appropriate. Adding those things implies that the viewer can be there too. It also makes it much harder for cookbook-type photographers to copy your image. It makes it disc proof. . . .

What is mythical in the Midwest? The American way of life is mythical. Farms, farm people. A tire swinging from a tree. Wheat. Wheat is much more mythical than corn. Waving fields of wheat, details of ears, those sell. So do fields of sunflowers. Roads. Roads everywhere. Plenty of roads in the Midwest. Straight, empty roads, winding roads, dirt roads, switchback roads. Roads imply so many things....

In New England, red or white barns and villages with white churches are mythical. In the mountains and Northwest, waterfalls especially. Waterfalls are huge. They mean purity, cleanliness, even more. . . . Wherever a photographer goes he should think about myths and what and who makes the place special, then photograph those things from his or her unique point of view. But be selective. Twenty good pictures are worth much more than a thousand pointless ones. I say photographers should use a 35mm camera like a view camera. Think a lot before you shoot. . . .

We have people who do those things well who make in the six figures. Quite a few who make \$50,00-\$75,00 a year. . . .

SM: You are always inspiring! Thank you very much.

An Interview with Van Bucher

Van Bucher is a photographer and former stock agency picture editor. He is now a freelance picture researcher in New York City.

SM: People are being so gloomy about the future of travel stock, especially because of the new photo clip discs on the market. Is this affecting your work?

VB: No, and I don't think it will. Clients who hire researchers do so because they like our taste and respect our knowledge. They want more than conventional or generic images. For instance, I'm currently researching pictures to be used in an advertising campaign for a major airline. I'm sure that something from Prague and all the other places on their list are on one or other of those discs, and in most of the big stock catalogs, but a famous landmark isn't what they want.

SM: What do they want?

VB: Something that conveys the feeling or spirit of the place without being too obvious. Something with a flow of life, a character, an individuality about it. Stock discs and catalogs don't usually have that. Most show just a few shots of featured places. For instance, a software maker asked me to preview its travel disc, and asked me to name a place. I typed in Tel Aviv, a city I know well. Up came three pictures of the most touristy places in Tel

Aviv, just obvious shots of the Shalom Tower, the beach and the Diaspora Museum. None were suitable for the type of project I am involved in. Tel Aviv like most cities has its romantic corners.

SM: Where do you look for such pictures?

VB: In the files of stock picture agencies that I know from experience are likely to have what I need.

SM: Do you ever contact individual photographers?

VB: Rarely, because I'm busy, and often the job is a rush. If I absolutely know someone has pictures that would work, I will go to look, or ask them to send me a selection.

SM: Do you choose pictures from illustrated catalogs?

VB: No, again people who buy catalog images don't need me. My clients are often looking for a different point of view. For instance, I work for quite a few textbook and encyclopedia companies. They use a lot of pictures of people, also travel. The problem with most pictures in the catalogs is that the people are too perfect, often look too posed; the travel photo styles seem more aimed at a certain kind of advertising than editorial use.

SM: So you would suggest that photographers try to work through a stock agency. How should they approach that?

VB: Locate agencies through the PACA list, and see their specialties and wants. Zero in on agencies that seem to fit. Then telephone the agency. Agencies usually have someone whose job is first contact with new photographers. They will ask what subjects you have and how many pictures, and often, what film stock and what equipment you use. Those things give a basic idea of your level of photography. If they are interested, they will ask you to bring or send work in for a detailed look. (Never send work without being asked.) Don't give up if the first agent doesn't take you.

SM: It's still tough for small photographers. What about the "want list" services for individuals who don't yet have enough pictures to be interesting to a stock agency?

VB: I think those listings could be helpful, especially to new stock photographers, because they give an idea of what stock is wanted, so even if you don't make any or many sales, that's a valuable learning tool.

SM: Thank you very much.

Advice to Photographers from AGE Fotostock

AGE Fotostock is a stock agency based in Barcelona, Spain, with offices in two Spanish cities. Their annual catalog is distributed to over fifty countries; well-known U.S. photographers participate. AGE's brochure requesting new submissions from U.S. stock photographers gives the best advice I have seen. These excerpts from it are reprinted with permission.

AGE:Edit conceptually for us, [do not send] only descriptive shots. A cup of coffee could be just that.... or a concept that evokes the flavor of Paris. You are the photographer, you decide what you want to express with your photography. . . .

Don't inspire yourself by looking at catalogs. . . . those very few that show some interesting concepts are out of fashion the very first minute they appear on the market. . . .

Stay tuned to market trends and submit accordingly.... Magazines and TV will give you the feeling of the new trends. Browse through as many magazines as possible, including (especially) foreign ones and explore TV commercials as much as you can.... Then edit or produce and submit....

Photography is still here and Photoshop is only a tool. . . . You discovered Photoshop,

eh? And now a new rainbow of possibilities is opening in front of your eyes, true? Yes, it is true, if you understand that Photoshop is not a way of improving all the images you take. Photoshop cannot resolve a photographer's limitations....

Don't ignore your experiments. Send them to us! . . .

Experiment, experiment, experiment. It's what a stock shooter in want of attention needs to do today. Experiment with any kind of technique, film, processing, lens, exposure.... that might.... give a different look to an otherwise ordinary subject....

Edit with a sense of humor. Show us your most analytical eye. Being a photographer is not only about reacting to a clients' needs. . . .

Photography is such a powerful tool in your hands [allowing] you to capture the reality around you [from] unexpected angles [and with] different moods....

Don't send us many versions of the same idea. Give us only the one you believe in. . . . Don't repeat yourself with images that have a proven sales record. . . .

To Market Your Stock You Will Need as a Minimum

- Several hundred good, clearly identified, and accurately captioned pictures, that are classified or filed so that you can locate them easily.
- A list to mail out summarizing the pictures you have. (Stock lists can be a simple summary of the main subjects of the pictures you have in your file.)
- A mailing list of people who might use your kind of stock. (See also chapter 10.)
- Persistence, enthusiasm, energy, and patience.

Necessary Paperwork and Stock

Paperwork for stock is extensive, which is why I think that not having to do it is worth paying an agency commission. To avoid lost pictures, and to show business activity, you must keep meticulous records of all stock submissions and returns, on forms that specify terms and conditions. (You may copy and adapt the forms shown below.)

To be paid within reasonable time, send invoices promptly. You may need to charge and remit sales taxes. Learn about your state sales-tax laws. To deduct stock expenses for federal and state income tax purposes, you must keep thorough records of everything you spend producing and marketing your images. In addition to the obvious costs of making stock pictures (film, labs, dupes, props, assistance, travel, camera depreciation, and repairs, etc.), also record what you spend on telephone/fax calls, computer and supplies, and Federal Express and mailing. Store all receipts and canceled checks for seven years. If they audit you, the IRS will also want to see substantial evidence of business activity (even if no profit is generated) before allowing deductions. This is true whether you work through a stock agency or independently.

Computer "Stock Photo Management" and Pricing Guide Programs

There are several computer programs for managing stock advertised in the *Photo District News*. I don't use one because I don't market stock extensively myself.

Card's computer slide captioning program is popular, and their PhotoQuote program is widely praised for easily accessible stock pricing via your computer. (See resources.)

SAMPLE STOCK PICTURE DELIVERY MEMO (Photographer's letterhead)

Date:

Attn: Mr. George Photobuyer Client: Worthy Tool Company

25 Greanleaf Avenue Nicetown, IN 12345

Notice: The pictures listed below are submitted, at your request, for examination only. They may not be reproduced, duplicated, photocopied, electronically scanned, digitized, stored on disc, or used as artist or photographer reference without a signed licensing agreement from photographer or his (her) agent. The client agrees not to project these valuable images, or expose them to sunlight, heat or dust, or to subject them to damp or humid conditions. Client (named above) is responsible for loss or damage from moment of receipt until returned to the photographer.

The pictures may be examined free for two weeks (or period of your choice). After two weeks a holding fee of \$1 (or other fee) per picture per day will be charged, unless noted to the contrary below.

Please check, count, and acknowledge receipt of images by signing below. After five days, count will be assumed correct, and pictures acceptable for reproduction.

#	SUBJECT	FORMAT	COLOR/B&	W VALUE
1	Basalt Rocks at Giant's Causeway*	35mm vert	color	\$2,500
	Northern Ireland, UK			
2	Andes Mts. views, Chile	35mm vert	color (each) \$1,500
1	Dents du Midi Mts., France; snow	35mm vert	color	\$1,500
1	Rock of Gibraltar, sunset, backlit*	35mm vert	color	\$4,000
1	Foothills and Himalayas, India	35mm vert	color	\$1,500
2	Vertical faces, Shawangunk Mts., NY	35mm vert	color (each) \$1,500
	* Denotes especially valuable image, as per our telephone agreement.			

A research fee of \$60 (other amount) will be charged if no images are used. This fee is deductible from license fees of over \$500.

Return: This submission is conditioned on the return of all items, undamaged, unaltered, and unretouched. Client (named above) assumes all risks for the items listed from the time of receipt by client to the time of receipt by photographer, or his (her) agent.

Your carrier loss or damage: Reimbursement for loss/damage shall be amount(s) indicated above. Do demand a receipt from your carrier, and insure shipment.

Receipt acknowledged for client:	
Signature	Date

SAMPLE STOCK PICTURE LICENSING AGREEMENT (Photographer's letterhead)

Attn: Mr. George Artbuyer Worthy Tool Company 25 Greenleaf Avenue Nicetown, IN 12345 Date:

Client Purchase Order #

My Invoice #

LICENSE TO REPRODUCE THE FOLLOWING ORIGINAL COPYRIGHTED PHOTOGRAPH(S) SUBJECT TO THE CONDITIONS LISTED BELOW AND ON THE REVERSE OF THIS INVOICE:

Terms and Conditions: Client assumes all responsibility for loss or damage to this original transparency until it is returned to the photographer. The value of the image for insurance purposes is: \$4,000.

Payment of licensing fee shall be made within thirty (30) days of the receipt of this invoice, or upon publication, whichever is sooner. Interest of 1.5 percent per month will be charged on unpaid balance. Photographer's name and copyright notice shall be reproduced in no less than / point type, adjacent to the image, in the form prescribed on the reverse.

(Note: A well-accepted valuation standard in the industry, that has stood up to court challenges, is \$1,500 per good-quality image. In this case I have valued the excellent shot at \$4,000 because it has sold before and has future sales potential. Different photographers have differing requirements about publication of copyright notices/credit line, but by asking for them, your copyright is protected.)

Picture is described as follows: One vertical 35mm original Ektachrome color transparency, The Rock of Gibraltar at Sunset, #SM 24251. (Use a file number.) Photograph is not model released.

Rights Granted: Use is limited to front cover of catalog for drilling tools, size $8" \times 10"$, 20 pages, print run 50,000, distributed in the United States of America only.

(Note: Be as specific as possible; the ASMP Stock Picture Handbook and other recommended books detail how to negotiate stock prices for advertising, annual reports, packaging, greeting cards, TV, etc. Specify a time limit, size limit, additional usage rights [use on the drill packaging, for instance] and foreign language uses if applicable. An additional fee, often 50 percent, may be charged for reuse in a Japanese-language version of the catalog, for instance. For books and magazines, the print run as well as the size the picture is reproduced are among factors determining the price.)

LICENSING	FEE:	\$850.00

No New York State Sales Tax due for Indiana (out-of-state) delivery. (*Note:* Consult an accountant for details of sales tax laws.)

Than			
Than	1	YUL	1.

(Signed) Phantastic Fotographer/Rosemary Representative	Date	

Stock Newsletters

If you are serious about stock, reading one or more of these should help:

Jim Pickerell (see interview above) the photographer, coauthor of *Negotiating Stock Photo Prices*, and now a stock agent who obviously knows a great deal about the stock business, publishes a newsletter called *Selling Stock*, largely aimed at professionals, six times a year. For a sample and details write Suite A2, 110 Frederick Avenue, Rockville, MD 20850. Phone (301) 309-0941.

The Stock Photo Report is a well-regarded monthly newsletter edited by photographer Brian Seed, who was a cofounder of the Click/Chicago agency (now owned by Tony Stone Images, a part of Getty Communications). This report costs \$225 for photographers, \$250 for agencies. Get a sample copy, details and subscriptions from 7432 Lamon Avenue, Skokie, IL 60077, USA. Phone (847) 677-7887; fax (847) 677-7891; e-mail: bseed@wwa.com.

Rohn Engh, founder of PhotoSource International and author of the popular *Sell and Resell Your Pictures* publishes *PhotoStockNotes*, a monthly. In my opinion this one is aimed at the less-experienced stock photographer (that doesn't mean it isn't useful). For a sample copy, write PhotoSource International, 1910 35th Road, Osceola, WI 54020. Phone (715) 248-3400.

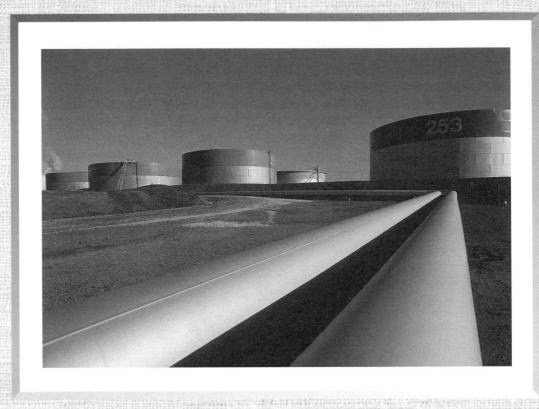

The second secon

have already said that travel photography is highly competitive and usually not extremely well paid. Many travel specialists, including myself, also do some location photography, because the same kind of seeing, thinking, skills, and equipment are called for when you work for organizations, corporations, and large and small business.

The Where and How of Location Photography

I have photographed in factories, offices, hospitals, warehouses, chemical plants, television studios, banquet halls, farms, mines, supermarkets, industrial parks, on oil tankers and freight trains, in the clean room of a pharmaceutical factory, on top of a coal slurry conveyor belt and an airport control tower, in bank vaults and maternity wards, college classrooms, art museums, and numerous conference rooms, law offices, and schools.

I've been to Perth Amboy, Port Elizabeth, and Paulsboro, all in New Jersey, to shoot refineries and docks for annual reports; Arlington, Virginia, for insurance company public relations; and Columbus, Indiana, to photograph the architecture of a whole small city for a magazine. In Montreal the shoot was for an American bank; in Branford, Connecticut, a hospice for advanced cancer patients for a woman's magazine. In Oyster Bay, New York, I photographed a community constructing an adventure playground (magazine); Sandia, New Mexico, for a solar heating research facility (corporate brochure); and San Diego, California—once to photograph sergeants at the Super Bowl for a U.S. Army recruiting campaign, and again to document a nuclear-research facility. In New York, I have run all over the city photographing a top rock group (album cover and publicity), Japanese executives in posh corporate offices (magazine), straphangers in the subway, and tough blue-collar workers on tugboats and trucks (annual report). At various times I've also shot backstage at the circus, many theaters, and on television talk show sets.

So, location photography is varied and interesting. It is often visually exciting, professionally challenging, hard physical work, and fun. It is also well paid. Freelance fees range from about \$800–\$1,000 daily for average jobs to several thousands of dollars a day on the level of top-name annual report specialists.

Location photography can be cold (a lot of annual report work is done outdoors in winter) and frustrating (there's often a lot of hanging around). To get pictures you can rarely interrupt or disrupt whatever is going on. The people you will be working with have their own jobs to do, because (however well the high-up powers say they have prepared for your coming) you are only an interruption of the local meeting, production run, safety inspection, or whatever. So location photography calls for tact, and, often, your best peoplemotivating skills too. Branch offices are often not well prepared for the arrival of a photographer in their midst, so you have to convince the people there to help you. Woe betide you if you don't.

Skills Needed For Location Photography

The single thing that almost all location shoots have in common is difficult to terrible lighting conditions. For instance, hospital operating rooms are normally lit with average room-level fluorescent light on the ceiling, which would call for some form of magenta filtration depending on the film you are using. But a circle of very high powered tungsten lights shines on the area where the doctors and nurses are working. Do you shoot tungsten or daylight film? Filtered or unfiltered? (I usually go with unfiltered daylight film. Negative film that can be reversed on a scanner and color corrected is another solution.) You often have contrast problems, because the light-to-dark ratio at the location may be more than transparency film can comfortably handle, so you must angle your shots to favor the bright or dark areas, or risk burned-out highlights or black holes. Hospital safety regulations, which are highly understandable, have always prevented me from adding any of my own lighting. It is possible that ABC, CBS, or NBC could get a dispensation. I've never been able to.

While you can light most other location situations, the areas to be covered are often large. If you light them completely, which is certainly possible, it calls for knowledge, plus a lot of equipment and assistance. My way of working is to combine available with added light, using rather long exposures for the background area if necessary. I light the important areas with several flash or strobe units, used combined or separately or both, whichever seems best for the situation. I use daylight film with an appropriate filter on the lens, and opposite colored gels on the lights to bring the color into balance. (See chapter 5 and chapter 7.)

Working with People on a Location Shoot

A crucial factor on most location assignments is to be able to motivate people. Whether it's getting on with the teacher whose class you are inevitably interrupting (or having no nonsense with her students who all seem to think they are on *America's Funniest Home Videos*), or coaxing shy, reluctant, or uncooperative production line workers, it's the location photographer's job to sort out the people problems, get subjects to pose, and bring home good pictures for the client. Time spent getting friendly with people before the shoot is never wasted. And don't forget to say "thank you" afterwards (send prints if you have promised them) and to take away any photographic debris.

If you are shooting for an annual report you will have had meetings (probably quite a few meetings), usually with the graphic design firm that is handling the report but also the client's representative—often the public affairs director (or similar title)—about the situations that must be covered. If it is a large corporation with many locations, travel must

BUSINESS VISAS AND "CARNETS"

For detailed information on carnets and where to obtain them, query the commercial departments of foreign consulates. Also see *The Location Photographer's Handbook* by Ken Haas, recommended later in the chapter.

be scheduled efficiently to avoid retracing steps unnecessarily, and also to coordinate with any irregularly scheduled or seasonal events that the client wants to include in the report. Stockholders meetings, board of directors meetings, and the like call for you to dress well; whereas if you are climbing about on a "cat cracker" (catalytic cracker) in an oil refinery in January you must be warm and well protected in layers of clothes that can survive the odd dab of oil.

When you are on any industrial location shoot, you will almost certainly be accompanied by a member of the company's staff. Be very, very nice to this person. They can make or break your shoot. Be understanding about their problems; they have probably been taken away from their regular job as a safety engineer, public relations assistant, etc., to help you. While it may be a fun break from routine, they will have to catch up on their normal work later. So show appreciation.

Group and Celebrity Portraits

A very frequent business/corporate assignment is the group portrait. Plan the shoot and test film in advance, set up lighting well before your subjects assemble. It is easy to arrange groups pleasingly if everyone is of the same importance or rank—as in "team" pictures. Just arrange people by height and space them. If necessary use stairs, benches, or even ladders or scaffolding to stagger the height with large groups. When photographing groups of important people, it is of course imperative that they be placed according to rank, with the company president, chief designer, or other principal very prominent. Sometimes, this person can sit down when others stand. It is especially important to have everything well organized when you photograph a big businessman, prominent politician, or other "star"—your time with them may be very limited.

If you are shooting real stars, they are usually great subjects, but be sure and see their last movie, TV show, or play before you meet them! No actor is ever tired of talking about himself. (I say this from long personal experience.)

Neil Selkirk, a top portrait and annual report photographer, who works with the political and business elite around the world, told me he always does meticulous research before photographing important people, especially in groups. From aides, he gets data on rankings, and heights, and lights the location using "stand-ins" (substitutes). He marks seating or standing positions with name tapes. Everything is prepared for assembling everyone and starting the session immediately and quickly when the group arrives.

Shooting for Public Relations

I have made publicity albums and stills for presentations for banks, furniture manufacturers, insurance companies, textbook publishers, tourist public relations and the U.S. Postal

THINGS YOU SHOULD NEVER DO ON LOCATION

Warning: Never, ever touch any piece of the client's machinery or equipment in an industrial facility, and don't ever plug in a light or even switch one on or off without permission. You could cause problems with union personnel, or create a safety hazard. If you do run into any serious problem, have or cause an accident or damage, consult a lawyer immediately. You should also carry professional liability insurance that protects you in case an action or piece of equipment of yours injures someone or damages something while you are photographing. Workmen's Compensation Insurance is necessary if you hire assistants. For detailed information consult the brokers of photography insurance mentioned in chapter 15, or your own broker. For more, read the ASMP Guide to Business Practices in Photography, and/or the Legal Guide for the Visual Artist, by Tad Crawford (see bibliography).

Service, among others. Be prepared for a lot of pressure when shooting big meetings and important executives. An assistant is invaluable to help with lighting. Most of the public relations jobs I have worked on have been for corporate or business clients, but travel clients use them too.

Most public relations clients want prints, in a rush. Use a good minilab and explain that small prints will be delivered within twenty-four hours, but tell the client that enlargements take longer. Personally, I charge a good day rate plus film and processing, have the film developed and small prints made, then I let the clients have the negatives to make reprints or enlargements for themselves. Some public relations specialists like to make money from reprints, so hold on to negatives.

Location Shooting with Changing Light Conditions

When you are shooting where the light is constantly changing; in such places as rock concerts; theaters; dance, opera, or other auditoriums; or in welding shops, smelting mills, and so on; the program camera comes into its own. You are often not allowed to use (or are not near enough to use) flash, so load with fast film (400 ISO or higher) and fire away. The program exposures under difficult, fast changing light conditions will be good to excellent in most cases, better than if you used manual exposure with spot meter readings. I prefer shooting on S (shutter priority) setting with a program camera, it gives me the most creative control.

Hazards and Legalities of Industrial Location Shooting

Quite often location shooting is done under difficult or even somewhat hazardous conditions. I once got very sick (with severe vomiting and diarrhea) after spending two days photographing a refinery in Venezuela, because of an allergic reaction to petroleum vapor ingested through the skin of my uncovered arms and legs. You will normally be asked by the client to sign a release from liability when shooting industrial pictures. You may not be able to do the job unless you do sign a release, and you may choose to do so. Obviously, be very cautious always, and obey all safety regulations about hard hats and shoes, protective goggles, and earplugs.

Note: If you do a lot of location shooting, you should certainly carry insurance. (See also chapter 15.)

THE LOCATION PHOTOGRAPHERS' HANDBOOK

For professionals and would-be professionals I highly recommend *The Location Photographer's Handbook* by Ken Haas, a top annual report specialist. This book has been out for a while, so some addresses may be out-of-date, but it includes an amazing amount of detailed information assembled from experience, government documents, and official sources; it gives helpful advice on handling big-time location shoots, and on working in about 170 countries and territories. A tiny sampling: What diseases are prevalent in Burma, how to import photo equipment into Bhutan, the public holidays in Burkina Faso. It also describes how to get a carnet, the best place to sit on a plane, lists sunrise and sunset times for different latitudes, and much, much more. Reading the four closely written pages on diarrhea should help you decide whether you are a true traveler or just a timid tourist!

Where to Start in Location Photography

If you think that location photography is for you, start in your own area and build up a portfolio. If you have any access to business or corporate or industrial or institutional situations, use that access to shoot pictures for a corporate-type portfolio. (See also chapter 9.) After you have a portfolio and at least some experience, you can approach small business, corporate, and other clients like contractors and real estate firms; hospitals, schools, camps, and colleges; malls and restaurants; government offices and public utilities. They all need pictures at times. (See also chapter 10.)

Freelancing for Corporations

Many larger corporations employ freelance photographers fairly often. This field is very competitive because it is well paid. The better your pictures, and the more businesslike an impression you create, the better chance you will have at succeeding. Prepare a resumé and include it with your portfolio of appropriate samples. Don't show pictures of cute kids or models or colorful travel shots; what corporate clients want to see are good pictures of management and workers, interesting, well-designed photographs of industrial subjects, and of course anything pertaining especially to their field.

Circulate your portfolio to corporations that interest you. Contact the human relations department for names of the individuals who commission photography. Remember that corporations are more formal than editorial or advertising clients, so dress in appropriate business attire when soliciting work.

Annual Report Photography

Some of today's annual report photographers are photojournalists who also do some annual report and corporate work to supplement their editorial income. Increasingly though, photographers specialize only in corporate work. If you aim first at smaller companies in your own area, you will build your portfolio and your skills, and can move up. The specialty of shooting blue-chip companies' annual reports and corporate brochures is highly competitive, because it is very well paid. Top freelancers who work regularly for the biggest corporations make as much as, or more than, top advertising photographers. Most of

this top paying work is given out by graphic design firms who are members of the American Institute for Graphic Arts, or AIGA. (See later in the chapter.)

Staff Photography for Corporations

Many corporations in America and Canada employ staff photographers to produce brochures, quarterly reports, pictures for in-house magazine and public-relations use, as well as some annual report work, although this is almost always supplemented by the work of a well-known freelancer. Some corporate photo departments are small, some quite large. Today most such jobs go to graduates of good photography schools, which also provide leads for jobs. Credentials are needed to get ahead in the hierarchy of the corporate world.

A few years ago I had a mature student who was a very good photographer. He was a former marine pilot who had quit a staff photographer's job at a big aviation company. When I asked him why he was getting a degree he said that he had made \$15,000 a year less in salary than a colleague doing the same job for the same length of time who had a bachelor of fine arts in photography!

Further Sources of Information on Corporate and Industrial Photography

Look at corporate annual reports; magazines like *Fortune, Forbes,* and *Business Week;* and at big trade/industry magazines to see the work of top corporate/industrial specialists.

The American Institute of Graphic Arts (AIGA) is headquartered at 164 Fifth Avenue, New York, NY 10010. It has regional chapters. They sell a mailing list of their graphic designer members, who commission a lot of annual report and location photography. Call or write for more information and the address of the chapter nearest you.

Industrial Photography, by Jack Neubart, is well-illustrated and based on interviews with top photographers and clients.

Il photographers, amateur and professional, who expect to bring back fine pictures from a travel shoot normally need to plan in advance and to be well organized before leaving. Without proper planning, you risk going to a destination in the rainy season, or wasting time on arrival finding out where things are, leaving something important behind—all of which could cause you to fail to get pictures you need. (But, do be flexible enough to seize unexpected opportunities when they arise.)

When You Plan a Big Trip, Where Do You Start?

Before leaving, professionals should thoroughly discuss with the client (or stock agency) what needs to be covered. (I make a shooting list.) For a personal trip, think about goals, and write them down in detail. Then, get a map and guidebooks, and maybe use the Internet (see chapter 11) and work out an itinerary, perhaps with the help of a travel agent.

Fix dates as far ahead as possible; you or the client will save a lot of money on airline tickets. True travel professionals, however, are prepared to go anywhere at short notice to take the rush jobs that often come up, and are able to handle last minute changes of plans.

The more you can find out beforehand about any destination and job the greater your chances of a successful shoot. Much planning and preparation should be done before you leave home; but, you should also try to arrive at your location ahead of time to "scout" for good locations and vantage points, and to make local contacts. This is especially important when you haven't done much traveling previously. Later on, you can pull together a shoot based on experience, even if you don't have much time to plan ahead. If you are professional, and you are asked to hop on a plane on one day's notice, take the job (as long as your skills are up to it) and cram on the plane and on arrival at your destination!

Using a Travel Agent

A travel agent's time is valuable. To help him or her, do as much of your research as possible before talking to the agent. Be as specific as you can about where you have to go and what you have to or want to cover.

Allow the travel agent to do what he does best, use the computer to plan airline routings that will save you time and money, and find options in your price range for hotels, car rentals, etc.

Good agents have traveled a lot themselves. They can often offer detailed suggestions based on personal experience, and will knock themselves out to get last minute reservations or elusive information for established clients. A travel agent will probably charge a service fee if you buy only an occasional cut-rate ticket. This may also be the case if extensive research is required; several overseas phone calls have to be made; or if changes in your itinerary involving reticketing or reservation changes are made.

You should expect enthusiasm, prompt callbacks, and patience from any good travel agent if you do have to change an itinerary.

How Much Time Will You Need to Photograph a Place?

In general, you need at least a week to get an impression of the highlights of a big city, two weeks or longer for the very largest like London or Tokyo.

One to three weeks should be enough for many regions—and small countries, allowing driving 200–300 miles a day, plus one to three days each for important towns. There is no way you could cover a large country with many special places of interest, like France, Egypt, or Japan, even moderately thoroughly in less than a month; longer would be better. If you are specializing in an area or country, and can afford it, several visits at different seasons will give you more varied weather and events, and will be less tiring than one very long stay. You won't have to worry about keeping your film refrigerated either.

Professionals should be able to come up with highlights of almost anywhere in just a few days, if that is all the time available, or if that is what the client's budget permits! (See also the next chapters.)

Scouting Locations

For most of my career, I have worked almost exclusively for magazine, tourism, and corporate clients. They tell me where to go and more or less what to shoot. My job is then to select the most photogenic things from their lists and make the best possible pictures of them. I do my on-the-spot research by walking a lot in cities, and by driving in other areas.

Nowadays I am initiating some personal travel projects for filling in my stock coverage, for books and other projects, or simply for going places I have always wanted to go. I then plan shoots with rather loose guidelines. Stock specialists tell me they plan meticulously, to fill gaps in coverage or update it, often guided by stock agencies as to needed subjects.

Location scouting means finding the best places to photograph, and travel photographers do this all the time. For insight on how a professional "location scout" approaches his work, I asked the advice of my neighbor Les Fincher (originally a still photographer on movie sets), who now "scouts" locations for television commercials, feature films, and occasional big-budget advertising still photography. Les suggests than some travel photog-

raphers who know an area well may find that "scouting" locations is a useful source of additional income.

A Trip Planning Exercise

As an exercise, research and plan a trip to a place that you want to photograph, even if the trip is not imminent. Dust off the skills you once used to write term papers. Visit a library, make phone calls, and assemble your materials. Of course use the Internet if you have access to it. Distill what you find about the place (its highlights, people, culture, and travel conditions) into a travel plan from guidebooks, Web sites, atlases, and the latest government advice for travelers (see later in the chapter).

Guidebooks, foreign government tourist authority offices, consulates, chambers of commerce, travel agents, airlines, hotel chains, car rental and cruise companies, and the World Wide Web have the information you need. The American and Canadian Automobile Associations (AAA and CAA) have excellent travel guides and maps, free for members. Travel magazines, fellow photographers, and people who've been there recently are also good sources of information.

If planning a shoot for a corporation, find out as much as you can about the company, from local contacts with the company, annual reports, business magazines, customers, suppliers, and employees.

Then:

- Summarize the important things you learn in writing.
- Make a shooting outline, or even a "story board"—a series of sketches of picture sequences.
- Then, write a proposal to a real or imaginary travel, tourism or location client, outlining the reasons you want to photograph the place you have chosen, and why these pictures would be interesting to their readers/guests/clients. Be as specific as possible. (Amateurs should list personal objectives.)
- If you wish to carry the exercise to its ultimate, make a travel budget. See the following section for a travel budget breakdown. Add the fee you would like to get. With this professional approach, you just might sell someone on the idea of paying you to do the job, or, you might talk yourself into making the trip.

Budgeting Travel

Budgeting is an essential part of travel planning for almost anyone. Professionals must almost always submit written bids or budgets for travel assignments.

For your information, I am not rich, and require half of the expenses and one-third of my fee be paid "up front" before I leave on any trip, and I expect a guarantee of full payment of actual expenses on presentation. (Balance of fee is normally payable on publication/acceptance, but other arrangements can be negotiated.)

Your budget should include the cost of:

- Travel insurance
- · International and domestic air travel
- Hotels (per night)
- Meals (per day)
- Car rental, gasoline, tolls, and parking per day

LES FINCHER'S TIPS FROM A LOCATION SCOUT

- Thoroughly discuss and make sure you understand all the client's requirements.
- Budget and shooting dates should be pinpointed.
- The scout must consider the format—stills, TV, movies—and the scope of the project. How
 many models/actors and crew are involved, the amount of spaces needed for camera movement, how many days of shooting, etc.
- The scout must then find what is needed. First travel to the general area you think the location will be—farm country, mountains, pretty village, etc.
- Then drive around the area. When you see something that resembles the requirement, approach the owner to clear it for shooting.
- Never lie about or minimize what shooting or filming at any location will mean in terms of
 problems for the owner. (This is to prepare them for the arrival of a film crew which can have
 forty or more people in it, plus lights—not so much of a problem for still photographers.)
- When you have a likely location, photograph the place from all four sides (both inside and out if necessary).
- Note the sun directions at different times of day.
- Determine the position of due north (with a compass).
- · Note the sound conditions if the shoot is for film or TV.
- Then find alternate locations.
- Offer the director, art director, or other client several choices (four or five is good)—there are
 many reasons why a good-looking place may not "work" for filming or still photography.
- When recording any location, shoot negative color film; snapshot-sized prints are the final objective. (Note: Many still photographers use Polaroids for scouting and testing models.)
- Most location scouts photograph in a panoramic style using a 35mm lens to move through
 the image area vertically (four or five shots for each side of the whole exterior, and of all interior walls in rooms being considered for the project).
- Local travel costs (busses, boats, ferries, subways, trains, taxis)
- Sightseeing tours
- Admissions to museums, other attractions
- Entertainment, if any
- Tips and miscellaneous expenses
- Photography fees, if any
- Model fees and/or gifts
- Film (estimate an average number of rolls per day; I use ten as a benchmark), include test rolls (some photographers mark up cost by 10 percent)
- Processing film (allow for extra charges for "pushing," "pulling," "clips," and Polaroid film for tests if used)
- Shipping film by FedEx, etc.
- Add a small amount for the unexpected things that do come up
- Of course, add your fee (by the day or by the job) to the estimate if this is a professional assignment

- Once prints are developed, tape them together to make strips, overlapping the pictures if
 necessary. It usually takes four or five pictures to show one side of a building, and it takes four
 strips of photos to show a building exterior, or a room interior. This method allows the photomontage to be viewed with a perspective close to normal vision, rather than distorted by
 wide-angle lenses or panoramic cameras.
- Always remember you are the eyes of the director. Don't leave any visual question unanswered.
 Photograph inside all rooms that might be used, showing all doors and windows. Photograph looking out of windows, and show surrounding landscape and buildings. Take close-ups of special architectural features, or possible problem areas.
- Outdoors note carefully on each strip of pictures: orientation, time of day, sun direction.
- Indoors note floor number, ceiling height, room size.
- Also note building height/number of stories, property size, whether nearby roads belong to town, city, county, etc. (for parking permits).
- Then you will need: owners/management/other contact names, business and home phone numbers, and local government and police numbers for any necessary permits. (Not often needed for stills.)
- Needed also: listing of local accommodation and restaurant facilities; availability of fax, Federal Express, and similar services; and, important for location scouting, a one-hour-photo lab.
- Finally, the location scout has to negotiate the price for the shoot, if the location is chosen.
- Location scouts almost always work in a hurry. Send the picture montage strips (glued onto legal-sized manila file folders, with all pertinent data written on individual folders) via overnight express to your client.
- If a location is approved, notify the property owner and fix a shooting date. (Also notify the owners of places not chosen.) Then you can return home.

Researching a Destination—New Zealand

I still have not been to New Zealand. For an exercise and because I want to go there, I researched the trip for the first edition of this book in a conventional manner. (The information has been updated below.) First I consulted The New Zealand Tourist and Publicity Office, Air New Zealand, and the *Insight Guide to New Zealand*. I called Hertz and Avis and a travel agency specializing in tours to New Zealand. I talked to two friends who were there recently and I carefully studied two picture books of New Zealand. (The Air New Zealand and New Zealand tourist office brochures that were sent to me are well illustrated too.) Through these means, I came up with a budget and itinerary for a three-week trip.

Budgeting a New Zealand Trip

Based on my research, the travel cost at the time of writing for a three-week independent trip from New York to New Zealand would be about \$6,000 (excluding film and processing, or the photography fee). Economy class advance purchase air fare from New York to Auckland costs about \$1,300 in winter, \$1,500 in spring and fall, and \$1,700 in summer.

(Remember the seasons are reversed Down Under.) Air New Zealand, Continental, and United are the carriers from the United States at present (you can also fly from Canada and Australia). An automatic transmission car for three weeks with unlimited mileage currently costs about \$1,500. (Less if you can drive a stick shift.) Single or double midprice motel rooms cost about \$40–60 per night at the time of writing. There are plenty of less expensive bed and breakfast, farmhouse, and cabin/campground accommodations too. Recreational vehicles (RVs) can be rented, and there are some luxury resorts that accommodate RVs. Allowing about \$50 per day for gas, modest meals (most motels have kitchenettes), and incidentals, land expenses should be around \$3,000 for three weeks. Add \$500 for internal tourist flights, ferries, boat and yacht trips, and unexpected expenses. (Two people traveling together would increase the land cost only about 10 percent, for meals.) A prebooked car and rooms are essential in late December and January. Prices fall somewhat in the spring and fall.

Group tours to New Zealand are less expensive than individual travel; a reason many people take tours. About \$3,000 is the current minimum basic cost of a three-week tour from New York to New Zealand, including air fare. (Of course your photographic opportunities will be somewhat limited if you take a tour, unless it's a photo tour.) For students or tight budgets, there are local trains and busses. Tent-camping sites and walking tours are available.

With this type of estimating, you can decide if personal travel is affordable, or if a stock shoot would be cost effective. Professionals can present clients with a detailed and accurate picture of expenses.

Highlights of New Zealand

New Zealand has about 3 million people and 70 million sheep. It is comprised of North and South Islands (a few tiny ones too) divided by the Cook Strait, and is about 800 miles long. The peak summer travel season (Christmas through January) is somewhat crowded (by New Zealand standards) at tourist spots because New Zealanders and Australians take their vacations at this time. At other times, you can happily drive around as your whim dictates. Spring and fall (the reverse of ours) have good light for photography but are cool in the evenings. Winter in New Zealand is cold in the South with heavy snow in the mountains, and rain in the North.

Auckland, where flights from North America arrive, is the principal city (population about 800,000). It is famous for yachting and is the largest Polynesian city in the world, with about 100,000 (mostly New Zealand Maori) residents of Pacific Island descent. It has good shops, interesting museums, etc. Auckland, though, is not the main reason to go to New Zealand. The spectacular scenery is. The "must sees" in New Zealand are:

North Island

On the North Island, places to go are the scenic and yacht-filled Bay of Islands; Rotorua and the thermal hot-springs region; and volcanic Mount Taranaki/Egmont and surrounding national park. Most tourists visit the Waitangi Treaty House where, in 1840, the peace treaty ending hostilities between Maoris and European settlers was signed. It is now a national shrine and museum. (I have mixed feelings about such monuments; I don't need to tell you who lost the wars, or their lands.) Many Maori people live in northeast New Zealand. Wellington, the capital, has a population of about 300,000 and is at the south-

ern tip of North Island. This is where car and passenger ferries make the three-and-a-half-hour, sometimes rough, crossing to Picton on the South Island.

South Island

The South Island is the more scenic of the two. The 12,350-foot-high Mount Cook and the glacier of the same name are in the country's most famous national park; a friend said the small-plane flight to the glacier and a stay in the Hermitage Hotel at its base were very enjoyable. The rolling Canterbury plains have enormous sheep farms and nice pastoral landscapes.

Milford Sound, Doubtful Sound, and the Fiord region are world famous. You can take day steamers and make wonderful pictures (but allow time if you need sunshine, because the fjord area has one of the highest precipitation rates in the world, and the fjords are often misty and foggy). The city of Christchurch, founded for Anglicans of good character (and still considered very English), is one of New Zealand's most beautiful. The Otago Lakes, especially Te Anau, are recommended as extremely scenic. Hikers can take the Milford Trek, a famous escorted walk of several days; high-season reservations are needed far in advance. It is possible to stay at a Maori "marae" or meeting house or on a sheep farm in several places to meet these very different types of New Zealander. The national sports passions are cricket, Rugby football, and lawn bowling. All are played fiercely, and a match or two should not be missed. You can do all or most of the above in a busy three weeks, if you fly between major centers. There are also scenic rail connections between the main cities of New Zealand.

Quite obviously, a deeper look at New Zealand would take longer than three weeks; if I were an ambitious young travel photographer I might backpack around the country for a few months.

If all this sounds very expensive, remember that New Zealand is a long way from New York. The airfare is about \$300 less from the West Coast. Compare prices to current costs to and in Europe or Asia.

New Information on New Zealand

Now that I am on the Internet I had terrific help via e-mail from New Zealand photographer Craig Robertson, who first contacted me through my Web site. He read the first edition of my book, and set me straight on a couple of points about his country, including the fact that cricket is an important national sport. So, I shamelessly asked for help. He generously replied in detail. Our e-mail correspondence is included in chapter 11, so that you can see the amazing amount of information that can be found on the World Wide Web.

Researching Lower-Cost Travel Destinations

A trip to New Zealand is expensive from the United States. But all the places listed below will produce fine travel pictures and, at the moment, the United States and especially Canada are great travel bargains attracting visitors from all over the world.

In the United States and Canada research a trip to New England (especially Maine and Vermont) if you live in the West; to the Southwest (especially Arizona, Utah, and New Mexico) if you live in the Northeast; to Montana or Wyoming if you live in the deep South;

or to the Louisiana plantation and bayou country and New Orleans if you are a Northerner or Midwesterner or a Canadian. Or, plan a trip from anywhere to Canada's maritimes, or British Columbia, which are both very beautiful; the Canadian dollar is currently discounted 15 percent against the U.S. dollar. Mexico, too, is currently a great bargain, and southern Mexico especially is an attractive travel destination.

Travel "Comps"

If you have a legitimate editorial assignment to go anywhere from a major publication, you may well be able (or the publication may be able) to get discounts, or even "comps"— (complimentary fares, passes, accommodations, etc.) for part or all of the trip. This does happen, although most top travel magazines pay their assignees' own way, for obvious reasons.

Bona fide members of the Society of American Travel Writers, who are well-published professionals, are often invited on trips by national tourist organizations. Membership requirements of this organization are very stringent, requiring extensive publication. There are a few photographer members. For requirements contact them at 1100 Seventeenth Street, Suite 1000, Washington, DC 20036. Phone (202) 785-5567.

Questions to Resolve with the Client before Going on Assignment

- Who is going to own the residual rights to your pictures? You should always keep control of your copyright, for residual and stock sales and because your pictures are your legacy that may possibly be valuable as art one day. (See also chapter 13.)
- Are all your travel, film, and incidental expenses for the assignment covered? Professionals should make sure that all legitimate, nonpersonal expenses are covered.
- Are travel time and editing time covered? The ASMP (American Society of Media Photographers) recommends that professionals charge half their photography day rate for this work.
- Are you being offered a guarantee of a certain number of days or pages at an agreed rate, or a flat fee for the job? Negotiate this with the client.
- Will the overseas office supply you with an interpreter/or translator if needed? Normally the answer to this is yes for a corporate business assignment and no to an editorial assignment; for the latter you will have to find your own on the spot. (I prefer students to professional guides.)
- Will the new cruise ship/other facility actually be completed when you arrive? Be sure about this one, and make sure you will be paid if you have to wait around.
- Do you need to photograph all the vessels/hotels public rooms/other subject matter, or just the important ones/part of it? Is the assignment in color or black-and-white or are both needed? Find out before you go. (If ever in doubt, do more, not less.)
- Are professional models lined up, or do you have to cajole the passengers/staff/local people into acting as models? Make sure to take appropriate language model releases. (See chapter 20.)
- Is time spent waiting due to bad weather and schedule conflicts allowed for in the schedule? Be sure airline reservations can be changed if the need arises.

- Is there any limit on the amount of film you may shoot? (Established professionals with good rapport with the client should not have to deal with this one.)
- Are there any other conditions?

Written agreements or contracts that spell everything out will save grief and money if you run into any problems later. My best advice: Never commit your own money to a job without an official company purchase order and a money advance. Ask for a detailed letter of assignment stating the client's requirements, terms, and the payment policy if the work ends up not being used through no fault of yours. Return a copy of the agreement, signed and dated, marked with the notation "Terms Agreed" before you leave. While some oral agreements hold up in court it's always better to get everything in writing.

Caution: Get a big percentage of your expense money and your guarantee "up front" (in advance). I ask for at least 50 percent of expenses and a percentage of the fee. Arrange for periodic "progress payments" on fee and expenses if the job is a long one. You still have to pay the rent at home.

When all the above is settled you can happily leave on your trip. Now all you have to worry about is doing a great job for the client.

Official Government Advice for Overseas Travelers

I do not presume to give security advice, except to recommend always keeping a low profile when traveling. If you are planning a trip to any area where unrest may exist, or where travel is difficult, consult the following for any possible advisories (warnings) on travel.

The U.S. State Department's Citizens Advisory Center is in Washington, D.C. Call (202) 647-5225 from a touch-tone phone and have a pencil and paper handy; the system is automated, you get answers by punching in different numbers. It sometimes takes time for the line to answer, so be patient. Get information about obtaining a U.S. passport, where to write for background papers on travel in general, and travel to specific foreign countries and regions. U.S. Public Health Service foreign immunization recommendations and requirements, and Consular Service foreign visa advice is also available. Travel advisories (warnings) are given out by the same number. These too are recordings obtained by punching numbers, and are changed daily or as necessary.

Note: This same telephone number is also the one to call if you have major problems (like the illness or death of a companion, or someone's arrest or disappearance) while overseas. In serious emergencies like those, of course, you can talk to a human being.

The travel background information is sent to you by mail, for a small fee, so allow time when using this service.

Booklets on many travel subjects are published by the U.S. Government Printing Office. They include *Foreign Entry Requirements* (#459X), which lists over two hundred embassies and consulates, *A Safe Trip Abroad* (#154X), *Tips for Travelers to Mexico* (#156X), and *Your Trip Abroad* (#158X). All of these booklets cost \$1 each. Order from R. Woods, Consumer Information Center-X, P.O. Box 100, Pueblo, CO 81002. Other governments have official travel advisory services and publish travel information also. For information on how to get much of this same type of information via the Internet, see chapter 11.

Professional Reference Books and Favorite Guidebooks

Ken Haas's *The Location Photographer's Handbook* is must reading if you photograph big shoots overseas on assignment. It contains information about carnets, health, safety, public holidays and more.

The Professional Photo Source includes listings of assistants, foreign consulates, labs, permits, rentals, repairs, stock agencies, stylists, travel/tourism information, and more. It is especially strong for New York and the U.S. East Coast, but it has good information about most of the United States and some for Canada, London, Paris, and Milan.

A good general guidebook is a friend when you are traveling. My first choice now is the Insight series of guides—first because they have lots of well-reproduced color photographs which give a sense of what a place looks like, and second because they are strong on cultural and historical background information. They include practical stuff about electricity, climate, public holidays, transport, etc., and information (not too detailed) on accommodations, from international class to campgrounds (with an emphasis on moderate prices).

Frommer's extensive guidebook series is fine; and have been around since my student days. Fodor's guides are long established, and cover most of the world. Michelin's Red Guide is indispensable for France; their Green Guides to different regions of France, as well as many foreign countries and cities (many of which can be had in English), are reliable and especially good for finding interesting hotels, restaurants, historic sites, and architecture.

The Lonely Planet Guide series specializes in Asia and Third World countries. These are illustrated with photographs and are now my choice of guidebooks when traveling off the beaten track. They have an interactive Web site as well (see chapter 11).

I list all these guidebook series because sometimes your preferred one doesn't cover where you want to go.

Maps

I've loved maps all my life. A map can set you dreaming, then will help you plan driving schedules, choose centers, and estimate time needed. Maps help with captioning pictures and make great souvenirs when marked with your travels. AAA's regional maps and guides of the United States are free to members. It's worth joining just to get these. They have Canadian information too. (So, of course, does the Canadian Automobile Association.) Rand McNally, Hagstrom, and Hallwag maps of foreign countries are widely available in North America. Get one for the country/region before you leave; detailed and city maps are best purchased at your destination. Maps as well as guidebooks can be found at many bookstores.

Today, some maps are available on the Internet.

Insurance for Traveling Photographers

You have to consider several kinds of insurance:

- Your medical insurance usually covers you overseas (except in wars) unless you stay away for six months or longer—check with your insurance company.
- Travel cancellation insurance and travelers' medical insurance (covering air ambulances, etc.) are available through travel agents.

- Camera equipment insurance for amateurs is usually available as a floater on household insurance. Consult insurance brokers.
- Baggage insurance (not professional equipment loss) is an option on some credit cards.

Professional Insurance for Photographers

ASMP offers its members several types of professional coverage:

- "Pro-Surance" covers studio content, including electronic equipment, valuable papers, worldwide camera coverage, and more. Reshoot insurance covers expenses caused by loss of exposed film due to lab damage and camera problems and more. The premium is based on annual billable expenses; it is not cheap—neither is the cost of reshooting a job.
- Other recommended types of insurance are: Personal or Commercial Liability and Workmen's Compensation Insurance (you must have this last in the United States if you hire assistants or models). For more, contact ASMP, other professional photo associations or insurance brokers. (Also see resources, in chapter 20.)
- The only group insurance for camera equipment alone that I know of is offered to members of the Professional Photographers of America (PP of A); (see resources in chapter 20).

Pretravel Checklist

At least a month before your trip get:

- Small passport pictures (get/make extra prints).
- Passport (if you don't have one already; I keep mine current).
- Visa(s), if needed.
- Required and optional vaccinations (ask your doctor or the U.S. Public Health Department).
- A carnet for your equipment if needed (see chapter 14).
- Insurance (personal and photographic—see earlier in the chapter; check and make sure all policies are current).

Reservations-Make them all as far ahead as possible, including:

- Airline ticket(s)—include domestic or connecting flights, overseas flights, and local flights at home or overseas. (*Note:* advance-purchase air tickets are often cheaper than those purchased at the last minute; but these are not a bargain if you must change plans frequently; unrestricted tickets carry no penalties. Standby tickets are always great bargains, if you can be very flexible. They are often available from New York to London, for instance.)
- Car rental reservations. (United States and Canadian driving licenses are accepted
 by rental companies just about anywhere. If you are going to buy, lease, or borrow
 a car abroad, check auto associations or consulates to see if a translation or a foreign driving license or special insurance is required.)
- Train, car, or local ferry or cruise reservations, if required.

Then get:

- Hotel/motel reservation confirmation(s)—important for the first night or two in crowded cities like London, and in busy tourist/resort areas.
- ATM card/Bankcard. Many overseas cash machines now accept North American bank cards. There are now cash machines in most airports and many other places overseas.
- Credit Cards—essential for modern travel to all but the remotest places. (I recommend carrying both an American Express card and either a Visa or Mastercard.) Activate the PIN cash advance numbers if you haven't done so already.
- An AT&T or other telephone company card. Also, carry your phone company's USA Direct (or equivalent) call-home number card; overseas calls charged to foreign hotels cost a fortune.
- Travelers Checks. American Express checks are accepted just about everywhere without a qualm; with some other checks you must go to banks to cash them, not always convenient. I like \$50 denominations. (Record all numbers; store one copy of the numbers at home; keep one copy in your wallet and another in your clothing bag.)
- Cash. A few clean U.S. one-, five-, and ten-dollar bills are handy in addition to \$50 in local currency. U.S. dollars are widely accepted for tips overseas.
- Professionals should take letters of assignment and introduction, and contact phone numbers. Make two copies of these. Pack the spare copy safely with your gear.
- Business address/telephone book or Palm Pilot.
- Daily planner or diary (or Filofax or laptop computer).
- Guidebook and map (supplement locally).
- An option is a cell phone (best rented in the locale you will be in).
- I carry my important papers en route in a flat courier's purse, with a wrist strap. It has compartments for passport, tickets, credit cards, traveler's checks, different currencies, etc. Or, be like New Yorkers and wear a waist pouch. Carry travel documents with you at all times when staying in cheap hotels or camping. In good hotels, put valuables in the safe while working.
- Carry a lightweight plastic file folder to conveniently store important but not vital items such as telephone number/address book, business cards, lists, maps, etc., and receipts and notes as you accumulate them. Store this in your luggage.

Checklist for Personal Items

- Personal address/phone number book.
- Glasses or contact lenses if needed; spare glasses, prescription.
- Medication if needed, and prescription(s).
- Toiletries, with personal hygiene items, Tylenol, etc. (I keep a kit with all this stuff packed in my bureau so as not to forget important trifles; to be stuck somewhere without a nail file can be miserable. I also keep a spare house key in this kit.)
- Thin wallet (to keep on your person when documents are checked).
- · Business cards.
- · Pocket calculator.
- Travel alarm clock or watch.
- Felt tip marker, ball point pen, pencils.
- Clothes. The less you can carry the better. Avoid anything that has to be dry-cleaned (often bad; usually expensive and slow overseas).

- · Comfortable walking shoes; lightweight dress shoes.
- Plenty of socks and underwear.
- A robe/nightwear.
- Easily washable working wear. (Mine is usually khaki or black pants, with a turtleneck and layered tops plus a loose wind/waterproof jacket with plenty of pockets.) I
 don't wear a photographic vest—I feel they make me look too conspicuous, and a
 possible target for thieves.
- Thin gloves, or ski glove liners plus mitts for really cold weather.
- One lightweight, hand-washable dressy outfit (mine is a black silk shirt, with flowing black pants or a long batik skirt, black silk socks and black Chinese slippers).
- Carry a swimsuit if you wish, but buy summer or winter resort clothes locally if needed; they look more appropriate than those brought from home, allowing you to "blend" better, and they make fine souvenirs.
- A lightweight raincoat or poncho is a must. (If you get one in a glaring orange or yellow, you can wear it to stand and photograph in the road!)
- I don't wear sunglasses (they get in the way of photography) but almost always buy a big hat or long peaked cap locally (they bring me luck).

Photographic Checklist

Well ahead of time, make a complete list of all the photographic items that you carry with you. List all serial numbers, for both customs and insurance purposes. Make several copies of this document, leave a couple at home in a safe place. (Or, obtain a carnet. See chapter 14.) Thoroughly check out any new or newly-repaired equipment. Test emulsions. (Shoot film for both.) Buy film.

You Will Need to Take

Copy this list as is, or adapt to your needs.

- Film
 - 35mm color transparency. Slow, medium, fast, tungsten; as needed
 - 120/220; large-format film as needed
 - Color negative film in sizes and speeds needed; Amateur, Type S, Type L
 - Black-and-white film, slow, medium, fast
 - Polaroid film, as needed for different cameras and backs
 - Film holders/roll film backs
 - Sima lead-foil bags for film
 - Ziplock freezer bags for storing film
- Camera bodies with bodycaps, as needed
 - 35mm
 - Medium format
 - Large format
- Special cameras (Digital, Polaroid, panoramic, underwater, etc.)
- Polaroid backs for camera format(s) used
- · 35mm lenses
 - wide-angle
 - normal

- telephoto
- zoom
- macro
- P.C./T.S. (perspective correction; tilt/shift)
- Tele-extenders
- · Lens shades if used
- UV filters (use as protectors on all lenses)
- Favorite Filters/gels
- · Gel holder
- Gel kits, gel sheets; gel frames for lights
- Cable release(s)
- Handheld meter(s), as needed
- · Soft fabric pouches or wraps for equipment
- Tripod
- Cable releases (include special release for dedicated/TTL cameras)
- · Camera clamp
- Disposable batteries of each size used
- Battery charger(s) dual voltage 110/220v
- Flash unit(s) and:
 - Dedicated remote cord for TTL flash
 - Rechargeable gel-cel battery pack(s) for flash
 - Flash foot to lightstand adapter (if needed)
 - Bounce card or dome for softening flash
 - Flash bracket if used
 - Slave unit(s)
 - Trigger unit(s)
 - PC (sync) cords
- Portable strobe pack(s) and:
 - Strobe heads
 - Strobe tube(s) and modeling light bulb(s) and spares
 - AC power cords for strobes
 - Slaves for strobe(s)
- Misellaneous
 - Voltmeter and neon tester
 - Tungsten Quartz light(s), if used
 - Foreign plug adapters
 - Pig tail(s)
 - 110-220v transformer, rated for your equipment
 - Light stand(s)
 - Umbrella(s)
 - Portable soft light bank(s)
 - Adapter ring(s) and struts for light banks
 - Reflector(s), collapsible; white, silver, gold, black
 - Small A clamps
 - Small screwdriver set
 - Vise grip
 - "Swiss Army"-type pocket knife

- Leatherman tool
- Tape—gaffer, electrical, masking, mailing
- Magic marker(s)
- Model releases: English, foreign language
- Rubber bands, Avery labels, 3" × 5" cards, notebook(s)
- Camera bag or backpack; under seat, sturdy, about $11" \times 16" \times 9"$
- Soft camera bag, with shoulder pad
- Shipping case(s) for strobe(s), light stands, tripod, umbrellas, etc.
- Luggage cart and shock cords
- Soft-sided bag (for clothes)
- Cheap crushable nylon duffle bag (for extras acquired en route)
- Large, strong, Army-style duffle bag (I put luggage inside this)
- Padlock(s), chain(s), and spare keys

	(-)/
_	Specialized professional items:
_	Misc:
_	Misc:

Tips for Hassle-Free Packing

Copy my lists (or make your own) then check off preplanning, personal, and photographic items as you pack them. It is all too easy to forget something important if you don't.

Your best bet is to make a list of everything photographic you own, and then choose what you will need on the assignment. Pack a day ahead. Take as little clothing as you can get away with.

I hand-carry onto the plane: cameras, film, lenses, and fragile items; a tiny toilet kit and a good book.

Last Minute Checklist

Professionals should call/check in with the client before leaving. Something may have changed at the last minute.

- Leave contact number; arrange how to keep in touch, perhaps via e-mail.
- Keep the home as well as the business number of the client on hand.
- Pay up your personal bills, and arrange for someone to return business calls and email and look after your studio, apartment, house, cat, plants (not to mention husbands/wives/loved others/kids, etc.) while you are away.
- Let other clients/contacts know you are/will be in an area, and for how long, and that you are available for assignment when the primary one is finished.
- Twenty-four to forty-eight hours ahead, order a cab, limo, or van to take you to the airport (if needed).
- Don't panic. If you did forget to pack something it's not the end of the world; you can probably get it locally. If not, and it's vital, you can probably call home and have it sent.

If you've done all the above, you should be able to sleep well before you take off!

ome people may think that doing a professional travel assignment is like going on a lovely paid holiday. It's seldom like that. When on assignment, photography is just about all I do for eight, ten, twelve. or sometimes more, hours a day. On assignment you must often be up before dawn for days in a row—and dawn is around 5 A.M. in many places during summer—to catch the first light or to drive or fly a long way to another destination.

Your Responsibilities to a Client

On any assignment you are spending a lot of someone else's money, and they are depending on you to bring back what they need, when they need it. Sometimes this is difficult. For instance, you may not be sent to a given location or country at the right time of year for the best pictures, but you have to make fine pictures anyway.

There is often pressure of time on an assignment, especially in these days of tight budgets. Or, there are problems with scheduling and coordinating the shoot that must be resolved on arrival, no matter how careful the advance planning. You must allow extra time for poor weather in some places, and occasionally need to be able, as Kipling said, to "keep your head when all about you, are losing theirs and blaming it on you."

Far from partying, I usually have room-service meals and watch local TV to unwind in the evenings. Travel assignments are challenging, demanding, exciting, and interesting almost always, but a vacation almost never. Almost.

Every single travel/location photographer has his or her own way of dealing with pressures and problems, getting mentally focused and keeping concentrated on the goal—good photographs. The following is my way.

Getting Started

If the first leg of the trip is by air, I book a car or van service to the airport to avoid struggling for cabs while dragging my heavy equipment cart. I arrive at the airport two or three

hours before check-in time. This gives me a choice of seats (I like an aisle seat near an emergency door on the left side of the plane; I get cramps in my right knee on long flights!) and time to get my film hand-examined, not passed through an x-ray machine. (This may not be possible outside the United States and Canada, see also chapter 15.)

Despite the advice I give other people, I always rush around a lot taking care of last-minute details before I leave home (or when making a long transfer between locations), so I try to schedule a free day before starting work in a new place. I would pay for this day myself if necessary but, luckily, most clients know that jet lag reduces efficiency and allow you that leeway on a trip. Ideally, make long intercontinental trips by day, arriving in time for dinner, a shower, and bed. You can do this trans-Atlantic or to South America. If you have time, long trans-Pacific flights (which are no thrill in a crowded plane with a cramped economy class seat) can be made easier by a stopover in, say, Hawaii or Tahiti, which is certainly no hardship.

On arrival I schedule a free day for meetings with local client representatives, scouting for locations, exploring, acclimatizing myself, and a little relaxation time before starting shooting. The worst moment for me on any travel assignment is when I have arrived at the destination and settled into the hotel, but have no pictures in the camera. I feel lost, not knowing where anything is, or whether I will be able to make any sense out of the place at all. One may have read all the guidebooks, talked to people who have been there, and talked to others about the job, but not until I have given a place a thorough onceover, and been out and taken a few pictures, do I feel that I'm in control. This nervousness applies even when I go on assignment to places that I know very well, like London, but of course is much stronger when the place is totally new. Shooting lists and letters of instruction are often made by writers, or editors, or business executives, and not by visual people. Some designers and art directors have such a specific vision, it makes you wonder if you can, or even want to, come close to it. Different people who work for your client may want different things from the same shoot.

At dusk in a strange city, tired after a long flight, sometimes you wonder if any of this is translatable onto film. Of course it always is, sometimes more successfully than others. It is your job as a professional travel photographer to make that translation; to capture the sense and look and feel of a living, breathing place onto little pieces of Fujichrome or Ektachrome. You have to make people who aren't there with you share what you feel, and also show them what the client wants to express in many cases. You know in your heart that you can do it, that you will do it, but stage fright is always there before you "go on." My father (who was a trans-Atlantic commuting actor) told me that fear before the performance is a mark of a good actor—perhaps it is a sign of a good photographer also.

When I am being paid to photograph, I always stay in a good, centrally located hotel. English-speaking staff, telephones that work at all hours of the day and night, and room service are all important when you are working long hours. I ask for a quiet room with a view, not too close to or far from the elevators.

To banish jet lag and nerves with physical activity, I start by turning my hotel room into a comfortable working environment. I separate equipment from clothes, and cameras from lighting equipment; lay out my notes on the desk, and put film in the mini-refrigerator. I hang my dress clothes in the closet, but never put anything except paperwork in (one) drawer. (I used to unpack completely when I first started traveling, but left behind a lot of nice clothes!) I put my travel alarm, photo frame, and books by the bed. Then I have a good soak in a hot tub after the plane ride, go down to the hotel lobby and buy a

MINIMIZING THE RISK OF THEFT WHEN TRAVELING

In a reputable hotel I am not worried about theft by the staff, but I don't take chances. I have, as I have already said, nondescript luggage, and I keep it and all the photographic equipment I am not carrying that day padlocked in the cases and out of sight in the closet.

- I put my valuable document case with travelers checks, credit cards I won't need, and cash
 into the hotel safe, keeping only a Visa card and enough cash for a day or two on hand. (I
 check my passport too, in many places, but keep it on hand in places where a police presence seems to make this a good idea.)
- I wrap exposed film each day in a freezer bag and date it, and put it away (in the hotel "minibar" in hot countries).
- When I'm paying the bills, and staying in mass-market, big-city, or budget hotels, especially
 those near railroad stations, I keep all documents on my person. (Use secure pockets or a money
 belt/pouch.)
- I also carry my cameras and other expensive equipment with me. If you must leave tripod
 and lighting equipment, extra film, luggage, etc. in such a hotel, I strongly suggest tipping
 (generously) the concierge, or a member of the front desk staff to lock your valuables in the
 hotel office.
- Caution: In hostels, campgrounds, etc. never leave anything for even a minute, however inconvenient. (Two English college students I know had all their money, checks, and passports stolen in a campground toilet at the Grand Canyon. They had left them in their backpacks, outside the stalls.)
- Never, ever, leave luggage unattended at airports, banks, bus stations, car rental offices, railroad stations, or in train compartments. (See also chapter 15.)

local map, a few postcards, and a perhaps a souvenir pictorial guidebook to the place. I usually chat to the concierge or hall porter about local transport and take a stroll in the vicinity of the hotel.

First thing next morning, I make phone calls to let any contacts know I have arrived, and arrange appointments if necessary. Then I drive (or am driven) around for an hour or two in the country (in towns and cities I walk) or take a taxi, subway, or bus to look at the "heart" of the area (as recommended by the guidebook, client instructions, the concierge or other locals).

If it is my first visit to a great city I will probably take a standard half-day sightseeing tour to get oriented. I'll take a camera on these trips (it would be asking to miss great pictures not to) but use the tour more to orient myself than to photograph. I take a map and mark locations, the direction of the sun, and time of day. I also list the positions of high viewpoints and interesting neighborhoods. I make notes of things I need to cover by neighborhood and plan a shooting schedule. Important outdoor locations have priority because of weather. Specific events/festivities obviously can't be moved, so I schedule around them too.

If required, I meet the client's local representative that first day and use her to help make appointments for "people pictures" and indoor locations, scheduling them for middays if possible, so I won't lose good early and late outdoor shooting light. As I said, especially on the first evening or two, I try to eat in my room, and like to relax and watch TV. (This

can be hilarious, because overseas it's often old, dubbed, American westerns; sometimes these days there's also CNN or a music channel.) The next day I start shooting.

Photographing at Tourist Facilities

To photograph hotel or resort architecture, rooms, and staff you have to coordinate with the management. These pictures have to be scheduled for when they won't disturb clients, often at midday. For interiors, I use a tripod always, and mostly 28mm and 20mm lenses, and I usually set up lights to photograph rooms. "Styling" rooms by adding flowers, a book, or a picture, or by moving plants, changing a bedspread, or removing little cardboard signs, TVs and little minibar refrigerators is often needed.

My favorite quick hotel exterior shot is with a nice line up of staff outside the main entrance. I pose gray-suited management, uniformed front-desk staff, imposing doorman in full regalia, pink-overalled maids, napkin-bearing waiters, and aproned luggage porters. This almost always looks good, and implies Service with a capital *S*, which the client loves. At the pool you can do handsome lifeguards and towel boys—you get the idea. Small hotels, inns, and restaurants are best photographed with the smiling, friendly owners out front.

Photographing Food

To photograph inside restaurants is tricky. You always have to go and talk to the chef in person, arrange for him to prepare something to be photographed (yes, they mostly are temperamental), and arrange a time when he (or quite often she nowadays) can pose. I sometimes draw the chef a picture of what I mean to do, so he or she can visualize the effect wanted. A kitchen usually needs "styling" (which means getting rid of ugly things, rearranging others, and perhaps bringing in special props, like a big fish, lobster, or colorful fruit and vegetables). I like a row of big, well-polished pans hanging in the background of kitchen shots. The best times to photograph chefs are usually about 11 A.M. and 5 P.M. because they've finished most of the work of preparing lunch or dinner, but the customers have not yet arrived. There is usually about a half hour lull for them at these times. I never tip chefs (they usually have more money than I do) but do get their name and address and send prints.

For food setups I always use a tripod, and usually use light bounced out of an umbrella and soft, high sidelighting. Sometimes I use tungsten light and film to blend with the overall lighting, but more often use a portable strobe or two joined Vivitars. (See chapter 7.)

I always try (and usually succeed) to find someone on the staff (it's often a management trainee or public relations person) to assist me when shooting in hotels and restaurants, because of the need to set up fast, move tables and food around, shoot, clean up, pack up, and get out smartly.

Photographing Tourist Staff

Although you can usually get off-duty hotel and restaurant staff to pose as clients, they don't often have the right clothes or "look" to be clients, and I don't use them as models unless desperate. I do like to photograph staff doing their work though, and tip them appropriately afterwards.

Sometimes staff will rescue an assignment, as when I had to photograph Harrod's department store in London. I was allowed one hour between 8 and 9 A.M. for two mornings before the store opened, because Harrod's does not permit photography of its customers, who often include royalty and the rich and famous. I photographed the large handsome doorman outside the main entrance and posed the head of the great Food Hall in his tailcoat and gray silk tie in front of shelves of caviar and truffles, marrons glacés, and hovering white-capped assistants. Then I made pictures of the butcher and his assistants putting frills onto lamb legs, and elegant young women at the perfume counter spraying themselves with stuff that cost more per ounce than many people earn in a week!

The staff were so pleased to be photographed that for the grand finale I was granted the special dispensation of fifteen minutes to photograph Harrod's famous tearoom in all its glory of massed iced cakes, chocolate biscuits, scones and clotted cream, while a line of hungry people waited not very patiently for me to finish so they could attack the goodies when the tea shop opened at 3 P.M. I had rented a 600-watt quartz hot light for this assignment, because I had to move around so fast, and bounced the light out of an umbrella and used tungsten film. Hot lights are very quick and easy to set up and knock down (for more see chapter 7). I should mention, though, that the Harrods' cakes were starting to melt a bit as I finished.

Photographing Tourist Guests

At hotels and resorts, you can scout for guests who will pose for you and sign releases (it's usually easy to find good-looking "models"; you may have to persuade some by reassuring them that they are very photogenic, otherwise you wouldn't have chosen them). Arrange optimum hours to shoot them at the pool, golf course, beach, etc., all of which look best at uncrowded times. Too many people at any of these spots makes the place look cheap. Buy the guest a "thank-you" drink later (on your expense account, of course) and, if possible, send "outtakes" (decent slides you can't use) later as a gift.

Photographing Monuments

You are almost bound to have to photograph the Sphinx if you go on assignment to Egypt, the Great Wall when in China, and the Taj Mahal in India. They, along with the Statue of Liberty, the Acropolis, and many other places you can easily think of, are symbols for a whole country or culture and are always in demand by tourism and business clients. American Express, Federal Express, and textbook publishers for instance, all use all of these "musts" in different ways.

You may find your first sight of a world famous monument disappointing; the Pyramids for instance, are a flat, dusty beige in overhead noonday sun, and are usually surrounded by crowds. You will have to decide how to make the Pyramids look their majestic best. (I hired a camel and driver and met them next day at dawn in the desert; the sun rose behind the Pyramids, the camel was silhouetted in front for a fine effect.) The Pyramids also look powerful at dusk, and there is floodlighting and a sound and light show just about every night at the Sphinx and nearby Pyramid.

When photographing any world famous monument or site, you must usually get up early to avoid crowds, or stay late, or do both. Sometimes, special permission is needed. Quite recently I had the Liberty Bell in Philadelphia to myself for an hour before the pub-

lic was admitted at 9 A.M. (Of course I needed permission from the local National Park Service superintendent.) At all monuments, look at the light, try new angles and a creative approach. There is always another good picture to be made of even the most familiar symbolic sights; they are almost all truly splendid things.

Capturing the Spirit of a Place

This is the most difficult thing to do of all, and no two photographers will do it in the same way. I can suggest that you be very thorough in your advance research and in scouting the location once you arrive, that you go back more than once to a scene that you like if it's necessary, and that you include as many local people as possible. If you are inexperienced it's very important not to forget photographic basics in the excitement of being there. Your own taste will be your ultimate guide, trust it—and your own talent.

Keeping Track of Pictorial Goals

Whether on a paid or self-assignment, you must be focused (literally and mentally) on what you want to express in your photographs. Think of the pictures you are taking at any given moment as part of a larger whole. Refer to your letter of assignment (or whatever instructions you received, or list of goals you set yourself) frequently to refresh your memory. It's easy to overlook something, especially if you weren't crazy to do a particular shot in the first place. Try to visualize how a real or imagined art director/designer/picture editor would use your photos.

If you shoot too many all-green-and-blue landscapes for instance, they will look boring laid out together in a magazine, tourism brochure, exhibit, or album of prints. Balance landscapes with architecture and people pictures, and make sunrise or sunset or interior exposures on daylight film, for warm color. Mix overall views, medium shots, and close-ups. Take verticals as well as horizontals, and make both right and left facing compositions.

Keeping Flexible

While careful advance planning is extremely important for any successful travel photography, and especially critical for travel assignments and self-assigned stock shoots, a plan should not be so rigid that nothing can be altered. Weather, local conditions, and problems with other people's schedules can change the best laid plans. If I can avoid getting locked into reservations, I always do so. If I go on a charter flight or restricted air ticket, I allow some extra time for contingencies that may force a change in plans. If nothing goes wrong (it usually doesn't) a few extra days at the end of the shoot "hanging out" with your cameras are great; I take some of my best personal pictures then. At such times, you can scout for new story ideas, take stock shots, or, of course, just relax, which is divine but makes me feel rather restless after a day or two!

Locally, be flexible, too. You must be able to stop eating in the middle of lunch if the sun comes out while you are photographing in Ireland—the pretty light may only last for fifteen minutes, and if you keep lunching you may miss the shot you have been trying to get for two days. If you suddenly learn about a local festival that will make all the difference to your coverage of Hong Kong, you must change your reservations to Bali, whatever the later problems. Lord so-and-so may cancel three appointments (very politely, and

MAKE A SHOOTING LIST

- Note what you have to cover on a shooting list, it helps a lot as the assignment proceeds.
- Plan shots in series grouped by location, or by special equipment or assistance needed, or by any other method that makes sense to you.
- Check off items one by one as you photograph them. Sometimes you may want to go back to redo something you have already covered, if the weather improves dramatically for instance.
- I personally believe that people who shoot for stock have a bigger problem with balanced
 coverage that those working on assignment with outlines supplied by a magazine or commercial client. Successful stock photographers tell me that they assign themselves specifics,
 and make very detailed shooting lists, often with a daily schedule. Many work closely with
 their stock agencies, to produce coverage the agency feels is needed.

with good reason) before you can photograph him in his country house; the shoot will probably be rescheduled on the one night you had a theater invitation to a hit show in London.

Evenings at the theater are rare, though I love them. When I'm working on assignment, that's usually all I do. If I am photographing on the beach, or at a pool, I don't go swimming. If I'm shooting a market I'm not shopping. If I'm shooting in a restaurant or at a party, I don't drink (I've observed this last rule since an evening, long ago, when I lost some important party shots because I'd had a few drinks and didn't load a camera properly!)

Do the fun things after you've got your pictures—if you have the strength.

Pacing Yourself

When traveling on a long professional assignment, take an occasional complete day off, especially on a trip with several segments. You need it not only to rest, but also to get your receipts and expenses sorted out, organize notes for captions, mark any film rolls that slipped into the corners of bags, get your laundry done, and, especially, mentally assess the quality of the coverage you have so far. People on personal trips can of course take as many days off as they please!

On a day off, run a roll or two of test film through a local lab to check camera function and exposure. You can also use the day to telephone and schedule appointments and shooting dates. I have been known to cheer for one rainy day, and to revel in the chance to do nothing much in the middle of a hectic assignment. I enjoy room service, television, and a few peaceful hours as the raindrops fall.

Choosing a Center

I try very hard not to photograph on days that I fly, drive very long distances, or change hotels, all of which mean packing, unpacking, and rearranging my equipment for quick access.

Changing hotels is especially disruptive, so I try to work from a center if possible. I would rather stay in one place for a week than move three times, even if it means a lot more driving, because when I am organized in my hotel room it becomes my home quickly. I get to

KEEPING TRACK OF FILM FOR LATER PROCESSING

As you shoot, mark each cassette or roll with a removable adhesive Avery label (they come in all sizes and colors and are available at stationery stores) or use black permanent Magic Marker on film cassettes, to keep track of your subject matter. Mark each individual film cassette, for instance: Day 1, roll C; Day 3, setup B, roll D, etc., or whatever system makes sense to you. At the end of a day or take, put the film in freezer bags, squeeze the air out, and rubber band the bag closed. Mark date/location, etc., on the bag and then keep it cool until processing.

When you get the film processed (I recommend waiting until you get home for this), you can ask the lab to identify each roll with your removable marked label. First though, divide the film into groups. Then, process the film in two or three separate batches to minimize the slight but real risk of a lab losing or damaging an entire take. (Professional insurance to protect you for this is available from ASMP, see chapter 15.) Use the identifying labels also to select rolls for any necessary clip tests when developing.

know the staff, who can help a lot; and I learn where my favorite roads and views are, and about local events that often make for good, non-cliché, pictures.

A few years ago I had to photograph the large state of Bavaria in southern Germany. I had been there before, and knew I didn't want to stay in its largest city, Munich, because of city traffic and parking problems, and because the countryside was the focus of the assignment. I chose a good hotel (the Sonnenblick) on the outskirts of the resort town and regional center, Garmisch-Partenkirchen. Then I planned trips to the castles of Neueschwanstein and Hohenschwangau, the handsome lakeside resort of Lindau and many lesser-known places. I soon got to know the most scenic roads (even back roads are almost all fast and good in Germany) and found off-the-beaten track, half-timbered or painted villages, a beer festival in July, pretty lake steamers, brooding stretches of the Black Forest, and lots of locals, including a woodchopper with a feather in his green hat who looked straight out of the Brothers Grimm! Of course I also photographed Oberammergau, with its elaborately painted houses, woodcarving shops, and bearded males and long-haired women preparing for the next year's Passion Play.

I have no problem photographing as well as driving two hundred or three hundred miles in a day if necessary; of course, if you have a driver you cover more ground and it's less tiring. In Bavaria I was alone, and covered more in the nine days I stayed in Garmisch than I would have been able to if I had moved three or four times. I did burn a lot of gas though, but fortunately the client didn't complain.

Shipping Film Home for Processing

If you are going on a long trip with several stops, you may need (or wish) to ship film home for processing. (I don't like overseas processing.) Use a well-known shipping agency like FedEx, DHL Worldwide, or UPS. If possible let your lab or representative know beforehand you will be shipping film from overseas. After marking instructions on all the rolls, wrap batches of film in two layers of plastic bags, then wrap the whole package in newspapers for insulation. Tape that together and include detailed instructions for your trusted lab, then put the package in a sturdy box. (You can also use a Sima lead bag or two if you are worried about x-rays; see also later in this chapter and chapters 5 and 19.) Hand deliver

WARNING, WARNING FOR TRAVELING WITH FILM!

In the first edition of this book, I said I usually packed some film in my checked luggage. Now, because of the powerful new scanners that will check baggage at more and more airports, things are different. So: *Never, ever put film into checked baggage!*

These scanners give a light dose of x-rays at first, but if the operator finds anything unidentifiable (like bricks of film inside lead bag) the power is automatically turned up, until the rays can penetrate. This of course will ruin any film. Kodak and the other film makers have all issued warnings on the subject. There is no solution in this age of terrorism; carry what film you can, and buy extra if needed at professional photo dealers overseas. Have film shipped home buy air for processing, using a trusted air shipping service (see above).

the film to the shipping agency of your choice. Mark the package "Undeveloped Film, Do Not X-Ray, Keep Cool and Dry." You can ship the film in two or three separate packages to minimize possibilities of loss.

The forwarding company will deal with customs forms. Send the film to your lab, client, or other representative. Make sure they know that the film must be processed immediately on arrival. Arrange and if necessary pay for all this before you leave home. Federal Express or one of the others have offices just about everywhere. (See also chapter 15.)

Airport Security and the X-Ray Problem

I now carry all film I will need for a short trip onto the plane with me, because of new baggage scanning machines that are powerful enough to damage film even if enclosed in lead foil (see below.)

Despite the signs at airports, even moderate-power cumulative x-rays are not good for film. For carrying unused or exposed unprocessed film with you for several segments of a long foreign assignment (and through several mandatory airport security inspections), first ask for a hand inspection. (By law, agents must agree in the United States.) If that plea fails, and it may in some foreign countries, put your film in Sima lead-foil bags before passing it through the x-ray machine. The "Jumbo" size bag holds about sixty rolls of 35mm film; the price is reasonable, under \$25. Big Sima pouches are obtainable at professional photo dealers. I use the bags double-thickness in third world countries. (See chapters 5 and 19.)

When passing through overseas airports, put a few rolls of 1600 speed film on top of your hand-carried film package. That will convince many (not all) foreign security people to hand inspect your film, and save it from cumulative x-rays. I personally don't know anyone whose film has been damaged by airport x-rays, and have never seen film damaged by x-rays (I am told by Kodak that it looks like wavy shadows on developed film), but you can never be too careful.

Handling Travel Paperwork

When traveling and photographing, professionals must take the time to keep track of all expenses, or you will lose on both income-tax deductions and client reimbursements. (See the model expense report in chapter 20; you may copy and use it.)

I don't have a laptop computer, but I do note the exchange rate the first day I arrive in

a country, and keep a "Daybook" or diary of petty cash spent each day. (I keep all receipts, you never know if you will be audited; see also later in this chapter.) You may like to carry a currency converter; I use a calculator.

Pay all possible bills with credit cards. American Express cards have no preset spending limits, but you must keep your payments current. You may pay at any office abroad if you are on a long trip. Visa and MasterCard are accepted in some places and countries (especially at smaller hotels, restaurants, national railroads, and local transport companies) where Amex cards are not, and payments should also be kept current.

Always keep all money exchange receipts. You may need them to change money back into dollars, and the fee is a tax deduction for professionals. (Take my advice and never deal in black market currency. It is against the law, you will usually be dealing with unsavory people, and you risk being stuck with money you can't exchange back into dollars.)

Returning Home

Don't relax your travel vigilance when you land on home ground (it's easy to do when tired); keep track of all your bags until you are safely inside your own front door. Call your client or stock agency and say you are home. (They do care!) After any assignment/trip always have your film processed as soon as possible when you arrive home; the color can "shift" and image quality deteriorate quite quickly, especially if you had to keep the film unrefrigerated at any time during your travels.

First sort film into two, three, or more batches, identifying rolls by the dates/numbers/ letters you marked on Avery labels; then take a few key rolls to the lab immediately and refrigerate the rest. If you need exposure adjustment or more clip tests this can be decided after viewing the first of the take. Process the rest of the film in successive batches as quickly as possible.

When you have all the film back, edit, rough out group captions, stamp it with your name and copyright symbol, and rush it over to the client who is almost always impatient for that first look!

Tidying Up Loose Ends

Your last chores will be writing up expenses, making detailed caption sheets for the pictures (I keep mine on the computer), sorting out equipment, and getting it checked out and cleaned after an arduous trip. Then, bill the client as soon as possible.

Planning Personal/Vacation Travel

If I am traveling without an assignment, I plan an itinerary also (but a more relaxed one, of course) to see and photograph places that interest me. I let people know where I will be traveling, and call my answering machine quite frequently, just in case someone wants something from where I will be at the last minute. It happened once when I was "hanging out," as my daughter says, with friends in Rome. That first small assignment blossomed into a client that I had for twenty years.

On a personal trip, I don't usually carry more than two cameras, a lightweight tripod, and a small flash unit with external batteries and a charger. I take about four lense, and search for beautiful landscapes (which I like to photograph more and more) as well as in-

BILLING AND RECORD KEEPING FOR TAX PURPOSES

Bill the client and file your records as soon as possible, both to get paid quickly and also so that you remember what those funny little pink tickets and diary notations were for. (The U.S. Internal Revenue Service does not require receipts for items costing less than \$25, diary/daybook listings are accepted.) Keep and file the daybook. I advise keeping the pink tickets too; I am supercautious because I have been audited several times.

Include a statement on all your invoices that your terms are net thirty days. Many businesses today charge 1.5 percent per month interest on any unpaid balance; because final payments can take much longer than the customary thirty days, especially in lean economic times. (See the sample invoice later in this chapter.)

teresting people. I'll also do buildings and interiors if they are important. I do take plenty of my favorite slow and fast film.

I live modestly when traveling at my own expense, but that does not mean the trip is not fun or successful. I went to California some years ago because I wanted to get to know the state better, it was during an airfare war. I had previously done two assignments in San Diego, so I spent my three weeks mostly exploring the northern part of the state.

First, I spent a week in San Francisco (where I sublet a vacationing chef's apartment through a mutual acquaintance); then I got a good deal on a rental car and drove up through the wine country, cut to the coast at Mendocino, and drove up through redwood country as far as the Oregon border and saw great Victorian "lumber barons" mansions at Eureka. I returned inland, through the Trinity National Forest, gold mining and garlic growing country, then returned to the coast to see the famous sights of Carmel and Monterey, Big Sur, the Seventeen Mile Drive at Pebble Beach, and the rest of California Highway 1 down the rugged blue misty coast. I stopped near San Luis Obispo to photograph William Randolph Hearst's mansion—or palace—San Simeon, one of the greatest houses I have ever seen. Reservations for the mandatory tours are limited; book a few days ahead. Professionals should send a copy of the letter of assignment to the Rights and Reproductions Coordinator, Hearst San Simeon State Historical Monument, 750 Hearst Castle Road, San Simeon, CA 93452 to make arrangements. If it's a last-minute assignment, have your picture editor call the administration at San Simeon direct.

On the trip, I checked out Santa Barbara and loved the historic mission and Spanish-style architecture but was shocked by the number of oil rigs so close to the beautiful shore. Then I drove across Los Angeles on several freeways (but could not stop to photograph) passing the Hollywood sign en route (it's copyrighted). I spent a night in an art-deco first class cabin on the grand old Queen Mary in Long Beach and finished the trip by spending a few days with friends in Anaheim, where my daughter flew out to join me. We saw Disneyland together for three days before returning home.

I have sold quite a few pictures from that trip: the misty Golden Gate Bridge and redwoods; Disneyland and Caroline with Mickey Mouse; also of Point Lobos with and without Japanese tourists; vineyards in the Napa Valley; and even of California highways. Stock sales have long since covered the expenses of that odyssey, and more. I have since made another half-dozen trips to the Golden State, and love it. Highlights: Yosemite National Park, where Ansel Adams's ghost looked over my shoulder—rather inhibiting. I don't expect sales from that place. (Go well out of season to avoid crowds.) San Diego with its great

SAMPLE TRAVEL ASSIGNMENT INVOICE (Photographer's letterhead) Attn: Mr. Whizz Bang, Sales Director Sensational Tours Inc. 222 Landmark Avenue New York, NY 100?? Date: June 14, (year). Invoice for assignment to photograph hotels, inns, and tourist facilities in England May 24-June 8, (year). Rights granted: Use in tourism brochures from ______ to _____ (insert dates). (Note: Set time or other usage limit; this is negotiable, and should satisfy both parties.) Round-trip economy (but go business class if you can!) airfare: New York/London (based on current fare) \$600.00 Local expenses are denoted in Pounds Sterling (photocopies of receipts are attached) and converted at \$1.67 to the pound (use current rate). London taxis, busses, subways.......44.25 One week compact car rental180.00 Two nights Ye Olde Spotted Swanne, Stratford96.00 One night Roman Villa, Bath58.00

zoo, Death Valley, and Joshua Tree National Parks, and Anza Borrego State Park, all in the desert, are fine too. New Yorkers either love Los Angeles or hate it (it's mutual). I love the Big Orange, a truly great city. I can also honestly report that you don't need a car to photograph Los Angeles; the buses, taxis and the new subway work very well. I recommend West Hollywood where I stay as a great Los Angeles location. It's convenient to downtown, historic (and seedy) Hollywood, the beaches at Santa Monica and Venice, Beverly Hills, and most of the nightlife of Los Angeles. There are mid- and budget-priced hotels there too.

If you drive any distance on the freeways, plan your route ahead.

THE TRAVEL SHOOT

Misc. meals en route	154.00
Gas	
Admissions, tips, misc.	
Total expenses (in Pounds Sterling)	£1,700.45
Total expenses (in U.S. \$)	\$2,839.75
(Note: Pay everything possible by credit card to save problem panies will translate this into U.S. dollars, often at better rate	
Add cost of 86 rolls film and processing @ \$15	\$1,290.00
(Note: Add cost of Polaroids, clip tests, "push/pull" and rush	charges etc., if used.)
Total expenses	\$4,129.75
Agreed fee: 14 days @ \$500.00 per day (or as ne	egotiated) \$7,000.00
Total	\$11,129.75
Less received in advance	\$7,500.00
Balance due	\$3,629.75
All photographs to be returned, unaltered and unretouch	
tax due. (Note: check your own state sales tax regulations.) terest will be charged on the unpaid balance.	Terms net 30 days; 1.5% per month in-
Thank you,	
14 - 14 - 14 - 14 - 14 - 14 - 14 - 14 -	
(Signed) Phantastic Photographer	Date

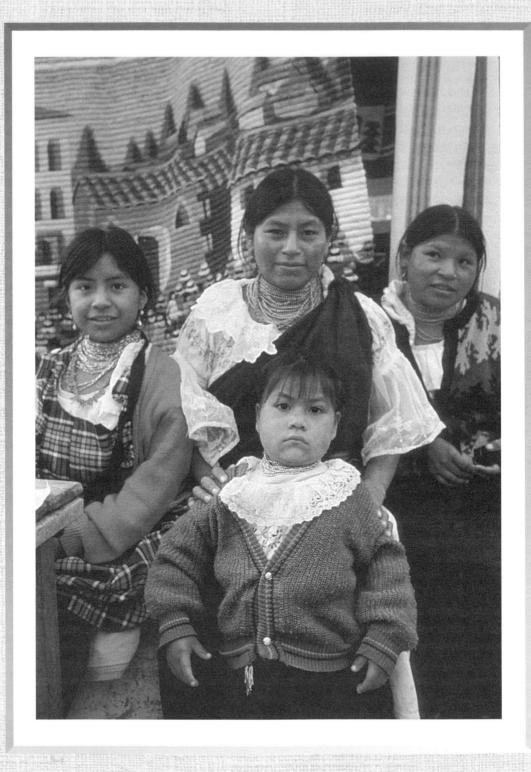

he places recommended in the next three chapters are all worth photographing. Many are also well-known symbols of a country, region, or city—such travel pictures tend to be good sellers. Wherever you go, also make every effort to photograph interesting people (get model releases wherever possible) as well as go off the beaten track.

Dig into guidebooks to research less obvious sites; talk to people who have been there; surf the Internet; and contact regional and national tourist offices or airlines for additional travel information.

The United States

The United States is an increasingly popular destination for tourists from all over the world. "The States" is easy to travel in, with comfortable motels at low prices. (These seem bargains to Europeans and Asians.) What I like best in photographing here is that within any region there is more cultural and visual variety than most realize. (What I like least is road-side food!)

New York City

My adopted home of New York is marvelous to photograph, and most people are friendly—but of course be somewhat cautious. Tourist areas like Times Square are well policed, but don't work in lonely spots with valuable equipment without an assistant or companion to keep an eye on the surroundings. (While crime has fallen in New York recently, such precautions are always wise in most places today.)

The Statue of Liberty is a symbol for the entire United States as well as for New York. View it from Brooklyn and New Jersey as well as from Battery Park and Liberty Island. The Brooklyn Bridge, Empire State Building, World Trade Center, and Times Square are other major New York symbols or "icons."

Spring and fall days in New York have exceptionally clear light; at Christmas the decorations are spectacular especially in Italian sections in all five boroughs; Fourth of July and other holiday fireworks are mostly set off on the East River.

Dusk shots of Manhattan made from the Empire State Building, RCA Building, or World Trade Center observation towers, or the walkway of the Brooklyn Bridge, are classic. So is the view east to lower Manhattan from the park beside the Exchange Place PATH train station in Jersey City (a short ride across the Hudson River).

May, June, and September have block festivals, great for photographing people. New York's Chinatown grows ever larger, an authentic quarter with outdoor food markets is east of the Bowery around Grand Street. Italian religious festivals are held in all boroughs June through September. Just about every population group in the city has a parade one day of the year.

Brooklyn's photo opportunities include the Caribbean communities' Labor Day parade on Eastern Parkway. Take the D subway train to Coney Island to photograph working New Yorkers (and tourists) relaxed and at their best. Rides are open June through Labor Day; the Mermaid Parade is in mid-June; boardwalk and beach are there all year. The Brooklyn Botanical Gardens are at their best late March through June and September to October.

The Bronx has Yankee Stadium, with colorful baseball bars nearby. Other world-class highlights are the New York Botanical Garden and close by, the Bronx Zoo.

The Staten Island ferry, a free twenty-minute trip from Manhattan's Battery Park across New York harbor is the greatest photographic bargain in the world. The ferry passes the Statue of Liberty and Ellis Island, though not too close. Staten Island boasts New York City's only historic village, Richmondtown Restoration; the rest is mostly suburban.

Boats leave every hour from Battery Park, Manhattan, for Liberty and Ellis Islands. Be prepared for hideously long lines, spring to fall. For photography with a tripod inside, permission is required at both sites; apply well in advance, with a copy of assignment letter, to: The Superintendent, Statue of Liberty/Ellis Island National Monuments, Ellis Island, NY 10004.

For quarterly event lists and maps, contact the New York Convention and Visitors Bureau, 810 Seventh Avenue, New York, NY 10019. Phone (212) 397-8200. Web site: www.nycvisit.com.

To use a tripod for a professional shoot on any public sidewalk or park in New York City apply for a permit to the Mayor's Office for Film, 1697 Broadway, New York, NY 10019. Phone (212) 489-6710. The office is efficient—getting a free permit takes about ten minutes, but you may have to show proof of liability insurance. (Note: for most purposes in New York, you can actually do as I do, and shoot like an innocent tourist. The locations where permits are essential are listed below.)

To use any professional-looking tripod at Lincoln Center, Rockefeller Center, South Street Seaport, Battery Park City, or on the observation decks at the Empire State Building and World Trade Center, you will need permission. Apply in advance to these privately owned sites' public relations departments. Tourists with small tripods are not usually bothered. To photograph inside the world symbol of finance always requires proof of an assignment; apply to the Communications Department, New York Stock Exchange, 11 Wall Street, New York, NY 10003, phone (212) 656-6215.

New York State

"Upstate" New York is rolling and beautiful, has nice, small towns, and industrial cities that will surely make a comeback one day just because of the architecture. Niagara Falls and the Adirondack National Park are highlights. I have a house in the Town of Shawangunk in the Hudson Valley, an hour-and-a-half from the Big Apple. The area is mostly orchards and fields full of black-and-white cows; it looks a lot like parts of England.

Across the Hudson River at Hyde Park, the large but simple Franklin Delano Roosevelt home is next door to the ornate Vanderbilt Mansion, one of America's stateliest homes. Get advance permission for professional photography indoors at either place.

Farther north and west in New York State, Saratoga is famed for horse racing and Chautauqua for culture; both have great gingerbread architecture. Our wine-producing region, the Finger Lakes, is extensive and you can visit wineries. Taughannock Falls and Watkins Glen have Victorian-looking waterfalls; my pictures of them somehow look like antique postcards.

Niagara Falls, New York, is not my favorite city—the motel strip on New York 62 is classic kitsch. The falls themselves are the greatest natural attraction in the eastern United States. Get close-ups of Horseshoe Falls from the west side of Goat Island. Niagara Falls, Ontario, has parks, a floral clock, and great views. Take one of the Maid of the Mist boats close to the falls for terrific picture opportunities. (Use an underwater camera, or protect cameras on this excursion; rain ponchos are provided.) Make time exposures of the floodlit falls at dusk from the Canadian side.

Pennsylvania

Go to Philadelphia in May to see crew racing on the Schuylkill River (and crews tending boats) along Boathouse Row, illuminated at night. The area is good for city skyline pictures too. Delancey Street runs across Philly to posh Rittenhouse Square; it's pretty to handsome all the way. The Italian Market in the South End and the "center-city" covered Reading Terminal Market are fun. National Park Service permits are musts for photography with a tripod at historic sites; arrange to visit before opening hours at the Liberty Bell and Independence Hall, which are always mobbed.

Near Philadelphia, Valley Forge has reconstructed soldiers' log huts, and George Washington's stone farmhouse headquarters. I like it under snow, when the shivering army is easily imagined. Route 120 from Williamsport (where the Little League Baseball World Series is held in August) runs past pleasant scenery to the edge of the Allegheny National Forest; close is Hyner View, the so-called Grand Canyon of Pennsylvania. Gettysburg battlefield is worth photographing; prosperous farmland nearby is lovely.

New England

People in Maine, Vermont, and New Hampshire are very friendly, despite the jokes made about them. Smaller villages are typically crowned with white wooden churches. Mixed hardwood and pine trees, hills, mountains, lakes, and, in Maine, the rocky shore, lighthouses, and ocean, make scenery as lovely of its type as can be found anywhere. I especially like East Jamaica, Vermont, near Bennington, and Castine, Maine. The fall foliage season in New England is world famous and runs from early September to late October (earliest near the border of Quebec). In Massachusetts in fall the Berkshires around Pittsfield are photogenic. Boston has the charming Beacon Hill district of brick houses and cobblestone streets. Cambridge has Longfellow's mansion and Harvard; the Harvard Yard is good to photograph in fall when it is full of fresh-faced students pushing bikes. Don't miss the Cape Cod National Seashore.

Rhode Island has whaling captains' houses at Bristol, yachting and the nineteenth-century summer "cottages" (mansions) of America's aristocracy at Newport, and misty, mysterious Block Island. Connecticut has Mystic Seaport historic restoration with fine old ships, some picture-perfect villages, including Lakeville, and Foxwoods, a huge casino.

Roads and accommodations can be jammed in New England at fall foliage time. I have stayed in Vermont then without reservations; many homeowners rent a room or two at peak season. (Book hotels and inns early; find rooms through local tourist bureaus or chambers of commerce.) Don't miss a church supper (good food, cheap, and a way to meet and photograph locals).

Washington, D.C.

To me, Washington, D.C. is the most beautiful city in America. Of course, the U.S. Capitol is the icon. Walk around it for different great views. The Canadian Embassy is across from the East Wing of the National Gallery of Art, both are part of a much-photographed view up Pennsylvania Avenue to the Capitol. A 300mm telephoto lens shot from the Iwo Jima Memorial across the Potomac includes the dome of the Capitol, the Washington Monument and the Lincoln Memorial together. Get great Washington photos at cherry-blossom time, but it's hard to predict when in March/April this falls. I like the capital at Christmas when the huge national and fifty appropriately decorated state Christmas trees are in their glory. The subway and busses go most places; taxis are cheap. A car plus permits for professional photography from the appropriate National Park Service bureaus are essentials for George Washington's Mount Vernon and Thomas Jefferson's Monticello. Both mansions are nearby, in Virginia.

New Jersey, Delaware, Maryland, Virginia, North Carolina

New Jersey has sweeping beaches, old-fashioned beach resorts, and even a modest mountain or two in the northwest. Atlantic City has Donald Trump's Taj Mahal and other casinos; nearby is Cape May with Victorian houses, also the Brigantine National Wildlife Refuge, famed among birders.

Rehoboth Beach, Delaware, and Ocean City, Maryland, are family resorts complete with rides, fishing, pleasure boats, gingerbread architecture, and crowds in summer. Around Chesapeake Bay on Maryland's eastern shore, there are a few undiscovered villages; find your favorites with a car. Baltimore has a redeveloped harbor and a great aquarium.

The Delmarva Peninsula is flat farmland all the way to Cape Charles, Virginia, a town famous among fishermen—the Black Drum fish caught around there in May have to be pushed around in wheelbarrows.

The Assateague, Maryland, and adjacent Chincoteague, Virginia, National Seashore protected areas have booming surf and white beaches. In summer hike away from the parking areas to avoid crowds. The wild ponies of Chincoteague are round up on a day in August when there are huge crowds. In March and mid/late November millions of migratory birds stop over in the wildlife refuge. Cape Hatteras, North Carolina, is another beautiful National Seashore.

The South

The restoration at Williamsburg, Virginia, with costumed villagers and crafts demonstrations is fine to photograph—avoid holidays. Professionals need permission and may be able to arrange private time at crowded attractions. The University of Virginia, designed by Thomas Jefferson, is an architectural masterpiece at Charlottesville. The Skyline Drive along the Blue Ridge Mountains (start at Front Royal) is winding, lovely, but often hazy. Spring and fall are best seasons, foliage color is at its peak sometime in late October.

TO USE A TRIPOD IN WASHINGTON

Security is tight in Washington, D.C. To photograph with a tripod at, near, or in just about all the famous places requires a permit; apply well in advance. The National Park Service, National Capitol Region, Public Events Office handles the monuments. Call them at (202) 619-7225. The Capitol Police, Sergeant at Arms Office, issues necessary permits for outdoor photography with tripods in the Capitol vicinity, and for (assigned) indoor photography, phone (202) 224-3121. To photograph inside the White House requires a letter of assignment to get a permit; send it as far ahead of time as possible to the White House Usher's Office, Washington, DC 20500.

In West Virginia, Harper's Ferry is situated at the confluence of the Potomac and Shenandoah Rivers, and has terraces of old stone houses as well as the ruin of John Brown's fort—and arsenal.

The countryside of western North Carolina around Asheville is mountainous; great folk art is made in the region. I've photographed Cherokee woodcarvers, quilt makers and doll makers in the region. The Biltmore Mansion near Asheville is an American stately home built to resemble a French château by a Vanderbilt. The Great Smoky Mountains National Park is the most visited in the East, has many deer, some wild bears, and great scenery.

I have three times taken a boat along the Intra-Coastal Waterway, between Newport, Virginia, and Miami, Florida. See the naval port of Newport, full of battleships, tankers, and smaller craft, and nearby historic Portsmouth and the Dismal Swamp Canal (named before travel public relations; it's not at all dismal) south of Elizabeth City, North Carolina.

Charleston, South Carolina has white wooden Georgian houses and in the harbor is Fort Sumter, where the American Civil War began. Savannah, Georgia, is noted for gardens, restored cotton warehouses along the riverfront, and flowery streets of wooden homes.

I "did" Atlanta years ago, and revisited it recently. The place has grown so much it was almost unrecognizable. The Martin Luther King Memorial is always surrounded by groups of solemn kids; Coca-Cola Headquarters, and the panoramic view from the revolving Atlanta Tower are other "musts." Old Stone Mountain outside the city has heroic-size carvings of Southern Civil War scenes.

In Florida, Cumberland Island is a nature refuge, and there are decaying mansions of nineteenth-century industrial barons. (Some descendants still visit.) The beaches are empty, with wild horses to be seen. Jacksonville has a drawbridge over the Intra-Coastal Waterway, Cape Canaveral is a thrill. (There is rampant motel development nearby, great for my kitsch collection.) Rich Palm Beach reminds me of Bermuda, with pink and white houses. I must be the only person living in America who has never been to Walt Disney World. Fort Lauderdale is quite rich also, with wall-to-wall pleasure craft and cruise ships in the harbor.

Miami Beach's historic South Beach has restored 1920s and '30s art deco hotels, plenty of palm trees, and at the right season, gorgeous models and celebrities of all sexes. European fashion photographers rediscovered the place a few years ago. Miami's Little Cuba, or Calle Ocho, around Sixth Street, has great restaurants. Sanibel Island has white beaches and the great Ding Darling bird sanctuary—go in January for greatest bird variety. Close

to Miami is Viscaya, a Spanish-style villa with waterfront gardens often used for fashion shoots.

In New Orleans, the iron-balconied houses of the French Quarter, the cathedral in Jackson Square, and Preservation Hall where jazz players can be photographed without flash (they appreciate a tip) are all icons. There's a great cemetery (don't go alone) and nearby plantations too.

The Center and Midwest

Nashville, Tennessee, has the Grand Old Opry (but it's now in a theme park) and Pigeon Forge, given over to mass-market entertainment. Don't miss Dolly Parton's Dollywood.

Columbus, in southern Indiana, is an elegant city of 35,000 where most of the finest modern architects of the twentieth-century have designed buildings.

A great Chicago view is from the Hancock building. I head to the Wrigley Building and North River for "instant Chicago" pictures, and have sold some of them as stock—which suggests the city is underphotographed.

Minneapolis and Minnesota have the promised lakes, plus prosperous farms and huge corn silos; South Dakota is to me awesome, as flat and as green as a billiard table in spring, with the Black Hills and the Badlands erupting at the western edge. Wyoming boasts the Devil's Tower, with a colony of prairie dogs frisking beneath it, and Cody has a great western art museum, rodeos and nearby unspoiled high plains scenery.

Yellowstone National Park is mostly in Wyoming. The wildlife and scenery are awesome; avoid the crowded summer season if you possibly can.

The Southwest

For me, the most spectacular landscapes in the world are in the American Southwest. Fly to Phoenix, Albuquerque, or Salt Lake City and drive in a circle through Arizona, New Mexico, and Utah and you can't go wrong photographically. Avoid high summer, if possible (although a lot of fine Indian festivals are held then), because of crowds and heat. If you start from booming Phoenix as I did, see Scottsdale; then drive up via Sedona and Oak Creek Canyon to the Grand Canyon. If you can't get a reservation in the park, try the logging town of Williams about fifty miles south of it, on the old Route 66; it's relatively unspoiled, with plenty of motels.

Grand Canyon National Park is open twenty-four hours a day, every day. Go in spring, fall, or winter if you can. Take the West Rim Drive to Hopi Point for sunset views (in summer you must park and use a shuttle bus). The East Rim Drive is open to cars all year. I like the views from close to the museum at Yavapai Point on the East Rim in the early morning. Take the East Rim Drive through the Painted Desert to Cameron (you can stay at a historic trading post there).

Monument Valley is a Navajo Nation—administered park straddling Arizona and Utah. Monument Valley is the most photographed landscape in the United States, an icon for the west; you have seen the strange red buttes in countless car commercials and in movies too. Go; it's a spiritual experience. The great red rock formations rise sheer from the valley floor, and Navajo gods seem close. I recommend staying at least a couple of days here, to catch sunrises and sunsets and ever-changing cloud effects, and just to soak up the feeling of the place. Don't miss the North Window, Artist's Point, and John Ford's Point. If you take a Navaho guide, he will show you views not seen by unaccompanied visitors. Camp in the park itself, or stay in nearby Goulding's Lodge, a motel that blends in with

the rocks around it. Nearby is Goulding's trading post, now a museum dedicated to John Ford movies.

From Monument Valley take Route 163 north to Utah—it's like driving through a Georgia O'Keefe painting—a landscape of round hills striated with red, gray, and black layers. Utah has the superb Bryce Canyon, where great views are a couple of steps from the car. In Arches and Canyonlands National Parks, you must hike to the great spots.

New Mexico has Canyon de Chelly with Indian pueblos, Chaco Canyon, Taos, Georgia O'Keefe's ranch, and historic, expensive Santa Fe. Besides the scenic attractions, on almost any back road in the Southwest you'll come across almost-abandoned one-gas-station towns, with old-timers wrinkled and dried by the desert heat. (The young of all races leave, mostly for the delights of Los Angeles.) In late summer in the desert, you get spectacular cloudscapes and intense thunderstorms.

Texas

I have been to Dallas, Houston, and El Paso, and plan to see Big Bend National Park and spring wildflower fields around Austin. In Houston I photographed oil-related things; the ship canal is a fine industrial landscape. In Dallas, must sees are the skyline, the infamous Texas School Book Depository building, and Neiman Marcus' store. El Paso is surrounded by mountains and mothballed aircraft; nearby is Mexico's Ciudad Juárez.

Nevada

Las Vegas is unbelievably photogenic. The strip (and the newest casino) changes all the time. Drive around the rather compact city to discover Vegas for yourself; or take busses and taxis. At nearby Laughlin, I had no trouble photographing inside Harrah's casino. The 1930s Hoover Dam is awesome. Nevada's ruler-straight empty highways are fun to drive fast on.

California

Disneyland, palm trees, and the Hollywood sign are icons. So are redwoods. California's three great cities each have a character of their own. My stock pictures of California have done especially well in Japan. I have discussed California photo highlights in detail in chapter 16.

The Northwest and Alaska

In Washington State I especially recommend driving the circle from Seattle around the Olympic Peninsula and Olympic National Park. Don't miss wild rocky Ruby Beach under tall cliffs, the great Hoh rainforest, or Hurricane Ridge. I stayed at Kalaloch Lodge on a three-mile long beach.

Seattle's Pikes Place Market vendors toss huge salmon around and enjoy being photographed. A suburban hill east of town gives skyline views. Eastern Washington has wheat, and summer rodeos and county fairs too.

Montana is rugged and romantic; some spots like Gardiner at the North entrance to Yellowstone are crowded in summer these days. See the monument to the Battle of the Little Big Horn, then explore back roads and trails.

Alaska is scenic, no doubt about that. The locals are friendly, and it's currently a redhot travel destination, therefore much photographed. I toured for three weeks by car and small plane, went to the Kenai Fiords National Park with great glaciers, to Katmai National

TEMPORARY IMPORTATION OF PHOTO EQUIPMENT INTO THE UNITED STATES

Canadian and foreign tourists and photographers should carry itemized lists, with serial numbers, of all equipment they bring into the United States. Get them stamped by customs on leaving home, and show them to U.S. Customs on arrival. If you have a "reasonable" amount of equipment, a verbal declaration that you are doing an assignment and temporarily importing used equipment—"tools of the trade"—will satisfy the United States Customs inspector. You may be asked to state when you are leaving.

If you carry high-priced, new-looking equipment, avoid problems by getting a carnet before you come. (See chapters 14)

Park where I had a marvelous time photographing brown bears catching salmon, and visited Denali National Park too. I was fortunate to see Mount Denali (formerly McKinley) clearly on successive days. Cautions: Restrictions on photography in Denali are severe, and Alaska can be rainy, foggy, and chilly even in summer. Alaska is expensive, and tourist spots are crowded because the season is only three months long. For these reasons, and perhaps because I come from cool Britain, I prefer sunnier places. I do plan one day to take the one-week or longer trip on the public ferry that runs up and down the highly scenic inside passage between Bellingham, Washington, and Anchorage, Alaska.

Canada

The Maritime Provinces

Nova Scotia is a province of Canada I know well. I have a theory that in about a hundred years time, the last truly unspoiled beautiful places will have what the English call "unsettled" weather. Nova Scotia is such a place. You don't go there to get suntanned (although the last few summers have been fine). Coming from the south, take a car ferry from either Portland or Bar Harbor, Maine, to Yarmouth, Nova Scotia, which has a lovely harbor. It's usually misty with small gray islets draped in seaweed and a fine lighthouse. Nova Scotia has hundreds of miles of rugged sea coast, a temperate, changeable-to-damp climate, an interesting and sad history (not to the credit of the British), and is to me another place with haunting spirits lurking in the atmosphere.

Go there spring to fall; see very authentic highland gatherings, many Scots went to Nova Scotia in the mid-1700s. You can meet their descendants and also those of American Loyalist families who backed the wrong horse in the Revolutionary War and fled north when King George lost it. Other Nova Scotians are descended from slaves who escaped to freedom; the province was one of the terminals of the Underground Railroad organized by American abolitionists.

Many Nova Scotian French Acadian settlers were expelled by the British at the time of the Napoleonic wars and went to Louisiana and became "cajuns"; a few managed to stay; others returned later. Today there are many quaint French villages, especially north of Yarmouth on the road called "French Shore," with several enormous wooden Catholic churches.

At Port Royal, there is a recreation of the oldest settlement in Canada, founded in 1604 by Samuel de Champlain. The place to see the enormous rise and fall of the Bay of Fundy

TRAVEL ADVISORIES

This book mentions a few places that have U.S. State Department or other nations' travel advisories (warnings) on record. While caution is advisable, be aware that problems may affect only part of countries or regions under advisory, and that there are sometimes problems in places where no advisories have been issued. If in doubt about safety, get up-to-the-minute information via the Internet, or by phone from U.S. or Canadian Consulates overseas before you go. See chapter 11 and resources in chapter 20.

tides (at fifty feet the highest in the world) is close to the town of Truro. I camped nearby at Bass River.

On Nova Scotia's south coast, Lunenburg is a picturesque port; pretty Peggy's Cove is often overrun by tourists. Nearby Blue Rocks is better. Cape Breton Island is joined to the rest of Nova Scotia by a causeway and is famous for a scenic coast road. Along it find pretty French-speaking fishing villages; Cheticamp, Margaree Harbor, Grand Etang, and Pleasant Bay are a few. On the south coast Keltic Lodge is a white wooden resort hotel located on a piney cliff jutting into the Atlantic.

There is a huge restoration of a seventeenth-century French fortress city, Louisbourg, near the town of Sydney. The road is bad but worth the drive; locals wear authentic costumes and uniforms. You can stay on the site.

In New Brunswick, another place to photograph great tides is the Fundy National Park. St. John is a pleasant city; Digby, a ferry terminal. Machias Seal Island has great puffin colonies (it is also claimed by Maine).

Everyone calls the small province of Prince Edward Island charming; I haven't been there. Newfoundland is rugged and beautiful. Some years ago I explored the Terra Nova National Park, with gray shingle fishing villages on stilts (one is named Salvage). There were huge wooden racks of salt cod drying in the sun, fishing boats bobbing in rocky coves and flocks of sea birds. St. John's, Newfoundland, has colorful pubs on George Street.

Goose Bay, Labrador, has a strategic airport, and is the bleakest place I have ever been!

Quebec

Montreal is clean, safe, and sophisticated. Some people don't speak English, but virtually everyone understands it. Montrealers are much more appreciative of foreigners' efforts at French than many French people. Place Ville Marie is the heart of downtown; explore side streets nearby. There are fine views from Mount Royal Park. See the Expo site and if you can, drive north to the photogenic, almost totally French-speaking Gaspé Peninsula. Quebec City has a superb site on steep hills and is eastern Canada's premier tourist attraction, the decisive battle for Canada between Britain and France was fought there. There are fine hotels, great food, and ambiance year-round. An ice carnival is held in February.

Ontario

The Toronto skyline is famous, there is a subway and shopping malls; the city is cosmopolitan. I have discussed Niagara Falls, Ontario, under New York State (my apologies to Canadian readers). Ottawa, Ontario, the dignified federal capital of Canada, is situated on the historic Rideau Canal, and it too has a famous ice festival in February.

One of the two "icons" of Canada is, of course, a redcoated Royal Canadian Mounted Policeman (RCMP, or "mountie") on horseback. Most RCMPs today wear blue uniforms or plainclothes, drive cars, and keep a low profile, but you can see them parade in full splendor in various provinces from May to September. Consult provincial tourist offices or the Ceremonies Department at RCMP headquarters in Ottawa. In early May, dates and places of performances are set for the season. The RCMP especially recommends the last week of June in Ottawa each year, because the band, the Musical Ride, and equestrian events can all be seen then.

British Columbia

British Columbia has two beautiful cities. The bigger, Vancouver, has a big Asian population and the fine harbor is surrounded by hills reminiscent of Hong Kong; the Gaslight district should not be missed. Compact Victoria is said to be English in feeling. It does have red busses and the ornate Empress Hotel where tea time is a ritual. Get shots of another icon of Canada, totem poles, at the display around the art museum. Butchart Gardens outside Victoria are an elaborate must see in summer.

British Columbia's resort cities of Banff and Lake Louise each have a gigantic châteaustyle hotel and great mountain views. In Banff, Jasper, and several smaller national parks, moose and Dall sheep can often be photographed from the road. I have been as far north as McBride in the center of BC, and driven down the Icefields Parkway, with great Rockies views at every turn.

Safety Tips for Traveling Photographers

- Always carry money and documents in a safe place, especially if using public transport. (Lots of New Yorkers use zippered waist pouches.)
- Remember that thieves watch airports worldwide. When in transit carry your own camera and film bags.
- Count the total number of pieces of luggage you have, and keep all luggage close to you at all times.
- Never flaunt cash, especially large bills; be cautious when leaving banks or exchange offices, and also if using street cash machines.
- Do not wear expensive clothes, or any jewelry, in the street.
- Dress to blend as much as possible with the locals; in nondescript fashion in bigcity streets and poorer areas.
- Carry all photographic equipment, including tripods, in inconspicuous bags. (I sometimes wrap my tripod in a black garbage bag.) Don't work alone outdoors at night. I put black tape over the Nikon name plate of my cameras to make them look less expensive.
- Never leave any luggage of any kind, especially camera equipment, unattended, even locked in the trunk of a car.
- Be cautious when leaving airports in rental cars, or when driving on lonely roads or in poor sections of cities. (Cars with out-of-state, rental, or foreign plates can be targets for thieves in many countries.)
- Don't photograph police, soldiers, or military installation in most countries, or slums in many countries. Most poor people resent being photographed and could react

TEMPORARY IMPORTATION OF PHOTO EQUIPMENT INTO CANADA

U.S. tourists entering Canada with a couple of cameras, a few lenses, and a reasonable amount of film will probably have no problem (but should carry an itemized equipment list, with serial numbers, and have it stamped by a U.S. Customs official before leaving).

In practice, enforcement of Canadian customs regulations seems to depend on where you enter the country. Customs officials at Niagara Falls, Ontario are easygoing, and I have never had to show my equipment or pay a bond there. It is also quick and easy to enter Canada by car from Maine or Vermont. But at Yarmouth, Nova Scotia, Canadian customs officials seem to stick to the letter of the law, and I had to put up a \$500 cash bond on one trip. (I got the money back on leaving.) Customs examination at Montreal airport is quite strict; the Washington-British Columbia border control seems relaxed.

Professionals who enter Canada with equipment should list everything, get the list stamped by U.S. Customs before leaving the U.S. and carry an assignment letter and copies of receipts with them, along with plenty of traveler's checks. You may have to pay a bond and a temporary import tax at the port of entry. Cash or traveler's checks only are accepted. This is refundable on leaving. You may need a business visa, a carnet and an insurance bond to shoot professionally in Canada. Consult Canadian consulates, or provincial tourist offices.

angrily if you attempt to sneak pictures. Slums, sad people, and the like are not true travel photography subjects. (See also chapter 16.)

Where to Get Official Travel Information

State, regional, and provincial tourist offices, and local chambers of commerce are all good bets for U.S. or Canadian information. Many foreign countries have national tourist offices in New York and/or Los Angeles, Chicago, San Francisco, Toronto or Montreal. Some are represented in Atlanta, Boston, Dallas, Denver, Miami, New Orleans, Seattle, and Vancouver, too. National airlines often have tourist information, as do embassies in Washington or Ottawa, or the nation's Mission to the United Nations in New York. Many of these places now have Web sites. To get information via the Internet, use search engines like Yahoo (www.yahoo.com) or Altavista (www.AltaVista.com) to find relevant sites. (See chapter 11.)

The Caribbean and Central America

Almost everywhere in this beautiful part of the world is highly photogenic, and weather and cloud effects are often spectacular. My cautions are to avoid photographing in harsh noon light, and to always ask permission before taking pictures of people, especially of poorer people.

Bermuda

Strictly speaking, Bermuda is in the Atlantic, but it has a somewhat Caribbean "feel" to me. Rent a motor scooter and tour to see pastel painted houses with stepped white roofs designed to catch rain, and fabulous pink beaches. My favorite is Coral Beach. Snorkel from

reefs by caves at the far end. Take an underwater camera; the fish are fabulous and the ocean turquoise. The town of St. George has a historic quarter. Bermuda's bobbies (cops) wear British-type helmets and Bermuda shorts and are much photographed. Get overall island views from Gibbs Hill Lighthouse, and from Hamilton harbor ferries. Bermuda is somewhat built-up, but not yet spoiled. Avoid Easter (packed with students). September is mild, green after August storms, my favorite month.

Puerto Rico

My advice to photographers going to Puerto Rico is to see the restored Spanish colonial quarter of San Juan first. Then, visit the ramparts of El Morro Castle commanding San Juan harbor, and just outside the city, Luquillo Beach—a splendid crescent enclosed by coconut palm trees; buy split coconuts and roast pork from little roadside stands. The "must" expedition is to the rain forest of El Yunque; this is not Amazon-sized but you can get jungly pictures there. I recommend then driving around the island for the best pictures. Look for resorts with great palm-fringed golf courses and fine white beaches. I also like little ports on the north coast that have bright-painted houses and boats.

The United States Virgin Islands

Both St. Thomas and St. Croix, have great beaches; rent a car and drive around on both islands. Hitch (or pay for) a ride on a Hobi-Cat for pictures of the islands from the glorious turquoise water. To live a recreated Winslow Homer scene, take an islander's sailboat from Christianstead, St. Croix to the Virgin Islands National Underwater Park. (I once photographed a skipper who steered his bright yellow boat with a rope tied to his big toe and to the rudder.) The park is fabulous for snorkeling—and I'm told, scuba diving. Of course take an underwater camera, or at least take a glass-bottom boat ride.

I have never been to the British Virgin Islands, which I'm told are beautiful, quiet, with good camping and a couple of exclusive resorts.

The Bahamas

The "must" in Nassau is the straw market. People shop for straw hats, and tourist carriages are drawn by horses wearing straw hats. The old British colonial architecture and the waterfront area where small interisland boats unload are picturesque. The police wear white uniforms with British-style helmets. It's okay to photograph them. Freeport permits gambling (cameras are allowed inside casinos with special permission; if you get it you must bring your own models during times the casinos are closed to the public). Exterior casino architecture is fun. Bahama out-island beaches are some of the most gorgeous in the world with clear turquoise water the temperature of a tepid bath. To sail around on a Hobi-Cat or Sunfish is divine. Ask permission before taking "people pictures" in the Bahamas.

Haiti

Haiti is my favorite place to photograph in the Caribbean—a beautiful place of artists, craftsmen, and terrible poverty. (Avoid photographing sad things and pay everyone for pictures.) There is wonderful ornate wooden gingerbread architecture throughout the capital, Port au Prince. The cathedral is decorated with murals, and the central covered market sells superb paintings and handicrafts and is great for people pictures.

There are white beaches an hour from Port au Prince. In the interior are thatched villages that look like some I saw in Africa. Fly or drive from Port au Prince to the citadel of

UNDERWATER PHOTOGRAPHY ADVICE FROM A NONEXPERT

Rule one for underwater photography is to get close to your subject. Refraction changes one's perception of size underwater (things look about 25 percent bigger than they are in reality). The light is very blue even a few feet below the surface; it gets deeper blue as you go down. A cautionary note for snorkelers: Underwater pictures taken just below the surface are blurry if high shutter speeds are not used. Because of big waves pushing me around, I once took a lot of blurred pictures in Virgin Islands reefs, and suggest you do better by shooting 400 ISO film at shutter speeds of at least 1/500 of a second. Better yet, use underwater flash.

Professional underwater photographers use slow films like Velvia, and mostly work extremely close up with flash. Flash brings normal color back to marine life and vegetation, and stops motion.

Even underwater duffers can get good fish and coral pictures just below the surface, if water is calm and if you wait and let the fish come close. (Carry fish food to encourage this!) I have made good shots in the shallow reefs off Coral Beach in Bermuda. It's also fun to shoot underwater in swimming pools, clear lakes, and streams.

Nikon's Nikonos professional underwater cameras are famous. Canon, Konica, and Minolta make point-and-shoot cameras for beach use and (shallow depth) underwater pictures. Ewa Marine cameras are recommended by some. Kodak and Fuji make disposable (shallow depth) underwater cameras. (See also chapter 3.)

Underwater Photography, by Charles Seaborn, gives an expert's advice. If you are serious, and want to take an underwater photography course, the Nikon School of Underwater Photography is well thought of.

Sans Souci. It takes an hour by plane, a day by jeep. The roads are awful but the scenery is verdant, mountainous and worth the jolting. Toussaint Luverture's fortress is a romantic ruin; a cemetery in the nearby town is full of pastel tombs, flowers, and boys leading goats. I bought a painting by the roadside for \$5 in U.S. dollars. The artist was pleased to make the sale. If you speak French you will do fine in Haiti; educated people all speak it.

Jamaica

I have been driven all over Jamaica; by a tourist board representative and by British friends living in Kingston. Highlights: The Land of the Maroons, in the remotest part of the Blue Mountains. Dunn's River Falls and nearby Ocho Rios. A visit to a ruined sugar mill. White Brahma cattle with egrets sitting on their shoulders. Banana plantations. River rafting on the Rio Grande. Small country villages on Sunday, with people dressed up for church. The great fruit and vegetable market at Montego Bay.

There is some antitourist feeling in Jamaica, a poor country where a few visitors have been less than courteous to the locals. Never take people pictures without first asking permission. Pay for releases. Don't even think of photographing the slum areas of Kingston.

Martinique

Martinique is a green, mountainous island that politically is a department of France. Mont Pelée, which erupted in the early 1900s killing many thousands, is in the north. The formerly most important city of Martinique, Saint Pierre, was almost destroyed at that time but is still photogenic, and has a memorial to the volcano victims. The island capital, Fort de France, did not excite me much but does have good French/Caribbean restaurants. The

big tourist attraction of Martinique is the museum commemorating Napoleon's beloved Empress Josephine who was born in La Pagerie. My favorite things to photograph on the island were the wonderful plants and trees. It rained a lot when I was in Martinique. I haven't been to the other big French island, Guadaloupe.

Trinidad

The carnival at Trinidad is less well-known than the one in Rio but is one of the great shows of the world; preparations start immediately after the last one ends and heat up around Christmas. If you get to Port of Spain a week before Shrove Tuesday, you will see massed steel bands, parade rehearsals, and festivities, and, for the three days before Ash Wednesday, huge parades of brilliantly costumed people everywhere. Apart from Carnival, the island has a bird sanctuary, sugar cane plantations, asphalt pits, and some industry. Cautions about peoples' attitude to tourists also apply here. Nearby Tobago is said to have great beaches and to be rather quiet.

The Antilles

The island of Sint Maarten/St. Martin is half Dutch and half French. It has many beaches. The Dutch side is now quite built-up, and the Dutch capital Phillipsburg has a busy nightlife; the French side of the island is quiet and the more exclusive hotels are there.

The nearby island of St. Barts is totally French, a charming, green, hilly dot in the ocean, and now is very exclusive and expensive. It is a favorite vacation spot for wealthy French families.

Central America

If you love colorful ceremonies and Indian culture, gorgeous handicrafts, fine beaches, and places that are not too touristic, much of Central America will appeal to you. It is also a current travel bargain. Check travel advisories before you go.

El Salvador

El Salvador is a small country on the Pacific and one of the physically loveliest places I have ever been. I spent a week photographing dormant volcanoes, ancient ruins in the jungle, roads lined with brilliant-yellow flowering trees, almost deserted white and black sand beaches, colorful fishing ports, and the pleasant (at least in the part I stayed) city of San Salvador. The people I met were nice too.

Panama

The Panama canal is the "must"; the Gatún Locks are a good picture point; great railroad engines called "mules" tow ships in and out of the immense lock chambers. I went to the San Blas Islands on a cruise ship. The island women are famous for "bolas"—cloth panels intricately cut and appliquéd in brilliant colors. Once they were used for blouses and shirts, now they are produced as art for tourists. Antique bolas are much prized. (I bought two and made some nice pictures of the seller also.)

Mexico

I may be the only person who likes the border towns between Mexico and the United States (but not everything there of course). I've been to Ciudad Juarez, Nogales, and Tijuana. Of

course they aren't the real Mexico, nor do they show our neighbor at its best, but there are wonderful markets, craft shops, delicious food, amusing things to photograph, and nice people. The less attractive things can be avoided fairly easily. I have been to Cancun and Cozumel on a cruise; these resorts aren't authentic Mexico either, but I enjoyed them. Check travel advisories before going to southern Mexico; when things are quiet, I plan an extended trip there.

South America

I have made five visits to South America; my first big travel assignment was for an airline when I spent six weeks touring Chile, Argentina, Brazil, and Peru. I've been to Ecuador and Venezuela too. Here are my impressions:

Argentina

Argentina is a huge country, physically varied, and has not been much visited in recent years. Happily, the political situation has improved, and Argentina is coming back onto the tourist map. Buenos Aires (often called BA) is a sophisticated city; it looks a lot like Paris in places. Buenos Aires is definitely underphotographed because my stock pictures of it still sell more than twenty-five years later. I attended the ballet at the famous Teatro Colon (and rode in the elevator of the elegant Plaza Hotel with Dame Margot Fonteyn and Rudolph Nureyev on several occasions).

I love cemeteries; the elaborate La Recoleta is the most ornate I have ever seen and is shown off as a tourist attraction. The brightly painted corrugated-iron houses and funky restaurants of La Boca, an Italian workingman's district, are made for photographers. (I went to a "futbol" match in the big stadium in La Boca, and was one of about ten women in a crowd of some 100,000 passionate male fans; Argentina is a former World Cup soccer winner.) There are big outdoor restaurants on the outskirts of Buenos Aires where parrijade—sides of beef and many smaller unnameable (and some, to my palate, uneatable) cuts of meat—are grilled over open pits.

Mar del Plata is a crowded seaside resort near Buenos Aires. Bariloche is an alpine-inspired town in foothills at the southern end of the Andes, at the edge of Patagonia. There are fine hotels; it's an exclusive ski resort in winter, a center for walkers in spring and fall. The nearby forests were the model for the forest drawings in Walt Disney's classic "Bambi." Close to Bariloche a chain of lakes leads to nearby Chile. The biggest Argentine lake is called Nahuel Huapí; it's surrounded by Andean peaks. I took boats and busses from Chile to Argentina. The two-day trip includes this lake, and can be done in reverse (from Bariloche to Osorno, Chile). I recommend it if you don't mind a night at a plain hotel in Peulla, Chile (reservations are advised). The lakes are gorgeous—I checked and it's all still possible. I drove across part of Patagonia, from Bariloche to the city of Trelew, founded by Welsh settlers (the Welsh are long assimilated and Spanish is the language spoken today). The Patagonia I saw was basically gray, flat, and desolate.

I'm told there are still fairs where gauchos (cowboys) perform great feats of horsemanship, but all I saw of the great Argentine cattle industry were a few gauchos driving small herds of cows or sheep.

Iguassu Falls, on the Argentine/Brazilian border, is one of South America's greatest natural attractions.

Brazil

Sadly, friends tell me that street crime in downtown Rio de Janeiro has reached epidemic proportions. Check advisories; don't work alone; use caution downtown and on beaches; and keep an eagle eye out for your gear.

The Brazilian countryside is much more peaceful. Ouro Prêto, in the state of Minas Gerais, is a national treasure, a perfectly preserved Portuguese colonial town with pastel-colored baroque churches and houses dating from the seventeenth and eighteenth centuries. There are also nice young mining students; one of them, who spoke good English, guided me in the town, which should be a must for all visitors to Brazil. The church of Bom Jesus do Matozinho is at nearby Congonhas. It has carvings of the twelve apostles outside. They were sculpted in the eighteenth century by a master called Aleijadino, which means "little cripple" in Portuguese. Recife (formerly Pernambuco) has fine beaches and a colonial quarter but is now mostly modern. I plan to go to Salvador (formerly Bahia) with my Brazilian friends; they say the city is colorful and the state has hundreds of miles of gorgeous empty beaches. The Pantanal in Mateo Grosso province has been recommended to me for wildlife photography.

The views of the great Iguassu Falls from the Brazilian side recommended as terrific, better than those from Argentina.

Chile

Chile is still a country for travelers, not tourists; it is now considered extremely safe. The beauty of Chile is not in its capital, Santiago, although see the main sights around the Plaza de Armas and vicinity, and visit the big vineyards an hour or so south of Santiago. The main reason to visit the country is southern Chile, a great combination with travel in Argentina's lake district (see above). The flight from the United States to Santiago, over the cordillera of the Andes and the 22,000-plus-foot-high Mount Aconcagua, is grand enough, but the route from Santiago to Puerto Montt is even better. The flight takes about two hours, you follow a chain of Andean peaks and eventually see four perfectly coneshaped, snow-capped volcanoes (each alone looks as beautiful as Mount Fuji). The biggest, most famous peak is Osorno; and once in a while it smokes. I stayed a few nights in the working port of Puerto Montt, with bright-painted warehouses, fishing boats, and seabirds in abundance. Small boats go to neighboring islands, and big ones down to Punta Arenas the southernmost city of Chile. Busses and taxis connect Puerto Montt with Puerto Varas and Ralun, where there is an attractive alpine-style hotel.

The air in southern Chile is clear (there is a major observatory in the region). The countryside has well-tended wheatfields and vineyards owned largely by the descendants of German settlers. Occasional horsemen go by.

Small steamers ply the major Chilean lakes, called Lago Llanquihe, Lago de Todos Santos, and Lago de Esmeralda; they probably still depart at unpredictable hours. (I missed one lake steamer because it left early, a not uncommon occurrence with local transport in Latin America.) Stay overnight in Peulla, Chile and connect with steamers over the border on Argentina's Lake Nahuel Huapí and buses to the fine Argentine town of Bariloche, center of a popular ski resort area (see Argentina, above). If you go further south in Chile from Puerto Montt (I didn't) you will reach the Paine, or Torres de Paine National Park; I have been told that the Torres are four spectacular jagged pink mountains, and very photogenic. The area is popular with naturalists, trekkers, and climbers who want solitude,

beautiful scenery, and the opportunity to view wildlife, and who don't mind roughing it or cold weather. Colonies of guanacos live in this national park and there are penguins further down, and whales off the coast. Boats leave for the numbing, stormy reaches of Cape Horn, Tierra del Fuego and Antarctica from Punta Arenas in the extreme south of Chile.

Valparaiso, north of Santiago has a mild climate. This busy port was founded by British settlers in the early nineteenth century and is surrounded by hills where cable cars climb steep streets with English names. Viña del Mar is across the bay from Santiago. I saw and photographed fine parks and mansions and ate delicious "ceviche"—fresh seafood marinated in lime—served at a flowery terrace restaurant overlooking the water.

Lan Chile, the national airline, is the place to get travel information.

Ecuador

The boom in green tourism is the reason for Ecuador's current popularity. To photograph birds, giant tortoises, and marine life up-close (and if you don't mind heat and humidity), take a cruise among the Galápagos Islands; it's best to arrange this in advance with a reputable tour company. A 400mm lens will help your bird shots. Don't miss mainland Ecuador. The colonial section of Quito, the capital, a Unesco World Heritage site with good hotels and some beautiful churches, is worth several days. Otavalo has a famous Indian crafts market on Saturdays, excellent for people photography. Banos is the jumping off point for mountain expeditions; the road to go there is called the Avenue of the Volcanoes. I plan to visit Amazonian Ecuador when things there are calmer. Check advisories.

Peru

Lima was the capital of Spain's great empire in all of the Americas, so it is worth lingering to view sights that include the fantastically decorated Lima Cathedral. The glass coffin and gruesome, mummified, purported remains of the conquistador Francisco Pizarro are the cathedral's top attractions. The Lima Gold Museum with surviving Inca masterpieces is a must. Ornate buildings surround the huge central Plaza de Armas where everyone strolls on summer nights. This is a good place to get pictures of people. It almost never rains in Lima so the city is rather dusty, but the center is quite well kept. From Lima, take a plane to Cuzco, a busy city with Indian markets, colonial churches, and a good art museum. Ask permission for people pictures here; you may sometimes be refused, but of course the Inca descendants' religious beliefs should be respected.

The highlight of any trip to Peru, and a world highlight, is the ancient Incan stronghold or temple of Machu Picchu. The train from Cuzco to Machu Picchu makes many twists and turns as it labors past villages where Indians spread out goods to sell by the tracks. Other Indians lead strings of laden llamas with fluttering eyelashes like pretty young girls—you can almost touch the beasts from the open windows of the train as it labors up steep sections of track. Alarming gorges, which I didn't care for, can be seen en route. I had only one day at the ruins, a stupid piece of planning. You should stay over at least one night, two or three if possible. Walk around the temples and climb to shoot down on the complex and the peak of Huayna Picchu behind it. Sunset and sunrise there must be wonderful. My stock pictures of Machu Picchu have been steady sellers. Italian friends made a nature movie in the Iquitos region of the Amazon jungle, and said it was marvelous. It's a place I want to visit some day.

Venezuela

Caracas is a busy city with broad boulevards and tall skyscrapers. It has a colonial past, but to me this is well-hidden. Like all the Latin American cities I have visited, it does have terrific nightlife. Venezuela's Caribbean coast and Margarita Island are popular with New York area tourists. I made a brief stop at Margarita from a cruise ship; this was pleasant but the beaches were quite crowded.

The considerable money in Venezuela comes from oil; I photographed a refinery in the desert at Punto Fijo and oil derricks in Lake Maracaibo. Also on Lake Maracaibo are fishing villages on stilts, where Indian people travel by dugout canoe. I photographed from one with an outboard. The resort area of Merida in the Venezuelan Highlands is said to be beautiful and pleasantly cool. Angel Falls, Venezuela's greatest natural tourist attraction, is the world's highest and is in the southern, hot and jungly part of the country. People go trekking in the area.

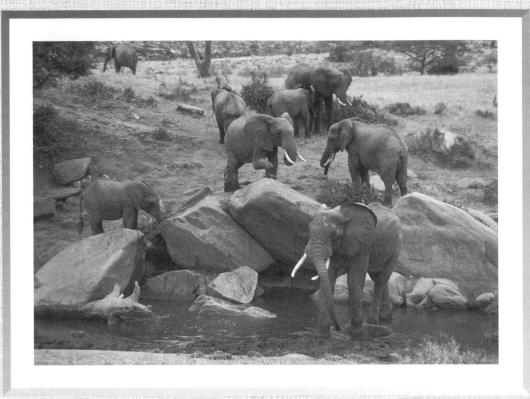

urope is the world's most popular travel destination and has been photographed over and over again, but Europe does change. There will always be new ways of approaching classic views, and people everywhere are an inexhaustible subject.

The United Kingdom

The weather in Britain can be awful or fantastic for photography. A sparkling clear spring, summer, or fall day with big multicolored clouds (yes, there can be) sailing by is as good as weather can get. Best shooting is in late April, May, and June, or September and early October.

London

London is highly photogenic. I grew up there and have returned at least annually for over twenty-five years. I have shot assignments year-round and visited in February and November too, so it's not just fond memory saying this. In winter, you are generally much warmer outdoors in London than in New York.

The photographic "icon" of London is Big Ben. The classic view is from Westminster Bridge, with red busses and black taxis on the bridge. Red-coated guardsmen, the Beefeaters at the Tower of London, Tower Bridge, double-decker red busses, Underground (subway system) signs, red telephone booths, and mailboxes are all icons of London too.

London theater is a huge tourist attraction; a great shot of several theaters together can be made from lower Shaftesbury Avenue. Two historic theaters are in the Haymarket; several more are in the Strand. For shopping scenes, Knightsbridge and Harrods are upscale; Carnaby Street is for punk; the King's Road, in Chelsea, is trendy; and the Portobello Road market is famed for antiques and junk stalls.

London Transport operates sightseeing tours on open-topped busses; these leave from near the Piccadilly, Marble Arch, and Victoria Underground Stations. The two-hour tour will show you the highlights—the Houses of Parliament and Big Ben, the Tower of London and Tower Bridge, the Bank of England, St. Paul's Cathedral, Buckingham Palace, and

major shopping thoroughfares—Piccadilly, Oxford Street, Regent Street and the Strand.

To explore London further by bus and Underground, buy a day, week, or monthly pass, and get on and off busses or trains where and when you wish.

For people photography, hang around markets, parks, and pubs. I am often asked for pictures of interiors of pubs and winebars. They are everywhere (get model releases). These can often be had for the price of a few pints. Londoners relaxing also go to Kensington Gardens, Hyde Park, and St. James' Park, all of which are attractive. Catch bowler-hatted bankers, city financial types, and brokers streaming to and from work near the Bank and Liverpool Street Underground stations.

High Victorian architecture and many museums are in South Kensington. Georgian terraces are around Regent's Park and in Islington. The convenient and cosmopolitan Bayswater, Queensway, and Lancaster Gate districts where I grew up have small hotels, late Victorian terraces, and pubs. They flank Kensington Gardens on its north side.

If you need the use of a car, a driver who knows London is a must—the modern one-way system in the twisty old streets was deliberately designed to discourage Londoners from driving (they weren't discouraged). Rush hours on the arteries of central London are hideous. Parking is metered. A device called a "boot" is clamped on your wheel for overtime parking.

Southern England

West of London is Berkshire, with pretty countryside and Windsor Castle.

The county of Kent south of London has the great house of Knole with a deer filled park; nearby is Sissinghurst Castle, a romantic ruin. Its White Garden created by the writer V. Sackville-West is one of the most famous in England.

Also in the south of London is Sussex, a county where I lived for a while as a kid. Near St. Margaret's Bay are good views of the White Cliffs of Dover. Sussex is upscale commuter country but has protected, empty, grassy "downs" (uplands) among unspoiled places; Bodiam Castle is splendid.

Wiltshire is a big county in southern England. It has mysterious Stonehenge (which now has to be protected by fences), Salisbury, with the tallest cathedral spire in England, ancient white horse images cut into chalk downs, and Lacock Abbey where Fox Talbot made his photographic discoveries. A museum commemorates his work. Many Wiltshire villages have charm, I visit Aldebourne, with a medieval church, nonconformist chapel, two pubs, a village green, two stores, and half-timbered thatched cottages.

The Southwest

Wells Cathedral in Somerset has swans in a moat beside it. Minehead is a charming village on a steep hill. The handsome city of Bath made famous by the Romans and Jane Austen is Somerset's number one tourist spot. It has Roman baths and superb Georgian architecture. The Royal Photographic Society Museum is there too.

In the toe of England, Cornwall and Devon are counties famed for mild climate and beauty. Don't miss Dartmoor, Devon, or Moushole (pronounced Mauzel), a Cornish fishing village painted by some of Britain's most famous artists. Avoid crowded mid-July to the end of August if humanly possible.

The Heart of England

The Cotswold Hills in Gloucestershire and Warwickshire are considered quintessentially English, with castles, cathedrals, stately homes, and many villages like Bibury built of mellow stone. Stratford-upon-Avon is touristic, but do the Shakespeare route and see a performance at the Royal Shakespeare Theater. (No photography is permitted inside.)

Spring and fall are ideal times to visit the Cotswolds and I have covered traditional Christmas there twice. Snowshill often gets snow; foxhunts are led by men in pink coats (I root for the fox, but the hunt is beautiful). Hotels in the region "do" a traditional Christmas package, comprising four or five days of caroling, parties, entertainment, and good food.

East Anglia

Cambridge is a jewel. Parts of the university, especially Kings College dating from the thirteenth century, are world-class architectural treasures. Go in spring and fall when students are in residence, and walk along "the Backs"—the college gardens by the River Cam. Go further east in May to see endless flower fields in bloom (it's flat like Holland, just across the North Sea). There are great churches dating from the regions prosperous sixteenth-century heyday as a center of the wool trade. Boston, Lincolnshire, has one of the biggest churches and is where the Pilgrim Fathers started their journey to America, via Holland.

Norwich is a historic city with a cathedral. Not far away is Flatford Mill and other recognizable Norfolk scenes painted by the great landscapist John Constable.

Northern England

I love the mountainous Lake District in northwest England (most of it is a national park) with lots of sheep, narrow roads with thick stone walls, and ancient slate-roofed farmhouses. The Langdale Valley is a favorite spot of mine, relatively remote and lovely. Beatrix Potter's house at New Sawrey is a great but often crowded attraction. In April and May blossoms and spring lambs make the lakes look idyllic on fine days, in September or October the bracken turns nice colors and skies are usually clear. Avoid July and August if possible. British vacationers, walkers, and climbers fill the park and, in truth, it rains quite a lot. A Lakeland Games gives chances to photograph locals; at Wastwater in early October events include sheepherding demonstrations, wrestling, and fell races. Prizes are awarded for traditional crafts, like carving shepherd's crooks.

I spent childhood vacations with relatives in the mountainous (for England) Peak District near Buxton, Derbyshire; it is another big chunk of northern England that is mostly national park.

In the North York Moors National Park, Bylands Abbey is a great ruin of a monastery destroyed by the forces of King Henry VIII. The Yorkshire moors also boast Haworth Parsonage, home of Emily Brönte and her siblings. The picture-perfect (on a fine day) Yorkshire Dales are where James Herriot's fictional vets practiced.

In Northumbria, remains of the Roman Wall built to keep out Scottish tribes are photogenic, as are Bamburgh and Alnwick castles built to keep out the vikings. Most of the county looks peaceful and agricultural.

Scotland

Edinburgh, Scotland's capital, has a looming medieval castle on a rock, Georgian squares and crescents in the New Town, a university and a medical school. The Edinburgh Festi-

val in late August and early September attracts world-class talent and crowds and keeps the city international, which it has been since Mary Queen of Scots returned from France.

Glasgow, once called the second city of the British Empire, has a vigorous cultural life and fine Victorian architecture. It was once known for bad slums too; most of these are gone today. The center of the city, spruced up, is definitely on the tourist map.

Edinburgh and Glasgow are an hour apart, and a day's drive from the western highlands and rugged islands off the west coast of Scotland. I think these places will be refuges for people who appreciate beauty and relative solitude long after sunnier places are wallto-wall condos.

The port of Oban has ferries to islands, including Mull. Stay in Tobermory and drive around Mull, then take a boat to the Isle of Iona, with a resident monastic community. Tiny Staffa, with strange eight-sided black basaltic rock formations was the inspiration for Mendelssohn's *Fingal's Cave* overture. Barra in the Outer Hebrides was featured in the classic British movie *Tight Little Island*. (A whole shipload of scotch was wrecked there the 1940s.) From Barra, ferries run to Harris, Lewis, and the rugged Isle of Skye. A bridge will soon join Skye to the mainland—great for the residents I'm sure; sad for those who loved its isolation.

Wales and the Borders

Mother vacationed (and took many pictures) at quaint Tenby. My nieces both went to university in Wales; they recommend the whole west coast as scenic. Caernarvon Castle is considered the finest in Wales. Snowdonia in north Wales is a national park. Portmeiron, the "folly" of a famous Welsh architect, Sir Clough Williams Ellis, is an Italianate group of buildings on Wales' west coast that were featured in "The Prisoner," a classic television series. It is now an exclusive resort hotel. South Wales is industrial; the capital Cardiff is coming back as a cultural center. On the border between England and Wales is the Brecknock Beacons National Park, relatively uncrowded in summer.

Northern Ireland

Northern Ireland is beautiful and worth photographing. Don't even think of being an investigative photojournalist here! Stick to scenery and ask permission for people pictures and you will be fine. The winding Antrim coast runs north from Belfast (not a pretty city) past Carrickfergus Castle and the pretty fishing villages of Cushendun and Cushendall to the strange basalt rock formation called the Giant's Causeway (and a golf course where I once caught a perfect rainbow on film). Return via Lough Neagh, Ballymena, Antrim, Newry, and the mountains of Mourne.

The Republic of Ireland

I've been many times to the Irish Republic. The people are friendly, funny, and kind. The most scenic part to my eye is Connemara in the far west. Ashford Castle at Cong is a great country hotel; well-to-do French, Belgians, and Germans go there for salmon fishing and good food.

I once photographed a lady in County Donegal who knitted sweaters to augment her pension. Her slate roofed white cottage had a peat fire with a perpetually brewing kettle on the hob, family portraits of kin in England, America, and Australia, and a world-class collection of china souvenirs.

Boats from the fine small city of Galway sail to the isles of Aran. You will alight by coracle—traditional craft made of tarred canvas stretched over woven frames of saplings.

The Lakes of Killarney, the Ring of Kerry, and the "Gaeltacht"—the Irish-speaking area on and around the seagirt Dingle Peninsula—are in the far southwest. In central Ireland at Ballinasloe, the annual September Pony Fair is where I got some all-time favorite people pictures of Ireland. Few traditional thatched cottages remain in Ireland, but photograph some at an attractive museum village at Bunratty close to Shannon airport.

Ireland's capital, Dublin, is newly prosperous and has ornate pubs, the Georgian Parliament buildings, the Trinity College (university) area, and Merriam Square and its surrounds. The General Post Office on O'Connell Street, where the Irish rose against centuries of British rule on Easter Sunday, 1916, is a shrine of Ireland.

I am asked for pictures to illustrate the works of Swift, Yeats, Wilde, Shaw, Joyce, O'Casey, and Behan, also shots of their birthplaces, residences, and more. An essay on great Irish writers might make a travel feature, or a rewarding stock project.

France

France is one of the most photographed places in the world, but who would let that stop them from visiting one of the lovliest and most civilized places on earth? Plenty of places are still off the beaten track.

Paris

I need hardly say that the "icon" of Paris is the Eiffel Tower. My favorite view of the tower is looking over sculptures, pools, and powerful Trocadero fountains across the Seine (get off at the Alma Metro station, cross the wide plaza, and walk down some steps). For a fine dusk view of the tower plus all Paris, go to the Montparnasse tower (Tour Montparnasse) observation deck.

Other "must" Paris shots are of the Pont Alexandre III with ornate lamps (a favorite of fashion photographers), Notre Dame at twilight from the quais of the left bank, and the Arc de Triomphe (preferably with huge French flag displayed beneath). This can be guaranteed only on July 14, Bastille Day, the French national holiday, which has great firework displays, but also, alas, some street hooliganism.

In Paris, I have often stayed in Saint Germain (a student area with plenty of hotels in all price ranges), or with friends in Passy (an expensive but convenient neighborhood). If a client is paying, I stay in the city center, as close to the Opera Metro station as possible.

For a first visit to Paris take a Cityrama double-decker sightseeing bus tour. They leave from the rue de Rivoli near the Place des Pyramides; close by is a photogenic golden statue of Saint Joan of Arc. You wear earphones for the taped tour commentary and pass the Place de la Concorde (where aristocrats lost their heads in the French Revolution), the Tuileries Gardens (where French boys in flapping shorts sail model boats), the Church of the Madeleine, the Invalides hospital and Napoleon's tomb, the Place de la Bastille, and new opera house. You also pass two of the world's greatest museums, the Palais du Louvre, and the Musée D'Orsay (visit both later). You'll see Notre Dame (always packed with people), la Sainte Chapelle (go back and visit this gorgeous chapel on your own), the Seine, and many bridges, including the Pont Alexandre III, as well as the Avenue Champs Elysées and the Eiffel Tower. Then navigate Paris on your own by bus, metro, or taxi.

Many people visit Paris to shop. To photograph two extremes see both the fashionable boutiques on the rue du Faubourg Saint Honoré, and the Saturday flea market near the Porte de Saint Ouen metro stop. Take an open *bateaux mouche* (sightseeing boat) to pho-

tograph from the Seine; walk along the quais of the left bank past Notre Dame for pictures of young lovers, dog walkers, booksellers, and barges.

Modern Paris includes Charles de Gaulle Airport at Roissy, where you whizz on escalators through plastic tubes between floors. There are more of these at the Centre Pompidou (popularly called the Beaubourg), the huge modern art museum. The surrounding shopping/entertainment area has a wild mixture of people. The science museum complex at La Villette on the eastern outskirts of Paris and the La Defense suburb to the west are both ultra modern and worth a visit. I.M. Pei's glass pyramid stands in front of the Louvre Museum. Parisians don't like it, but they didn't like the Eiffel Tower at first either.

The traditional Marché de Passy is held three times a week on the narrow, pedestriansonly rue de l'Annonciation. Smart Parisians, workers from the district, foreign diplomats' wives and servants shop there for fresh produce, kitchen utensils, wine, overalls, and more. On the same street are a gourmet food store, bakeries, antique shops, and a bookstore. (To get there, take the metro to Passy or Muette stations and walk a few blocks.)

Euro Disneyland is at Marne-la-Valleé, east of Paris. The R.E.R. will get you there from the center of the city in forty minutes. It's worth a look.

French Provinces

I've seen most of France, and love almost everywhere except the jam-packed Riviera and the somewhat dreary northeast close to Belgium.

Alsace, with timbered villages and houses with window boxes full of flowers is almost photo fool proof. It has a charming mountainous "wine route"; the historic cities of Strasbourg and Colmar (both with superb ancient centers) and great food and drink. I photographed a master baker in Colmar who's forebears have worked in the same building since 1776!

Burgundy is the richest province of rich France; boasting distinctive architecture with steep multicolored tiled roofs, the most famous vineyards in the world, friendly people, and food and drink to die for. Photograph vineyards and ripe grapes in September. Don't miss the fourteenth-century Hospice de Beaune, or the photography museum at Châlons-sur-Sâone, birthplace of Nicéphore Niépce, finally getting his due as the man who first captured a photographic image. Burgundy, surprisingly, is uncrowded even in the French vacation month of August.

Brittany is a one of my favorite regions of France, though the weather is often damp. The southern coast is more sheltered than the north (which is famous for fierce winter storms). Take "bright" Provia or EPP film to photograph Brittany's Celtic carvings, large and small stone fishing villages, lighthouses, cliffs, seabirds, and wide, empty (except in midsummer) beaches. Take a ferry from the naval port of Brest or from Le Conquet, a pretty fishing village and resort, to the still remote island of Ouessant, with great rocks lashed by surf, a lighthouse museum, colonies of seabirds, and old ladies (a few still wear island costume) who lead sheep around on rope halters. I am soon leaving for my sixth visit; Ouessant is a truly magic place. Get hotel reservations six months ahead for midsummer; the island has few rooms, and some French families return year after year. You can stay in a bird-watching hostel too; the place is a paradise for ornithologists in spring and fall.

Mont St. Michel, on an islet at the border of Brittany and Normandy, is all too much on the beaten track. If you go into the citadel on a summer day you will be almost overpowered by visitors. Arrive late; photograph it from across the marshes at sunset; then stay overnight to have the place almost to yourself at dawn.

The wide World War II Normandy invasion beaches have hunks of rusted tanks and trucks embedded in the sand; the Pointe du Hoc is where Texas rangers stormed an impossible clifftop fortification. Endless cemeteries above the beaches are deeply affecting; there are usually a few American or Canadian or British veterans looking around. For another Normandy mood, go to Monet's house and garden at Giverny. These are as lovely as the paintings, but get there at opening time in summer. Professionals can get permission to photograph when the gardens are closed to the public.

In the Loire valley some of the most famous châteaux offer "Son et Lumière" programs (the French invented the sound and light show). Elegant buildings bathed in different colored lights make fine photographs.

In the southwestern Langedoc region of France is Carcassonne, a restored medieval fortified city. The movie *Robin Hood Prince of Thieves* was shot there. If possible, plan to stay overnight in fall. Photograph the floodlit inner citadel and outer ramparts, at "blue time" and at dawn; then you can feel the mood of the place. Nearby is Minérve, a redroofed village in a gorge that was a stronghold for heretics in the thirteenth century.

The only part of Provence I like in summer is well north of the jam-packed coast (but the Negresco Hotel in Nice and the Grand Hotel in Cannes are still great). Drive through Haut Provence to find fortified stone villages and fields of flowers; two charming French films, *My Father's Glory* and *My Mother's Castle*, based on Marcel Pagnol's childhood, show the region to perfection. Go further north for the unspoiled Dordogne region.

Chamonix-Mont-Blanc is a skiing mecca of the French Alps; the succession of cable car rides past the Aiguilles du Midi is a thrill. The peaks are snowcapped even in midsummer, but at their best in winter. Albertville is center of the region that hosted the Winter Olympics a few years ago. To see Corsica fly or take a boat from Nice. It's a rugged island; the birthplace of Napoleon.

I plan to keep going back to France until I am ninety-five, God willing.

Monaco

Highlights of the principality are the pink Palace where in summer white-clad sentries in peppermint-candy-striped boxes stand guard against hordes of tourists. Palatial yachts fill the harbor, the botanic gardens are lush, and the outside of the great old casino is floodlit at dusk. Photography is never permitted inside it—but go in to look at the gamblers.

The Netherlands (Holland)

Windmills and tulips say Holland to the rest of the world. This makes the Dutch, members of a very modern culture, laugh a lot. A car is a help, but not a must, to photograph Holland. Trains and busses are excellent—or bike in that world center of cyclists. Amsterdam is handsome but it's difficult to get good pictures from low canal boats. To get "instant Amsterdam" pictures stand on bridges around Rembrandt's red-shuttered house near the Spui, and, in the late afternoon, shoot from the cruise boat pier in front and to the left of the central station. The big flower market near the gold-topped Munt Tower is a morning shot. Denizens of the red light quarter around the Zeedyke and their customers do not appreciate being snapped at any time of day. Photography without flash is okay in the Rijks Museum and Van Gogh Museum.

Marken and Volendam are picturesque, touristic, and the places to find locals posing

in Dutch costumes (they charge for photographs). The winding, flower banked River Vecht is lined with small gabled houses and crossed with white drawbridges straight out of Van Gogh paintings.

Rural Holland at first sight seems a mass of highways and electric pylons. Take back roads in the countryside to find much charm. Zaanse Schans, near Zaandam with three active windmills and traditional green painted houses, is one of the best museum villages in Europe and the place to take some icon photos. Unspoiled Haarlem has pretty street and canalscapes, a great cathedral and Frans Hal's fine house, now a museum of his paintings. Haarlem is close to great commercial tulip field displays. Photograph them, and the Keukenhof Gardens at Lisse, in bloom for six weeks between early April and late May.

Madurodam near Rotterdam is a miniature Holland built as a memorial to a young man who died in World War II. A famous row of windmills is at Kinderdjke near industrial and modern Rotterdam, but my favorite group of windmills is set in pastoral country at Aarlandervein, near Arnhem. Willemstad, a fortified town surrounded by water, is a national monument.

The *Stichting Stamboek van Rond und Plat Bodem Jachten* is great for people photography and boat pictures. This colorful "Reunion of Round and Flat-Bottom Yachts" attracts sailing-barge enthusiasts, including Dutch royalty, for a week of racing, showing off boats, and socializing. It is held in July at a different port around the Ijsel Meer each year.

The city of Maastricht, with a big farmer's market, and the south of Holland in general is on few tourist itineraries, which is a pity. Carnival in Maastricht is a big event.

Belgium

The ancient convent—the Béguinage—by the river in Bruges is reason enough to go to Belgium. Nuns stroll in the gardens wearing long black robes with starched white "butterfly" coifs. Ornate seventeenth-century merchants' houses line the canals of Bruges and also of Ghent—where you should not miss the ultraformal and elegant Grand Café. The waiters wear classic black uniforms with white aprons down to the ground, and the price of a cup of coffee is what you might expect. The Grand Place in Brussels is enclosed by the finest merchants' houses of all, best photographed floodlit, and there are charming little old streets behind the huge Place. The Atomium and other attractions at the former Brussels World's Fair site outside the city are worth a look, as is Tournai, a historic city with a festival where papier-mâché giants are paraded each June. The biggest photography problem in Belgium is weather—it usually rains when I am there.

Denmark

Copenhagen's nineteenth-century Tivoli Gardens is open late spring to early fall. Moorish, Chinese, and other pavilions are lit with millions of colored bulbs; there are Danes among visitors from all over the world; and the Boy's Guard in black bearskin hats and red coats parade several times a day. Blue dusk is the magic time at Tivoli.

Blue-clad royal guards stand in sentry boxes at Copenhagen's Royal Palace; on holidays they wear red uniforms. Copenhagen's "walking street," the Stroget, leads from the main Radhus square to the harbor passing churches with tall green copper spires en route. (One spire is in the shape of intertwined dragons' tails.) An open-boat harbor cruise starts from the Nyhaven canal and glides past Copenhagen's icon, the statue of the Little Mermaid.

Nyhaven is flanked by bright painted brick buildings; sailors' bars, tattoo and other parlors. But it's clean and quite safe; in the daytime anyway. Aunt Minnie might get a kick out of it.

Rural Denmark is flat and green with yellow mustard fields and old farms and castles here and there. Good beaches are in Jutland. The Island of Funen is a resort. Hans Christian Andersen's hometown of Odense is picturesque; an extensive folk village is not far away. Hamlet's huge castle of Elsinore (Helsingfors) is ugly to me (and no Hamlet movies have been made there). It's close to where you take a ferry to Malmö, Sweden.

Sweden

Stockholm straddles several islands in the Baltic. The city is mostly modern with busy roads, but has an old quarter with narrow streets and tall churches around the royal palace. There is a huge open-air produce and flower market in downtown Stockholm, where I take my favorite people pictures. Close to it is a walking street lined with cafés. Don't miss the Carl Milles sculpture garden with hundreds of his graceful copper figures cavorting amid fountains. It is about an hour outside the city proper. The eighteenth-century royal palace at Drottningholm, and especially the superb small opera house in the grounds, should be seen. If you can get opera tickets you'll enjoy the experience. (You'll have to sneak opera photographs during the applause.) Evening cruises from Stockholm to nearby Baltic islands are pleasant in summer.

Norway

This to me is the most photogenic of the Scandinavian countries. Oslo has an impressive modern town hall overlooking the harbor, and a huge beer garden full of handsome youth in the middle of its small equivalent of Central Park. Opposite, the atmospheric Grand Café in the hotel of the same name once played host to Ibsen and Strindberg; many of the customers are still very formally dressed older Norwegians. The "must see" just outside the center of Oslo is the Vigeland sculpture park, with thousands of monumental nude figures illustrating life from birth to death.

If you drive from Oslo to Bergen, a scenic trip I recommend, go via the Hardanger Plateau. You will see deer and traditional-style sod-roofed cabins. It often snows there in summer.

A wood-paneled resort hotel, the Hovdestoylen, is at Hovden. I was there once when a group of Norwegian pensioners was visiting. Everyone congregated in the dance hall after dinner (dances are big throughout Scandinavia) and this was the only time in my life when eighty-year-old ladies came up and asked me to dance. We had a riotous time!

The west coast of Norway is often rainy; allow extra time to get good pictures. You will see many waterfalls. The fishing port of Bergen is surrounded by hills, has a busy harbor where tall ships sometimes visit, and a colorful daily fish and flower market. Bergen's wooden Hanseatic warehouses have been designated a world cultural monument by UNESCO; there is a well-restored old-town outdoor museum complex and a funicular with views over the city. Drive from Bergen via Voss to Sogndal where local ferries (which run frequently in summer) go up different fjords. (You must reserve months ahead for long mail boat cruises from Bergen to Lapland, the Arctic Circle and reindeer country.)

If you can visit the Geiranger fjord or Sognefjord or the Hardanger fjord in late May

when the apple blossoms are out you will see Norway at its loveliest. Seven-hundred-year-old wooden churches, tiny fjord-side villages, and waterfalls of all shapes and sizes can all be photographed, and the people proudly wear national dress for holidays. "Unsettled" weather in the west is the only real problem for photographers.

Finland

Helsinki is another agreeable Scandinavian capital with a harbor location and a great openair market. Sturdy white- and blonde-haired market ladies wear brilliant yellow, orange, and red cotton Marimekko overalls and hats, perhaps to ward off the blues of the long, dark Finnish winters. You can buy the usual fruit, vegetables, and flowers, plus woodenware, baskets, Lapp souvenirs, and reindeer skin mittens. The Seuraasari folk village nearby is well done. Around Helsinki you can photograph and visit some of the buildings designed by the great Finnish architects Aalvar Alto and Eero Saarinen. Finland's second city, Turku, has a castle and is where overnight ferries to Stockholm, Sweden, leave.

Most of the rest of Finland is empty of people; bright and dark green in summer, with shimmering birches and millions of pine trees. Towns are connected by arrow-straight roads; you pass a lot of blue lakes. Around the coast there are thousands and thousands of tiny islets, most big enough for just a few pine trees. If you know any Finns, you might get invited to sail out for a stay in a summer cabin, or a picnic and a sauna.

Iceland

I haven't spent long on this somewhat remote Scandinavian island, considered the western outpost of Europe, but I liked the brightly painted little capital of Reykjavík. The Icelandic people are friendly. I saw bubbling geysers, sheep, and wild ponies on moorlands near Reykjavík. I'm told the rest of the countryside is moorland, and that the late evening light in summer is sometimes extraordinary. An active volcano on an offshore islet is Iceland's biggest tourist attraction.

Germany

Big ceramic beer steins and folks wearing dirndls and lederhosen (leather shorts) symbolize Germany to many; find them easily in Munich beer halls.

My first visit to Germany was in the 1960s; I went with distinct apprehension. My father was in the British Army in two world wars. But Germany is lovely in many places. Germans as a people are among the most intrepid travelers in the world, and they appreciate and travel a lot in their own country too. Tourism facilities are unsurpassed. Young Germans (and many older ones) are friendly, open, and concerned about things that matter, like the environment. Accommodations range from world-class hotels to *zimmer mit fleisswasser* (rooms with running water) in private homes—all excellent of their own kind. Many of the world's top hotel managers today are German. I have made about twenty visits to the country. My favorite places for photographs are, from north to south: the city of Cologne (photograph the cathedral with a long lens from across the Rhine); the scenic stretch of the Rhine from St. Goarshausen to Boppard; and the quiet scenery along the Mosel/Moselle river from Koblentz to Trier. Then see the best-preserved medieval walled towns of Germany, Rothenburg (very crowded in summer) and Dinkelsbuhl.

I've described another favorite region of Germany, Bavaria, in chapter 15. While in Bavaria go to Baden-Baden, an elegant spa and casino city. It is a place to see very formal, wealthy Germans relaxing, and some very high-powered gambling indeed (no cameras are allowed in the casino).

Berlin

It's easy to use subways and buses to get around Berlin. I feel I hardly need to describe the city in detail because it's been on TV so much since the wall came down. There are fine shops and cafes and bright lights, especially on the Kuferstendam. There's a lively youth scene, bars and discos, and the Tiergarten, an enormous park with a zoo. A monument to World War II is the brown broken spire of the Kaiser Wilhelm Church, preserved next to a modern church seemingly built entirely of stained glass. Eastern Berlin is now a vast building site, changing every day, and the city will soon become Germany's capital again.

Munich

Munich is busy, almost totally rebuilt since World War II, but has an ornate medieval mechanical clock with dancing figures on the Rathaus Platz (city hall square). You can stand in the big square and photograph them in action every hour. The arts quarter, called Schwabing, has some great restaurants. Munich's huge beer halls can be fun or revolting, depending on the time of night and year you go. Personally I would avoid the heavy drinking season of Oktoberfest at any cost!

Not far from Munich, the Black Forest close to Triberg can be dark and spooky in bad weather. I once got lost there in a fog and felt that woodcutters, wolves, and Hansel and Gretel would appear any moment. In the area timbered thatched farmhouses, huge barns, and tiny cuckoo clock shops are to be seen at frequent intervals.

Switzerland

My favorite places: the car-free resort of Zermatt where you can photograph that ultimate Alp, the Matterhorn; if you can go in winter when horse-drawn sleds are the transport and cosmopolitan crowds of skiers fill the place, you will see Zermatt at its best. The Engadine, around St. Moritz, is a region of tiny villages and spring meadows full of yellow and blue alpine flowers. Surprisingly, it is uncrowded three seasons of the year. Not far from St. Moritz is the Romansch-speaking area of Switzerland. Go to Tarasp-Scuols and drive (or take the post bus) up a winding road to Ftan, or Fetan, once recommended to me by a Swiss tourism official as the most beautiful village in the country. I agree. Houses with painted designs on the thick stone walls cluster around a church with a spire that has an onion dome on top. Dark brown goats wander in the narrow streets and there are log barns and meadows full of pinkish-gray cows with long silky eyelashes eating cow parsley. The sharp teeth of the Dolomites stand high behind the village. I have been to Ftan in winter, spring, and summer and it is always lovely, always empty.

The Ticino canton borders Italy. Stone farms with thick slate roofs perch on hills; your car may be blocked by cows being herded along narrow roads; and cherry orchards bloom in May. The lakeside resort of Lugano seems to be the only place in the region with significant numbers of tourists.

You can manage easily without a car in Switzerland if you must—the trains and post buses are superb.

Lichtenstein

I feel this tiny country is designed mainly for people who collect stamps in their passports. A fine castle and some vineyards; the capital of Vaduz is given over to souvenirs, postcards, and duty-free cigarette selling.

Austria

If you drive to Austria from Switzerland, you can take the Arlberg pass if you have steel nerves and don't mind heights; but you can't stop for pictures because enormous trucks, tour buses, timid flatlanders like the British and Dutch in low-powered campers and cars, and motor bikes all clog the narrow winding road, which has terrifying drop-offs. I took the tunnel the second time. The Tyrol is the most mountainous part of Austria with many ski resorts. All houses are decked with flower boxes in summer, but the villages to me look best in winter.

Salzburg is a city that lives up to its reputation. It still looks like *The Sound of Music;* all the scenes were shot in and around the town and are recognizable. Salzburg ladies of all ages wear dirndls, men sport green knickers with red check shirts on all possible occasions, and there is a good open-air market. Though packed with visitors, especially at festival time, Salzburg still smiles at all of them. You are almost guaranteed to get good pictures if you take the funicular up to the Winkler Casino terrace in the late afternoon—aim your 200mm lens over red umbrellas and the spires of old Salzburg to the castle that dominates the city. All this is floodlit starting at dusk, which is unbelievably considerate to photographers. The narrow Getriedegasse is a medieval pedestrian street lined with wrought iron and stained glass shop signs (and just a few small flags that say Eis Kreme, Kodak, and Fujifilm too). A 43–80mm zoom works well here. The Salzkammergut is a busy and picturesque lake resort region outside Salzburg on the way to Vienna.

Vienna

This city is hard to get a visual handle on; the giant Ferris wheel in Prater Park, waltzers, and some "konditorei" interiors with Sacher torte are the best bet for instant Vienna pictures. Viennese ladies of a certain age in hats, and men in jackets and ties, sit for hours reading newspapers, sipping, and nibbling in coffee and pastry shops. There are open-air waltz demonstrations in summer in the city's public garden. The eastern end of Vienna is full of dusty textile shops, and has a famous Jugendstihl (art-nouveau) post office, built around 1910, that still looks modern.

Viennese and tourists alike go to the wine village of Grinzing outside the city to drink new wine and sing in summer and fall.

Southern Europe

If you like tradition and guaranteed warm weather, this part of Europe is for you. The problems for photographers are that some places are crowded in midsummer, and there is overbuilding in popular coastal areas.

Spain

I've already written that the tourism boom in Spain has made it the Florida of Europe. The Costa Brava is a favorite of my native countrymen, who have not improved it, and I would avoid at any cost the concrete jungle of cheap high-rise hotels at Torremolinos, Benidorm, and nearby resorts. But you can escape the masses by going that extra mile. For instance, an English friend has a house on the island of Majorca—up in the hills in pretty Fornelutz, set amid olive groves and windmills. The next town of Dera was home to the scholar and poet Robert Graves. My friend swims at Soller. These places are light years from the hordes that pack discos and bars of the capital of Palma.

The Costa del Sol around Malaga is busy but pleasant; Marbella is a chic resort. Andalusia is old Moorish Spain. Seville is crowded for Holy Week before Easter, largely with Spanish pilgrims. I once spent a week photographing it. The penitents' robes date from the Spanish Inquisition and were the inspiration for the costumes of the Ku Klux Klan. They are still scary, especially at night, when parades are lit by candles and torches.

My stock pictures of Granada and Cordoba have sold consistently; these places may still be underphotographed. In busy Toledo, see El Greco's paintings and house and the oldest synagogue in Europe; then drive around the Ebro outside the town for good views over the city and looping river from a tourist restaurant's terrace.

Madrid and Barcelona (where the "must" is Gaudi's Sagrada Familia cathedral) are both huge cities; I've visited them only in midsummer, when they are grillingly hot, so haven't enjoyed them as much as I doubtless should. Apart from covering the "musts," my preference in Spain is to drive in the interior of the country, to see smaller castles and traditional villages, vineyards, and olive groves, leaving the busiest places to others. In Spain, you may or may not want to photograph bullfights. If you do, get good front seats on the shady (sombra) side, and save film until late in the afternoon for good light and long shadows.

Portugal

Portugal is underphotographed. Apart from the southern Algarve coast, largely colonized by the British, Portugal is probably the least tourist-developed country in western Europe. Lisbon is a pretty city on hills with plenty of trees. The coast road from Lisbon to exclusive Estoril and a port at Cascais has sandy beaches, colorfully painted fishing fleets, and a Portuguese family holiday atmosphere.

North of Lisbon, the Atlantic coast facing the New World is exposed to winter storms. Nazaré is a formerly isolated fishing port surrounded by high cliffs; now it has many visitors. Only the old people still wear the traditional plaid costumes, but the boats are as colorfully painted as ever. Have a wonderful fish stew at one of dozens of plain restaurants along the beach. Portugal's second city, Porto, has long ties with Britain, because of the port wine trade. You can visit and photograph bottlers and enjoy samples.

In the center of Portugal are fields of cork and olive trees. The three E's—the towns of Elvas, Estremoz, and Evora—are especially worth photographing.

Italy

Italy was the first country where "tourists"—British aristocrats finishing their education—traveled. It has been the world's number one tourist destination ever since. With so much to offer I can only scratch the surface here. If you can visit the great sites out of season, do so. I like the mild spring, fall, and even winter weather in Italy too.

Venice

The gondola is the icon of Venice; gondoliers expect to be well tipped for pictures.

The Accademia bridge is the place to stand for sweeping Grand Canal views. Fleets of gondolas pass under it at dusk. The Arsenale is fine—and less crowded than other major Venetian sites. Blown glass is "the" shopping item. As I've said before, Venice is wonderful, but there are a zillion pictures of it out there, ditto for tourists. Shoot the less-known corners for any chance of feature or stock sales. Take local *vaporetti* (water busses) along the main canals; they are less jammed than express boats. Walk narrow back streets to seek out the life of the local people.

Florence

The best overall view is from the high Piazza Michelangelo across the Arno. The covered straw market is fun. The only hope you have of getting a snapshot or two of the original of Michelangelo's David is by getting to the Accademia museum half an hour before it opens, to be early in line. (The sculpture in the Piazza del Duomo is a copy.)

Rome

You don't have to start with an overall guided tour in this capital—the things you want to see are very close together. Start at my favorite spot, the circular Piazza Campidoglio, an architectural gem (however the statue of Marcus Aurelius designed by Michelangelo is absent for restoration at present). But there is another huge sculpture, a relief of a reclining man, in the piazza; nearby is a famous small bronze of Romulus and Remus being suckled by a wolf—it is the emblem of Rome. There are monumental fragments of Roman works, including a hand taller than a man, in the courtyard of the Capitoline museum, and many more Roman relics inside. Strangely enough, not every visitor to Rome goes to this marvelous place. Just below the piazza is the best Roman view I know of, straight over the ancient Forum. Nearby a bus terminus next to the white Vittorio Emmanual monument lets you easily reach anywhere in the city. A short walk away is the Colosseum and the entrance to the Forum.

The view up the Spanish Steps over the turtle fountain, from the Piazza de Spagna, is best in spring when huge tubs of azaleas decorate the steps. The house where the English romantic poet Keats lived is to the right.

Overall views of St. Peter's Square can be marred by crowd control barriers. Photograph St. Peter's from across the disappointingly sluggish Tiber; the view from the vicinity of the Castel san'Angelo is a classic. The Trevi Fountain is so popular you must go there early if you need a shot of it without thousands of tourists tossing in three coins.

Don't think of driving a car in downtown Rome. Roman drivers are descended from gladiators, and taxis are cheap. Drive or take a bus to Hadrian's Villa and the water gardens at Tivoli, outside the city. Both make splendid pictures, but oh, the crowds! (The Tivoli souvenir stands are so enormous and varied they are actually interesting as subjects in their own right.)

The Rest of Italy

Be sure to save film for some of these scenic Italian towns and regions: Cortina D'Ampezzo, the center of a famed winter resort area (the surrounding Dolomite peaks are strangely shaped and dramatic). Sirmione, with a beautiful castle and moat. The tiny workingmen's islands of Burano and Chioggia, near Venice, with bright painted houses. Porto Ercolo, now a an exclusive seaside resort. Lucca, with a fine market. The Renaissance hill towns of Ravenna and Siena, with some of the greatest art and architecture ever created. They draw a lot of visitors but not as many as Florence or Venice. Assisi is under restoration after earthquakes.

The best way to photograph in Italy's countryside is to drive, stay off the autostradas and find your own favorite small towns and villages. I recommend Route 222 from Siena, which takes you through the Chianti wine country. In June, on back roads from Florence to Rome, you will pass fields of red poppies shaded by olive trees, with occasional white oxen or black cows grazing in them. The hilly area near Rome called the Abruzzi has small fortified towns, each perched on a separate hill. I like Norcia.

Caution: Be careful of your equipment and money in the old Trastevere quarter of Rome, indeed in all of the city and farther south. I had my pocket picked while photographing an opera performance at the Baths of Caracalla, but a nice policeman gave me a ride to my hotel in his squad car. The vast majority of Italians are of course honest. I once left a camera in a Venice trattoria after a rather vinous lunch. It was returned to me by anxiously waiting waiters when I found the place again two hours later. Obviously though, you can't rely on such honesty anywhere.

South of Naples park overnight only in guarded places. I have known tour-bus drivers—who could only find street parking—to sleep on the bus to prevent the tires from being stolen!

I have driven from Brindisi in the toe of Italy to Naples and Rome, and don't especially recommend the long drive (except for seeing Pompeii, which can be done from Rome). The south of Italy is mostly flat, the towns drab. Naples itself is like an old grand duchess down on her luck. Capri is beautiful, but way too crowded in summer for my taste; the Blue Grotto can feel like Coney Island sometimes. If you go to Capri, go off-season, and see the Swedish writer Axel Munthe's villa.

Greece

Greece is a country I visit at the drop of a hat, anytime, with or without a camera. One of the truly great vacation places of the world. The only problem is that in midsummer, practically every northern European agrees with me.

Athens

I'm not a person who must have every comfort, but my advice is to invest in an air-conditioned hotel room in smoggy Athens in summer. I have stayed in the best (the elegant Hotel Grande Bretagne) and one of the worst hotels in Athens (the latter will be nameless, a humid, mildewy, none-too-clean sweatbox on Omonia Square).

The Grande Bretagne is on Syntagma Square. There you can lounge on overstuffed swing chairs under white umbrellas and eat (and photograph) sinful ice creams. Across the square, the six-foot-plus burly *Evzones* (elite guards) stomping up and down in front of the pink presidential palace don't look in the least like ballet dancers in their white uniforms with

frilly skirts, cute red pillboxes, thick white wool stockings, and heavy black clogs.

After you have "done" the Acropolis with a wide-angle lens (get there early or just before closing time) and photographed it at "blue time" with a telephoto from the Pnyx hill (stay until dark if there is a sound-and-light-performance, these start around 9 P.M.). Then you can sup, and photograph under narrow streets roofed with grapevines in the ancient Plaka district.

When you have seen the National Archaeological Museum, where photography is allowed but requires a fee even for amateurs (this is true here and in most Greek museums), see the fabulous Monastiraki flea market. Then you've done the best of Athens and can take a ferry from Pireaus to just about any Greek island. These, to me, are the real reasons to go, and to photograph, Greece.

The Greek Islands

Near Athens, Hydra has a superb harbor, Poros nice beaches. The more distant Cyclades are the most beautiful of all the Greek islands. "Musts" to see and photograph, crowded in July and August, are Mykonos (and nearby sacred Delos) and high Santorini and its neighboring volcanic islet which still smoulders slightly. Amorgos (where I once spent a very enjoyable week), Astipálaia, Folegandros, and Naxos are my suggestions for more off-the-beaten-track islands. Most small island hotels are clean but basic; as an alternative you may find a nice room with a family. Patmos in the Dodecanese is a cruise ship stop. It has a famous monastery with only a few ancient monks remaining; Greek friends vacation there.

Corfu, off the Albanian coast, is green and lovely but for my taste too full of English-owned villas with names like Bide-a-Wee and Dunroamin. It boasts a perfectly beautiful little monastery on an islet that is much photographed but unfortunately right under the approach to the Corfu airport. I've stayed in the big thatched-hut Club Med on the island which is nice and quite cheap.

The ruins of Knossos on Crete, the Greek island closest to the African continent, are a "must" see; the beaches are good but crowded in summer. Rhodes is to me the most beautiful of the big Greek islands. In summer here too though, the beaches and major sites are crowded.

Delphi, on the mainland again, is Greece's most sacred site, with the Temple of Diana my favorite vantage point. Early morning light is best.

Eastern Europe

Eastern Europe has much to offer photographers because the years of Communism have preserved a very traditional way of life. You might not want to live where horse carts are still used for transportation for instance, but there is no denying they are very photogenic.

Bosnia, Croatia, and Serbia

Obviously, check travel advisories before visiting any part of the former Yugoslavia. Croatia has a marvelous Adriatic coastline. I'm told that summer beaches are pretty empty right now (though German and Austrian visitors are slowly returning)—there are some lovely quiet islands off the coast. Dubrovnik was a former outpost of the Venetian Republic. It is one of the most beautiful and complete walled cities in Europe, and has been restored.

Photograph down onto it from nearby hills.

Inland, Mostar, once a part of the Turkish Ottoman Empire, formerly was a picturesque and rather Eastern-looking small city, with mosques, a fine market, and an ancient bridge (now destroyed). I'll wait before returning. I have spent time in Belgrade, now the capital of Serbia. It had some interesting sights, but my feelings about Serbian atrocities mean I cannot suggest going there.

Hungary

Budapest is reclaiming its reputation as the Paris of the east. It is one of Europe's popular travel destinations. Like Vienna, it has many historic coffee shops. The Café New York, brightly lit with hundreds of art nouveau lamps, is a hangout for the local intelligentsia; it makes for great pictures. Overall views down onto the Danube bridges, the enormous Hungarian parliament buildings and huge paddle steamers on the (brown, not blue) Danube are best taken from near the Hilton hotel (which rather tastefully incorporates a ruined monastery) and the Fisherman's Bastion on the high Buda side of the city. Outside Budapest, around Lake Balaton, there are lake resorts beloved by Hungarian, Austrian, and German city dwellers. Farther east is less trampled; there are three interesting K's, the cities of Kecskemét and Kiskunfélegyháza and the plains national park of Kiskunsag with lots of sheep (there are a lot of other K's in that area where I haven't been also).

Czech Republic

Prague is beautiful, but I have not been since the fall of Communism. When there, I felt that the beautifully preserved city tended to be too much like a museum (perhaps it is now getting some modern architecture). The views up from the sculpture-adorned Charles Bridge to Hradcany Castle and down from the Astronomical Clock tower onto the Old Town Square are especially fine. The Old Synagogue dates from the thirteenth century, and has a packed graveyard though almost no living Jews remain. There I once took a photograph that sums up my somehow sad feelings about Prague: in a spring drizzle, an American Jewish acquaintance walked, hunched over with pain, looking for the names of great-grand-parents. All his other relatives had died in a concentration camp.

The places I liked best in Czechoslovakia were the tiny villages of Bohemia, with many cottages that are now weekend retreats for well-connected families from Prague. They are often painted a cheery yellow and white, with dark red tile roofs. There is usually a village green with a pond, and honking flocks of fat geese, some being driven by buxom farm women wearing traditional aprons and kerchiefs.

Romania

I went to Romania only once, in the mid-1970s. I stayed two weeks and was driven around a lot by a chauffeur in a huge black Soviet limousine. He had Stalinist ideas about starting time, coffee breaks, lunch breaks, tea breaks, and quitting time. Since then, I have been selling stock pictures of Romanian dancers, Dracula's castle at Bran, the very nice folk village outside Bucharest (to paraphrase Will Rogers, second prize is two weeks in Bucharest), and the green hills of Transylvania. Perhaps, until recently, I was the only photographer ever to have visited the countryside of Romania!

Poland

I went to Poland one snowy March on a tourist-office-sponsored trip for magazine editors, writers, and photographers. We had red-carpet treatment, but that is not the only reason I loved Poland. Men in crisp uniforms with high boots, or rumpled suits and shapeless shoes, bent at the waist to kiss the hands of ladies of all ages. People in the streets carried single tulips decorated with ribbon—the Poles seem to adore flowers. In Warsaw I saw and heard the single most fantastic opera performance I have ever attended, in the biggest opera house I have ever seen. (It was Alban Berg's *Wozzeck*, with an ultramodern set, at the Teatr Wielki.) The old center of Warsaw is a monument to courage and ability to surmount disaster. Having been leveled, during the Warsaw Uprising at the very end of World War II, to stumps of rubble like a very old man's teeth, it had to be totally rebuilt. (There is a museum in the Old Town Market Square that has photographs documenting all this.) I was told that this square, and other important buildings, were painstakingly recreated according to paintings of the city by Canaletto, who painted Warsaw almost as lovingly as he did Venice.

Also in Warsaw are the remains of a gestapo prison, now a museum. Outside is a huge old tree, with shields painted with people's names nailed to it. They were covered with fresh tulips.

Warsaw has some very nice, cozy coffee shops with thick oriental rugs, and a lively disco scene. Despite the men's deplorable suits, the young women have a sense of fashion. In Warsaw I met a lovely artist, in her eighties, a sort of Polish Grandma Moses, who painted from memory scenes of her girlhood in what is now Byelorussia. I now regret not having felt free to spend the \$250 in dollars she asked for a large painting.

Near Lodz (pronounced something like "wooch") is a village where old ladies make dolls with Polish costumes, and cut and paste traditional pictures from bright tissue paper. I bought one for \$5. Cracow has an ancient market square that survived World War II. The flower market there was doing a booming business in March, perhaps because Polish winters are long, gloomy, and starved of color. I photographed winter in Poland in front of the fourteenth-century arcaded Cloth Hall from a low angle to avoid the clumps of coalsmoke-blackened snow that lay on the ground.

Pope John Paul II served as a cardinal in Cracow before his elevation. In the market square is the red-brick cathedral where he celebrated Mass. His birthplace, a yellow stucco house in a very small town not far from Cracow, has a shop on the ground floor.

I persuaded a guide to take me for a drive in the countryside. Horses and carts and horse-drawn sleds shared the road with a few cars and trucks. At a village market, most farm vehicles were horse drawn. (For me, not for them, this was lovely.) Country cottages were painted bright colors, often blue, and were half-timbered and thatched; very pretty but, my guide told me, very primitive.

Russia

I have been to Russia only twice, in 1963 and 1983. Those are now ancient times so I offer only a few suggestions for timeless things to see.

St. Petersburg

St. Petersburg/Leningrad is beautiful, faithfully restored, and somewhat museum-like in the center. Of course you will go to the Hermitage Museum in the Winter Palace. It's painted pale green outside, white and gold inside, and is mostly daylit, so photography is no problem. Stroll along the banks of the River Neva to see statues and cathedrals and the elegant admiralty building. I photographed rather jolly Russian sailors guarding the historic battle-ship Potemkin and took a hydrofoil to Petrodvorets, the tsars' summer palace outside the city. There are ornate gilded fountains; the imperial Russian eagle decorates gates and domes. The whole thing is superbly kept up. The monument to the 1941–1942 siege outside the city is very moving. Russian newlyweds put their wedding bouquets on the mass graves, and bemedaled war veterans are proud to be photographed. In midsummer, daylight lasts till 11 P.M.

Moscow

Red Square and onion-domed St. Basil's Cathedral, and the Kremlin complex with red marble walls and golden-domed churches, are the photographic icons in Moscow. You can photograph all of them from one spot in the middle of Red Square if you are lazy. After that, wander or take the subway to as much of the city as your spirit of exploration (and of course current political realities) permit. See the university district, and the popular Gorky Park. The Tretiakov Art Gallery has superb icons dating from the twelfth century. Russian circuses are the world's best; if you get a chance to go, do so. Photography is no problem.

I have not been to the rest of the former Soviet Union, now autonomous republics. I want one day to see Tashkent and Samarkand. Another ambition is to take the Trans-Siberian Express across Russia and Siberia. A member of my family, a great great-aunt who performed in a teenage dance act across Europe, did this in 1911! I know some people who have done the trip recently; they highly recommend it for atmosphere if not luxury.

The Middle East

This crucial part of the world is obviously to be approached with caution at the present time. It is also pretty inaccessible to women photographers, but the places I mention are easy to visit, and I have enjoyed my stays there. Of course, check government travel advisories before you go.

Turkey

When I was alone in Istanbul on my first visit years ago (and considered not unattractive) I did not feel as harassed as I have occasionally in other predominantly Moslem countries. (Church and state are separated in Turkey.) Istanbul is a fabulous, frenzied, teeming city, reminding me in a curious way of New York. You can shoot the great pointed spires of Saint Sofia and the minarets of many mosques as well as the Golden Horn (the backlit water really gleams just about every sunset) from the pierced iron Galata Bridge. The big smoky ferry and tug boats dashing to various spots along the film and beyond are also dramatic. To photograph in the warrens of the covered Grand Bazaar use fast film or flash. The Topkapi Museum (scene of the sixtiess caper *Topkapi*, featuring Peter Ustinov as an inept emerald thief) and its garden are musts. There are some wonderful, just slightly seedy, wooden hotels outside the city that somebody surely ought to use in a movie one day.

I flew from Istanbul to Izmir, on Turkey's south coast, but friends who visit family there recommend the overnight ferry (advance reservations are necessary). I took a car and driver down the coast as far as the small resort of Bodrum (mostly prosperous families from Istanbul and German visitors vacation there) and returned on the same road, seeing storks nesting on Roman columns, ancient painted houses, millions of olive trees, vineyards, wheat fields, and peasants riding camels en route. On another visit to Turkey, this time from a Greek cruise ship, I went to Ephesus, a great ruined Roman city famous for its eight-seater marble communal toilet among other attractions. The nearby modern town of Kuçadasi has a good bazaar. Check travel advisories before visiting Eastern Turkey, which borders on Iraq.

For suggestions on photographic etiquette in Moslem countries, see under Pakistan, in chapter 19.

Egypt

One of the world's great travel experiences, to be approached with caution at the present time. Check travel advisories. Cairo is huge and chaotic; I don't recommend wandering around without a guide. The "musts" are several beautiful mosques (where I as a woman was not permitted to penetrate beyond outer courts) and the Egyptian Museum, where photography of the treasures is permitted (without a tripod or flash). Guides prefer groups of tourists; I suggest finding an English-speaking taxi driver who will show you the city and take you out to the Pyramids and Sphinx for not too much money. (Make it clear that you will give him a good tip at the end if he does what you want and does not insist on visiting tourist shops.)

You will share the road to the Pyramids and Sphinx at Giza with chaotic traffic. Giza village is touristy. I hired a camel and driver to pose for me in the empty desert at dawn. About half a mile west of Giza, with the Pyramids backlit by the sunrise, is a good early vantage point, well away from the shops on the main road. There is an evening sound-and-light show at the Pyramids and Sphinx that makes for good pictures.

To visit Luxor and the Valley of the Kings near Luxor, fly or take a train. I flew for time reasons. The train is said to be air-conditioned, good, and currently not filled after the recent attack on tourists at Luxor. You can also cruise the Nile on luxury boats.

Israel

In Israel I photographed for the Christian pilgrimage trade, when things were temporarily peaceful. Obviously caution must be exercised today—do not attempt to be a crusading reporter! Jerusalem is of course the "must" in Israel, sacred as it is to Christians, Jews, and Moslems, and worth several days; the classic overall view of the city and the golden Dome of the Rock is from the beautifully planted Mount of Olives. I spent most of a day at the Western (or Wailing) Wall. Non-Jews (and women) cannot get too close; a medium telephoto lens is needed. (Dress conservatively and carry a head covering for visiting all religious shrines.) The place believed to be Jesus' birthplace in Bethlehem was to me a disappointment; it's marked by a small church smothered with ornate nineteenth-century silver ornaments; but the country around was positively biblical, with shepherds in robes tending flocks of goats. I'm told it's unchanged today.

To meet some Jewish Israelis I arranged a stay in a kibbutz called Nof Ginosir on the

Sea of Galilee, where oranges are grown; it was easily done on the spot and cost about the same as a moderate hotel. This was the thing that I personally enjoyed the most in Israel. When I inquired if the place could still be visited, the kibbutz hotel representative in New York said yes, but advance booking is now advised. He also told me that a two-thousand-year-old boat was discovered there, close to the shore, about five years ago. It had been preserved almost perfectly in sand and silt, and is now in a small museum at the kibbutz. It was certainly a fishing boat.

Morocco

A wonderful country for photography. Tangier is a cubistic white harbor city, with very good hotels. *Caution:* I hated all the professional local guides I met there on my three different visits; they seemed to think of me only as a walking cash machine, to be steered into tourist shops (where of course they hoped to earn a commission on my purchases). If you know of, or can find any willing locals like young photographers, or students, to show you around, avoid guides in Tangier.

Professional guides in Marrakesh are more considerate and proud of their city. The good hotels of Marrakesh are like lovely oases with big swimming pools (which I much enjoy in the great heat, though I don't usually swim when working). The great square of Djemaa El F'na is one of the most fabulous "people photography" places in the world, with story-tellers, snake charmers, dervish dancers, water carriers hung with brass cups and jugs, all purveying their talents and wares to sightseers in from the countryside. Take a guide there, smile a lot, and hand out small tips for all pictures. Since some people take pictures in the square for a living; I would be very cautious about handing out free Polaroids here. The entire Street of Wool Dyers is hung with skeins of brilliant saffron, purple, red, and blue, drying in the sun.

In June each year there is a festival outside Marrakesh's city walls, then horsemen perform at a gallop and shoot off rifles into the air. Needless to say, one June when I found out that the festival was starting two days after I had planned to leave, I extended my stay.

All mideastern countries except Israel are of course Moslem; again, see etiquette for photographing in Moslem countries in the section on Pakistan, in chapter 19.

East Africa

Whatever it takes, go; go to see, experience, and photograph the annual migration of wild-life while it's still there. Not only will you get great pictures, but your mere presence may help to preserve the ever more endangered animals and the game parks beleaguered by poachers and farmers. Tourists bring much needed hard currency to East Africa.

Kenya and Tanzania

My month in Kenya and Tanzania is still my favorite of all the marvelous assignments I have had to date; and I'm looking forward to returning. My stock pictures from East Africa have been steady sellers for years. *Caution:* Kenya's capital Nairobi is currently plagued with crime; check travel advisories.

To photograph wildlife use long lenses (from a minimum of about 200mm to 400mm, or even 600mm). The Land Rover I rented from the United Touring Company was spe-

cially adapted for photography/filming, and had a sturdy platform with holes for a tripod and a sliding roof. A window clamp (or a beanbag as minimum) should be used for photographing from inside tourist minibusses, or from hired cars without sunroofs.

Almost all wildlife pictures are taken from vehicles; get one with four wheel drive and a roof opening if you are on assignment. The animals ignore Land Rovers and minibusses, seeming to think them part of the landscape. Wide-angle lenses are useful to show animals from up close, or in herds in the landscape.

If you can avoid entering Kenya or Tanzania as a professional photographer, do so. There are quite stiff commercial photography fees to pay. I'm told too that you run the risk of the odd customs official seeking a "consideration" to pass your equipment. As many tourists carry several 35mm cameras and lots of film, posing as a tourist is not usually any problem. If in doubt, query Kenyan and Tanzanian consulates before you leave. (See also chapter 15.)

Always ask permission to photograph people in Africa; some, like the Masai in Kenya, routinely expect payment. I don't totally blame them, and I always tip well if the subject is cooperative. After all, I am making money off him or her. An alternative is to buy a craft object at the many places they are sold, and then, with the help of your guide, ask permission for photographs. I have two charming paintings bought in East Africa, and I photographed the artists besides.

For safety, it is recommended today that you always travel in East Africa with a guide from a reputable safari outfitter, and that you stay on the beaten path of established game lodges.

Many tourists go to game parks to see as many different animals as possible. When they spot a certain species, they check it off on a list, take a snap or two, and then quickly move on to add others to their "collection." (You can believe this or not, but I know it from experience!) So, the only group safaris I can wholeheartedly recommend to serious photographers are specialist tours; some are led by well-known photographers. Inquire of travel agents and see advertisements in classified sections of travel, outdoor, and photography magazines.

Zimbabwe

Check advisories before traveling to Zimbabwe. This country (formerly Rhodesia) has fine game parks, and a "must see"—the famous Victoria Falls, largest in Africa and guaranteed to produce a rainbow in the afternoon. Drive around the rim for best vantage points. Fly over the falls in a light plane, too. There are hotels nearby; and a model African village where masks and crafts are made for tourists and evening dance performances are offered.

Republic of South Africa

Now that apartheid is over, one can go to South Africa with a clear conscience. The country is beautiful, and hotels are good. Ask permission for people pictures everywhere. Johannesburg is a modern city of skyscrapers; street crime is a problem. On most weekends outside the city, photograph athletic displays by gold miners who dance for tourism and competition.

Near Middelburg, about two hours northeast of Johannesburg, there is a living museum village of N'debele people. They wear dignified robes and headdresses and are famed for

TIPS FOR WILDLIFE PHOTOGRAPHY

I personally feel that normal photographic skills plus patience and an awareness of light are what are needed to get pretty good wildlife photographs. To get great shots you need more, though the great wildlife photographer Art Wolf once said to me "The hardest thing about photographing animals is finding the animals." He was being modest of course. If in doubt about your reflexes, practice at a zoo where the animals are uncaged behind moats, as the lions are in the African plains area of the Bronx Zoo here in New York. (If it weren't for the different vegetation you could almost imagine yourself in the Serengeti!)

Bird sanctuaries, wildlife parks, and refuges everywhere are also good places to hone skills. Use slow- to medium-speed film, the highest possible camera shutter speeds, and a sturdy tripod with long heavy lenses. For sweeping landscapes with and without animals, use wide-angle as well as telephoto lenses.

When on safari, patience is one absolute necessity. The other is to get up before dawn (around 5 A.M.) to be ready for sunrise when many animals are active and the light is beautiful. Shoot till about 8 or 9 A.M., rest at midday, and photograph animals again from late afternoon through sunset (around 7 P.M.) carly and late are when the animals feed. I work with 20mm, 28mm, 35–70mm, 80–200mm, 300mm lenses plus 1.4× and 2× tele-extenders, and use all of them for photographing wildlife. My pictures of lions and elephants especially have sold well as stock.

artistry. The village called Botshabelo has houses decorated with yellow, brown, and blue geometric designs on a white ground, looking like early twentieth-century avant-garde art. Women do the painting and can be persuaded to pose in their best striped wool blankets. Buy some of their intricate beadwork—it is decorative and moderately priced. If you give out Polaroid prints the ladies are thrilled.

Cape Town is beautifully situated facing the Indian Ocean and was originally a coaling and repair depot for British Navy ships. There is a scenic cable car ride up to the famous flat-topped Table Mountain behind the city—the mountain is quite often covered by a white "tablecloth"—a thin layer of clouds. Nearby is beautiful, fruit growing Cape Province. The most famous resident of this southernmost province is Archbishop Desmond Tutu.

My favorite place to photograph in South Africa was the wine growing area around Paarl, north of Cape Town. Drive the wine route to visit and photograph many wineries; some are in two-hundred-year-old step-gabled Dutch Colonial (Boer) mansions painted bright colors, there are high blue mountains behind. At the end of your shoot, taste excellent wines too.

Near Port Elizabeth, the so-called garden route is also pleasant.

It's probably worth the drive to say you have seen the southernmost tip of Africa at the Cape of Good Hope, where there is a lighthouse and a shingle beach covered in enormous tendrils of seaweed as thick as my arm.

I have not yet visited the famous Kruger Park, but am told there is plenty of wildlife to be seen there.

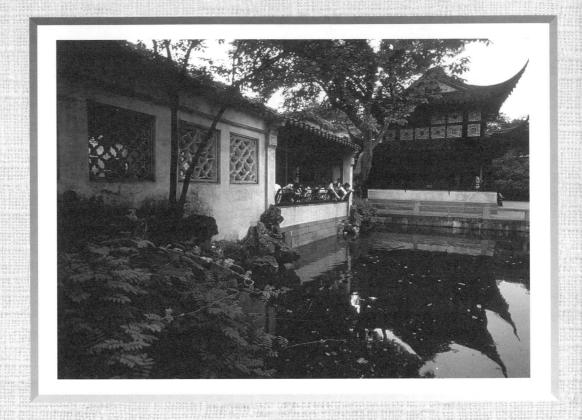

sia is visually and culturally varied, the people are friendly and hotels and service are among the best. The icon for the Pacific region is a gorgeous beach with palm trees—almost everyone's idea of a perfect vacation.

With people venturing ever further afield, both these regions are "hot" travel and tourism destinations.

Japan

I am an out-and-out Japanophile. I have made four long visits there and mostly traveled alone. Not only do the Japanese make superb cameras, their country is superb to travel in. If you love cities as I do, you will rejoice in being able to walk almost anywhere in Tokyo or Kyōto at 3 A.M. and risk nothing worse than a few giggles from tipsy teenagers. Japan has some of the best hotels I have ever stayed in, period, and Japan is often fun. I have a great stock agent in Tokyo, Bob Kirschenbaum, founder of Pacific Press Service, who speaks, I am told, wonderful Japanese. I once spent an evening with him and American travel photographer Mike Yamashita, whose Japanese, he says, is serviceable. With these guys, I toured the small bars of Tokyo. In one, the Francophile host wore a beret and looked a lot like the thirties movie actor Charles Boyer. With our (somewhat) mutual French, and two translators, I sipped Suntorys, chatted till late into the night, and felt like a resident.

Tokyo

Shinjuku is a supermodern and fun entertainment district. (Don't miss the Yodobashi camera store billed as the world's largest. They have things in the immense store you can't get even in New York, like wonderful Minolta soft-leather shoulder bags.)

Japan is an extremely formal country. People constantly bow, shake hands, and exchange business cards. (Get a bilingual one printed overnight at any good Japanese hotel.) The daily opening of the Keio department store in Shinjuku is a ritual almost as elaborate as Changing the Guard in London. (Be outside the Keio's main entrance at 9:30 A.M.)

Tokyo's subway is jam-packed, clean, fast, cheap, safe, goes everywhere, and connects with mainline trains. It has station signs in English. Taxis are not expensive (that is relatively speaking; everything in Japan is expensive for Americans and Canadians); taxi drivers wear white gloves. In the evenings on the Ginza, most taxis don't stop for mere tourists; they are off on errands having to do with regular patrons, like bar hostesses. Near the main Ginza subway entrance is a second floor restaurant with huge windows; get a cup of coffee and a pastry and sit by the window at "blue time" for a superb view of the dazzling neon-lit street. (Take a tripod.)

The Akasusa Kannon temple has a great red gate with a huge red paper lantern hanging from it. It's an icon of Tokyo. Crowds of pious people burn sticks of incense around a bronze cauldron at the entrance. Surrounding the temple is a big market with hundreds of stalls selling necessities like windup toys, kimonos, kitchenware, and electronics.

Tokyo's Ueno Park is another great "people photography" place and has the national art museum too. Do not miss the huge classic screens painted with gold and delicate flowers, or the photography section. Tokyo's enormous Tsukiji fish market is great in the early morning; one of the chase scenes in the thriller *Black Rain* was filmed here.

The Imperial Palace is surrounded by a wall and moat in tranquil, green Hibiya Park. Get nice pictures of it from around the Nijubashi Bridge; there is a subway stop of the same name. I like photographing the bleachers in front of this spot (and in front of all important monuments in Japan) where local photographers record endless groups of kids in bright caps or severe dark blue, high school uniforms.

The Meiji shrine is a "must" place in Tokyo; it's peaceful and beautiful with red-and-white robed priests. Worshipers crowd in on festival days.

The Rest of Japan

Outside Tokyo, take the train everywhere; don't even think of driving unless you are in the capable hands of a Japanese or international corporation. Rental and chauffeured cars cost a fortune; most roads are poor with signs only in Japanese. Attractions about an hour from Tokyo by fast train include the great Buddha of Kamakura (groups of kids line up for pictures in front of it all day long) and the Fuji-Hakone National Park, where lake steamers are an agreeable way to see and photograph the region. Alas, the sacred Mount Fuji is often smogged in. If you stay a night or two at the ornate wooden Furama Hotel nearby you will have a better chance of seeing it than you will on a one-day trip.

When traveling alone in Japan (you should; it's fun and totally safe) have your destination and hotel name written down. If you get lost (and you will) nice people will come and rescue you; some will insist on going far out of their way to get you where you want to go. The price is letting them practice their English, which is often fairly incomprehensible, but everyone enjoys the whole exchange.

Nikko is a huge shrine beloved by the Japanese; it is always jam-packed, but the crowds are agreeable. "Do" Nikko in a day from Tokyo by train and bus. The Nikko temple complex is an absolute riot of carved, painted decoration that includes the three wise monkeys, dragons, and other beasts. There are also forests of stone lanterns and a pretty, real forest around it.

Take the "shinkansen" or bullet train from Tokyo to Kyōto; it passes Mount Fuji. To try to see Fuji, get a seat on the right, reservation required. Get to the station early for pictures of the trains themselves; they leave very frequently. Be prepared to leap on (or off) your bullet train, the doors stay open for about one minute.

The jewels of Kyōto are increasingly hidden among tall buildings of the modern city, and include the Ryoan Zen garden, the Golden Pavilion, the Silver Pavilion, and the garden of the Heian Shrine that has a splendid scarlet torii gate. Japanese families, with women wearing kimonos, go to this pretty place to celebrate birthdays, christenings, and festive days, and have their pictures taken. They don't mind if you photograph them too. My stock pictures of all this have been good sellers.

As all the popular shrines in Kyōto (and elsewhere in Japan) are crowded, especially in spring and fall, you will have to be patient and wait for gaps in the streams of people when you want to evoke mood. I was once in Kyōto for the lantern festival, which is pretty at night; alas, the participants wore eyeglasses, wristwatches, and sneakers with their ornate costumes, which spoiled the period mood of the parades a bit for me.

I have never seen a geisha outdoors in the Gion district of $Ky\overline{o}to$ where they work, but have managed to grab a few quick shots of young apprentice geishas, called "maikos," hurrying somewhere. If you want a private appointment to photograph one or the other, it can be arranged by your hotel concierge, but at an extremely high price. Even to arrange a private tea ceremony in a Japanese home is expensive. An easy way to get pictures of maikos and geishas, a tea ceremony, puppeteers, traditional actors, and musicians is to attend the Gion Corner show for tourists, which is good and quite inexpensive.

I prefer Nara to Kyōto. It is quieter. There is a huge thirteenth-to-eighteenth-century wooden Buddhist temple set in a park where fuzzy horned deer eat bread out of your hands, and there is a Shinto temple too. Near Nara and Kyōto is Japan's second city and major port, Osaka, from where I boarded for a cruise down the coast of China. Osaka castle is an impressive copy of an antique original. The Tennoji botanic garden is pretty.

I have not been to Hiroshima or southern Japan or to the northern island of Hokkaid \bar{o} and hope to do so one day. They have been highly recommended to me.

Korea

If you watched the Seoul Olympics on television you know that Korea doesn't look like the reruns of TV's *M.A.S.H.* anymore. It has one of the fastest-growing economies in the world, and Pusan, where I spent two days on my way to China, is a great place to buy sneakers and much other merchandise. There are a few lovely old sites remaining nearby. The Sokkuram is an ancient man-made grotto which contains a famous three-times lifesize marble Buddha sitting in a quiet cave in a hillside near Kyjŏngju. Pulguk-sa is a collection of small temple halls painted brilliant colors. The very extensive temple complex at T'ongdo-sa has many gray-clad Buddhist monks, fierce-carved temple guardians and brilliantly painted and decorated ceilings.

The government built resort at Bomun is popular with locals as well as foreigners. I took pictures of a bride and groom as they posed on an ornamental stone bridge. She wore a traditional long pink dress, he a dignified gray robe. I liked the many lively markets and friendly, outgoing Korean teenagers; many speak good English. I thought that the national dish of kimchi (aged, fiery cabbage) was strange but delicious.

Taiwan, Republic of China

Taiwan is another of those supergrowth Pacific economies, with horrendous traffic in the capital Taipei, where building sites are everywhere. But there is the great National Palace

Museum with exquisite art—don't miss it. (Photography without flash is permitted; take an FLD or 30M filter for the fluorescent lighting.) The Grand Hotel gets my vote for the most spectacular hotel I've ever seen (it's a huge, red-pillared palace decorated with painted dragons and a curved gold-tiled roof set in extensive grounds). Taipei has a huge temple, Lung Shan, and smaller colorful temples, fine for people-watching and respectful photography.

I was taken by a Taipei tourism official to the Fu-Shing Dramatic Arts Academy. There, students from the age of ten spend eight years learning the characters and elaborate make-up required for the traditional Chinese opera. The seniors are very accomplished. It is a splendid place to take photographs. I am told you can have your Taipei hotel call 790-9127 or 793-4028 to arrange a visit. The same tourist official also took me to an enormous place curiously named the Hoover Theater Restaurant, which has a rather good, well-lit revue with pretty girls, singers, acrobats, and dancers. Taking pictures of the acts with a telephoto lens was no problem; the audience was fun too. (Some of the other entertainment places in Taipei are definitely not for Aunt Minnie.) Finally, the movie posters and advertising signs in Taipei are spectacular and Taiwanese food is absolutely superb; there are many fine restaurants.

A popular tourist excursion from Taipei is the day flight to the marble Taroko Gorge. The misty, gray-and-green place is nice but no Grand Canyon; there are a couple of pretty pagoda-shaped temples in the vicinity and a village where costumed aboriginal people perform dances for tourists.

A fine bamboo forest is near Sun Moon Lake, a favorite resort for Taipei's citizens. The Wen Wu Temple there is a photographic must. (This is usually a two-day excursion from Taipei.) If you drive (or much better, are driven, local drivers are ferocious) in the countryside of Taiwan, you will see peasants in conical hats tending rice fields, little boys leading water buffaloes, fishing boats on lakes, and quiet traditional villages.

Hong Kong

Hong Kong is one of the world's great travel destinations, pulsing with life. The fabulous harbor is surrounded by mountains and packed with skyscrapers. You can often see ancient junks under full sail among modern shipping of all nations. Great views for photographers are inexpensively reached via the funicular tram to Victoria Peak, the sturdy Star Ferries that crisscross the harbor and the top decks of the brightly painted but ancient British tramcars of Hong Kong Island. Double-decker busses ply Nathan Road, which is festooned with huge neon signs; it is the busiest and widest shopping street in the tourist and hotel area of Kowloon. There are observation lounges with great views in most good high-rise hotels. Street markets are good places to photograph people. The "Poor Man's Night Club," a night market near the pier where ferries leave for China, is especially lively.

On the other side of Hong Kong Island from the central business district is Aberdeen, with fantastically painted and neon-decorated floating barge restaurants (which alas serve very indifferent food). See thousands of people who live permanently on their junks at the Typhoon Shelter at Aberdeen. Hire a small boat to photograph them up close if you wish.

I was once in Hong Kong for the annual Fishermans' Festival in June. Then junks decorated with huge multicolored silk banners paraded along the harbor; there were dragon dances, fireworks, and street decorations in the densely packed residential sections near

the water of western Hong Kong Island. The major Dragon Boat festival is held each September. Wander in Hong Kong to find pictures; you won't have far to walk. If you want people pictures, take a Chinese-speaking friend, acquaintance, or guide; you will do much better than if you go alone. Unlike the mainland Chinese, Taiwanese, and Koreans, Hong Kong residents who do not work finance or the tourist industry are not particularly friendly to strangers. Not unfriendly, but they tend to turn away.

Big camera shops are located at the beginning of Nathan Road in Kowloon. One good one is on the ground floor outside the Hyatt Hotel. (Keep New York prices in mind before buying!)

A problem for photographers in Hong Kong is the weather. Summers are hot and humid, misty or rainy; sometimes the place is fogged in. Avoid July and August if possible. Fall is clear and probably the best time to go.

China

China is absolutely one of the world's greatest travel photography destinations. The regime's achievements are impressive if you don't like traveling among desperately poor people, which I do not. Children are healthy (with a lower infant mortality rate than our own!), streets swept clean, and the ordinary people friendly (though I am told now much more reserved than they were before the terrible events of Tienanmen Square). There are plenty of comfortable hotels in China today, and the landscape, cultural monuments, art, and people are such that I am told by a travel agent friend that China will soon be a "hot" travel destination again.

I have been to China twice, the first time in 1977 (thinly disguised as a housewife) on a tour from Hong Kong along with a great many other American and European journalists and photographers calling themselves executives, teachers, planners, and other innocuous occupations. This was just before the United States and China resumed diplomatic relations. We went to Guangzhou (formerly Canton) and surrounding farms, factories, and villages. Guangzhou was then just what I expected, men and women all in uniform blue, seeming millions of bicycles, and there were red banners with slogans, red flags, and pictures of Chairman Mao everywhere. Because it is so near Hong Kong, I am told that Guangzhou is now the most prosperous and "fashionable" city in mainland China.

Years later, I cruised down the China coast on a luxury liner. We called at Dalian (formerly Port Arthur), Quingdao, and Tianjin (formerly Tientsin) where we took a train for Beijing. There I was lucky enough to have a private car and a charming guide, Mr. Liu, who spoke perfect English. Of course, he showed me first the Imperial City (use wide, wide-angle lenses to show the whole scene). We went to the Forbidden City, the Summer Palace, the Marble Boat, and the nearby Sun Moon Lake and the Temple of Heaven. (If you want a very good preview of all this, rent the video of Bertolucci's *The Last Emperor*, large parts of which were actually filmed in the Imperial City.) We also walked around the small streets of Beijing. At that moment the watermelon harvest was at its peak; there were mounds of melons on almost every corner, and melon eaters everywhere, even on bicycles. The next day we drove via the Ming Tombs, guarded by fierce, oversized stone warriors, to the Great Wall, passing misty and very Chinese-looking mountains en route.

The Chinese are enthusiastic tourists in their own country, but rather than sit on benches for group portraits as the Japanese do, they rent Seagull cameras (similar to Rolleiflexes) at the site, buy a roll of black-and-white film, and take their own pictures.

Entrepreneurs develop negatives in little booths on the spot. There were plenty of these guys at the Great Wall; presumably the prints are made by other entrepreneurs when the tourists arrive home.

The Great Wall is jammed with Chinese and foreign visitors on the side to the right of the main entrance, where you walk up a steep section of the wall to a fortress. To the left of the entrance, if you climb a more gentle few hundred yards, you will have the wall almost to yourself. It snakes for miles over sharp green mountains before disappearing from view. Once in a while a solitary walker, or a couple of solders in white peaked caps, or a few giggling girls in flowered cotton dresses, may go by.

If you saw Steven Spielberg's *The Empire of the Sun,* you will recognize Shanghai; the waterfront, it seems, has hardly changed since the 1940s setting of the film. Shanghai's streets are jammed but not depressing; I did not see beggars. People sit on string chairs and play cards or chat; outdoor shoemenders and barbers and vendors of just about everything ply their trades. Food markets and outside busy movie theaters, which have huge hand-painted posters, are good places to photograph people. So is the waterfront park near the Bund, where early morning groups of fitness enthusiasts perform tai chi chuan exercises.

Tourists are hardly left alone in China for a second. I don't think that in China the guides understand the concept. But in Dalian, I managed to sneak away from fellow cruise members. Dalian is a naval port, a seaside resort for Shanghai dwellers, and an interesting place. I walked on the beach and photographed a football team with a red banner, sailors in caps with pompoms, and well-muscled Chinese men in briefs doing acrobatics. My guide reproached me when I found him, and said he could get into trouble if I did that again. (I apologized by buying him a book later.) In Dalian I saw a factory that makes shell pictures; their main market must be the Chinese restaurants of the world. In another seaside city, Quingdao, vacationers from Shanghai gathered edible shellfish into pails; these looked like the winkles beloved by the working-class English. As Quingdao also has a long pier with a pagoda on top, the place felt to me quite a lot like Brighton, England. Briefly a German concession port, the Germans left behind the art of brewing delicious Quingdao beer.

My favorite place in all China is Souzhou. A part of the thousand-year-old Grand Canal runs through the city which some travelers have called the "Venice of China." There are ancient gray houses with brown-tiled roofs lining the narrow canals; a steady stream of straw-roofed barges are pushed along the canals by boatmen with bamboo poles. It all looks like a Chinese painting. Outside Souzhou, the barges sail in narrow channels through lush green rice fields.

In Souzhou is one of the single most wonderful houses I have ever seen, the mansion and lovely water garden of the Humble Administrator. It seems a seventeenth-century court official was sent from Beijing to root out corruption in the provinces. He was so thorough in exposing tax evaders that the bribes that had to be paid him to look the other way were much higher than the bribes had ever been before. The stunning mansion is the result. It has a dark brown tiled roof with upswept corners meant to ward off evil spirits; they are supported on great pillars of polished dark brown wood as smooth as silk. Inside, some rooms are dotted with elegant, simple furniture. Others are just roofed terraces that look out onto streams, bridges, and artfully placed rocks set among ponds filled with water lilies and huge lotus plants. Patience is needed to get pictures without too many visitors (the place is quite quiet at lunchtime). Get a preview by visiting the Chinese court in the Metropolitan Museum of Art in New York.

Singapore

Singapore is a very successful, now ultramodern, city-state governed, and peopled mostly by Singaporeans of Chinese extraction. There are many Malay, some Indian, and a few European Singaporeans too. Take a boat tour for views of the massed shipping and downtown skyscrapers of this famous harbor. This city's surroundings are flat; though there is a cable car that gives good views from the top of a hill called Mount Faber to a nearby small island.

There are great hotels and great shopping in Singapore. Most workers live in high-rise apartment blocks. Kids wear British-type school uniforms. A photogenic place in Singapore is the Tiger Balm Gardens, a riotous jungle of life-sized and larger than life-sized concrete figures of men and beasts illustrating Chinese folklore, painted in brilliant colors. (There is a smaller version in Hong Kong too.) My other favorite place is the bar of the Raffles Hotel, dating from British colonial days and celebrated in the short stories of Somerset Maugham. This bar is about the only remnant though, of the romantic Singapore of tiny Chinese shops and river boats, some of which still existed on my first visit in 1969. (Most residents don't miss the old city I'm sure.) Sit in the Raffles' courtyard garden under fanshaped palm trees, and sip the Singapore gin slings served there. They are powerful, photogenic (pink with small white paper umbrellas) and will restore you after a hard day's shooting.

Stalls selling Chinese fast food cooked over steaming woks near the riverfront are good to photograph, the food is good too. There is a well-done tourist show where you can photograph pretty Chinese and Malay ladies in costume, and a day excursion to a Malay-sian mainland fishing village where naked boys dive from boats for coins.

Malaysia

I have only been to Malaysia once—briefly. The city of Kuala Lumpur has some nice mosques, good hotels, and a splendid railway station with minarets. I'm told that economic problems have stalled the huge recent construction boom, and that there are many unfinished projects. I'm sure you could still make the trip I did, to photograph a nearby rubber plantation. This was totally new and interesting to me.

Absolutely every guidebook I have read highly recommends the interior of Malaysia, and it's a "hot" destination for the with-it young, especially from England, Germany, Sweden, and Australia, so I'm mentioning it here even though I don't personally know it. A former student of mine (a scuba diver) went to the island of Tiamin and says it is uncrowded, inexpensive, and unspoiled, though accommodations are not luxurious. Diving equipment and even underwater cameras can be rented locally. Penang is famous to the British, and I'm told it's still a relatively undiscovered place with hospitable people and gorgeous beaches. The Cameron Highlands are said to be cool and reminiscent of England. Sabah and Sarawak on Borneo are still considered exotic but are increasingly visited by travelers who want to find "unspoiled" Asia, also to see the Sepilok Ourang Utan reserve. Malaysia is a Moslem country. (See notes under Pakistan, later in the chapter.)

Thailand

The city of Bangkok is both wonderful and awful. There are wonderful hotels, including the Oriental (which often makes "world's best" lists in travel magazines), immense gor-

geous temples, friendly people, great food, and lots of shopping bargains. There is also terrible traffic and crowding, a humid climate and pollution in summer, bad smells in several places, and a lot of ugly buildings. Do not let the bad things put you off visiting Bangkok. Best temples are Wat Phra Keo (the Temple of the Emerald Buddha), which is elaborately decorated with gold-leaf covered stupas, and gray-and-white stone Wat Po, where a huge reclining Buddha lies decorated with flowers. You could spend days in either temple and not take all the possible pictures. There are usually groups of smiling and unselfconscious purple or saffron-robed monks walking around under orange umbrellas in both places. It's fun to walk around Bangkok's side streets and see all the little shops; machinery repair shops of all kinds are especially busy in the city, often spilling onto the sidewalk—sometimes I've seen whole cars in the process of being dissected.

There is a pleasant evening river cruise, and an outdoor show for photographers where you can shoot Thai dancers in towering gold headdresses and fierce kickboxers having a real go at each other.

Bangkok's once famous canals have mostly been filled in; to see a floating market you must now go about forty miles outside the city. Damnern Saduak still has a good floating market. Hire a private guide with a boat, and glide along klongs where pretty ladies wearing blue pajamas and wide raffia sun hats sell vegetables and fruits arranged with artistry on narrow pointed boats that look a bit like gondolas. My stock pictures from this place have sold very well.

My photographer friends the Fishers, who lived in Thailand for two years, recommend a day trip from Bangkok to the Bridge on the River Kwai and say that Chiang Mai, Thailand's other great tourist attraction, is much cooler than Bangkok. It's a great handicraft center, and a fine jumping-off point for excursions to remote mountain villages.

The Philippines

I recommend the Philippines visually. Manila has broad boulevards, good hotels, color-fully painted "jeepneys" to get around in, and mostly pleasant people. However, street crime is a big problem, even in politically stable times.

Ancient Spanish-built Fort Santiago has thick walls you can walk around; nearby is Manila Cathedral. There one Palm Sunday I photographed thousands of devout celebrants wearing their best clothes and carrying palm fronds and crosses. There are beautiful handicraft shops in Manila, and a craft village near the airport.

Popular day excursions from Manila are a drive to Taal Lake and a ferry trip to fortified Corregidor Island, where Douglas MacArthur once said "I shall return." I liked best the bus rides themselves, once outside the city; the busses pass low-lying fields, abundant road-side fruit stands, small farms and villages. A short flight from Manila goes to Bagiuo, a resort with pleasant gardens that is an escape from city heat. The surrounding scenery is of piney mountains.

Indonesia

Indonesia is a lovely country, although currently troubled. But the charm of Indonesia is most definitely not in its capital, Jakarta, where in 1969, I stayed three sweaty, mosquito-bitten nights in the worst hotel I've ever been stuck in, in my life. (The electricity was out, so therefore was the ceiling fan; the shower barely worked; the mildewed, broken-tiled toilet

had no seat and dripped continually; and the desk clerk offered to come and take my mind off my troubles.) The city was packed for an international conference, so I was bumped out of my comfortable room at the Hilton by a high-ranking military delegation. Jakarta now has more hotels, and I am sure they don't do things like that to visitors. But the experience soured me on the city, which I'm told is still hot, crowded, and, in places, smelly.

Java

Jakarta is on the island of Java, which, like most of Indonesia, is Moslem (see later in this chapter for tips on photographing in Moslem countries).

The interior of Java has a great tourist attraction, the splendid temples of Borobudur, which are still not on everyone's Indonesian itinerary.

A former student of mine, an enthusiastic underwater photographer, took a big ferry from Jakarta to Kelymutu Island, and another ferry to Lombok. There are tourists in all these places, but not too many. There are also dive shops.

Bali

The charms of tiny, Hindu Bali are legendary. I have been there twice, stayed on the wide Sanur Beach, and spent a total of three weeks being driven around every nook and cranny of this beautiful island. I went back eight years after my first visit, when Bali was more crowded but still very peaceful almost everywhere. I am told that the southern coastal strip has recently become rather developed, and that Kuta Beach in particular is for what is sometimes called the "Four-S set" (sun, sea, sand, and sex). It has bars and discos and is popular especially with young people from the Antipodes, and divers like a former student who dived nearby to photograph a wreck of an American ship sunk by Japanese gunfire in World War II. (For more on underwater photography see the section on the U.S. Virgin Islands, in chapter 17.)

Bali is still lovely and unspoiled in the interior, although some roads are crowded, and some locals now ask for tips if you want to take their picture. You can hire a car with a driver for not too much money, circling the island in one day if you must; or you can drive yourself, though I wouldn't care to. There are Hindu temple festivals to see somewhere almost everyday, women carry towering gold-paper decorated, flower-and-fruit offerings on their heads. Most villages stage different traditional dances regularly for festivals; these are not tourist offerings, although tourists are welcome. The Legong, Barong, and Ketchak dances are highly stylized, very different from each other, and should all be seen. At Batubalan, dance performances for tourists are given daily; these are very well done and highly photogenic. Dances are also staged at the big Sanur Beach hotels. I have stayed twice at the oldest, the Bali Beach. It is an ugly concrete tower, but is very nice inside. The terraced front rooms look out over broad sands; the sea is dotted with outrigger canoes.

Quieter, and more authentic, are the central villages of Celuk, Mas, and Ubud; these are arts and crafts centers and have some very pleasant, quiet hotels. If you ask your guide, he will take you to see good artists and craftsmen at work. In Bali, often several people at one time work on the same painting, which makes for amusing photographs.

My favorite big Balinese temples are at Tanah Lot, Goa Lawah, and Purah Besakih, but there are plenty of tiny ones too, whose names are known only very locally. If you get a chance to see a Hindu funeral, take it, and your camera. If you are respectful, photography is no problem. The funerals are beautiful and not at all sad. Once you have done the highlights in Bali, as usual the best thing of all is just to drive until you see a scene that

you like, and then get out and walk around to photograph. Young Balinese women no longer go bare-breasted outdoors—too many photographers perhaps?

Bali is verdant, with no real seasons. Within a few miles of each other on the same day I have photographed steep rice terraces in first growth, a man with a brace of pink oxen plowing wet paddy fields, people in plaited sun hats planting rice; and others tending young shoots. A few miles farther on, the population of a whole village was communally threshing rice. When you get out of the touristy beach areas, you may find a tiny village market, a funeral procession, a priest and followers walking through rice fields under fringed white umbrellas, or a man driving geese or oxen. A lovely thing to do in Bali is to hire your own outrigger canoe at just about any beach and glide out (with 20mm lens on one of your cameras) to photograph your boatman, the shore, and mountains—and just to feel Balinese for a while. Don't rush through Bali; give it time to reveal itself.

I should add after all this enthusiasm that so many photographers have been to Bali that my stock sales have not been great, though I have lovely pictures—Bali is definitely overphotographed.

Cambodia

Times change, and hardy tourists are slowly returning to the beautiful, tragic land now called Kampuchea. My 1969 visit was a high point of my travels; the city of Phnom Penh was charming, filled with monks wearing bright orange and each carrying an orange or lemon-colored umbrella (I'm still selling stock pictures from that visit). Phnom Penh also had lovely handicrafts shops; beaten silver table decorative items were a local specialty. The real reason for a travel photographer to go to Cambodia though, is to see the temples of Angkor Wat and nearby Angkor Thom, truly among the great works of man. I know that the monks may well not be there, and that the temples are partly overgrown by jungle again, but, I still say if you get a chance to visit Cambodia and see Angkor Wat, go.

India

India is a wonderful country, the world's most populous democracy, but it is definitely not for the timid. Despite its terrible political and religious and population problems; and despite the fact that to travel in India means you cannot ignore poverty, beggars, and sometimes despair; India is a great place for photographers. The Indian people are almost all friendly to Westerners. Among the great things I have photographed are the Jain Temple in teeming Calcutta, the bazaar in Srinagar, floating flower sellers and houseboats on nearby Dal Lake, and the mighty Himalayas near Gulmarg. These last three are all in Kashmir, which currently is closed to foreigners because of the conflict between the Moslem majority seeking independence, and the Indian government.

Moghul masterpieces I have photographed in India include the world-famous inlaid marble Taj Mahal in Agra (it's every bit as beautiful as it is supposed to be; go early or late for good light and to avoid crowds); the great outdoor observatory and pink palaces of the city of Jaipur in Rajasthan; and the Red Fort in India's capital, New Delhi, which also has a fine modern government area.

The most sacred place in India, and my favorite place there for photography, is the city of Varanasi (formerly called Benares). To photograph the thousands of Hindu pilgrims who daily immerse themselves from the ghats (stone steps) along the river Ganges, hire a pri-

BEGGARS

As hard as it may seem, do not give money to beggars or even candy to children in Calcutta, or anywhere in India; many people are professional beggars, and even if they are not, you will almost instantly be inundated with hundreds of people pressing close, a very uncomfortable feeling indeed. When you travel in India, you must accept that you cannot solve its problems.

vate boat with guide and glide past the many riverside temples. Each day, starting at first light, thousands of colorfully, fully-clothed people climb down the steps leading to the wide Ganges, immersing themselves in the holy river, and washing vigorously with soap. Dawn light is behind you, and flat onto the crowds, making for great zoom-telephoto lens shots. From time to time, ornate funeral barges full of mourners scattering the ashes of someone cremated and throwing wreaths of lotus flowers, float past in the middle of the river. Tiny lanterns are floated too. On the eastern bank of the river, vultures wait. Occasionally, corpses are not incinerated for specific religious reasons; for instance, members of the Parsee sect are left exposed in Towers of Silence. I did not see this, but I did see the tiny arm of a baby in the river. In the city, which is not very large, there are hundreds of temples and many houses decorated with paintings of gods and traditional designs. Because of the huge pilgrim trade, there are busy sidewalk markets where cheap holy pictures, brassware, painted toys, silk and cotton fabrics, and brilliantly colored piles of powdered makeup and spices are sold.

In the afternoon, hire a car and drive a few miles in any direction outside Varanasi to find farm country that looks positively biblical, with white oxen pulling unpainted wooden carts and turning waterwheels, men in long white tunics and girls in white saris, and occasional small villages made of pale mud-bricks. Everywhere, and always, there are people stooping in the fields.

My best friend, a keen amateur travel photographer, recently spent three weeks touring and photographing Rajasthan: She says do not miss the Ranthambhore Tiger Reserve. She also says that the Lake Palace Hotel in Udaipur is one of the most fabulous places she has ever been, with the highest Indian standards of beauty and design and the highest Western standards of comfort.

I strongly suggest you deal with a good travel agent or tour company and have confirmed reservations before you go to India, unless you are very young, strong, patient, and adventurous. Comments on getting and changing reservations and coping with officialdom in the Pakistan section (see later in this chapter), apply to a very considerable extent in India also. (See any of Raghubir Singh's books, for a preview of beautiful India.)

Pakistan

I have been to Pakistan twice; it is the Moslem country I know best. The North West Frontier Province is the most exotic, romantic, and remote place I have ever been, with endless photographic opportunities. The bazaar in the provincial capital of Peshawar is packed with thousands of jewelry and carpet sellers, arms dealers, and sidewalk dentists with shops decorated with ferocious pictures of false teeth. There are sweet and tea shops, spice dealers, portrait photographer's studios, and much more. The men are often turbaned, robed,

PHOTOGRAPHING IN MOSLEM COUNTRIES

Both men and women should dress very conservatively at all times, and show as little skin as possible. Long pants are a must for both sexes. Women photographers should wear tops with high necklines and cover their arms at least to the elbow. Wearing a loose coat (I have a long baggy Gap jacket), or tunic to the knee over pants, will make women less conspicuous and better able to photograph in crowded markets, bazaars, etc.

To photograph inside mosques, first inquire if this is allowed. It is in Pakistan. (In more conservative Moslem countries this may not be permitted.) Certain areas of mosques are restricted to women, so I had to watch where I put my tripod. Everyone must remove shoes at the entrance to any mosque. Women must cover the head, shoulders, and arms.

Always ask for permission before taking pictures of men. In Pakistan, they are often extremely handsome and (in my experience) quite willing to pose. Men should never try to photograph women, veiled or unveiled, in the street, because this may cause local men to become angry. Women can photograph some women, with permission, if they first have established some personal contact with them. Ask parents' permission before photographing children. In certain remote corners of Pakistan's North West Frontier Province, such as the beautiful Hunza Valley, the women do not cover even part of their faces, are not quite so shy, and may be photographed, with their permission.

As I have mentioned elsewhere, to me a camera is sort of like a mask at a masked ball. It protects me and gives me anonymity. I am therefore not uncomfortable photographing alone in, say, the bazaars of Peshawar. However, a well-traveled woman writer I know says she prefers not to go to such places unaccompanied, even when very conservatively dressed, because she feels she doesn't belong.

and bearded; the few women you see are partly or completely veiled. Brilliantly painted trucks, motorized rickshaw taxis, busses, horse carts, and bikes thread their way through narrow streets. People are friendly; I was never refused permission for a photograph in the two-and-a-half-days I spent in the bazaar.

The outing to the fabled Khyber Pass from Peshawar to the Afghanistan border is a great photographic journey. You leave Pakistan proper and pass into Pathan tribal areas, where robed, turbaned men routinely wear bandoliers of enormous bullets and carry either beautiful old rifles or high-powered automatic weapons, which is a bit unnerving. The start of the pass is marked by an arch shaped like a fortress, soon after come several forts and military barracks left by the British (in the 1890s) who were able to occupy this remotest corner of the empire for only four years. The border is now guarded by the Pathan tribesmen, and also by the crack Pakistani Khyber Rifles regiment, which surprisingly retains many British traditions. They even have a bagpipe band which plays on special occasions! I was lucky enough to visit their mess, which is decorated with portraits of noted guests, including Presidents Bush and Carter and their wives, General Douglas MacArthur, and Queen Elizabeth and Prince Phillip.

It would be marvelous if Pakistan had more responsive tourist representation in North America. In lieu of this, take multiple copies of a letter of assignment and apply immediately on arrival to see all this, because permission to visit the tribal areas and Khyber Pass must be obtained from the Pakistan Tourist Development Corporation. This body has a branch in Dean's, a government-run hotel in Peshawar. Allow at least two days for permission to materialize. (I stayed in Dean's, which is shabby but clean and adequate, with

pleasant service.) My advice is to take a Peshawar taxi to the Khyber Pass, choosing a driver who speaks some English (many do). This will cost about \$60.

From Peshawar, fly or take a hired car to Pakistan's capital, Islamabad, which has a fine modern mosque, and stay overnight (the Shalimar Hotel in the twin city of Rawalpindi is convenient for the airport and will store luggage) for the early morning flight to Gilgit, the biggest town in the mountainous far north of Pakistan. The flight only operates in clear weather and is breathtaking; you fly eyeball to eyeball among great peaks (there are said to be eighty-seven that are over 23,000 feet high) that are perennially snow covered; the highest one I glimpsed was Nanga Parbat (26,660 feet); on some days they say K-2, at 28,251 feet the second highest mountain in the world, is visible.

In Gilgit, stay at the Serena Lodge, which has comfortable rooms with terraces overlooking the Hindu Kush Range, and a nice restaurant with views of 25,550 foot-high Mount Rakaposhi. In Gilgit, you can hang out in the small, colorful bazaar, take day trips by jeep, or arrange to go on a trekking expedition. Northern Pakistan, which is one of the great trekking areas of the world, has several private companies that arrange overland excursions.

I used the services of Walji's Adventure Pakistan, a private tour operator with a representative in Stamford, Connecticut. The cost of a new bright blue jeep, a driver, and an excellent guide, Amjad Ayub (who turned out to have assisted National Geographic photographer Jonathan Blair when he was in the region for three months), was about \$65 for a six-hour trip. Amjad (whose English was fluent and idiomatic) recommended a drive as far as his village of Karimambad for a day-long look at the area. We drove along the new Karakoram Highway which joins Pakistan with China. The highway clings to the mountains and looks down onto the scenic and fertile Hunza Valley. Early in November, when I was there, poplar and fruit trees were gold and bronze; just past their best; mid-October is peak time for fall foliage. April is the time for spring green fields and white and pink fruit blossoms.

Longer tours by jeep, starting from Gilgit, and proceeding along the Karakoram highway into western China as far as Kashgar, can be made by prior arrangement; but remember a visa for western China takes about six weeks so come prepared. The Karakoram Highway, a world-class construction feat by Pakistani and Chinese engineers and laborers, follows the fabled "silk route" first taken by Marco Polo. Open to tourists only since 1986, it is increasingly popular with European and Japanese touring companies; and a few U.S. operators are also offering travel along this route.

Skardu is another northern town where treks and also serious mountaineering expeditions originate. As always, they should be arranged in advance. You can fly to Skardu from Islamabad, or go by jeep from Gilgit. I was not able to get there, but met a tour operator who offers a program for trekkers to sleep in luxurious Mongolian-type yurts (tents), which sounds interesting. Don't ask me about photographing on mountaineering expeditions—I am afraid of heights. Read Galen Rowell's *Mountain Light* for expert advice.

While you are in this corner of Pakistan, fly at dawn from Peshawar to Lahore, a pleasant city with some of the greatest Moghul architecture of the subcontinent. Primary viewing is the enormous red stone Badashi Mosque. It has three onion domes and four great minarets, was built by the Emperor Aurangzeb in 1674, and is one of the most splendid buildings I have ever seen, almost as beautiful as the Taj Mahal. Right opposite is the Lahore Fort, and nearby the marble Wazir Khan mosque, which alas I did not have time to see. I had a plane to catch (see later in this chapter). I know that Lahore is worth a stay of several days and plan to return someday, preferably in early March, when the National Agri-

A CAUTIONARY NOTE ABOUT THIRD WORLD TRAVEL

You will need a sense of humor and adventure when traveling in third world countries. Do not expect Western standards of efficiency in Pakistan, a poor country. Communications are bad. While the private sector works reasonably well, dealing with public officialdom on all levels can be boring, time-consuming, and frustrating. The large bureaucracy is slow and rigid at best; incompetent and infuriating at worst. I recommend making all your major travel arrangements before you arrive in the country, and sticking to them. Airports in particular can be a hassle—trying to get or even change a plane reservation is a major operation that can often take hours (the reason I could not see more of Lahore). Immigration and check-in at airports are unregulated madnesses that can rival the New York subway at rush hour. Security is a stringent, time-consuming process.

I took three cameras, several lenses and fifty rolls of film into Pakistan and was never queried about this. Hand luggage may be examined over and over and even scanned more than once. Do not put film in checked luggage. Hand carry film, but put it all into Sima lead bags (I use them doubled), for security scanning. Remove all batteries from cameras, flash units, even alarm clocks and flashlights, and put the batteries in checked luggage, or they may be seized from hand baggage. Be prepared to open everything, and to be personally patted down very thoroughly indeed.

cultural Show, a week of animal exhibits, polo matches, and displays of horsemanship and military pageantry take place.

Sociologically, Pakistan is not as depressing as India; I saw few beggars in Lahore, none in Peshawar. The traffic is very heavy on major roads between big cities, rush hour in downtown Lahore has to be experienced to be believed.

Pakistan is one of the most interesting places I have ever been, is definitely underphotographed, and seems to me to provide a different view on the Moslem world. English is widely spoken, there are English language signs almost everywhere, and some newspapers in English too. Hotels in the deluxe, first-class and moderate price ranges exist, and the food is great if you like mild-to-hot curries, shish kebabs, interesting variations on rice, and yoghurt and dried fruits and nuts. Most Pakistanis I met like to talk and to know what Westerners think about their country. I would have enjoyed meeting some professional women, who exist in quite large numbers especially in Karachi, a huge, sophisticated and crowded city.

Pakistan International Airlines (PIA) is the source of tourism information on the country, with offices in the United States and Canada. Do not count on them for the level service you get from, say, the British Tourist Authority. PIA does a good job in the air. They give free hotel rooms between their flights connecting small Pakistani cities with international gateways such as Islamabad, Lahore, and Karachi, a reason to fly PIA the whole way. However, their ground service leaves something to be desired.

In my file drawer of places to go, Pakistan is a top off-the-beaten-track destination for seasoned travelers, not casual visitors. Visually and culturally it is well worth the effort. If you can, go.

The Pacific: Australia and New Zealand

In Australia, I loved Sydney—a lively, beautiful, and fun city. To get a feel for it, take almost any ferry from downtown Circular Quay, close to the Sydney Opera House, big hotels, and business district. The ferries crisscross the famous harbor and give fine views of Sydney's icon, the great sail-winged opera house, and also of famous Sydney Harbor Bridge. Attend a performance at the opera house if you can; it encompasses several venues besides the principal opera/concert hall.

The best view of the Opera House and the Sydney skyline at sunset is from Mrs. Maquarie's Chair, a viewpoint in a downtown park. A monorail that runs from downtown Sydney to Darling Harbor also gives fine views en route. Darling Harbor is a shopping/entertainment area on the site of old docks, with a fabulous aquarium.

Paddington is a "trendy" quarter of pastel painted Victorian row houses with cast-iron balconies. I stayed in the quiet Bayswater Road district, in a moderately-priced Best West-ern. This area is convenient, ten minutes from downtown but near King's Cross, an entertainment area with a dubious reputation. Frankly King's Cross seemed pretty tame to me, even late at night.

A photogenic British-type pub in downtown Sydney is the Royal. An Australian-style pub (with outdoor barbecues) is the Oaks Hotel on Military Road in the suburb of Neutral Bay. A wonderful fish restaurant is Doyle's, on a beach in the suburb of Doyle's Bay.

Don't miss going to a Test Match (world-class cricket) if you are in Sydney (or Melbourne) when one is being played. See lifesaving demonstrations at Bondi and Manley Beaches close to downtown Sydney. In midwinter (August) I didn't see any. I'm told many Sydneysiders celebrate Christmas with a picnic on these beaches.

I spent a pleasant week in Melbourne with friends. It is cosmopolitan, and busy. Tramcars ply the streets, the Victorian covered market is superb, there is a fine walk along the Yarra riverfront, and a great museum where I saw my first Aboriginal art. Forty miles from Melbourne is the Healesville Nature Reserve, well worth a visit, and a place where koala and kangaroo pictures are guaranteed.

Australia's number one tourist attraction is the Great Barrier Reef. Most of the reef is within the Great Barrier Reef Marine National Park. The Whitsunday Islands at the southern end of the park are the most developed, with many hotels and sailing centers. There you can hire your own boat or even helicopter to get to the reefs. You can skin-dive and take a diving course; Walter Koch, a former student got his advanced underwater certification at Airlie Island, and says dive shops are everywhere along the coast. Snorkeling and photographing coral and fish from a glass-bottomed boat are other options, depending on your aquatic abilities, taste, and pocket book. Heron Island has a resort hotel, and guided walks on part of the nearby reef at low tide are possible. Lizard Island near quiet Cookstown is further north, and recommended for those who prefer being closer to nature than to their fellow man; there is an exclusive resort there, as well as camping facilities. Close by, Hinchinbrook Island is even quieter, for campers only.

I went to Port Douglas in Northern Queensland in winter. Alas, storms for the week I was there prevented the big boats that take tourists to the reef from sailing. I saw the rain forest instead, as well as birds and crocodiles on the Daintree River.

Note: Swimming is inadvisable in far north Australian waters because of jelly fish. (For underwater photography suggestions, see the section on the Virgin Islands in chapter 17.)

I stayed for three days at Yulara in Australia's "red center"—the desert of the great Australian Outback; nearby Ayer's Rock is especially holy to Australia's Aboriginal people. Also

holy and close by are the Olgas, a group of twenty-eight great round red rocks. I photographed both at both sunrise and sunset, and did get some fine color effects. The whole area is preserved as the Uluru National Park, and administered by Aboriginal people.

You can learn about the "Dreamtime"—the heart of Aboriginal belief—and see art in the park region. (*The Songlines*, by the late Bruce Chatwin, is a fascinating book about these first Australians, and their spiritual ties to just about every living creature, hill, rock formation, and watering place in the country.)

The Katunga National Park in the Northern Territory is Australia's largest. I plan to go there on my next visit to Australia.

Everything I now know about New Zealand is detailed in chapters 11 and chapter 15.

The Pacific Islands: Hawaii and French Polynesia

Of course, the northern Pacific archipelago of Hawaii is an American state, but seems to fit here best. I have stopped briefly on Oahu; the famous view of and from Diamond Head is fine at dusk. A drive around the lush interior of Oahu is enjoyable, you pass some lovely houses. Downtown Honolulu is congested. I stayed in a quite unpretentious hotel right on Waikiki Beach, which I liked. Almost everything in Honolulu except the hula-hula shows seem to celebrate Polynesian cultures from further across in the Pacific, which is amusing. The Arizona Monument to the victims of Pearl Harbor and the Cemetery of the Pacific in the great green bowl above Pearl Harbor had the effect on me that all war memorials do, they made me want to cry.

French Polynesia

I have always wanted to go to the South Pacific, and in May 1998, spent some frequent flier miles on a trip to Tahiti, Moorea, and Bora-Bora, all in French Polynesia. From New York to Los Angeles, I flew United, the rest of the trip was on excellent Air New Zealand.

The city of Papeete is busy and not too pretty; but I loved the huge Central Market where everyone was pleasant when I asked permission to take pictures. Interisland ferries left the dock area right opposite my hotel (the midpriced, old but clean and comfortable Royal Papeete). At night hundreds of "roulottes"—restaurants on truck beds—drove in to the area to sell delicious cheap food. There were many other good places to eat; the standout was Le Retro, a classic French sidewalk restaurant-cum-sidewalk café. The place is opposite the yacht harbor, a gathering place for locals, plus owners and crews of elegant boats from all over the world, resting and recuperating after crossing half the Pacific.

From Papeete it's a long one day drive around Tahiti by rented car. The Gauguin Museum, several nice stretches of coast and farm land, and rather traditional Tahiti Iti (or little Tahiti), a small bulge off the end of Tahiti Island, were highlights.

As I was at the docks, I took day trips to Moorea to see that island; the ferry took forty-five minutes each way. On day one, I hopped on and off local busses and photographed at a posh honeymoon hotel, on day two rented a car and saw cocoa cultivation, Cook's bay, high viewpoints, and beaches, and on day three, a Sunday, photographed people in their best going to church. That was the only time that people have come up to me, introduced themselves, then kissed me, while I was working!

The highlight of the trip was eight nights in Bora-Bora. I took the fast ferry to Ono-Ono and stayed in a charming, rather disorganized guest house on a beach, Chez Maeva

Masson. There, Madame Rosine Masson looked after Polynesian residents mixed with guests from Brazil, Canada, Denmark, France, Germany, Spain, and the United States. We cooked family style, especially after I got food poisoning at the best (American owned) restaurant in Bora-Bora!

There is nothing much to do in Bora-Bora except shop, once you have driven round the island, which takes about two hours. I spent most days on the beach swimming in the most gorgeous deep turquoise water I have ever seen. I took Rene's launch to the sandy motu (reef) that runs all around the island, and made some classic palm tree shots in late afternoon.

Bora-Bora, it must be said, is getting overbuilt with honeymoon hotels. I had planned to visit Huahine and Maupiti, quiet nearby islands, but rough weather and unexpected rain caused me to fly directly back to Papeete.

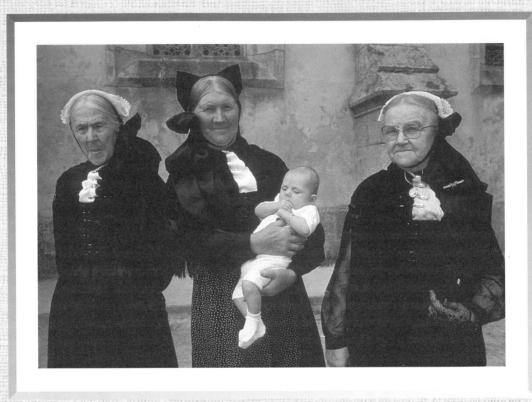

Il of these model releases may be copied or adapted for your own use. I suggest reproducing them three to a page; keep two copies, and give the model one. Add your name and address and phone number if you wish. It reassures models and I have never had any problems from doing this.

Short Form Model Release, and Translations

English

M	ODEL RELEASE
Date: Place:	
I	
(PL	EASE PRINT CLEARLY)
hereby grant	
permission to use, copyright, and publish t vertising and trade in all lawful media.	the photographs taken of me today for purposes of ad-
Signed	

French

AUTORISATION		
Date:	Lieu:	
Je, soussigné(e)	(VEUILLEZ ÉCRIRE EN LETTRES D'IMPRIMERIE)	
l'utilisation, l'enregist jour à des fins publicit	rement du copyright et la publication des photos prises de ma personne ce taires et commerciales dans toutes les médias legaux.	

Spanish

AUTORIZACION DE MODELO			
Fecha:	_Lugar:		
Yo	(POR FAVOR, ESCRIBA EN LETRA DE IMPRENTA)		
a utilizar, registar como prop todos los medios de difusión	niedad intelectual y publicar con fines publicitarios o comerciales, en legímos, las fotografías que entrego en la fecha.		
Firmado			

Portugese

	AUTORIZAÇÃO DO (A) MODELO
Data:	Lugar:
Eu	(FAVOR ESCREVER CLARAMENTE)
por meio desta, concedo a	
	va dos direitos autorais e de utilizar e publicar as fotografias tiradas da publicitários e de comércio em todos os meios de comunicação legais.
Assinado	

		Α		

Italian

Tuttutt
AUTORISAZZIONE DI MODELLO
Dato: Luogo:
IO(SCRIVERE IN MODO CHIARO)
(SCRIVERE IN MODO CHIARO)
con la presente garantisco a
il permesso di adoperare, esercitare i diritti e pubblicare le fotografie fatte a me oggi per scopo pubblicitario e per la vendita ai giornali.
Firmato
German
ZUSTIMMUNG ZUR VERÖFFENTLICHUNG
Datum: Ort
Ich(BITTE DEUTLICH DRUCKEN)
makes believed
gebe hiermit
Erlaubnis, die Fotografien, die heute von mir aufgenommen wurden, in allen legalen Medien der Werbung und des Gewerbes zu benützen, hinsichtlich urheberrecht gesetzlich zu schützen und zu veröffentlichen.
Unterschrift
Dutch
TOTSTEMMINIS VANIMODE!
TOESTEMMING VAN MODEL
Dalum: Plaats:
lk
Ik,(GELIEVE IN DRUKLETTERS TE SCHRIJVEN)
geef hier aan
toestemming om de foto's die vandaag van mij zijn gemaakt te gebruiken, het kopijrecht te behouden en de foto's te publiceren in advertenties of te gebruiken voor alle wettige media.
Ondertekend

Danish

ERKLÆRING			
Dato:	Sted:		
Jeg	(VENLIGST SKRIV MED BLOKBOGSTAVER)		
tilladelse til at benyt annoncering og salg	te copyright og offentliggøre de billeder jeg har taget I dag med henblik på i alle offentlige tilgængelige media.		

Finnish

VALTUUTUS
Päivämäärä: Paikka:
Minä(PAINOKIRJAIMIN)
annan täten luvan
käyttää ja julkaista kaikin oikeuksin minusta tänään otettuja valokuvia mainos-ja mynnine- distämistarkoituksissa kaikissa laillisissa julkaisuissa.
Allekirjoitus

Norwegian

FULLMAKT			
Dato:	Sted:		
Jeg	(VENNLIGST SKRIV TYDELIG)		
gir herved			
retten til å bruke og og alle legale publil	distribuere fotos hvor i jeg figurerer, inkludert opphavsrett; i media, a sjoner.	nnonser	
Signatur			

Swedish

FULLMAKT			
Datum:Ort:			
Jag			
(VÄNLIGEN TEXTA TYDLIGT)			
beviljar fotografen			
tillstånd att använda och publicera bilder fotograferade av mig i reklamsyfte i alla lagliga publikationer.			
Signeras			

Icelandic

	LEYFI	
Dagur:		
Staður:		
Ég		(skrifið með prentstöfum)
veiti hér með		
ótakmarkað leyfi til útgáfu lj öllum löglegum fjölmidlum.	ósmynda sem teknar voru	af mér í dag í tilgangi auglýsinga og kynninga í

Hungarian

MODELL ENGÉDELY			
Dátum:Ile	ység:		
Én			
	(KÉRJÜK NYOMTATOTT BETÜKKEL)		
engedélyt adok	(fényképész neve)		
hogy a rólam ma készült fényké ujságban, folyóiratban vagy bár	peket felhasználja bármilyen hirdetésben vagy egyéb szakmai célra, mi más hirközló szeryben.		
Aláirás			

Polish

Polish	
PO	OZWOLENIE NA PUBLIKACJE
Data:	_
Miejscowość:	_
fotograffi, zrobionej obziś, używan	am aby mię fotogtrafować. Także pozwalam aby kopje mojej no w reklamach handlowych i w środkach masowego przekazu.
Podpismo:	
Russian	
	РАСПИСКА в передаче прав
Дата:	Место

_____(просьба писать разборчиво)

Greek

настоящим разрешаю _

Подпись

ΠΡΟΤΥΠΟ ΑΝΑΚΟΙΝΩΣΗΣ. ΗΜΕΡΟΜΗΝΙΑ ΤΟΠΟΣ ΕΓΩ δια του παρόντος δίδω την άδεια να χρησιμοποιήσετε κόπυραιτ (Δικαίωμα πνευματικής εργασίας) για να δημοσιεύσετε τις φωτογραφίες που μ έχετε βγάλει σήμερα για διαφημιστικούς και εμπορικούς σκοπούς σ' όλα τα νόμιμα μέσα ενημερώσεως. Ο, η υπογεγραμμένος(η)

использовать, обеспечивать авторское право и публиковать свои фотографии,

сделанные сегодня, для целей рекламы и торговли во всех законно

зарегистрированных средствах массовой информации.

D	_	1	Γ	۸	0	_	0	
П		L		Α	5	E	2	

Turkish

Tarih:	
Yer:	
Ben,	
her türlü kanuni reklam ve medys ticaretinde kullanilmak gayele	ri ile bugun çekilen fotoğraflarının,
her türlü kanuni reklam ve medys ticaretinde kullanilmak gayele telif ve yayımlanma iznini bu vesileyle veririm.	

Arabic

تصريح
التاريخ: ــــــــــــــــــــــــــــــــــــ
المكان: ــــــــــــــــــــــــــــــــــــ
انا، ـــــــــــــــــــــــــــــــــــ
اعطي بهذا التصريح الاذن باستعمال وبتسجيل الحقوق وبنشر الصور المأخوذة لي
اليوم لاغراض الدعاية والتجارة في جميع الاوساط الاعلامية الغانونية
التوقيع

Hebrew

שחרור הדוגמן	
	: תאריך
	מקום:
(אנא כתוב ברור)	הנני:
בזה היתר לשמוש. לזכויות יוצרים, והדפסה של התמונות בהם אני היום, למטרות פרסום מסחרי בעיתונות הפועלת עפרי החק.	
:10:	על החת

Chinese

	弃权书
18	时间:
3	地点:
1	我,
ŕ	为广告和贸易的目的,使用、取得版权及出版其今日为我所拍之照片。
4	签字:

Japanese

日時:							
場所:							
私			(k	はっきり	と書い	て下さ	い) は、
						に	対して、
本日私を撮影し	」た写真を、す	けべての合流	去的な媒体	*におけ	る広告	及び商	業目的の
ために使用し、	著作権を設定	とし、公表で	することを	E. 20	書面を	以て許	可します

Indonesian

PENGELUARAN MODEL					
Tanggal:	Tempat:				
Saya	(TULIS DENGAN JELIS)				
dengan ini memberikan					
izin untuk meggunakan, hak cipta dan penerbitan foto-foto gambar saya yang diambil ini hari untuk.keperluan periklanan dan diperdagangkan diseluruh hukum media.					
Tertanda					

Korean

12	전리	933
_		,00

達本: _____

· (注 €) ____ 는 (성 髮 走 差 对 买 升 用)

아래 얼쳐란 권리를 ______에게 49 At

i 내가 오늘 모델로 줄면한 모든 A인에 관한건다.

/ 山北 公司 里里里 爱时老 经 外间 彭州田巴 미니아 메레에 상임 광고 젊으로 전부 또는 料配 針 些 翻述 思.

MS:

Tagalog (Philippine)

PAHAYAG NG MODELO

Pook: _____ (pakilimbag nang malinaw) Ang nakalagda _____ ay nag bibigay - pahintulot kay ___ na gamitin at ilathalà ang mga larawang nauukol sa akin sa araw na ito sa hangaring ipabatid sa madla at ibaliwas sa lahat ng legàl na lathalà at himpilang pang-telebision. Lagda: ____

$\overline{}$	т	7			
- 1		n	1	7	1
- 1		L	ı	Æ.	L

u	ใบยินยอม
ข้าพเจ้า	(โปรดเซียนตัวบรรจง)
ยินยอมให้	
. 71 . 6 2 2	ยสิทธิ์และการตีพิมพ์ซึ่งรูปถ่ายของข้าพ เจ้าในวันนี้
นา ไป ใชตลอดจน เป็น เจาของลีกข	ขสทธและการตพมพชงรูบถายของขาพ เจา เนวนน
	เสทธและการตพมพชงรูบถายของขาพ เจา เนวนน ละการค้าตามวิธีของสื่อมวลชนที่ถูกกฏหมายโดยทั่วไป

Malay

PENGELUARAN MODEL			
Tanggal: Tempat:			
Saya			
(TOLONG TULISKAN SECARA TERANG)			
dengan ini, memberikan izin kepada			
untok megunakan, ka cipta dan menerbitkan semua gambar-gambar saya yang diambil pada hari ini untok.dipergunakan pada adpertensi dan perdagangan berdasakan hukum yang berlaku.			
Tandatanggan			

Swahili

MFANO			
Tarehe:	Mji:		
Mimi	(MAANDISHI MAKUBWA TAFADHALI)		
natoa kibali kwa			
kutumia picha zangu zilizopigwa leo na kuzichapisha kwa matangazo ya biashara inavyohitajika kwa nija zote halali za mawasiliano.			
Sahini			

Hindi

नमूना आज्ञा-पत्र
तिथि
स्थान
并
अनुमती देती हूँ
कि उन सभी अपनी तस्वीरों
की जो आपने आज ली हैं
सभी अधिकृत प्रकाशन सामग्री
में विज्ञापन हेतु प्रयोग करने का
आप की पूर्ण अधिकार प्रदान
करती हूँ ।
हस्ताहार

Urdu

رمازت مرآ اتا وت
مِبَ سمی
اس ا مرك اجازت دې سرك كه ترج چوميري لمورس ك
ائى سى د. ئراكتى بىردى رت اسى لى لى لى
وا سَلَى اللهِ
>

Bengali

وهما کی کے رشا کی در اسط امار ت
01/2 2 010 pris = 10,00
Jen 1:5 2 40 mo mo 10 10 10 10 10 10 10 10 10 10 10 10 10
S192 2 2 20001
6111001mg 20011121
. د تنخط

For the translations, my sincere thanks to:

Mahmut G. Aygen; CEDOK; Andrew Chang; P. K. Chockwe; Gvernment of India Tourist Board; Olivia Grayson; Grazia Neri, Milan; Mora Henskens; Mubarak Hussain; Maria Javier; Eleni Koumas and Lucy Marpiletti; Sabina Lida; Hella Koln Mills; Pacific Press Service, Tokyo; M. Atiq-ur-Raman; Adang Sanusi; the Scandinavian Tourist Boards; Singapore Tourist Promotion Board; Stock Photos, São Paulo; Tourism Authority of Thailand; and the United Nations Camera Club. For assistance in obtaining translations, thanks also to Suzanne Goldstein, Audrey Gottlieb, and Nadeem Nazar.

STANDARD COMMERCIAL MODEL RELEASE			
Date: Location:			
For good and valuable consideration, receipt of which is acknowledged,			
I,(PLEASE PRINT NAME)			
(PLEASE PRINT NAME) hereby and irrevocably consent to the use, copyright, and publication of the photographs taken of			
me today by			
and those whom he/she may designate, including			
for purposes of advertising and trade, in all lawful media.			
Signed	Phone #		
Address			
Witness	Date		

I.	CIAL MODEL RELEASE FOR MINORS	
	(PRINT CHILD'S/CHILDRENS' NAME[S])	
	(PRINT CHILD'S/CHILDRENS' NAME[S])	
a minor/minors, age(s)		years,
hereby give permission to	(PHOTOGRAPHER)	
and(NAME O	PF COMPANY/CORPORATION)	
	s taken of my child today, in all lawful media.	
Signed	Date	
Address		
The pictures are described as follows:		

LIMITED MODEL RELEASE (Use for unpaid models who do not wish to sign a blanket release.)			
Location Country			
Group Name/Number(OR, NAME OF CRUISE SHIP, HOTEL, ETC.)			
Tour Director(OR NAME OF CRUISE DIRECTOR/HOST, ETC.)			
I, the undersigned hereby give(PHOTOGRAPHER)			
and(CORPORATION)			
permission to use, copyright, and publish the photographs taken of me today, alone or in company with others, in their tour/cruise/hotel/resort brochures.			
My name \square may \square may not be used.			
Name Date			
Address			
Telephone #			
Signature			
If the subject(s) is/are a minor/minors, please also complete the portion below:			
I am the legal parent/guardian of			
age(s) years, and I hereby give permission for the use of his/her/their picture(s) in your brochures.			
His/her/their name(s) \square may \square may not be used.			
Signed			
Relationship			

Note: A model release is required for all recognizable pictures of people in any form of tourist promotion, including travel catalogs. The type of limited release above can be used for "models" who are clients of your tourism client.

Some may be prominent professional people and all have probably paid a lot of money for the trip/cruise/hotel, etc. Such "models" are frequently willing to pose—even enjoy it—but are unwilling to sign an unlimited model release. Also, your client may not wish you to ask their clients to sign an unlimited release, not wishing to exploit them.

Client "models" can also write out a letter of permission by hand; some with legal training may prefer to do this. Of course, with any type of limited release, it would be very unwise to use these pictures later on for general stock purposes.

PROPERTY/ANIMAL RELEASE			
l,	(PRINT NAME)	_ the owner of the property/animal	
located at/described as			
	(PHOTOGRAPHER)		
the right to use, copyright and publish the pictures taken of my property/animal for purposes of advertising and trade in all lawful media.			
Signed		Date	
Address	P	Phone #	
Address	P	Phone #	

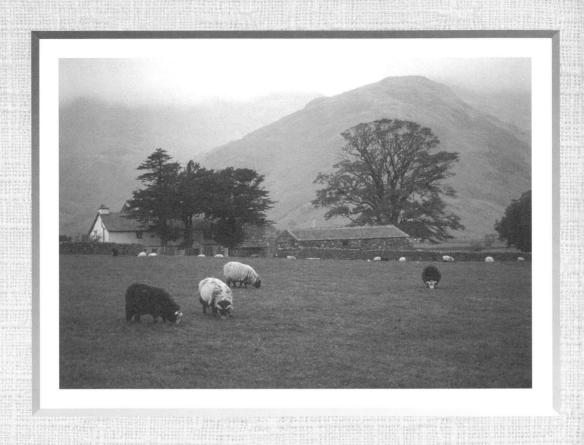

Appendix: Resources

pace limitations mean I can only list the U.S. contacts for photographic corporations. Please note that all addresses, phone numbers, toll-free (800 and 888) numbers, and fax numbers can change. Web site URLs can change also. Remember the invaluable services provided (free) by telephone directories and Internet Web search engines. The directory of toll-free numbers that can be called from your area is reached at (800) 555-1212. This applies also to Canadian listings.

Official Government Travel Advisories

U.S. State Department travel advisories, also official background papers on over 140 countries and access to health advice, are available on the Internet at the State Department's Web site (http://travel.state.gov/), or phone (202) 647-5225.

The Canadian Department of Foreign Affairs and International Trade posts travel advisories and more in English or French on its Web site (*www.dfait-maeci.gc.ca/*). Canadians can get travel publications from the Canadian Government Publishing Center, Supply and Services, Canada, Ottawa, ON K1A059; phone (819) 956-4802.

Also, the British Foreign and Commonwealth Office publishes travel advisories and other advice on its Web site (www.fco.gov.uk/travel/) and the Australian Department of Foreign Affairs and Trade has an official Web site listing advisories (www.dfat.gov.au/consular/advice).

Photographic Equipment Manufacturers

35MM AND MEDIUM-FORMAT CAMERA SYSTEMS

Bronica GMI Photographic Inc. 1776 New Highway P.O. Drawer U Farmingdale, NY 11735 Tel. (516) 752-0066, fax (516) 752-0053

Canon USA
1 Canon Plaza
Lake Success, NY 11042
Tel. (516) 488-6700, fax (516) 354-9007
www.usa.canon.com

Contax Yashica Inc. 100 Randolph Road, CN 8062 Somerset, NJ 08875 Tel. (908) 560-0060 www.contaxcameras.com

Fuji (See under film.)

Hasselblad 10 Madison Road Fairfield, NJ 07004 Tel. (800) 338-6477; (201) 227-7320 fax (201) 227-3249 www.hasselbladusa.com

Leica 156 Ludlow Street Northvale, NJ 07647 Tel. (800) 222-0118 or (908) 767-7500 fax (908) 767-8666 www.leica-camera.com

Mamiya America Corp. 8 Westchester Plaza Elmsford, NY 10523 Tel. (914) 347-3300, fax (800) 321-2205 www.mamiya.com

Minolta Corp. 101 Williams Drive Ramsey, NJ 07446 Tel. (201) 825-4000, Fax (201) 327-1475 www.minolta.usa.com Nikon Inc. 1300 Walt Whitman Road Melville, NY 11747 Tel. (516) 547-4200, fax (617) 494-0249 www.nikon.usa.com

Olympus Corp. Crossways Park Woodbury, NY 11797 Tel. (800) 221-3000, fax (516) 349-2471 www.olympus.com

Pentax Corp. 35 Inverness Drive East Englewood CO 80112 Tel. (303) 799-8000 www.pentax.com

FIELD AND SPECIALIZED CAMERAS

Fuji (See under film)

Linhof HP Marketing Corp. 16 Chapin Road Pine Brook, NJ 07058 Tel. (201) 808-9010

SinarBron Inc. 17 Progress Street Edison, NJ 08820 Tel. (908) 754-5800

Toyo Cameras (See Mamiya America Corp. under cameras)

Wisner Classic Mfg. 732 Mill Street P.O. Box 21 Marion, MA 02738 Tel. (508) 748 0975

Zone VI Inc. P.O. Box 219 Newfane, VT 05345 Tel. (802) 257-5161

LENSES

Schneider Schneider Corporation of America 400 Crossways Park Drive Woodbury, NY 11797 Tel. (516) 496-8500 www.schneideroptics.com

Sigma Corp. of America 15 Fleetwood Court Ronkomkoma, NY 11779 Tel. (516) 585-1144 www.sigmaphoto.com

Tokina Optical Corp. 1512 Kona Drive Compton, CA 90220 Tel. (800) 421-1141; (213) 537-9380 fax (516) 496-8524

FILM

Eastman Kodak Co. 343 State Street Rochester, NY 14650 Tel. (800) 242-2424; (716) 724-4000 fax (716) 724-0663 www.kodak.com

Fuji USA Inc. 555 Taxter Road Elmsford, NY 10523 Tel. (800) 755-3854 or (914) 789-8100 fax (914) 482-4955 www.fujifilm.com

Polaroid Corp. 575 Technology Square Cambridge, MA 02139 Tel. (800) 343-5000; (617) 577-2000 www.polaroid.com

LEAD-FOIL FILM PROTECTOR BAGS

Sima Products 8707 North Skokie Blvd Skokie, IL 60077 Tel. (708) 679-7462

FILTERS AND GELS

Cokin Filters (See Minolta Corp. under cameras)

Hoya Filters Uniphot Corporation Woodside, NY, 11377 Tel. (718) 779-5700

Kodak Filters (See Eastman Kodak under film)

Rosco Laboratories 38 Bush Avenue Port Chester, NY 10573 Tel. (914) 937-1300 www.rosco.com

Schneider/BW Filters (See under lenses)

Singh-Ray Filters 2721 SE Highway 31 Arcadia, FL 34266 Tel. (941) 993-4100 www.Singh-Ray.com

Tiffen Corp. 90 Oser Avenue Hauppage, NY 11788 Tel. (516) 273-2500 www.tiffen.com

FLASH AND STROBE MANUFACTURERS

Balcar Tekno Inc. 38 Greene Street New York, NY 10013 Tel. (212) 219-3501

Broncolor Inc. (See Sinar Bron, under field and specialized cameras)

Comet World Corp. 311–319 Long Avenue Hillside, NJ 07205 Tel. (908) 688-3210

Dyna-Lite Corp. (Same address as Comet World) Tel. (908) 687-8800 www.dynalite.com Lumedyne Inc. 6010 Wall Street Port Richey, FL 34668 (813) 847-2777 www.lumedyne.com

Metz Inc. (See Bogen Photo Corp., under flash/ strobe accessories)

Norman Enterprises Inc. 2601 Empire Avenue Burbank, CA 94063 Tel. (818) 843-6811 www.normanflash.com

Speedotron Corp. 310 South Racine Avenue Chicago, IL 60607 Tel. (312) 421-4050

Sunpak Inc.
ToCAD America
401 Hackensack Avenue
Hackensack, NJ 07601
Tel. (201) 342-2400
www.sunpak.com

Vivitar Corp. 9350 De Soto Avenue Chatsworth, CA 91313 Tel. (800) 700-9862, fax (818) 700-2890 www.vivitarcorp.com

FLASH/STROBE ACCESSORIES

Bogen Photo Corp.
565 East Crescent Avenue
Ramsey, NJ 07446
Tel. (908) 862-7999
www.bogenphoto.com
(Manfrotto lightstands, tripods; Metz flash units,
Gossen meters, more)

Chimera Inc. 1812 Valtec Lane Boulder, CO 80301 Tel. (800) 424-4075; (303) 444-8000 (Portable fabric light boxes)

Cougar Design 114 East 13th Street New York, NY 10003 Tel. (212) 420-1860 (Custom Vivitar accessories and lightstands) Ikelite
50 West 33rd Street
Indianapolis, IN 46308
Tel. (317) 923-4523
(Lite Link slave for Canon and Nikon flashes; underwater gear)

Kirk Enterprises 107 Lange Lane Angola, IN 46703 Tel. (219) 665-3670 (Double flash brackets, custom equipment, more)

LPA Design
13 Shelburne Road South
South Burlington, VT 05403
Tel. (802) 864-8572
(Pocket Wizard sixteen-channel radio slave/trigger combinations)

Photoflex
333 Encinal Street
Santa Cruz, CA 95060
Tel. (800) 486-2674
www.photoflex.com
(Shoe-mount multiclamp for flash units, portable reflectors, more)

1075 Stewart Avenue Garden City, NY 11530 Tel. (516) 222-0611 www.qtm.com (Rechargeable batteries; slaves, triggers; Q-Flash, more)

Ouantum Instruments

S.A.I. Photo Products.
126 Somers Court South
Moorestown, NJ 08057
Tel. (609) 778-0261
(NVS-1 Double-powered Vivitar modification and acessories)

The Saunders Group
21 Jet Drive
Rochester, NY 14624
Tel. (716) 328-7800
www.saundersphoto.com
(Vivitar accessories, Domke bags, Wein slaves/
triggers, Lepp and Srobofrome flash brackets, and
more)

Underdog Flash Batteries
Jon Falk Lights Ltd.
P.O. Box 324
Collingswood, NJ 08108
Tel. (609) 854-6543
www.underdog-battery.com
(Under-camera rechargeable flash batteries)

Wein Triggers and slaves (See Saunders Group, above)

HOT LIGHTS

Lowel Light Manufacturing Corp. 140 58th Street Brooklyn, NY 11220 Tel. (718) 921-0600

Smith Victor Corp. 301 North Colfax Griffith, IN 46319 Tel. (219) 924-6136

BAGS AND CASES

Calzone Case Co. 225 Black Rock Avenue Bridgeport, CT 06605 Tel. (800) 243-5752

Lightware Inc. 1541 Platte Street Denver, CO 80202 Tel. (303) 455-4556, fax (303) 477-1235

LowePro USA 2194 Northpoint Parkway Santa Rosa, CA 95407 Tel. (707) 575-4363

Tenba Quality Cases Ltd. 503 Broadway New York, NY 10012 Tel. (212) 966-1013 www.tenba.com

Linhof Tripods (See under cameras)

TRIPODS

Gitzo Tripods (See Calumet Photographic, under catalogs)

Manfrotto Tripods (See Bogen Photo Corp., under flash/strobe accessories)

Slik Tripods Slik America Inc. 3 Westchester Plaza Elmsford, NY 10523 Tel. (914) 347-2223, fax (914) 347-5617

Tiltall Tripods (See Hoya/Uniphot, under filters)

HAND-HELD LIGHT METERS

Gossen Meters (See Bogen Photo Corp. under flash/strobe accessories)

Minolta Meters (See under cameras)

Sekonic Meters RTS Inc. 40–11 Burt Drive Deer Park, NY 11729 Tel. (516) 242-6801 www.sekonic.com

MISCELLANEOUS ACCESSORIES

PermaPak
Division of Photoco Inc.
4347 Cranwood Parkway
Cleveland, OH 44128
(Rechargeable flash battery packs)

Pic Light Stands American Photo Instruments 12 Lincoln Boulevard Emerson, NJ 07620 Tel. (201) 261-2160

 The specialized items listed below are rented or purchased from professional photographic dealers. The head offices will be able to refer you to nearest dealers.

110-220/240V PORTABLE TRANSFORMERS

Signal Transformers 500 Bayview Ave Inwood, NY 11696 Tel. (516) 239-5777, fax (516) 239-7208

Stancor Products 131 Godfrey St Logansport, IN 49647 Tel. (219) 722-2244

GENERATORS

Homelite Division of Textron Inc. 1441 Carrowinds Boulevard Charlotte, NC 28241 Tel. (800) 242-4672

Honda Motors America Inc. Power Equipment Div. 4475 River Green Parkway Duluth, GA 30136 Tel. (404) 497-6400

A.C./D.C. POWER INVERTERS

LTM Inc. 11646 Pendleton Street Sun Valley, CA 91352 Tel. (800) 762-4291; (818) 767-1313

Trace Engineering Co. Inc. 5917 195th NE Arlington, WA 98223 Tel. (206) 435-8826, fax (206) 435-2229

Vanner Inc.
4282 Reynolds Drive
Hilliard, OH 43026
Tel. (614) 771-2718, fax (614) 771-4904
www.vanner.com

GYROSTABILIZERS

Kenyon Gyro Stabilizers Ken Lab Inc. P.O. Box 128 Old Lyme, CT 06371 Tel. (203) 434-1619

Mail Order Equipment Catalogs

B and H Professional Photo Sourcebook 420 Ninth Avenue New York, NY 10001 Tel. (212) 444-6630; (800) 947-6650 www.bhphotovideo.com (Well-illustrated 600 page pro catalog and smaller pro/am monthly catalog)

Calumet Photographic

890 Supreme Drive
Bensenville, IL 60106
Tel. (888) 888-9083
www.calumetphoto.com
(This manufacturer, distributor, and mail order
house offers catalogs illustrating almost everything
photographic. Stores in Chicago, Los Angeles, and
New York.)

Helix Camera and Video 310 South Racine Chicago, IL 60607 Tel. (312) 421-6000; (800) 621-6471 (General and underwater specialist catalogs)

Recommended Repair Services

Professional Camera Repair Service 37 West 47th Street New York, NY 10036 Tel. (212) 382-0550 (Custom work; accept repairs from all over the world. Ask for Rick Rankin or Herb Zimmerman.)

Flash Clinic
9 East 19th Street
New York, NY 10003
Tel. (212) 673-4030
(Sales and service; custom work, on professional flash/strobe equipment)

Professional Organizations

Advertising Photographers of America (APA) 333 South Beverly Drive, Suite 216 Beverly Hills, CA 90212-4314 Tel. (800) 272-6264 (Chapters in major cities)

AP New York (APNY)
27 West 20th Street, Suite 601
New York, NY 10011
Tel. (212) 807-0399
(New York advertising photographers)

American Institute of Graphic Arts (AIGA) 164 Fifth Avenue New York, NY 10010 Tel. (212) 807-1990 (Many members are graphic designers)

American Society of Media Photographers (ASMP) 14 Washington Street
Princeton Junction, NJ 08550-1033
Tel. (609) 799-8300, fax (609) 799-2233
www.asmp.org
(Chapters nationwide; many editorial photographers are members)

American Society of Picture Professionals (ASPP) c/o Woodfin Camp and Associates 2025 Pennsylvania Ave.
Washington, DC 20006
(Members are professional picture researchers; some photographers also)

Canadian Association of Photographers and Illustrators in Communications 400 Eastern Avenue, #250 Toronto, ON M4M 1B9 Tel. (804) 751-0471

Picture Agency Council of America (PACA) P.O. Box 308 Northfield, MN 55057-0308 Tel. (800) 457-7222 (Members are stock picture agencies. Publish directory.)

National Press Photographers Association (NPPA) 3200 Croasdaile Drive Durham, NC 27705 Tel. (919) 383-7246 (Most members are newspaper photographers)

Professional Photographers of America (PP of A) 229 Peachtree Street NE, Suite 2200 International Tower Atlanta, GA 30303 (Offers good insurance; many members are commercial studio owners)

Society of American Travel Writers (SATW) 1100 17th Street, Suite 1000 Washington, DC 20036 Tel. (202) 429-6639 (Some photographers or writer/photographers are members)

Society of Photographers' and Artists' Representatives (SPAR) 60 East 42nd Street, Suite 1166 New York, NY 10165 Tel. (212) 779-7464

Professional Publications and Media Guides

Bacon's Publicity Checker
Bacon's Media Directories
332 South Michigan Avenue
Chicago, IL 60604
Tel. (800) 621-0561; (312) 922-2400
fax (312) 922-3127
(Directory of consumer and trade magazines classified by subject)

PDN (formerly the *Photo District News*)
P.O. Box 1983
Marion, OH 43305
Tel. (800) 669-1002
(Indispensible monthly trade paper for professional photographers)

Photographers' Market (annual) Writers' Digest Books F and W Publications 1507 Dana Avenue Cincinnati, OH 45207 Tel. (513) 531-2222

Professional Photo Source Inc. 568 Broadway, Suite 605A New York, NY 10012 Tel. (212) 219-0993 (Directory of where to find photo needs, talent, and more)

Standard Rate and Data Guides
Standard Rate and Data Services
3004 Glenview Road
Wilmette, IL 60091
Tel. (800) 323-4588; (708) 256-6067
(Directories of magazines and advertisers, classified by subject, with circulation figures and billing.
Annuals. Special Canadian directory.)

Travel Industry Personnel Directory
Business Guides Inc.
3922 Coconut Palm Drive
Tampa, FL 33619
Tel. (813) 627-6800
www.cgis.com
(Exhaustive listing of travel resources, tourist offices, etc.)

Photography and Stock Directories and Want List Services

Individual assignment and/or stock photographers and some agencies advertise in these directories. Some can now be viewed on the Internet.

American Showcase 915 Broadway New York, NY 10010 Tel. (212) 673-6600

The Black Book 10 Astor Place, 6th floor New York, NY 10003 Tel. (212) 539-9800 The Blue Book of Travel Stock/The Green
Book of Nature and General Stock
AG Editions
41 Union Square
New York, NY 10003
Tel. (212) 929-0959
www.ag-editions.com
(Also publisher of the Guilfoyle Report of stock
want listings)

Direct Stock
10 East 21st Street
New York, NY 10010
Tel. (212) 979-6560, fax (212) 254-1204

PhotoSource International
Pine Lake Farm
Osceola, WI 54020
Tel. (715) 248-3800
www.photosource.com
(Want lists, newsletter; Web site where photographers can market work)

Stock Workbook Scott and Daughters 940 North Highland Avenue Los Angeles, CA 90038 Tel. (800) 447-2688; (213) 856-0008

Bibliography

Recommended Books of Travel and Related Photographs

These reflect my personal taste; they are not all "pretty" pictures.

Allard, William Albert. *The Photographic Essay*. Boston, MA: N.Y. Graphic Society/Bullfinch Press, Little Brown Co., 1989.

Brandt, Bill. *Literary Britain*. New York: Aperture, 1986. (See anything else by Brandt also.) d'Archimbaud, Nicholas. *Splendid Hotels of Europe*. Atlanta, GA: Turner Publishing, 1994.

Fabian, Rainer and Hans-Christian Adam. *Masters of Early Travel Photography*. New York: Vendome Press/Viking Press, 1983.

Haas, Ernst. The Creation. New York: Penguin Books, 1988. (See anything else by Haas.)

National Geographic, editors of. *The Art of Photography at National Geographic*. Charlottes-ville, VA: Thomasson Grant Inc., 1988.

Rajs, Jake. America. New York: Rizzoli, 1990. (See anything else by Rajs.)

Singh, Raghubir, and Jean Deloche. *The Grand Trunk Road*. Thames and Hudson, New York/London, 1996. (See any/all of Singh's books on India.)

Rosenblum, Naomi. A World History of Photography. New York: Abbeville Press, 1984.

Recommended Business, How-To, and Specialist Photography Books Published by Allworth Press, New York

American Society of Media Photographers. *ASMP Professional Business Practises in Photography,* Fifth Edition, 1997.

Crawford, Tad. Legal Guide for the Visual Artist, Fourth Edition, 1999.

Farace, Joe. Photographers Internet Handbook, 1997.

Heron, Michal. How to Shoot Stock Photos That Sell, Revised Edition, 1996.

Heron, Michal, and David MacTavish. *Pricing Photography: The Complete Guide to Assignment and Stock Prices*, Second Edition, 1997.

McCartney, Susan. Nature and Wildlife Photography: A Complete Guide to How to Shoot and Sell, 1994.

Piscopo, Maria. *The Photographer's Guide to Marketing and Self-Promotion: How to Find and Keep Good Paying Clients*, Second Edition, 1995.

Published by Amphoto, New York

Allen, Bryan. *Digital Wizardry: Creative Photoshop Techniques*, 1998 (An advanced book; great pictures and explanations; great taste.)

Brackman, Henrietta. The Perfect Portfolio, 1984.

Freeman, Michael. Light, 1988. (See his other books also.)

Krist, Bob. Secrets of Location Lighting, 1987.

Lloyd, Harvey. Aerial Photography, 1990.

Marx, Kathryn. Photography for The Art Market, 1988.

McCartney, Susan. Mastering Flash Photography, 1998.

McGrath, Norman. Photographing Buildings Inside and Out, 1996.

Meehan, Joseph. Panoramic Photography, 1990.

Neubart, Jack. Industrial Photography, 1989.

Perweiler, Gary. Secrets of Studio Still Life Photography, 1990.

Seaborn, Charles. Underwater Photography, 1988.

Kodak Workshop Series. Published by Silver Pixel Press, Rochester, NY

Electronic Flash, 1996.

Existing Light Photography, 1996.

Using Filters, 1997.

Kodak Pocket Guides Series, 1985. Published by Simon and Schuster, New York

35mm Photography

Nature Photography

Sports Photography

Travel Photography

Other Recommended Books

Davis, Harold. Photographer's Publishing Handbook. New York: Images Press, 1991.

Engh, Rohn. Sell and Resell your Photos. Cincinnati, OH: Writer's Digest Press, 1998.

Haas, Ken. Location Photographer's Handbook. New York: Van Nostrand, Reinhold, 1990.

Hedgecoe, John. The Book of Photography. New York: Alfred A. Knopf, 1990.

Hollenbeck, Cliff. Big Bucks. Selling your Photography. Rochester, NY: Amherst Media, 1996.

Kodak, Eastman, Ed. *The Joy of Photography*. Reading, MA: Addison Wesley Publishing, 1990. Also, *The Joy of Photographing People*. 1983.

Maran Graphics Inc. *Internet and World Wide Web Simplified*. Foster City, CA: IDG Books, 1995.

Pickerell, Jim and Cheryl. *Negotiating Stock Photo Prices*. Rockville, MD: Pickerell Marketing, 1998.

Purcell, Ann and Carl. *Guide to Travel Writing and Photography.* Cincinnati, OH: Writer's Digest Books, 1991.

Recommended Guidebook Series

Frommers Guides. New York: Prentice-Hall Press. Random House. Insight Guides. APA Publications (HK) Ltd., Prentice Hall Travel, NY. Lonely Planet Guides. Berkeley, CA. (Especially good for third world countries.)

Index

A	filters for, 65
accessories. See exposure meters; flash units; tripods	black Cinefoil, 99
Adobe PhotoShop, 18, 160	book photography, 171–72
advertising. See marketing; promotional photography	bookstores, recommended, 7
aesthetics, developing, 5. See also quality	Bosnia, photographing in, 278-79
Agfa films, 56	bounce cards, 97
airports, carrying film through, 39, 54, 237	bounce lighting, 76
albums, photo display, 143	Bronica camera systems, 36
amateur photography, 6–7, 191	Bucher, Van, interview with, 197–98
American Institute of Graphic Arts (AIGA), 147, 210	budgets. See expenses; fees
American Society of Media Photographers (ASMP), 167	business cards, 146
American Society of Picture Professionals (ASPP), 186	business skills, 22, 180, 199, 223-24, 237-38, 239. See also
American Standards Association (ASA) film speeds, 44	marketing; sample documents
anachronisms. See inconsistencies, avoiding	business visas, 207
animal release, sample, 319	buying
apertures. See exposures; f-stops; lenses	camera equipment, 33–34, 36
architectural photography, 117–20	lighting equipment, 108
practice assignment, 127–28	
See also interior photography	C
archival storage, 144, 145	Calumet products
art, studying, 4-5, 14-15	camera systems, 37
assistants, professional	catalogs, 40
portfolios for, 141	Cambodia, photographing in, 296
traveling with, 20-21	camera bags, 39–40
working with, 176	camera dealers, cautions about, 34
See also representatives	cameras
Australia, photographing in, 301-302	basic travel kit, 28
Austria, photographing in, 274	care, maintenance, 38–40
automatic flash units, 89-90	choosing, 32
available lighting, 55, 78–79, 81. See also daylight	digital, 160–63
photography	electronic (point-and shoot), 25–26, 38, 47
	large-format, 37–38
В	mechanical, 40
backlighted exposures, 46, 75	medium-format, 36–37
Belgium, photographing in, 270	multiple, 31
billing, 238, 239	Nikon, 32
black-and-white photographs	panoramic, 36
evaluating quality of, 58	Polaroid, 35–36
exposure times, 43–44	recommended systems, 30–31
film, 55–56	35mm SLR, 26-27, 32-33, 35, 322

See also care and maintenance; equipment; lenses	contract sample (magazine assignment), 178-79
Canada, photographing in, 253	contrasty lighting, 77–78
Canon products	copyright ownership, protecting, 190
cameras, 32	courses. See training
lenses, 35	Croatia, photographing in, 278-79
perspective-correcting lenses, 119	Czech Republic, photographing in, 279
care and maintenance	
cameras, lenses, 38-40, 65	D
film, 54, 59–60	dawn, photographing at, 73
filters/gels, 65, 67, 69	daylight photography, 71–72, 75-78. See also lighting,
See also shipping	natural
Caribbean, photographing in, 253–56	deadlines, 150
carnets, 207	dedicated/TTL flash units, 90-92
catalogs	flash fill, 47, 90
archival storage, 145	with slow sync mode, 93
photo equipment, 40, 326	delivery memo sample (stock photographs), 200
center-weighted exposure meters, 46–47	Denmark, photographing in, 270–71
Central America, photographing in, 256–57	diffusing light, 77, 97
checklists	digital photography
last-minute, 227	cameras, 160–63
pretravel, 223–27	digitizing images, 55
Child, Andrew, interview, 161–63	interview with Andrew Child, 161–63
China, photographing in, 291-92	See also computers; marketing
chromogenic films, 56	DIN scales, 44
cityscape photography. See architectural photography;	directories
landscape photography	list of, 328
clients, working with, 150, 173-74, 208, 220-21, 227,	promotional, 147–48
229. See also markets; marketing; social skills	stock, 192
clip tests, 49, 51	travel industry, 177
clothing	domain names, 159
in photographs, 114–15	dome light diffusers, 97
wearing, during shoots, 298	dusk, photographing at, 73, 79-80. See also lighting,
Cokin filters, 64-65	natural
color	_
balancing, 67	E
color-compensating (CC) filters, 65	e-mail, 154, 156–59
color wheel, 63	editing photographs, 18, 139–41
evaluating quality of, 58	equipment and tools for, 141, 160
printers (computer), 161	Egypt, photographing in, 282
	-37 - 7 - 3 - 7 - 3 - 7
printing, large format, 143	Ektachromes, 57
printing, large format, 143 shifts in, 82	
	Ektachromes, 57
shifts in, 82	Ektachromes, 57 electronic cameras (point-and-shoot), 25–26
shifts in, 82 See also lighting	Ektachromes, 57 electronic cameras (point-and-shoot), 25–26 built-in light meters, 47
shifts in, 82 See also lighting color negatives (prints)	Ektachromes, 57 electronic cameras (point-and-shoot), 25–26 built-in light meters, 47 how to choose, 38
shifts in, 82 See also lighting color negatives (prints) exposures, 44–45	Ektachromes, 57 electronic cameras (point-and-shoot), 25–26 built-in light meters, 47 how to choose, 38 emulsions, film, testing, 61
shifts in, 82 See also lighting color negatives (prints) exposures, 44–45 film for, 55	Ektachromes, 57 electronic cameras (point-and-shoot), 25–26 built-in light meters, 47 how to choose, 38 emulsions, film, testing, 61 enlargements, 143
shifts in, 82 See also lighting color negatives (prints) exposures, 44–45 film for, 55 color temperature meters, 48, 66	Ektachromes, 57 electronic cameras (point-and-shoot), 25–26 built-in light meters, 47 how to choose, 38 emulsions, film, testing, 61 enlargements, 143 equipment
shifts in, 82 See also lighting color negatives (prints) exposures, 44–45 film for, 55 color temperature meters, 48, 66 color transparencies (slides)	Ektachromes, 57 electronic cameras (point-and-shoot), 25–26 built-in light meters, 47 how to choose, 38 emulsions, film, testing, 61 enlargements, 143 equipment for architectural photography, 118–19
shifts in, 82 See also lighting color negatives (prints) exposures, 44–45 film for, 55 color temperature meters, 48, 66 color transparencies (slides) exposures, 44	Ektachromes, 57 electronic cameras (point-and-shoot), 25–26 built-in light meters, 47 how to choose, 38 emulsions, film, testing, 61 enlargements, 143 equipment for architectural photography, 118–19 basic, 27–40
shifts in, 82 See also lighting color negatives (prints) exposures, 44–45 film for, 55 color temperature meters, 48, 66 color transparencies (slides) exposures, 44 film for, 56–57	Ektachromes, 57 electronic cameras (point-and-shoot), 25–26 built-in light meters, 47 how to choose, 38 emulsions, film, testing, 61 enlargements, 143 equipment for architectural photography, 118–19 basic, 27–40 bringing into Canada, 253
shifts in, 82 See also lighting color negatives (prints) exposures, 44–45 film for, 55 color temperature meters, 48, 66 color transparencies (slides) exposures, 44 film for, 56–57 scanning into computer, 160	Ektachromes, 57 electronic cameras (point-and-shoot), 25–26 built-in light meters, 47 how to choose, 38 emulsions, film, testing, 61 enlargements, 143 equipment for architectural photography, 118–19 basic, 27–40 bringing into Canada, 253 bringing into United States, 250
shifts in, 82 See also lighting color negatives (prints) exposures, 44–45 film for, 55 color temperature meters, 48, 66 color transparencies (slides) exposures, 44 film for, 56–57 scanning into computer, 160 commissions. See fees	Ektachromes, 57 electronic cameras (point-and-shoot), 25–26 built-in light meters, 47 how to choose, 38 emulsions, film, testing, 61 enlargements, 143 equipment for architectural photography, 118–19 basic, 27–40 bringing into Canada, 253 bringing into United States, 250 for editing, 141
shifts in, 82 See also lighting color negatives (prints) exposures, 44–45 film for, 55 color temperature meters, 48, 66 color transparencies (slides) exposures, 44 film for, 56–57 scanning into computer, 160 commissions. See fees composition, 15–18 "comps" (discounts), 220	Ektachromes, 57 electronic cameras (point-and-shoot), 25–26 built-in light meters, 47 how to choose, 38 emulsions, film, testing, 61 enlargements, 143 equipment for architectural photography, 118–19 basic, 27–40 bringing into Canada, 253 bringing into United States, 250 for editing, 141 for interior photography, 120
shifts in, 82 See also lighting color negatives (prints) exposures, 44–45 film for, 55 color temperature meters, 48, 66 color transparencies (slides) exposures, 44 film for, 56–57 scanning into computer, 160 commissions. See fees composition, 15–18	Ektachromes, 57 electronic cameras (point-and-shoot), 25–26 built-in light meters, 47 how to choose, 38 emulsions, film, testing, 61 enlargements, 143 equipment for architectural photography, 118–19 basic, 27–40 bringing into Canada, 253 bringing into United States, 250 for editing, 141 for interior photography, 120 list of manufacturers, 322–26
shifts in, 82 See also lighting color negatives (prints) exposures, 44–45 film for, 55 color temperature meters, 48, 66 color transparencies (slides) exposures, 44 film for, 56–57 scanning into computer, 160 commissions. See fees composition, 15–18 "comps" (discounts), 220 computers, 23, 153–54	Ektachromes, 57 electronic cameras (point-and-shoot), 25–26 built-in light meters, 47 how to choose, 38 emulsions, film, testing, 61 enlargements, 143 equipment for architectural photography, 118–19 basic, 27–40 bringing into Canada, 253 bringing into United States, 250 for editing, 141 for interior photography, 120 list of manufacturers, 322–26 mail-order catalogs, 326
shifts in, 82 See also lighting color negatives (prints) exposures, 44–45 film for, 55 color temperature meters, 48, 66 color transparencies (slides) exposures, 44 film for, 56–57 scanning into computer, 160 commissions. See fees composition, 15–18 "comps" (discounts), 220 computers, 23, 153–54 color printers, 161 digital cameras, 160–61	Ektachromes, 57 electronic cameras (point-and-shoot), 25–26 built-in light meters, 47 how to choose, 38 emulsions, film, testing, 61 enlargements, 143 equipment for architectural photography, 118–19 basic, 27–40 bringing into Canada, 253 bringing into United States, 250 for editing, 141 for interior photography, 120 list of manufacturers, 322–26 mail-order catalogs, 326 need for quality, 29–30
shifts in, 82 See also lighting color negatives (prints) exposures, 44–45 film for, 55 color temperature meters, 48, 66 color transparencies (slides) exposures, 44 film for, 56–57 scanning into computer, 160 commissions. See fees composition, 15–18 "comps" (discounts), 220 computers, 23, 153–54 color printers, 161	Ektachromes, 57 electronic cameras (point-and-shoot), 25–26 built-in light meters, 47 how to choose, 38 emulsions, film, testing, 61 enlargements, 143 equipment for architectural photography, 118–19 basic, 27–40 bringing into Canada, 253 bringing into United States, 250 for editing, 141 for interior photography, 120 list of manufacturers, 322–26 mail-order catalogs, 326 need for quality, 29–30 how to buy, 33–34, 36, 108
shifts in, 82 See also lighting color negatives (prints) exposures, 44-45 film for, 55 color temperature meters, 48, 66 color transparencies (slides) exposures, 44 film for, 56-57 scanning into computer, 160 commissions. See fees composition, 15-18 "comps" (discounts), 220 computers, 23, 153-54 color printers, 161 digital cameras, 160-61 displaying/marketing photographs, 159-60	Ektachromes, 57 electronic cameras (point-and-shoot), 25–26 built-in light meters, 47 how to choose, 38 emulsions, film, testing, 61 enlargements, 143 equipment for architectural photography, 118–19 basic, 27–40 bringing into Canada, 253 bringing into United States, 250 for editing, 141 for interior photography, 120 list of manufacturers, 322–26 mail-order catalogs, 326 need for quality, 29–30 how to buy, 33–34, 36, 108 renting, 106–107
shifts in, 82 See also lighting color negatives (prints) exposures, 44-45 film for, 55 color temperature meters, 48, 66 color transparencies (slides) exposures, 44 film for, 56-57 scanning into computer, 160 commissions. See fees composition, 15-18 "comps" (discounts), 220 computers, 23, 153-54 color printers, 161 digital cameras, 160-61 displaying/marketing photographs, 159-60 e-mail, 156-59	Ektachromes, 57 electronic cameras (point-and-shoot), 25–26 built-in light meters, 47 how to choose, 38 emulsions, film, testing, 61 enlargements, 143 equipment for architectural photography, 118–19 basic, 27–40 bringing into Canada, 253 bringing into United States, 250 for editing, 141 for interior photography, 120 list of manufacturers, 322–26 mail-order catalogs, 326 need for quality, 29–30 how to buy, 33–34, 36, 108 renting, 106–107 repair services, 326
shifts in, 82 See also lighting color negatives (prints) exposures, 44–45 film for, 55 color temperature meters, 48, 66 color transparencies (slides) exposures, 44 film for, 56–57 scanning into computer, 160 commissions. See fees composition, 15–18 "comps" (discounts), 220 computers, 23, 153–54 color printers, 161 digital cameras, 160–61 displaying/marketing photographs, 159–60 e-mail, 156–59 photo management, 199	Ektachromes, 57 electronic cameras (point-and-shoot), 25–26 built-in light meters, 47 how to choose, 38 emulsions, film, testing, 61 enlargements, 143 equipment for architectural photography, 118–19 basic, 27–40 bringing into Canada, 253 bringing into United States, 250 for editing, 141 for interior photography, 120 list of manufacturers, 322–26 mail-order catalogs, 326 need for quality, 29–30 how to buy, 33–34, 36, 108 renting, 106–107 repair services, 326 for travel shoots, 225–27
shifts in, 82 See also lighting color negatives (prints) exposures, 44–45 film for, 55 color temperature meters, 48, 66 color transparencies (slides) exposures, 44 film for, 56–57 scanning into computer, 160 commissions. See fees composition, 15–18 "comps" (discounts), 220 computers, 23, 153–54 color printers, 161 digital cameras, 160–61 displaying/marketing photographs, 159–60 e-mail, 156–59 photo management, 199 photo-retouching, 160	Ektachromes, 57 electronic cameras (point-and-shoot), 25–26 built-in light meters, 47 how to choose, 38 emulsions, film, testing, 61 enlargements, 143 equipment for architectural photography, 118–19 basic, 27–40 bringing into Canada, 253 bringing into United States, 250 for editing, 141 for interior photography, 120 list of manufacturers, 322–26 mail-order catalogs, 326 need for quality, 29–30 how to buy, 33–34, 36, 108 renting, 106–107 repair services, 326 for travel shoots, 225–27 See also individual items (e.g., cameras)
shifts in, 82 See also lighting color negatives (prints) exposures, 44–45 film for, 55 color temperature meters, 48, 66 color transparencies (slides) exposures, 44 film for, 56–57 scanning into computer, 160 commissions. See fees composition, 15–18 "comps" (discounts), 220 computers, 23, 153–54 color printers, 161 digital cameras, 160–61 displaying/marketing photographs, 159–60 e-mail, 156–59 photo management, 199 photo-retouching, 160 travel planning, 154–59	Ektachromes, 57 electronic cameras (point-and-shoot), 25–26 built-in light meters, 47 how to choose, 38 emulsions, film, testing, 61 enlargements, 143 equipment for architectural photography, 118–19 basic, 27–40 bringing into Canada, 253 bringing into United States, 250 for editing, 141 for interior photography, 120 list of manufacturers, 322–26 mail-order catalogs, 326 need for quality, 29–30 how to buy, 33–34, 36, 108 renting, 106–107 repair services, 326 for travel shoots, 225–27 See also individual items (e.g., cameras) event photography

expense account policy sample, 180	manual, 89
expenses	for multiple exposures, 100
expense accounts, 180	multiple flashes, 98–99
during travel shoots, 215–16, 217–18	portable professional, 100–101
tracking, 237–38	remote, 95–96
exposures	flat lighting, 76
in available light, 81	flexibility, importance of, 234–35, 300
bracketing, 50	
clip tests, 49–51	food photography, 232
common errors, 49	formal events. See event photography
	frames, picture, 144
film types and, 43–45	France, photographing in, 267–69
long, 82	freelancing, corporate, 209
for dusk/night photography, 79–81	French Polynesia, photographing in, 302–303
Polaroid tests 51	Fuji products
See also film; lenses; lighting, artificial; lighting, natural	black-and-white film, 56
exposure meters, 28, 45–48	camera systems, 36
extreme zoom lenses, 27–28	color film, 55, 57
F	C
-	G
f-stops, 27, 29, 79, 93–94, 100. <i>See also</i> exposures; lenses	gaffer tape, 99
fast lenses, 27	gel factors, 62
feature photography, practice assignment, 130–31	gelatins, gels. <i>See</i> filters/gels
See also event photography; magazine photography	Germany, photographing in, 272–73
fees	getting started, 3–4
photography assistants, 176	ghost effects, 92
"reps," professional, 148	government travel advisories, 221, 251, 321
stock-related, 191, 192	gray cards, 46
See also expenses	Greece, photographing in, 277–78
film	guide numbers (GN), 93–94
amount needed, 19	gyrostabilizers, 38
bracketing exposures, 50	
caring for, 39, 54, 59-60, 237	Н
choosing, 54–59	Hasselblad camera systems, 36, 65
clip tests, 49–50	holiday cards, 146
emulsions, 61	Holland. See Netherlands, The
exposures (speeds), 43–45, 49–51, 79–82	Hong Kong, photographing in, 290–91
history of, 53	Horseman camera systems, 37–38
processing, 60, 236–37	Hoya filters, 64
pushing/pulling, 50	Hungary, photographing in, 279
reference guides, 59	riungary, priotographing in, 279
for stock photography, 189	I
for travel shoots, 58, 59	Iceland, photographing in, 272
See also exposures; lighting	Ilford films, 56
filter factors, 62	incident-light exposure meters, 46–47
filter packs, 66	inconsistencies, avoiding, 18–19, 114–15, 116–17. See also
filters/gels,	photographs, professional; technical skills
balancing colors using, 67	India, photographing in, 296–297
basic equipment, 60–64	Indonesia, photographing in, 294–96
care requirements, 65, 67, 69	industrial site photography, 208
with color temperature meters, 67	insurance, 176, 222–23
Kodak/Rosco equivalents, 68	interior photography, 120
using gels as filters, 67	practice assignment, 127–28
Fincher, Les, location scouting tips, 216–17	International Standards Organization (ISO) film speeds, 44
fine-art photography, 6-7, 142	Internet
Finland, photographing in, 272	marketing using, 159–60
flash fill exposures, 47, 90	personal Web sites/home pages, 159–60
flash/strobe exposure meters, 48	search engines, 154
flash units	travel planning using, 154–56
automatic, 89–90	See also computers; digital photography
batteries for, 96	invoice sample, 240–41
battery-powered, 28, 32, 85–86, 88	ISO. See International Standards Organization
with strobes, 99–100	Israel, photographing in, 282–83
dedicated/TTL, 90–92	
flash guide numbers (GN), 93	Italy, photographing in, 276–77
gaide	

J	low lighting, //
Japan, photographing in, 287–89	luggage, packing cameras in, 39-40
jobs, finding. See marketing	
	M
K	magazine photography, 167–70
Kenya, photographing in, 283–84	sample assignment letter, 169
Kodak products	sample contract, 178–79
films, 55–57	sample expense account policy, 180
filters/gels, 64, 66, 67	sample letter of assignment, 178–79
Korea, photographing in, 289	sample letter of introduction, 170
	sample query letter, 168
L	travel magazine computer sites, 156
laboratories, color printing, 143	See also feature photography; location photography
landscape photography, 115–17	"magic" lighting, 78
practice assignment, 125–27	mailers/flyers, 146
See also location photography; travel shoots	mailing lists, commercial, 146–47
last minute checklist (travel shoots), 227	Malaysia, photographing in, 293
Lee gels, 62	Mamiya camera systems, 36
Leica camera systems, 32, 35	manual flash units, 89
legal information, 172, 190. See also releases; safety	maps, 222
lenses	marketing tools
basic travel kit, 29	advertising, 147
caring for, 38–39	cards/mailers/flyers, 146
perspective-correcting (PC), 119	catalogs, directories, 147-48, 167, 177, 192
recommended, 34–35	Internet, Web sites, 147, 159-60
selecting, 27–29	mailing lists, 146, 199
types of, 35–36, 37	networking, 149, 186
See also cameras; equipment	newsletters, 202
letter samples. See sample documents	professional representation, 148
licensing agreement sample (stock photographs), 201	portfolios, 141–46
Lichtenstein, photographing in, 274	sales calls, 149-50, 191-92
light-balancing (LB) filters/gels, 65-66	See also markets; professional organizations
light boxes, making, 140	markets, 7–8
light diffusers, 97–98	book photography, 170–71
light meters. See exposure meters	corporate/industrial photography (location), 9, 209-
lighting, augmented	210
combining with natural light, 100	magazine photography, 168–70
flash guide numbers (GN), 93-94	newspapers, 171–72
flash units, 85-86, 88-100	stock photography, 185-87, 189-92, 199
light modifiers, 97	tourism-promotion, 8-9, 172-77
strobe lights (electronic flashes), 101-107	See also subjects
tungsten lights, 86–88	media guides, list of, 327-28
See also exposures; film	medium-format camera systems, 36-37, 39
lighting, natural	Minolta camera system, 35
bad weather, 74–75	mixed lighting, 78–79
choosing time of day, 73-74	model releases, 111-12, 177, 193
daylight, 71–72, 75-78	samples, 305–18
evaluating, 72	models
on location shoots, 208	nonprofessional, 175–76
reflectors for, 77	professional, 174–75
seasonal factors, 75	Monaco, photographing in, 269
See also exposures; film	monuments, photographing, 233–34
lighting philosophy, 71–72	Morocco, photographing in, 283
lightstands, 98	Moslem countries, photographing in, 298
Linhof camera systems, 37	
location photography, 9	N
good business practices, 208	negative space, 16–17
group/celebrity portraits, 206–207	Netherlands, The, photographing in, 269–70
at industrial sites, 208	networking, 149, 186
public relations photographs, 207–208	neutral density filters, 66
skills needed, 206–207	New Zealand, photographing in, 218–20, 301–302
scouting locations, 214, 216–17	researching, 156–59, 217–19
social skills for, 206–207	newsletters, stock photography, 202
at tourist facilities, 232	newspaper photography, 171–72
The state of the s	

night photography, 73, 80–81	choosing pictures for, 142, 144
practice assignment, 132–33	Internet-based, 147, 159–60
Nikon products	professional, 141–45
film camera systems, 30-31, 65	showing, 145
digital cameras, 161	portraiture
lenses, 35	formal, 115
perspective-correcting lenses, 119	group and celebrity, 207
Norway, photographing in, 271–72	practice assignment, 124–25
7, p 3 p	tips for, 114
0	See also people, photographing
Olympus products	Portugal, photographing in, 275
digital cameras, 161	
film cameras, 35	practice assignments
perspective-correcting lenses, 119	ethnic neighborhood, 130–31
perspective-correcting lenses, 119	formal event, 133
P	night photography, 132–33
	resort promotion, 131–32
packing	still-life photography, 128–29
cameras, 39–40	tourist event, 133–34
for travel shoots, 39, 227	See also technical skills
Pakistan, photographing in, 297–300	pretravel checklist (travel shoots), 223-27
panoramic cameras, 36, 39	pricing
PC lenses. See lenses	location shoots, 205, 208
PDN. See The Photo District News	magazine photographs, 172
Pentax camera systems, 35, 36	stock photographs, 187, 191, 199-201
people, photographing	See also fees
achieving intimacy, 113	print albums, 142, 143
costumes and clothing, 113-15	print portfolios, 142
paying subjects, 112–13	printers, color (computer), 153
releases, 111–12	prints
staff/guests, 210, 232-33	enlargements, 143
tips for, 112–14	exhibition-size, 143
in tourism photographs, 174–75, 177	exposure for, 43–45
See also portraiture	filing, 144
people, working with. See clients; social skills	framing, 144
perspective-correcting (PC) lenses, 119	portfolios, 142
perspective, handling, 118	storing, 143, 144
Philippines, The, photographing in, 294	See also film
photo business newsletters, 147	
Photo District News (PDN), 23, 146	processing film, 60
photo retouching. See editing; retouching	professional assistants. See assistants
	professional organizations, 326–27
photographs, professional, 2–4	American Institute of Graphic Arts (AIGA), 147, 210
black-and-white in, 58	American Society of Media Photographers (ASMP), 16
color in, 58	American Society of Picture Professionals (ASPP), 186
composition, 15–18	Picture Agency Council of America (PACA), 191
editing, 139–41	Society of American Travel Writers, 220
film for, 19-20, 55–58	professional photography. See photographs, professional;
intangible qualities, 13–14, 19, 114–15 234	technical skills
subjects for, 111	professional representation, 148
tourism photographs, 176–77	professionalism, 4. See also quality; technical skills
tips for creating, 19	promotional directories, 147–48
tips for improving, 136–37	promotional photography (advertising)
See also inconsistencies, lighting; subjects; technical	practice assignment (resort), 131–32
skills	public relations, 207–208
Picture Agency Council of America (PACA), 191	tourism promotion, 8-9, 134-35
"pigtails," 106	property release, sample, 319
point-and-shoot cameras, 25-26, 38	public relations photography. See promotional photogra-
flash fill with, 90	phy
Poland, photographing in, 280	pulling/pushing film, 50
polarizing filters, 66	3, F3
Polaroid products	Q
film, 51	quantum Q-flash, 101
cameras, 35–36, 36–37, 38	quality. See photographs, professional
portfolio albums, 143	James Processing Processional
portfolios	

R	Society of American Travel Writers, 220
rear curtain flash sync, 92	speed, film. See exposures; film
reciprocity failure, 82	soft box light diffusers, 98
record-keeping, travel expenses, 237-38, 239	soft lighting, 76
reflected-light exposure meters, 45-46	South Africa, Republic of, photographing in, 284-85
reflectors (light diffusing), 77, 97-98	South America, photographing in, 257-60
reimbursable expenses, keeping track of, 237-38	Spain, photographing in, 275
releases. See model releases	special effects
remote flash units, 95-96	filters for, 66
repairs, 40	flash fill, 90
representatives ("reps")	See also lighting, augmented; lighting, natural
professional, 148	sports events, photographing, 172
self-representation, 148–50	spot exposure meters, 47
researching destinations. See travel shoots	staff photography, 210
retouching, 18, 55-56, 160. See also editing	still-life photography, 120
Robertson, Craig, New Zealand travel tips, 219	practice assignment, 128-29
Rolleiflex camera systems, 36	stock agencies
Romania, photographing in, 279	advice from AGE Fotostock, 198-99
Rosco gels, 62, 67, 68	working with, 189–92
Russia, photographing in, 280-81	stock photography, 6, 183-85
	Bucher, Van, interview with, 197-98
S	business practices, 187
safety issues, 208	catalogs for 192
using strobe lights, 103	delivery memo, sample, 200
travel advisories, 221	fees, prices , 187
during travel shoots, 252–53	film formats, 189
sales calls, 149. See also marketing	geographic/geologic features in, 117
sample documents	licensing agreement, sample, 201
assignment confirmation, 169	marketing, 185–87
contract (magazine assignment), 178–79	model releases for, 111
delivery memo (stock photo), 200	newsletters about, 202
invoice (travel assignment), 240-41	Pickerall, Jim, interview with, 194–95
letter of introduction (magazine assignment), 170	Steedman, Richard, interview with, 195-97
licensing agreement (stock photo), 201	subjects for, 188–89
magazine query, 168	Sutton, Bug, interview, 192-94
model releases, 305–18	See also subjects; travel shoots
property/animal release, 319	storage, 143
travel assignment invoice, 240-41	archival, 144, 145
scale, adding to landscapes, 117	strobe lights
scanning	portable, 101–102
prints, 55	powering, 104
transparencies, 160	renting, 106–107
search engines, Internet, 154	safety issues, 103
seasonal photographs, shooting, 75	studio, 101
self-assignments, 124, 234. See also training	traveling with, 105–106
self-promotion. See marketing	using, 102–104
self-representation, 148–50	style, personal, developing, 13–15
selling. See marketing	subjects
Serbia, photographing in, 278–79	building exteriors, 117–20
shipping companies, 39-40, 236-37	building interiors, 118, 120
shooting lists, 235	choosing, 111
side lighting, 75	getting to know, 4
Singapore, photographing in, 293	landscapes, 115–17
Singh-Ray filters, 64	people, 111-15, 174-75, 177, 210, 232-33
single lens reflex (SLR) cameras, 35mm. See 35mm SLR	still lifes, 120
cameras	for stock photography, 188–89
skills needed. See business skills; social skills, technical skills	tourist facilities, 131–32, 173, 232–33
slave and trigger flash units, 95–96	See also location photography; markets; travel shoots
slide portfolios, 142	sunlight. See daylight photography
slides (black-and-white). See black-and-white photographs	sunrises, sunsets. See dawn photography; dusk photogra-
slides (color transparencies). See color transparencies	phy
slow sync mode, 93	Sutton, Bug, interview with, 192–94
sneaking pictures, 82	Sweden, photographing in, 271
social skills, 22-23, 173-75, 206-207. See also travel shoots	Switzerland, photographing in, 273

T	timing and pacing, 214, 235-36
Taiwan (Republic of China), photographing in, 289-90	tracking expenses during, 237–38
Tanzania, photographing in, 283–84	travel advisories, checking, 221
tax-deductible expenses, keeping records of, 237–38	traveling
technical skills (technique), 4	alone, 20
for architectural/interior photography, 120	caring for film during, 59–60
developing, 13–14, 72	
location photography, 206–207	luggage, 39–40
	needed skills for, 20
for magazine photography, 166	with others, 20–21
practice assignments for developing, 124–35	See also travel shoots
required, 15	tripods, 29–30
for tourism photography, 173	mounting flashes on, 95
Thailand, photographing in, 293	for night photography, 80
theaters, photographing in, 82	using in Washington, D.C., 247
theft, minimizing risk of, 231	trouble-shooting
35mm SLR camera systems, 26–27, 32, 322	bouncing light in emergencies, 97
three-quarter lighting, 76	exposure errors, 49
Tiffen filters, 64	flash problems, 89
TTL flashes. See dedicated/TTL flash units	ghost effects, 92
top lighting, 77	masking unsightly elements, 19
tourism photography. See promotional photography	reciprocity failure, 82
tourist facilities, photographing in	See also travel shoots
cruises, 173	
practice assignment, 131–32	tungsten lights, 86–88
resorts, 232	Turkey, photographing in, 281–82
	II
See also event photography; travel shoots	U
Toyo camera systems, 38	umbrellas (light diffusers), 95, 98
training	underwater photography, 255
courses and workshops, 4–5, 9–10, 26, 85	United Kingdom, photographing in, 263-66
egg exercise, 21	United States, photographing, 243–50
looking at light, 72	University Products catalog, 145
practice assignments, 124–35	
requirements for professionals, 4, 15	V
trip planning quantity 215	ti t1 220 20
trip planning exercise, 215	vacation travel, 238–39
See also technical skills	vacation travel, 238–39 variety, importance of, 16
See also technical skills	variety, importance of, 16
See also technical skills transparencies. See color transparencies	variety, importance of, 16 view cameras (large-format), 37–38
See also technical skills transparencies. See color transparencies travel advisories, 251, 321	variety, importance of, 16 view cameras (large-format), 37–38 visual problems. <i>See</i> inconsistencies/anachronisms
See also technical skills transparencies. See color transparencies travel advisories, 251, 321 Travel Industry Personnel Directory, The, 177	variety, importance of, 16 view cameras (large-format), 37–38
See also technical skills transparencies. See color transparencies travel advisories, 251, 321 Travel Industry Personnel Directory, The, 177 travel information, online, 154–56, 253	variety, importance of, 16 view cameras (large-format), 37–38 visual problems. <i>See</i> inconsistencies/anachronisms Vivitar-283 automatic flash, 92–93
See also technical skills transparencies. See color transparencies travel advisories, 251, 321 Travel Industry Personnel Directory, The, 177 travel information, online, 154–56, 253 travel magazine photography, 165–70	variety, importance of, 16 view cameras (large-format), 37–38 visual problems. <i>See</i> inconsistencies/anachronisms Vivitar-283 automatic flash, 92–93
See also technical skills transparencies. See color transparencies travel advisories, 251, 321 Travel Industry Personnel Directory, The, 177 travel information, online, 154–56, 253 travel magazine photography, 165–70 practice assignment, 130–31	variety, importance of, 16 view cameras (large-format), 37–38 visual problems. <i>See</i> inconsistencies/anachronisms Vivitar-283 automatic flash, 92–93 W want-list services, 186, 328
See also technical skills transparencies. See color transparencies travel advisories, 251, 321 Travel Industry Personnel Directory, The, 177 travel information, online, 154–56, 253 travel magazine photography, 165–70 practice assignment, 130–31 travel photography, history of, 5–6	variety, importance of, 16 view cameras (large-format), 37–38 visual problems. <i>See</i> inconsistencies/anachronisms Vivitar-283 automatic flash, 92–93 W want-list services, 186, 328 Washington, D.C., photographing permits, 247
See also technical skills transparencies. See color transparencies travel advisories, 251, 321 Travel Industry Personnel Directory, The, 177 travel information, online, 154–56, 253 travel magazine photography, 165–70 practice assignment, 130–31 travel photography, history of, 5–6 travel shoots	variety, importance of, 16 view cameras (large-format), 37–38 visual problems. <i>See</i> inconsistencies/anachronisms Vivitar-283 automatic flash, 92–93 W want-list services, 186, 328 Washington, D.C., photographing permits, 247 weather, bad, shooting during, 74–75
See also technical skills transparencies. See color transparencies travel advisories, 251, 321 Travel Industry Personnel Directory, The, 177 travel information, online, 154–56, 253 travel magazine photography, 165–70 practice assignment, 130–31 travel photography, history of, 5–6 travel shoots basic photography kit, 28, 29	variety, importance of, 16 view cameras (large-format), 37–38 visual problems. <i>See</i> inconsistencies/anachronisms Vivitar-283 automatic flash, 92–93 W want-list services, 186, 328 Washington, D.C., photographing permits, 247 weather, bad, shooting during, 74–75 Web sites
See also technical skills transparencies. See color transparencies travel advisories, 251, 321 Travel Industry Personnel Directory, The, 177 travel information, online, 154–56, 253 travel magazine photography, 165–70 practice assignment, 130–31 travel photography, history of, 5–6 travel shoots basic photography kit, 28, 29 behavior during, 229–32, 297	variety, importance of, 16 view cameras (large-format), 37–38 visual problems. <i>See</i> inconsistencies/anachronisms Vivitar-283 automatic flash, 92–93 W want-list services, 186, 328 Washington, D.C., photographing permits, 247 weather, bad, shooting during, 74–75
See also technical skills transparencies. See color transparencies travel advisories, 251, 321 Travel Industry Personnel Directory, The, 177 travel information, online, 154–56, 253 travel magazine photography, 165–70 practice assignment, 130–31 travel photography, history of, 5–6 travel shoots basic photography kit, 28, 29 behavior during, 229–32, 297 budgets, costs, 215–16, 217–18	variety, importance of, 16 view cameras (large-format), 37–38 visual problems. <i>See</i> inconsistencies/anachronisms Vivitar-283 automatic flash, 92–93 W want-list services, 186, 328 Washington, D.C., photographing permits, 247 weather, bad, shooting during, 74–75 Web sites
See also technical skills transparencies. See color transparencies travel advisories, 251, 321 Travel Industry Personnel Directory, The, 177 travel information, online, 154–56, 253 travel magazine photography, 165–70 practice assignment, 130–31 travel photography, history of, 5–6 travel shoots basic photography kit, 28, 29 behavior during, 229–32, 297	variety, importance of, 16 view cameras (large-format), 37–38 visual problems. <i>See</i> inconsistencies/anachronisms Vivitar-283 automatic flash, 92–93 W want-list services, 186, 328 Washington, D.C., photographing permits, 247 weather, bad, shooting during, 74–75 Web sites establishing, 159–60
See also technical skills transparencies. See color transparencies travel advisories, 251, 321 Travel Industry Personnel Directory, The, 177 travel information, online, 154–56, 253 travel magazine photography, 165–70 practice assignment, 130–31 travel photography, history of, 5–6 travel shoots basic photography kit, 28, 29 behavior during, 229–32, 297 budgets, costs, 215–16, 217–18	variety, importance of, 16 view cameras (large-format), 37–38 visual problems. <i>See</i> inconsistencies/anachronisms Vivitar-283 automatic flash, 92–93 W want-list services, 186, 328 Washington, D.C., photographing permits, 247 weather, bad, shooting during, 74–75 Web sites establishing, 159–60 self-promotion using, 147
See also technical skills transparencies. See color transparencies travel advisories, 251, 321 Travel Industry Personnel Directory, The, 177 travel information, online, 154–56, 253 travel magazine photography, 165–70 practice assignment, 130–31 travel photography, history of, 5–6 travel shoots basic photography kit, 28, 29 behavior during, 229–32, 297 budgets, costs, 215–16, 217–18 choosing film for, 58–59	variety, importance of, 16 view cameras (large-format), 37–38 visual problems. <i>See</i> inconsistencies/anachronisms Vivitar-283 automatic flash, 92–93 W want-list services, 186, 328 Washington, D.C., photographing permits, 247 weather, bad, shooting during, 74–75 Web sites establishing, 159–60 self-promotion using, 147 <i>See also</i> computers; Internet
See also technical skills transparencies. See color transparencies travel advisories, 251, 321 Travel Industry Personnel Directory, The, 177 travel information, online, 154–56, 253 travel magazine photography, 165–70 practice assignment, 130–31 travel photography, history of, 5–6 travel shoots basic photography kit, 28, 29 behavior during, 229–32, 297 budgets, costs, 215–16, 217–18 choosing film for, 58–59 discount travel ("comps") for, 220	variety, importance of, 16 view cameras (large-format), 37–38 visual problems. See inconsistencies/anachronisms Vivitar-283 automatic flash, 92–93 W want-list services, 186, 328 Washington, D.C., photographing permits, 247 weather, bad, shooting during, 74–75 Web sites establishing, 159–60 self-promotion using, 147 See also computers; Internet wide-area exposure meters, 46–47 wildlife photography, 285
See also technical skills transparencies. See color transparencies travel advisories, 251, 321 Travel Industry Personnel Directory, The, 177 travel information, online, 154–56, 253 travel magazine photography, 165–70 practice assignment, 130–31 travel photography, history of, 5–6 travel shoots basic photography kit, 28, 29 behavior during, 229–32, 297 budgets, costs, 215–16, 217–18 choosing film for, 58–59 discount travel ("comps") for, 220 electricity concerns, 106	variety, importance of, 16 view cameras (large-format), 37–38 visual problems. See inconsistencies/anachronisms Vivitar-283 automatic flash, 92–93 W want-list services, 186, 328 Washington, D.C., photographing permits, 247 weather, bad, shooting during, 74–75 Web sites establishing, 159–60 self-promotion using, 147 See also computers; Internet wide-area exposure meters, 46–47 wildlife photography, 285 windows, light from, 78
See also technical skills transparencies. See color transparencies travel advisories, 251, 321 Travel Industry Personnel Directory, The, 177 travel information, online, 154–56, 253 travel magazine photography, 165–70 practice assignment, 130–31 travel photography, history of, 5–6 travel shoots basic photography kit, 28, 29 behavior during, 229–32, 297 budgets, costs, 215–16, 217–18 choosing film for, 58–59 discount travel ("comps") for, 220 electricity concerns, 106 film for, 58, 59	variety, importance of, 16 view cameras (large-format), 37–38 visual problems. See inconsistencies/anachronisms Vivitar-283 automatic flash, 92–93 W want-list services, 186, 328 Washington, D.C., photographing permits, 247 weather, bad, shooting during, 74–75 Web sites establishing, 159–60 self-promotion using, 147 See also computers; Internet wide-area exposure meters, 46–47 wildlife photography, 285 windows, light from, 78 workshops. See training
See also technical skills transparencies. See color transparencies travel advisories, 251, 321 Travel Industry Personnel Directory, The, 177 travel information, online, 154–56, 253 travel magazine photography, 165–70 practice assignment, 130–31 travel photography, history of, 5–6 travel shoots basic photography kit, 28, 29 behavior during, 229–32, 297 budgets, costs, 215–16, 217–18 choosing film for, 58–59 discount travel ("comps") for, 220 electricity concerns, 106 film for, 58, 59 tilm processing, 60, 236–37 insurance, 222–23	variety, importance of, 16 view cameras (large-format), 37–38 visual problems. See inconsistencies/anachronisms Vivitar-283 automatic flash, 92–93 W want-list services, 186, 328 Washington, D.C., photographing permits, 247 weather, bad, shooting during, 74–75 Web sites establishing, 159–60 self-promotion using, 147 See also computers; Internet wide-area exposure meters, 46–47 wildlife photography, 285 windows, light from, 78 workshops. See training World Wide Web. See Internet; Web sites
See also technical skills transparencies. See color transparencies travel advisories, 251, 321 Travel Industry Personnel Directory, The, 177 travel information, online, 154–56, 253 travel magazine photography, 165–70 practice assignment, 130–31 travel photography, history of, 5–6 travel shoots basic photography kit, 28, 29 behavior during, 229–32, 297 budgets, costs, 215–16, 217–18 choosing film for, 58–59 discount travel ("comps") for, 220 electricity concerns, 106 film for, 58, 59 tilm processing, 60, 236–37 insurance, 222–23 last minute checklist, 227	variety, importance of, 16 view cameras (large-format), 37–38 visual problems. See inconsistencies/anachronisms Vivitar-283 automatic flash, 92–93 W want-list services, 186, 328 Washington, D.C., photographing permits, 247 weather, bad, shooting during, 74–75 Web sites establishing, 159–60 self-promotion using, 147 See also computers; Internet wide-area exposure meters, 46–47 wildlife photography, 285 windows, light from, 78 workshops. See training
See also technical skills transparencies. See color transparencies travel advisories, 251, 321 Travel Industry Personnel Directory, The, 177 travel information, online, 154–56, 253 travel magazine photography, 165–70 practice assignment, 130–31 travel photography, history of, 5–6 travel shoots basic photography kit, 28, 29 behavior during, 229–32, 297 budgets, costs, 215–16, 217–18 choosing film for, 58–59 discount travel ("comps") for, 220 electricity concerns, 106 film for, 58, 59 tilm processing, 60, 236–37 insurance, 222–23 last minute checklist, 227 maps, 222	variety, importance of, 16 view cameras (large-format), 37–38 visual problems. See inconsistencies/anachronisms Vivitar-283 automatic flash, 92–93 W want-list services, 186, 328 Washington, D.C., photographing permits, 247 weather, bad, shooting during, 74–75 Web sites establishing, 159–60 self-promotion using, 147 See also computers; Internet wide-area exposure meters, 46–47 wildlife photography, 285 windows, light from, 78 workshops. See training World Wide Web. See Internet; Web sites writing, combining with photography, 167–68
See also technical skills transparencies. See color transparencies travel advisories, 251, 321 Travel Industry Personnel Directory, The, 177 travel information, online, 154–56, 253 travel magazine photography, 165–70 practice assignment, 130–31 travel photography, history of, 5–6 travel shoots basic photography kit, 28, 29 behavior during, 229–32, 297 budgets, costs, 215–16, 217–18 choosing film for, 58–59 discount travel ("comps") for, 220 electricity concerns, 106 film for, 58, 59 tilm processing, 60, 236–37 insurance, 222–23 last minute checklist, 227 maps, 222 in Moslem countries, 298	variety, importance of, 16 view cameras (large-format), 37–38 visual problems. See inconsistencies/anachronisms Vivitar-283 automatic flash, 92–93 W want-list services, 186, 328 Washington, D.C., photographing permits, 247 weather, bad, shooting during, 74–75 Web sites establishing, 159–60 self-promotion using, 147 See also computers; Internet wide-area exposure meters, 46–47 wildlife photography, 285 windows, light from, 78 workshops. See training World Wide Web. See Internet; Web sites writing, combining with photography, 167–68
See also technical skills transparencies. See color transparencies travel advisories, 251, 321 Travel Industry Personnel Directory, The, 177 travel information, online, 154–56, 253 travel magazine photography, 165–70 practice assignment, 130–31 travel photography, history of, 5–6 travel shoots basic photography kit, 28, 29 behavior during, 229–32, 297 budgets, costs, 215–16, 217–18 choosing film for, 58–59 discount travel ("comps") for, 220 electricity concerns, 106 film for, 58, 59 film processing, 60, 236–37 insurance, 272–23 last minute checklist, 227 maps, 222 in Moslem countries, 298 packing for, 39, 227	variety, importance of, 16 view cameras (large-format), 37–38 visual problems. See inconsistencies/anachronisms Vivitar-283 automatic flash, 92–93 W want-list services, 186, 328 Washington, D.C., photographing permits, 247 weather, bad, shooting during, 74–75 Web sites establishing, 159–60 self-promotion using, 147 See also computers; Internet wide-area exposure meters, 46–47 wildlife photography, 285 windows, light from, 78 workshops. See training World Wide Web. See Internet; Web sites writing, combining with photography, 167–68 Z Zimbabwe, photographing in, 284
See also technical skills transparencies. See color transparencies travel advisories, 251, 321 Travel Industry Personnel Directory, The, 177 travel information, online, 154–56, 253 travel magazine photography, 165–70 practice assignment, 130–31 travel photography, history of, 5–6 travel shoots basic photography kit, 28, 29 behavior during, 229–32, 297 budgets, costs, 215–16, 217–18 choosing film for, 58–59 discount travel ("comps") for, 220 electricity concerns, 106 film for, 58, 59 film processing, 60, 236–37 insurance, 272–23 last minute checklist, 227 maps, 222 in Moslem countries, 298 packing for, 39, 227 planning (researching), 21-22, 154–56, 213–15	variety, importance of, 16 view cameras (large-format), 37–38 visual problems. See inconsistencies/anachronisms Vivitar-283 automatic flash, 92–93 W want-list services, 186, 328 Washington, D.C., photographing permits, 247 weather, bad, shooting during, 74–75 Web sites establishing, 159–60 self-promotion using, 147 See also computers; Internet wide-area exposure meters, 46–47 wildlife photography, 285 windows, light from, 78 workshops. See training World Wide Web. See Internet; Web sites writing, combining with photography, 167–68 Z Zimbabwe, photographing in, 284 Zone VI camera systems, 38
See also technical skills transparencies. See color transparencies travel advisories, 251, 321 Travel Industry Personnel Directory, The, 177 travel information, online, 154–56, 253 travel magazine photography, 165–70 practice assignment, 130–31 travel photography, history of, 5–6 travel shoots basic photography kit, 28, 29 behavior during, 229–32, 297 budgets, costs, 215–16, 217–18 choosing film for, 58–59 discount travel ("comps") for, 220 electricity concerns, 106 film for, 58, 59 tilm processing, 60, 236–37 insurance, 222–23 last minute checklist, 227 maps, 222 in Moslem countries, 298 packing for, 39, 227 planning (researching), 21-22, 154–56, 213–15 pretravel checklist, 223–27	variety, importance of, 16 view cameras (large-format), 37–38 visual problems. See inconsistencies/anachronisms Vivitar-283 automatic flash, 92–93 W want-list services, 186, 328 Washington, D.C., photographing permits, 247 weather, bad, shooting during, 74–75 Web sites establishing, 159–60 self-promotion using, 147 See also computers; Internet wide-area exposure meters, 46–47 wildlife photography, 285 windows, light from, 78 workshops. See training World Wide Web. See Internet; Web sites writing, combining with photography, 167–68 Z Zimbabwe, photographing in, 284
See also technical skills transparencies. See color transparencies travel advisories, 251, 321 Travel Industry Personnel Directory, The, 177 travel information, online, 154–56, 253 travel magazine photography, 165–70 practice assignment, 130–31 travel photography, history of, 5–6 travel shoots basic photography kit, 28, 29 behavior during, 229–32, 297 budgets, costs, 215–16, 217–18 choosing film for, 58–59 discount travel ("comps") for, 220 electricity concerns, 106 film for, 58, 59 tilm processing, 60, 236–37 insurance, 272–23 last minute checklist, 227 maps, 222 in Moslem countries, 298 packing for, 39, 227 planning (researching), 21-22, 154–56, 213–15 pretravel checklist, 223–27 questions to ask before leaving, 220–221	variety, importance of, 16 view cameras (large-format), 37–38 visual problems. See inconsistencies/anachronisms Vivitar-283 automatic flash, 92–93 W want-list services, 186, 328 Washington, D.C., photographing permits, 247 weather, bad, shooting during, 74–75 Web sites establishing, 159–60 self-promotion using, 147 See also computers; Internet wide-area exposure meters, 46–47 wildlife photography, 285 windows, light from, 78 workshops. See training World Wide Web. See Internet; Web sites writing, combining with photography, 167–68 Z Zimbabwe, photographing in, 284 Zone VI camera systems, 38
See also technical skills transparencies. See color transparencies travel advisories, 251, 321 Travel Industry Personnel Directory, The, 177 travel information, online, 154–56, 253 travel magazine photography, 165–70 practice assignment, 130–31 travel photography, history of, 5–6 travel shoots basic photography kit, 28, 29 behavior during, 229–32, 297 budgets, costs, 215–16, 217–18 choosing film for, 58–59 discount travel ("comps") for, 220 electricity concerns, 106 film for, 58, 59 film processing, 60, 236–37 insurance, 272–23 last minute checklist, 227 maps, 222 in Moslem countries, 298 packing for, 39, 227 planning (researching), 21–22, 154–56, 213–15 pretravel checklist, 223–27 questions to ask before leaving, 220–221 reference books, 222	variety, importance of, 16 view cameras (large-format), 37–38 visual problems. See inconsistencies/anachronisms Vivitar-283 automatic flash, 92–93 W want-list services, 186, 328 Washington, D.C., photographing permits, 247 weather, bad, shooting during, 74–75 Web sites establishing, 159–60 self-promotion using, 147 See also computers; Internet wide-area exposure meters, 46–47 wildlife photography, 285 windows, light from, 78 workshops. See training World Wide Web. See Internet; Web sites writing, combining with photography, 167–68 Z Zimbabwe, photographing in, 284 Zone VI camera systems, 38
See also technical skills transparencies. See color transparencies travel advisories, 251, 321 Travel Industry Personnel Directory, The, 177 travel information, online, 154–56, 253 travel magazine photography, 165–70 practice assignment, 130–31 travel photography, history of, 5–6 travel shoots basic photography kit, 28, 29 behavior during, 229–32, 297 budgets, costs, 215–16, 217–18 choosing film for, 58–59 discount travel ("comps") for, 220 electricity concerns, 106 film for, 58, 59 film processing, 60, 236–37 insurance, 222–23 last minute checklist, 227 maps, 222 in Moslem countries, 298 packing for, 39, 227 planning (researching), 21–22, 154–56, 213–15 pretravel checklist, 223–27 questions to ask before leaving, 220–221 reference books, 222 returning home, 237–38	variety, importance of, 16 view cameras (large-format), 37–38 visual problems. See inconsistencies/anachronisms Vivitar-283 automatic flash, 92–93 W want-list services, 186, 328 Washington, D.C., photographing permits, 247 weather, bad, shooting during, 74–75 Web sites establishing, 159–60 self-promotion using, 147 See also computers; Internet wide-area exposure meters, 46–47 wildlife photography, 285 windows, light from, 78 workshops. See training World Wide Web. See Internet; Web sites writing, combining with photography, 167–68 Z Zimbabwe, photographing in, 284 Zone VI camera systems, 38
See also technical skills transparencies. See color transparencies travel advisories, 251, 321 Travel Industry Personnel Directory, The, 177 travel information, online, 154–56, 253 travel magazine photography, 165–70 practice assignment, 130–31 travel photography, history of, 5–6 travel shoots basic photography kit, 28, 29 behavior during, 229–32, 297 budgets, costs, 215–16, 217–18 choosing film for, 58–59 discount travel ("comps") for, 220 electricity concerns, 106 film for, 58, 59 film processing, 60, 236–37 insurance, 222–23 last minute checklist, 227 maps, 222 in Moslem countries, 298 packing for, 39, 227 planning (researching), 21-22, 154–56, 213–15 pretravel checklist, 223–27 questions to ask before leaving, 220–221 reference books, 222 returning home, 237–38 strobe lights, 104–107	variety, importance of, 16 view cameras (large-format), 37–38 visual problems. See inconsistencies/anachronisms Vivitar-283 automatic flash, 92–93 W want-list services, 186, 328 Washington, D.C., photographing permits, 247 weather, bad, shooting during, 74–75 Web sites establishing, 159–60 self-promotion using, 147 See also computers; Internet wide-area exposure meters, 46–47 wildlife photography, 285 windows, light from, 78 workshops. See training World Wide Web. See Internet; Web sites writing, combining with photography, 167–68 Z Zimbabwe, photographing in, 284 Zone VI camera systems, 38
See also technical skills transparencies. See color transparencies travel advisories, 251, 321 Travel Industry Personnel Directory, The, 177 travel information, online, 154–56, 253 travel magazine photography, 165–70 practice assignment, 130–31 travel photography, history of, 5–6 travel shoots basic photography kit, 28, 29 behavior during, 229–32, 297 budgets, costs, 215–16, 217–18 choosing film for, 58–59 discount travel ("comps") for, 220 electricity concerns, 106 film for, 58, 59 film processing, 60, 236–37 insurance, 222–23 last minute checklist, 227 maps, 222 in Moslem countries, 298 packing for, 39, 227 planning (researching), 21–22, 154–56, 213–15 pretravel checklist, 223–27 questions to ask before leaving, 220–221 reference books, 222 returning home, 237–38	variety, importance of, 16 view cameras (large-format), 37–38 visual problems. See inconsistencies/anachronisms Vivitar-283 automatic flash, 92–93 W want-list services, 186, 328 Washington, D.C., photographing permits, 247 weather, bad, shooting during, 74–75 Web sites establishing, 159–60 self-promotion using, 147 See also computers; Internet wide-area exposure meters, 46–47 wildlife photography, 285 windows, light from, 78 workshops. See training World Wide Web. See Internet; Web sites writing, combining with photography, 167–68 Z Zimbabwe, photographing in, 284 Zone VI camera systems, 38

Books from Allworth Press

Nature and Wildlife Photography: A Practical Guide to How to Shoot and Sell by Susan McCartney (softcover, $6\frac{3}{4} \times 10$, 256 pages, \$18.95)

Historic Photographic Processes: A Guide to Creating Handmade Photographic Images by Richard Farber (softcover, $8\frac{1}{2} \times 11$, 256 pages, \$29.95)

Creative Black-and-White Photography: Advanced Camera and Darkroom Techniques by Bernhard J Suess (softcover, $8\frac{1}{2} \times 11$, 192 pages, \$24.95)

Mastering Black-and-White Photography: From Camera to Darkroom by Bernhard J Suess (softcover, $6\frac{3}{4} \times 10$, 240 pages, \$18.95)

How to Shoot Stock Photos That Sell, Revised Edition by Michal Heron (softcover, $8\frac{1}{2} \times 10$, 208 pages, \$19.95)

ASMP Professional Business Practices in Photography, Fifth Edition by American Society of Media Photographers (softcover, 6¾ × 10, 416 pages, \$24.95)

Business and Legal Forms for Photographers
by Tad Crawford (softcover, includes CD-ROM, 8½ × 11, 224 pages, \$24.95)

Re-Engineering the Photo Studio by Joe Farace (softcover, 6 × 9, 224 pages, \$18.95)

The Writer's and Photographer's Guide to Global Markets by Michael Sedge (hardcover, 6×9 , 288 pages, \$19.95)

The Business of Studio Photography: How to Start and Run a Successful Photography Studio by Edward R. Lilley (softcover, $6\frac{3}{4} \times 10$, 304 pages, \$19.95)

Pricing Photography: The Complete Guide to Assignment and Stock Prices, Second Edition by Michal Heron and David MacTavish (softcover, $8\frac{1}{2} \times 11$, 152 pages, \$24.95)

The Copyright Guide: A Friendly Guide for Protecting and Profiting from Copyrights by Lee Wilson (softcover, 6×9 , 192 pages, \$18.95)

The Photographer's Guide to Marketing and Self-Promotion: How to Keep Good Paying Clients, Second Edition by Maria Piscopo (softcover, $6\frac{3}{4} \times 10$, 176 pages, \$18.95)

Overexposure: Health Hazards in Photography, Second Edition by Susan D. Shaw and Monona Rossol (softcover, $6\frac{3}{4} \times 10$, 320 pages, \$18.95)

Please write to request our free catalog. To order by credit card, call 1-800-491-2808 or send a check or money order to Allworth Press, 10 East 23rd Street, Suite 210, New York, NY 10010. Include \$5 for shipping and handling for the first book ordered and \$1 for each additional book. Ten dollars plus \$1 for each additional book if ordering from Canada. New York State residents must add sales tax.

To see our complete catalog on the World Wide Web, or to order online, you can find us at www.allworth.com.